Producing Animation

FOCAL PRESS VISUAL EFFECTS & ANIMATION SERIES

THE ANIMATOR'S GUIDE TO 2D COMPUTER ANIMATION
Hedley Griffin

PRODUCING ANIMATION
Catherine Winder and Zahra Dowlatabadi

Producing Animation

By
Catherine Winder and *Zahra Dowlatabadi*

Focal Press

An Imprint of Elsevier

AMSTERDAM BOSTON LONDON NEW YORK OXFORD PARIS
SAN DIEGO SAN FRANCISCO SINGAPORE SYDNEY TOKYO

Focal Press is an imprint of Elsevier.

∞ This book is printed on acid-free paper.

Library of Congress Cataloging-in-Publication Data
Winder, Catherine.
 Producing animation / by Catherine Winder and Zahra Dowlatabadi.
 p. cm.
 Includes index.
 ISBN-13: 978-0-240-80412-5 ISBN-10: 0-240-80412-0 (pbk. : alk. paper)
 1. Animation (Cinematography) I. Dowlatabadi, Zahra. II. Title
 TR897.5 .W65 2001
 791.43'3—dc21
 ISBN-13: 978-0-240-80412-5 00-069507
 ISBN-10: 0-240-80412-0
British Library Cataloguing-in-Publication Data
A catalogue record for this book is available from the British Library.

The publisher offers special discounts on bulk orders of this book.
For information, please contact:
Manager of Special Sales
Elsevier
200 Wheeler Road
Burlington, MA 01803
Tel: 781-313-4700
Fax: 781-313-4802

For information on all Focal Press publications available, contact our World
Wide Web homepage at http://www.focalpress.com

10 9 8 7
Printed in the United States of America

For Emily and Dylan

CONTENTS

5 The Development Process *91*

6 The Production Plan *101*

7 The Production Team *131*

8 Pre-Production *159*

9 Production *211*

10 Post-Production *255*

11 Tracking Production *273*

Appendix Animation Resources *287*

Index *303*

FOREWORD

A gray ocean. A black sky. Forty-foot waves pound the deck of a large ship that is being tossed about in a violent storm like a toy. A helicopter emerges from the clouds cutting a momentary path through sheets of blinding rain towards the vessel below.

Imagine being pushed out of the helicopter and lowered by a thin cable down to the troubled ship. You hit the deck hard, holding on for dear life, as a huge wave breaks over the bow. You stagger onto the bridge cold and wet, only to discover that the new high-tech navigation systems are down. You have been charged with taking command of the ship and steering it towards a top-secret location. You rally the crew: a rag-tag team of over 200 men and women assembled from around the world, who must now follow your lead and work in unison to keep the vessel afloat and on course . . .

Welcome to the world of producing animation! This is how I felt as I was handed 52 episodes of an animated series to produce with only 12 months left on the schedule. Gone were the original producers who had spent a third of the budget and all of the development time. Gone were the relationships with the overseas vendors. Nonexistent was the production methodology for the CGI portion of the show. The only thing left intact was the studio's enthusiasm for the project, a hungry network, and a tired crew. It was the greatest learning experience of my career . . . if only there had been a guide.

Full of contradictions and filled with the promise of great financial rewards and creative riches, the animation world is hard to define. It is a world that sits on the cutting-edge of technology, yet is still considered primitive for being so labor intensive. It is an industry that truly spans the globe, yet is surprisingly very small.

And to define an animation producer is harder still. One has to be part therapist, union negotiator, customs broker, technologist, artist, storyteller, international trade leader, attorney, filmmaker, talent agent, studio executive, mentor, and friend. It is incredibly challenging, all consuming, and in the end, very rewarding.

Though not all productions are storm-battered ships left adrift in wild oceans, both Catherine Winder and Zahra Dowlatabadi have courageously jumped into such situations and survived. It is from their extraordinary

range of experiences that we have for the first time a detailed look at the development and production process of producing animation.

David Lipman
Producer, *Tusker, Shrek*

Previous Credits: Head of Production for Feature Animation DreamWorks SKG; Executive in Charge of Production/Supervising Producer, Hanna-Barbera, Inc.; Vice President/Executive Producer, USAnimation, Inc.

ACKNOWLEDGMENTS

If it takes a village to raise a child, we should add that it took a metropolis to write this book. Many friends and colleagues were extremely generous in sharing their knowledge and time.

We would like to thank the following people for their invaluable input and help:

John Andrews, Jerry Beck, Laura Ben-Porat, Jeannine Berger, Lawrence Chai, Rick Danenberg, Hadi Dowlatabadi, Sylvia Edwards, Michael Eliasberg, Marci Gray, Van Griffith, Lowell Hall, Kym Hyde, Brooks Jewell, Marcia G. Jones, Fumi Kitahara, Igor Khait, Bob Kurtz, Laura Leganza Reynolds, Terry Lennon, George Maestri, Dave Master, John McCarthy, Brenda McGuirk, Jan Nagel, Bonnie Negrete, Chris Nelson, David Palmer, Trevor Pawlik, Kim Patterson, Donna Pilcher, Deborah Reber, Rory Richardson, Andrea Romero, Joanna Romersa, Dan Sarto, Kay Salz, Sue Shakespeare, Gina Shay, Colum Slevin, Roy Allen Smith, Don Spielvogel, Roxy Steven, Beth Stevenson, Terry Thoren, Mike Vosburg, Barry Weiss, David Womersley, and Doug Wood

We would also like to extend a heartfelt thanks to our reviewers, who played a very significant part in shaping this book:

Cheryl Abood, Viki Anderson, Kathy Barrows, Craig Berkey, Scott Bern, Gina Bradley, Ellen Cockrill, Lee Dannacher, Davis Doi, John Donkin, Edna Fuentes, Claire Glidden, Bob Gordon, Lucilla Hoshor, Jim Houston, Alex Johns, John Kafka, David S. Karoll, Megan Kennison, Heather Kenyon, Sarah Jane King, Hilmar Koch, Patrick Love, Jessica Koplos-Miller, Joyce Miller, Jerry Mills, Buzz Potamkin, Darrell Rooney, Myoung Smith, Mike Tavera, and Fiona Trayler.

We would like to express our appreciation to David Lipman for his succinct and creative way of describing what it takes to produce in the Foreword. Additionally, we thank all individuals whom we have quoted for sharing with us their definition of what makes a good producer.

We must make special mention of Drew Tolman, to whom we are deeply grateful for her extraordinary help in many areas, including researching books, journals, and organizations for the Appendix "Animation Resources," acquiring images, and formatting the production charts.

We also owe a special thanks to Ennio Torresan, Jr., artist par excellence, who did an amazing job in producing many of the illustrations for the book and allowing us to explore the characters of the lion and the rabbit.

We would also like to thank Jeff Starling for designing a magnificent background. To Wilbert Plijnaar, thank you for creating what we consider the perfect design for the cover of the book.

I, Catherine, would like to thank my husband, Craig Berkey, for his unconditional love, support, and patience. Throughout the writing of this book he was faced with almost daily compromises, but did whatever it took to help me achieve this goal. I would also like to thank Silvia Koleff for all of her wonderful help with Dylan. Knowing that he was in such good hands made it possible for me to spend the time I needed on the book.

I, Zahra, would like to thank my mother, Mahdokht Sanati, for being the incredible support that she has always been and for once again rearranging her life in order to allow me to fulfill my goal. I would also like to thank my uncle, Homayoun Sanati, for introducing me to *The Mathnawi of Jalalu'din Rumi* and the story of "The Lion and the Beasts." I cannot begin to thank my husband, Jim Beihold, enough for his infinite patience, encouragement, and fortitude. I consider myself amazingly lucky to be married to such a wonderful man.

1

INTRODUCTION

What exactly does an animation producer do? What is a creative executive? How much does it cost to produce one minute of animation? How do you put a production plan together for animation? Are there significant differences between producing a feature, direct-to-video (d-t-v) project, and television series?

This is just a tiny sampling of the many questions that we are asked as soon as we reveal our profession as animation producers. We tried looking for books to recommend to people interested in the topic, but realized there wasn't a suitable title out there. Although there are many well-written and useful books that discuss the technical process and art of animation (see Appendix, Animation Resources), there is nothing available that outlines the actual nuts and bolts of producing for major animation studios and distributors. As this is a significant missing piece of the picture, we decided to use our combined knowledge and experience and take on the challenge of providing it.

Producing animation is based on the ability to think logically, proactively, and creatively. It is a cerebral act that combines a technical knowledge of the animation process with individual style, experience, and gut instinct. Part of the problem of defining what an animation producer does is that the job function is truly amorphous. Throughout the animation industry, there is no single definition of what a producer does. And the role animation producers play on each project changes constantly. A producer's domain varies from production to production, as well as from studio to studio. The positive side of this variability is that producers are often able to shape the production to fit their own experience and expertise. On the flip side, it can lead to untested modes of production that can result in costly overages and frustrations for all involved.

In our opinion, the producer is the one person with the full overview and responsibility for a project from a creative, financial, and scheduling

1

perspective. Based on the creative expectations and fiscal parameters of the project, the producer pulls together an animation team. The producer sets up and manages both a production schedule and a budget, aiming to deliver the product at the agreed-upon level of quality. The producer is also in charge of keeping both the executives (or buyers) and the production team enthused and motivated. As this role is all encompassing, the knowledge base required to become a producer is quite extensive.

Our combined experience in the animation industry has been quite varied. Both of us progressed up through the ranks, and between the two of us, we have worked in almost all production capacities. Our job titles have included coordinator, production manager, overseas production manager, associate producer, line producer, co-producer, producer, executive producer, production executive, and vice-president of production. Zahra got her start in television production, but her career has been primarily focused on feature film and direct-to-video projects. Zahra's experience has been very hands on, working directly on the production lines. Catherine has worked in the areas of production and development for both television and feature films. Although she has rolled up her sleeves and produced several television series, the majority of her experience has been as an executive. She has overseen production facilities and projects in all formats, both domestically and internationally. She has also set up and run a studio from scratch. Combined, we have been involved in many different kinds of projects, including feature films, direct-to-video releases, television series, television specials, and short films.

We first met each other on an ill-fated production in 1991. We were both hired as troubleshooters in the last 10 months of production for an animated feature film. In a short time, we discovered that there was actually closer to 20 months' worth of work remaining to be done. With the story still in development, much of the production money was already spent. A completion bond company had moved into the production offices. The company was there to make sure that all production deadlines were met without failure so there would be no additional costs incurred. Their presence was a source of constant irritation for the producing team in Los Angeles.

The project was structured such that the pre-production and some of the production was completed in the LA studio. Due to the lack of available talent and budgetary and time restrictions, the work was then divided up and subcontracted to studios all over the world. Sections of the film were sent to Canada, Denmark, Spain, Australia, and Argentina. Every scene ultimately ended up going through a studio in Asia for clean up and ink and paint. Because each studio's availability and capabilities differed, the scenes had progressed to different stages of animation. Once scenes were finished in clean up, they were sent to LA for key effects and then back to Asia. The Asians were the "catch-all" studio, completing any artwork that was not finished.

department every week. Unless footage quotas are met in each category, there will not be enough work for the artists in the subsequent department to do. A domino effect ensues, causing the project to fall behind schedule. This offset travels all the way through the various departments to the end of the production line. While artists at the end of the production line have nothing to do, artists at the beginning of the production line are asked to undertake or work on the same scenes again and again. As revisions continue, these artists are caught in a vicious circle of not meeting their quotas. In the meantime, the time lag results in an escalation of department quotas in order to hit the film deadline, and the artists are pushed to produce more drawings every week. These circumstances create a self-defeating scenario in which the artists become demoralized, the production quality drops, and the project falls behind schedule and runs over budget.

My attempt to bridge the gap between development and production gave the executive a better understanding of the consequences of his rewrites and the various challenges I was up against. It also gave me an opportunity to get to know him better and understand why he felt the changes were so critical to the project. Together, we figured out how to solve the problems we were facing. We established an "on-hold" category so that scenes he believed could potentially change were held back from production, thereby avoiding the waste of talent, time, and money. He also requested to be copied on the production report in order to be more in sync with the project. Through our close collaboration, we were finally able to push the project forward and establish a mutually beneficial relationship between development and production.

Keeping in mind that each situation is unique, in this book we have attempted to define and clarify the process and procedures of producing animated projects with the focus on large-scale television, direct-to-video, and feature production using 2D or traditional animation and 3D Computer Generated Imagery (3D CGI). The intended audience for *Producing Animation* is broad, ranging from film students to industry professionals. Our primary goal is to create a basis from which a producer can springboard and structure a production based on its individual needs. This book will take the reader through all the steps necessary to set up a project, including selling an idea, developing and preparing an idea for production, as well as the actual production process. For the entrepreneur producer who is trying to sell his or her project, this book will describe the role of and identify the industry professionals to contact. *Producing Animation* outlines the various stages a property goes through before production starts. For the student or line producer who may be strictly interested in the production phase, we offer detailed information on how to budget, schedule, and track a project, as well as actual charts that can be used for such tasks. For professionals needing a basic knowledge of the animation business, this book provides answers to

ative goals and fiscal limitations of a project is the inherent challenge of every production. Despite having infinite potential paths to take, there inevitably comes a point in every production where choices have to be made and finalized. Having worked with many talented professionals, we have witnessed—and also experienced—the struggle to commit to creative decisions. Because this is so difficult, we have both wished we could refer these professionals to a source that explains the animation process and the implications of decisions made to the overall project.

On a project that I (Zahra) worked on as an associate producer, the development executive had an impressive live-action background, but no experience in animation. With the best of intentions to improve the film, this development executive took it upon himself to rewrite the dialogue for scenes, many of which had already been animated not just once, but multiple times. With the project rapidly falling behind schedule and going over budget, my job was to figure out which scenes could be safely worked on. Doing this would allow the project to meet production objectives and maintain momentum, as sufficient inventory would become available for each department. However, it was no easy task, as it seemed that no matter how I reworked the schedule and each department's weekly workload (also known as quotas), we were unable to move the project forward at a pace in keeping with the schedule. My top priority was to find a way to avoid the backward step of changing dialogue once a scene was animated. I had to devise a system that would allow us to catch scenes that required changes and stop them from entering production.

In order to get the work flowing through the animation department, I realized that I had to get on the same page as the executive. As an initial step, I invited him to attend dailies so he could get a sense of the process involved in animating a scene. (During dailies, scenes that have been completed through rough animation, clean up animation, effect, or color are viewed by the producer and director for approval.) While looking at the footage, the development executive was clearly impressed by the artistry that went into drawing each scene. My next step was to show the large stacks of drawing that made up the scenes we had just viewed. By his reaction, it was evident that the executive had not been aware of the staggering amount of work that went into getting the scenes animated.

I was very lucky because the executive was extremely smart and the brief introduction made him eager to learn more about animation. The first thing we had to establish was an understanding of the schedule. The timeline in animation can be deceptive for someone who is not familiar with the process. Even though we had close to two years of production time remaining, every day was already accounted for and there was little room for revisions. Together we explored the quota system—that is, how a production relies on getting a certain number of feet or seconds completed through each

planned for the Chinese New Year, which stopped production in the Asian studio for an entire week. At the same time, the LA crew had to contend with their own unexpected problem: the LA riots. It was not safe to be out on the streets, and the crew rightfully feared traveling to and from work. An angry driver had actually chased the head of the background department along the pavement of an LA street. In addition, all artwork shipments to and from the subcontracting studios were halted since the LA airport was very close to the hotbed of the riots.

As this was before the days of e-mail, we averaged 20 to 30 faxes a day to each other, trying to get a handle on the project. Fighting off packs of diseased dogs on the way to work helped Catherine limber up for the physical work ahead. As the entire studio took a daily nap, she would often have to climb up on the artists' desks to the shelves above in order to find missing scenes. (At some overseas studios, it is customary to sleep under the desk or on a cot since the crew literally works around the clock to get the work completed on time.) Meanwhile, back in LA, the artistic supervisor wanted to keep tweaking key elements even after they were approved. As production in certain countries was on hold until they could get the materials, Zahra had to do evening reconnaissance missions to keep the show moving. Staying until everyone had left, she would search and find the artwork. The next day she would get the director's approval and coax the artistic supervisor into relinquishing the scenes in order to ship them out.

Somehow, through all the chaos, we managed to revise the schedule so that it was manageable. We put a tracking system in place and got scenes completed through production. Most importantly, we were able to motivate our team and finish the picture on time. It took a lot of emotional fortitude and diplomacy, as we were in the middle of a war zone with very high stakes and fiery tempers. At the end of it all, we both naively assumed that there had to be an easier way to produce a film. Over the years, however, we have discovered that the complexity of the medium almost prohibits the possibility of a stress-free and orderly production. Many of the obstacles encountered are the direct result of the creative process itself and should be expected. On the other hand, many of the production snags are unnecessary and can be avoided with good planning and foresight.

Beyond committing to paper the nuts and bolts of producing animation, a primary purpose of this book is to help less experienced decision-makers (those new to the animation business, such as corporate executives and creators) to make smart, production-savvy decisions. Producing animation can be a highly rewarding experience. When developing a new project, there are no boundaries for creators, writers, and artists, as the characters and their world can be created from scratch on a blank piece of paper. The rules of the physical world do not apply. As a result of this freedom, the possibilities are limitless. Achieving the appropriate balance between the cre-

Because the project was being outsourced to so many different studios, it was unclear where the approximately 1,350 scenes had been shipped, and how far along the production pipeline they had progressed. To top it off, the anemic tracking system in place proved to be completely out of date. It was our job to figure it all out and get the film completed by the fixed delivery date. Zahra was based in LA while Catherine was at the subcontracting studio in Asia.

Once we got started, we quickly discovered that the project had been prematurely greenlit for production. (We should add that this is unfortunately a very common problem with animated projects.) None of the many changes taking place seemed to be able to fix its inherent story problems and only confused and complicated the production. At the home-base studio in LA, the script was continuously changing. Character and location designs were being completely re-done. Scenes were being added and taken out as fast as they were being completed. The final deadline, however, remained firmly intact. It was impossible to feel like we were making any headway. As a result, the production crew was quickly losing their enthusiasm for the project.

Given the number of studios working on the project, the cultural challenges were enormous. Receiving work from numerous animation studios, all communicating in different languages, made it extremely difficult for the American and Asian crews. Many of the artistic revisions had not made it all the way down the lines of communication to each studio around the world. Consequently, scenes that had already been fully animated had to be redrawn. Since it was often difficult to pinpoint exactly whose responsibility it was to make these changes, the burden rested on the Asian team to handle this additional work.

Naturally, the LA studio had the highest expectations and made demands that were impossible to fulfill under the circumstances. Working six to seven days a week to try and catch up left the Asian crew feeling unappreciated and unable to put their best efforts forward. As time was short and they were being pressured, they had to make artistic compromises in order to get the scenes completed. Unfortunately, these creative shortcuts led to further frustrations by the LA team and resulted in even more revisions. The Asian crew was expected to produce top-rate animation, but there was no time for this in the schedule, so both teams often locked horns. Part of the problem was that the subcontractors were producing a feature film thousands of miles away from the creative decision-makers. The quality control checkpoints were impossible to implement without some artistic compromise. In short, we had our work cut out for us with the two main crews feeling frustrated, unhappy, and burned out.

An important consideration that should always be taken into account when running an international production is cultural traditions and holidays, both in the US and abroad. With the clock ticking away, no one had

commonly asked questions, along with an overview of animation methodologies.

Unlike other forms of art, animation is a medium that is always changing. During the writing of this book, the industry has undergone phenomenal changes through technology and the Internet, making it almost impossible to keep up with all of its innovations. Many of the lessons we have learned, however, are fundamental to the business, no matter what the format or methodology. We hope that by sharing our own experiences we may help pave an easier path for future animation producers. Additionally, it is our sincere hope that the information in this book will entice new producers to enter the industry, and along with professionals already in the business, continue to push the frontiers of animation to more exciting and unforeseen territories.

Welcome to the wacky world of animation. We hope you enjoy its challenges, as there is nothing more satisfying than seeing the results of your hard work moving on the screen and the audience responding to it.

Commonly Asked Questions about Producing Animation

How do you become an animation producer?

The best schooling for a future producer is to begin as a production assistant and work up through the ranks of the production team. Starting from the ground up on an animated picture gives you the advantage of learning the process on a practical basis, and often helps you gain a deep appreciation and respect for the talent of both the artistic and the production teams. As a production assistant, you work directly with the artists. This allows you to get firsthand experience on how artwork is generated and handled. You will discover the detailed nature of animation, and why even the slightest mistake such as misnumbering a storyboard panel can quickly derail the production.

The next step up from production assistant is called coordinator, production supervisor, or assistant production manager. The titles used for this position vary depending on the studio's structure and the project's format. In this role, you are the liaison between the production manager, the department supervisor, and the artists. It is your job to keep the artists on schedule and track the flow of artwork. This position is highly beneficial, as you will begin to develop the ability to create schedules. You will be able to estimate how many artists are needed in order to meet the weekly quotas, and gauge an approximate amount of time required to complete a given piece of artwork. Establishing a good relationship with the artists and knowing how to motivate them is another key lesson you can learn in this position.

During weekly meetings held to review the artwork with the director, you get to see why a scene may require revisions and what creative solutions are used to fix the problem. Having successfully managed your team of artists, you may then be considered for the role of production manager.

The production manager takes on increased responsibilities, such as directly managing members of the production crew and artists from a budgeting and scheduling standpoint. With the aid of coordinators or assistant production managers, it is up to the production manager to keep the entire production on schedule. Although you may not be privy to the actual dollar amounts allocated to each category, with guidance from the producer, your primary goal is to stay on budget based on the fixed number of hours given to you. You will use these figures as a guideline to meet the production's objectives. As a production manager, you will wear many hats as you begin to work with both the creative and the business sides of a project. You will have the power to hire freelance artists and make deals with them in accordance with the budget. Most importantly, this role offers the ideal opportunity for you to shadow the producer and learn as much as possible. For more information on roles of the management team, see Chapter 7, "The Production Team."

Proving that you are able to meet deadlines, understand the production process, and complete a project within the allotted time indicates that you are prepared for the next challenge: taking on the duties of an associate producer or line producer. In this position, you are responsible for the overall financial aspect of a production, along with keeping it on schedule. Having now worked on numerous projects, you are knowledgeable about the creative needs specific to each show. By attending casting and recording sessions, you have learned what qualities to look for in a performer during an audition. You can assess what makes a good story. You are able to recognize strong character design and understand the importance of color choices. In this position, you can further sharpen your deal-making skills as you get exposed to how the producer and the business affairs department negotiate contracts with high-end artists, voiceover talent, and writers. By now, you have had an ample amount of training and should be able to create budgets and schedules and put together crew plans.

Each of your varied experiences should have taught you to think strategically, understand story structure, and balance both the creative and business ends of the process. You should be able to troubleshoot by quickly coming up with alternate options when faced with a problem. Once you have reached this point in the production hierarchy, your next advancement is to step into the shoes of a producer. (For more information on the different types of producers and their respective duties, see Chapter 2, "The Animation Producer.")

Why does it take so long to produce a traditionally animated project?

Producing a hand-drawn animated project is very labor intensive. You will often hear the question on animated features made in the US, "Is the scene on ones or twos?" This question refers to how many frames will be shot per drawing. If the animation is on "ones" (one drawing per frame with 24 frames per second), then you need 1,440 drawings for 1 minute. Multiply the drawings you need per minute for a 75-minute feature, and you have well over 100,000 drawings. Moreover, on average, you usually have 1 to 3 characters in each scene. If you were to count each of these images, then you quickly run into over 300,000 drawings.

So far, we have only focused on character animation. However, each scene also has a background. On average, every background has a minimum of two to three elements, but it can go beyond 60. A scene could be a 12-field setup (12 inches across) or it could be over 20 feet in length for long panning shots. It is not uncommon for a film to have over 1,000 painted backgrounds. In addition to the backgrounds, there is also the visual effects level (or all the non-character-related animation, such as rain, fire, and smoke) to consider, which will require hundreds and hundreds of effects drawings.

Described so far are the images you see on the final film. One of the extraordinary aspects of animation is that in reality, over half the work completed never makes it to the screen. For all the cleaned up animation, painted backgrounds, and cleaned up effects that we have already talked about (see Chapter 9, "Production," for more detail), there is also rough animation, rough layout, clean up layout, and rough effects. Prior to layout, there is also the storyboarding phase in which each sequence goes through many evolutions before it is ready for production. Before the storyboarding begins, there is the visual development phase during which artists create many drawings in order to come up with the final character designs and locations. If you take into consideration all the artwork, the sheer magnitude of labor involved on animated features becomes clear.

Up to this point, we have only written about the amount of *drawings* produced on a project. We have not touched on the other departments that don't actually draw, but are also central to the production's creative process, such as editorial, scene planning, animation checking, and ink and paint to name a few. In other words, the creation of the artwork takes a substantial amount of time, but you also need to add in the multiple hours required in other departments that play a significant part in completing a scene. If you were to follow the progression of a scene from the storyboard phase to final color (as we describe in detail in Chapter 8, "Pre-Production," and Chapter 9, "Production"), it is abundantly clear why the process is so slow and costly.

Are all artists called animators? What exactly is an animator?

It seems logical to call all artists working on an animated project animators, but it is not accurate. An animator can take a design of a character or an object and bring it to life through creating their movement and action. The animator's role can best be likened to that of an actor. Just like any other performer, whether it is in the theater, the opera, or the ballet, he or she takes center stage. But it is through the combined efforts of many talented individuals—such as visual development artists, storyboard artists, editorial staff, layout artists, clean up artists, technical directors, and many other staff members—that a show gets completed and offered to the public.

What kind of skills are required to get into the field of animation?

People often ask how to receive training in three main job categories: 1) an artist, 2) a member of the production staff, or 3) a voice-over actor.

Artists

The most important tool artists can have is a portfolio (or a sampling of their best work). It is an artist's calling card. If you do not have a portfolio, you must prepare some initial artwork to start building one. Taking classes offered at animation colleges or at the animation union are good places to begin accumulating samples of your work. Some studios have training programs that generally last three months, but they are rare and difficult to get in to.

For those artists who already have a portfolio, it is important for them to continuously update it. Keep copies of artwork from previous projects you have worked on. Recent sketchbooks should also be included. If you have many years of accumulated artwork, it is always wise to get help from fellow artists to select your strongest work. You should also research the show you are applying for and make sure that your portfolio includes artwork that is suitable for the project.

In hiring, every studio has its own specific requirements based on the status of their projects in production and pre-production. Initially, the best thing to do is to contact the recruiting office or Human Resources office of a studio and request information on their portfolio requirements. Follow the guidelines closely. Depending on your skill set (for example, whether you are an animator or a painter), the requirements for your portfolio pieces will vary. For detailed information on previous experience needed for different job categories, see Chapter 9, "Production."

The following is an example of the portfolio requirements.

When applying for an entry-level position in clean up animation, your portfolio should contain samples of:

- Clean up drawings and original roughs
- Flippable inbetweened scenes
- Life drawing sketches
- Artwork from personal or school projects
- Videotape of animation exercises

When you have all your artwork prepared, set up a time to drop off your portfolio. Most studios have weekly or monthly reviews and will then return your portfolio to you. Some artists prefer to make copies of their work and leave the copies at the studio so that their work is always available to the recruiting department. You may be asked to take a test. This procedure is very common in most studios. A standardized test is often a fair gauge of judging an artist's aptitude for the project.

Production Staff
There are several ways to get into production. While a portfolio is an artist's calling card, a resume or curriculum vitae (CV) should be used when applying for a future production staff position. Make sure you have a strong resume that emphasizes your abilities to organize, work with people, communicate, and juggle many things at once. It is important that your resume is easy to read and can be understood at a glance. It should not be more than two pages long. If you have listed individuals on your resume as references, it is wise to speak with them in advance to prepare them for a possible call. By doing so, you give your contacts a chance to review your work experience, and then, hopefully, they will be able to give you a glowing referral when the time comes.

If you have little or no production administration in your background, you should look to get on a project as an intern, production assistant, or a producer's assistant. If you attend a community college, you may be able to design a class in which you can get school credit in exchange for doing an internship at a studio. Computer skills are also an important asset. Having a working knowledge of software programs such as Filemaker Pro, Excel, and Photoshop can give you the winning edge by setting you apart from other candidates applying for the same position.

Voice-Over Actor
Most voice-over actors have agents who send them to auditions. If you don't have an agent, it is important that you assemble a tape that demonstrates

your voice range and talent. You should then research voice agencies and send them a tape. Be sure that the tape quality is professional.

When a voice-over actor is hired, the agent negotiates the deal and helps the actor with all of the contractual paperwork. The agent is then paid a percentage of the actor's negotiated fee. The average voice-over session takes approximately 4 hours, depending on the role. Pay rates vary based on the type of voice-over work being done, and whether the project is union or non-union (that is, Screen Actors Guild [SAG] or not). For union work, it is best to contact SAG directly to get the updated minimum rates. For non-union work, the amount paid is whatever you or your agent can negotiate.

Whether you have an agent or not, it is a good idea to take a voice-over acting class, as it will help you hone your skills and make potential contacts. Many of the voice-over coaches are professional voice-over directors who are looking for fresh talent. (For more information on auditions and casting, see Chapter 8, "Pre-Production.")

What effects have computers had on the animation industry?

Computers have altered the landscape of animation in two distinctly different arenas: 1) the use of Computer Generated Imagery (CGI or CG), a form of animation that enables the artist to draw 3D images using the computer, and 2) the use of the computer as a tool in the 2D production process often referred to as "Digital Technology."

A common misconception is the belief that the use of computer hardware and software enables an artist to just press a few buttons and—presto— the drawings are done. This is not the case, although there are instances in which computers can make the life of an artist a little easier. For example, computers can produce an "inbetween." However, this action can only take effect after the CG animator has completed the key frames or extreme poses. (See Chapter 9, "Production," for more details on inbetweening.) The main difference between 2D and CG animation is in the tools used. The artist who once drew with pencil and paper can now use the keyboard and mouse to create and shape images. This technique requires just as much artistic talent, expertise, and hard work as do other forms of animation.

Over the years, the number of CG projects has steadily increased. Examples of such films are *Disney's Toy Story* and *A Bug's Life* (produced in association with Pixar) and Pacific Data Images and DreamWorks' coproduction of *Antz* (see Figure 1–1). There are also an impressive number of CG television shows beginning to crop up, including Sony Pictures Family Entertainment Group's *Roughnecks: Starship Troopers Chronicles* (see Figure 1–2) and *Max Steel* (see Figure 1–3), and Nelvana Communications' *Rolie Polie Olie* (see Figure 1–4).

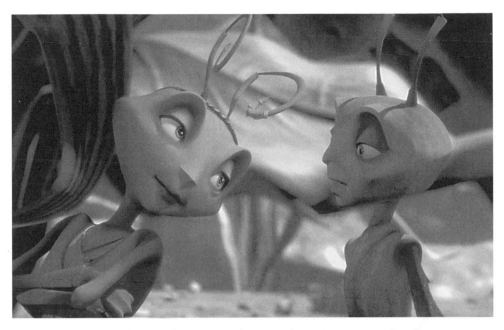

Figure 1–1 *Antz* (TM and © 1998 DreamWorks L.L.C., reprinted with permission by DreamWorks Animation)

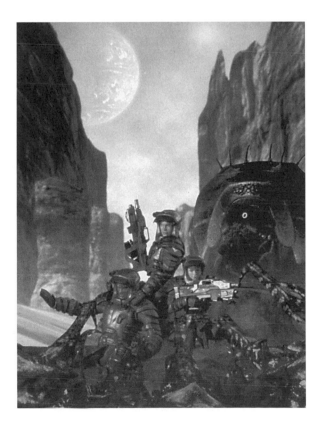

Figure 1–2
Roughnecks: Starship Troopers Chronicles
(TM & ©2001 Sony Pictures Family
Entertainment Group and Adelaide
Productions Inc.)

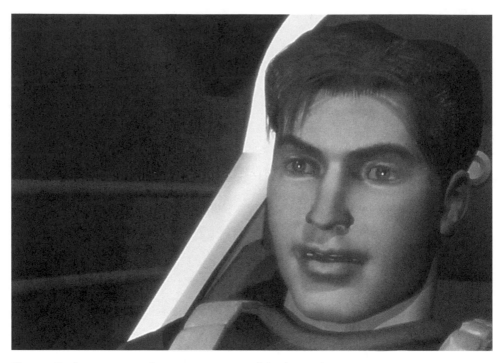

Figure 1–3 *Max Steel* (TM & © 2001 Adelaide Productions Inc.)

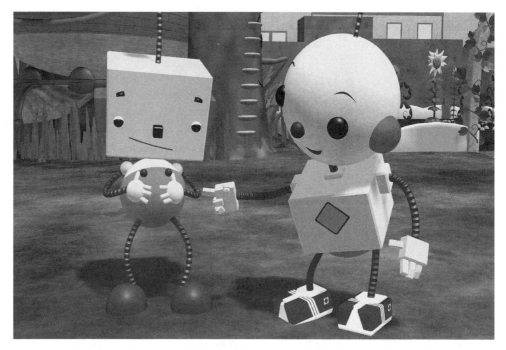

Figure 1–4 *Rolie Polie Olie* (Rolie Olie Polie Series ©1999 Nelvana Limited/Metal Hurlant Productions s.a.r.l. All rights reserved. Provided courtesy of Nelvana.)

Also on the rise are projects that use a combination of hand-drawn animation and CGI. In such films, characters, props, or environments may be generated in the computer and then combined with traditional animation. An example of this type of hybrid animation can be seen in Warner Bros.' *Iron Giant*. All the main characters are hand drawn, but the Iron Giant was created on the computer. Another title that fits into this category is Disney's *Tarzan*, in which the background elements such as the trees and bushes are 3D computer objects composited on traditionally drawn backgrounds and painted to look 2D. An impressive integration of 2D and CG imagery can also be seen in 20th Century Fox's *Titan A.E.* (see Figure 1–5). On this feature, close to 90 percent of the scenes contained CG elements either as the environment, character, or prop.

It used to be that creating CG animation was exclusive to production studios that were willing to invest millions of dollars in both cultivating talent and developing computer programming. Development of new software such as Flash, however, has turned the once elite form of filmmaking into a medium available to any individual with access to a desktop computer. Flash offers the animator step-by-step guidelines on how to use its tools to draw and time the animation and then import the finished product onto the web. Although web animation presently is limited, it is only a matter of time before the color depth and size of the file are no longer an impediment. Once the project is placed on a website, it has a potential viewership of over 100 million users. Since there are no intermediaries such as a distributor or an exhibitor, there are no commercial expectations for the project. This method of production enables the artist to have ultimate creative

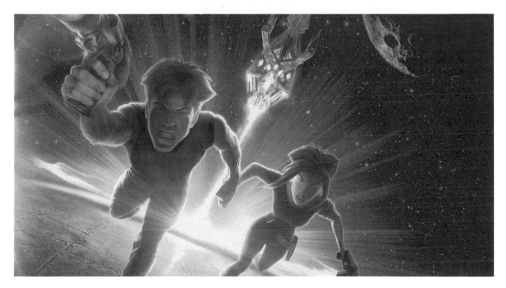

Figure 1–5 *Titan A.E.* (TM and © 1998 Twentieth Century Fox Film Corporation. All rights reserved.)

control and the most direct relationship with the viewer possible. (See the Appendix, "Animation Resources," for book titles on Flash animation.)

How does the production timeline for a CG television show compare to a television show that is produced traditionally?

Television shows that use the CG technique can definitely benefit from a shorter production schedule. One example is the Decode Entertainment Inc. television series *Angela Anaconda* (see Figure 1–6). This is a cut-out animation show that is produced entirely with computers. While traditionally drawn television shows take an average of 6 to 9 months to complete after the voice track has been recorded, *Angela Anaconda* is ready for delivery in three weeks. It all depends on the style of the show. It should also be noted that the increased speed in production is typically a direct result of being able to spend substantial time and money to develop and tailor the necessary software required for the show. These funds have to be spent up front in order to secure a functional production pipeline that will support the progression of a CG show from one stage to the next. This money is also used to cover the development of new software. It is a common misconception that there are existing software products in stores that can immediately result in savings as soon as the decision has been made to produce a show

Figure 1–6 *Angela Anaconda* (© 2000 DECODE Entertainment Inc. *Angela Anaconda* is a registered trademark of Honest Art, Inc. All rights reserved.)

using CG rather than traditional animation. See Chapter 9, "Production," for more information on the 3D CG pipeline.

What are the deciding factors for using CG elements on a traditionally animated show?

Two factors are involved in making such a decision: creative and production efficiency. At times, the director might select to have a CG character or background because of the actual look that the computer is capable of producing. Or, it may be a matter of speeding up production. Speaking in general terms, the option to create a character, background, or prop in the computer becomes a viable one when it is too difficult to animate or paint traditionally or when the element is an integral or recurring part of the show. In this case, the characters that are digitally produced tend to require no subtle acting, but are difficult to animate (such as the monster with multiple heads in Disney's *Hercules* or generic characters such as a herd of traveling oxen). Other items that are great candidates for CG production are vehicles with moving parts (such as wheels) or other types of props that can be easily created and reproduced. In choosing to use CG elements, it is critical to determine how much time will be involved in producing the CG elements in addition to the number of artists needed prior to the start of production. The amount and complexity of the artwork should also be considered in relation to the compositing and rendering capabilities available on the project.

What are the average budget and schedule for an animated show?

To obtain the most recent and accurate figures, we contacted a number of independent production houses and large studios with specific questions for each format. However, it is difficult to say exactly how much a project may cost since there are so many variables. Key items to be considered when putting together a budget include the project's purchase price; the cost of the key creative talent attached to the property; the type of story being told; the style, technique, and complexity of the animation; the format; where the animation is being produced; and the delivery schedule. (For more detailed information on how to budget, see Chapter 6, "The Production Plan.") Figure 1–7 presents a sample budget and schedule for features, direct-to-video, and television projects.

The budget for a feature film can be as low as 15 million dollars and as high as 100 million dollars and up. Direct-to-video projects range from 5 to 25 million dollars. A television series, depending on the number of episodes produced and the complexity of animation, has a very broad budget range. A low-budget show can start at 250,000 dollars per episode, while more high-end shows such as a primetime show like *The Simpsons* (see Figure 1–8) can reach over 1.5 million dollars.

THEATRICAL

FORMAT	LENGTH	AVERAGE FOOTAGE	AVERAGE # OF SCENES	DELIVERY FORMAT	PRODUCTION SCHEDULE	AVERAGE BUDGET (U.S.$)
FEATURE - 2D and 2D/CGI COMBINATION	75-85 min.	6750-7650	1250-1500	35mm, 70mm film	2-3 1/2 years	Low $15,000,000 High $120,000,000
FEATURE - 3D CGI	75-85 min.	6750-7650	1350-1700	35mm film	2-3 1/2 years	Low $25,000,000 High $100,000,000

DIRECT - TO - VIDEO

FORMAT	LENGTH	AVERAGE FOOTAGE	AVERAGE # OF SCENES	DELIVERY FORMAT	PRODUCTION SCHEDULE	AVERAGE BUDGET (U.S.$)
VIDEO - 2D	75-82 min.	6750-7380	900-1100	D-1	1-2 years	Low $5,000,000 High $25,000,000

TELEVISION

FORMAT	LENGTH	AVERAGE FOOTAGE	AVERAGE # OF SCENES	DELIVERY FORMAT	PRODUCTION SCHEDULE	AVERAGE BUDGET (U.S.$)
SHORTS - 2D	7 min.	630	60-130	D-1, D-2 Digital Betacam	3-6 months per episode	Low $75,000 High $650,000
NETWORK SERIES - 2D	22 min.	1980	300-450	D-1, D-2 Digital Betacam	9-12 months per episode	Low $350,000 High $1,500,000
NETWORK SERIES - 2D CGI and 3D CGI	22 min.	1980	350	D-1, D-2 Digital Betacam	14-18 weeks per episode	Low $300,000 High $450,000
CABLE SERIES - 2D	22-28 min.	1980-2520	250-475	Digital Betacam	3-12 months per episode	Low $250,000 High $850,000
TV SPECIALS - 2D	22 min.	1980	450-600	D-1, D-2 Digital Betacam	9-15 months	Low $650,000 High $1,000,000
	48 min.	4320	800-950	D-1, D-2 Digital Betacam	12-18 months	Low $1,200,000 High $2,000,000

Figure 1-7 Sample Budget and Schedule for Features, Direct-to-Video, and Television Projects

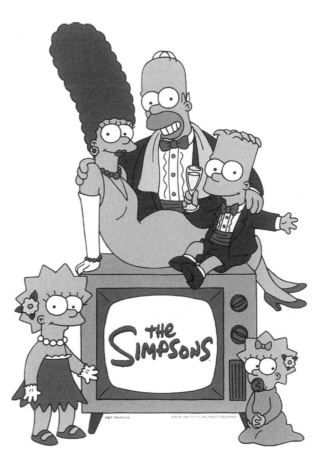

Figure 1–8 *The Simpsons* (TM and
© 1998 Twentieth Century Fox Film
Corporation. All rights reserved.)

2

THE ANIMATION PRODUCER

What Is an Animation Producer?

Attempting to define what an animation producer does has been our biggest challenge in writing this book. We discovered that for every rule we created, there were several exceptions. As a result, we decided to use the Producer's Guild of America's definition of the producer as a starting place. It is as follows:

> A producer initiates, coordinates, supervises and controls, either on his or her own authority (entrepreneur producer) or subject to the authority of an employer (employee producer), all aspects of the motion-picture and or/television production process, creative, financial, technological and administrative, throughout all phases from inception to completion, including coordination supervision and control of all other talents and crafts, subject to the provisions of their collective bargaining agreements and personal service contracts.

While much of the above definition is applicable, the animation producer's scope of responsibility varies based on his or her area of expertise and place of employment. At the major studios, most producers are "employee producers." Under this production structure, the studio's core executive group usually sets up and oversees all projects. They may, for example, hire a producer after a project has been developed and budgeted and is ready to go into production. Often times, an employee producer may not be responsible for all aspects of the production as outlined by the Producer's Guild of America's definition. A producer may not necessarily

need to create a budget; but they should have the skill required to manage it. In contrast to employee producers, smaller independent studios tend to be headed by the "entrepreneur producers." Due to lack of financial resources, these producers have to wear many hats. As a result, they often have to put together a budget themselves as well as oversee it.

There are multiple titles associated with the producer credit. The most commonly used are executive producer, producer, co-producer, line producer, and associate producer. Of course, there are many variations to the above list, including creative producer, consulting producer, supervising producer, and assistant producer, to name a few. Theoretically, titles are based on an individual's background and experience level. In some cases, however, they are based on what an agent or a representative is able to negotiate for their clients, wholly independent of their actual ability.

In other instances, a producing credit may be based on the format of the show. An example of this can be found in the area of credits accorded to television writers. For primetime series, most staff writers are given credit as producer and writer, while on a feature they would be given a writer credit only. Although there are numerous variations of the producer credit, for the purposes of this book, we've broken the job description into three basic categories according to the role/function they play on a production.

The first type of producer is the "deal maker." These producers help to gather the financial resources and potentially key players, including talent and/or a production studio, for a project. They generally have little or no creative input. Deal maker producers are usually non-exclusive, meaning that they can work for other studios and have multiple projects in progress. It is highly unlikely that they would focus all their time on a single production. Instead, deal maker producers hire a line producer to handle the actual production of a show for them.

The second type of producer is a person who facilitates pulling the entire production together. This "facilitator" producer generally does not draw or write, but has an overall creative understanding of both the drawing and the writing, and therefore has some artistic input. This type of producer is very hands-on during production, but their involvement in the level of production detail often depends on who they have working for them. Their main focus tends to be the budget and schedule, with the overall goal of meeting the creative demands of the project.

The third type of producer we will call the "creative" producer. These producers have the ability to draw and/or write and they are heavily involved in the creative decision-making process. While they do have responsibility for the budget and schedule, their emphasis is on the creative side. In this configuration, most often a line producer handles time and money management.

The following sections define the most common producers in detail.

Executive Producer

Typically, *executive producers* oversee the entire project from start to finish from both a creative and operational point of view. On the creative side, they oversee the hiring of key creative staff (that is, producers, the director, and writers). They are also involved in script development and the look of the show. Additionally, they give notes and input throughout the course of production. On the production side, they usually have input into and sign off on the project's production plan, including the budget and schedule. It is important to keep in mind that the role of these producers, in most cases, is defined by the individual person, his or her background, and the format the project is being produced in.

On features and direct-to-video projects, an executive producer tends to fall into the deal maker category. This type of producer is probably not exclusive to the project, but would have input in key areas negotiated up front. The executive producer would monitor the progress of production to ensure its timely delivery. In episodic television, the executive producer is usually considered the "show-runner" or creative visionary behind a production. Therefore, they would most often fall into the creative producer category. The executive producer is involved in all stages of development, including the creation of the bible (that is, the design of main characters and overall art direction; see Chapter 5, "The Development Process," for more information on this topic.) Once production begins, everything crosses the executive producer's desk so that he or she can review materials and give notes to ensure that the project remains in line with the overall vision. These materials include pre-production elements such as the script, artwork, and storyboards (see Chapter 8, "Pre-Production," for more information); production materials, including pencil tests and color (see Chapter 9, "Production," for more information); and post-production, where they are involved in editing as well as audio and video sessions (see Chapter 10, "Post-Production"). As the main point person for the buyer (who is either funding the production or is representing the individual/entity who is providing the funds), the executive producers are often the individuals who receive creative and legal notes to be implemented. They usually have input on marketing, air schedules, and viewing order, and are ultimately responsible for delivering the project on schedule and at the agreed-upon level of quality.

Producer

The most common type of animation producer best fits under the category of the "facilitator." Their job entails creating a budget, developing a schedule, and putting all of the production crew and/or subcontracting studios

and post-production team and facilities in place. The objective for this producer is to plan and structure the number of staff needed, hire the staff, and determine their start and finish dates. The facilitator producer has creative input in every phase of production along with the director. Their goal is to shepherd the project from its conception stage through final delivery, on budget and on schedule.

At some larger studios, this type of producer may also fall into the "creative producer" category, whereby they would play the dual role of producer and director. In this case, the studio's executives would be much more hands-on in terms of helping to monitor the production's budget and schedule, and doing deals with subcontractors, talent, crew, and outside facilities.

Line Producer or Co-Producer

The chief responsibility for the *line producer* or *co-producer* (hereafter referred to as the line producer) is establishing and managing the production budget and schedule. The line producer's role is very similar to that of the facilitator producer, but they have very little or no creative input on production. Often this individual is hired when the production is either recently green-lit or is close to approval. Line producers are held accountable for making sure that the production goals are met within the budget and timeline.

It should be noted that the title of co-producer is at times ascribed to the person who is simply attached to the project, and may be involved only in the conceptual or initial deal-making phase.

Associate Producer

The role of the *associate producer* is one step above the production manager. Associate producers tend to have a more in-depth production background than production managers, yet they do not have the level of experience to be given the title of line producer.

Similar to the role of the line producer, this job is strictly administrative. Using the budget and the schedule as a guideline, the associate producer works closely with the production manager in coordinating and tracking the flow of artwork from one department to the next during pre-production. When subcontractors are used on a production, the associate producer is in charge of overseeing the shipment of material to them. The associate producer may or may not be involved in post-production. Operating as a facilitator, their degree of control and decision making is contingent on the structure of the studio and/or production. Chances are they would not be in a position to make deals with outside facilities or subcontractors on their own. They would, however, probably be able to hire members of the production and artistic team based on the director's input.

On a feature, the producer delegates the detail management of the production to the associate producer. With the aid of the production manager, the associate producer is in charge of coordinating the efforts of upwards of 450 people. Constructing an efficient production pipeline starts with an approved script. However, on a feature production, the script develops and changes through most of the production so the only way to proceed is to peel away one sequence at a time. As each sequence gets completed through the storyboarding process, the associate producer evaluates its complexity, or how difficult it is to complete the artwork. Through close collaboration with staff members such as the director, the artistic coordinator (see Chapter 9, "Production," for more information on artistic coordinators), and the production accountant, the associate producer estimates the number of hours or cost of each sequence. If the dollar amount is acceptable, the sequence can go into production. When it exceeds the allotted budget, the associate producer's edict is to come up with alternative cost-cutting options. In order to keep the project on schedule and avoid unexpected overages, the associate producer will judiciously gauge the complexity level of every scene throughout the production. Commonly, the associate producer's duties start with pre-production and continue through the delivery of the final color film. He or she has little or no involvement in either the development or post-production phases.

Producer's Responsibilities

The responsibilities of the producer at each studio depend on a number of factors:

- The format/length of the project
- The technique and/or process of animation
- The organization of the studio
- The producer's experience and expertise

Based on these criteria, the producer may take on all or a combination of the areas listed below. Please note that when we indicate that the producer needs to obtain approval on specific line items, we are referring to getting final approval from the individual(s) responsible for overseeing and or funding the project (buyer/executive).

1. Create and obtain approval of a production plan including budget and schedule.
2. Finalize the script for production.
3. Select the director(s).
4. Establish creative checkpoints with buyer/executive. (See Chapter 9, "Production," for a detailed list.)

5. Cast and hires the artistic team. (See Chapter 7, "The Production Team," for more information.)
6. Identify and select subcontract production studios, if applicable. (See Chapter 7, "The Production Team," for more information.)
7. Negotiate deals with subcontract studios and outside facilities. (See Chapter 7, "The Production Team," for more information.)
8. Cast and hire the administration and production staff, including the line producer, co-producer, associate producer, and production manager, if applicable.
9. Cast the composer.
10. Complete and attain approval on key pre-production artwork, such as character designs, location designs, background concepts, and color models.
11. Conduct an ongoing evaluation of production output and department quotas.
12. Supervise staff and monitor the day-to-day progress of production.
13. Communicate the overall production priorities to crewmembers.
14. Establish and maintain relationships with all pertinent ancillary groups, including licensing and merchandising, publicity, distribution, and promotions.
15. Resolve disputes and conflicts within the production unit and all outside services.
16. View and approve all animation. (See Chapter 9, "Production," for more information.)
17. Approve retakes and revisions.
18. View and approve the director's cut.
19. Attain and approve the final cut.
20. Supervise the "spotting" of sound effects and music with the director.
21. Supervise and approve automatic dialogue replacement (ADR) and additional sound effects with the director.
22. Supervise the music recording session with the director.
23. Supervise the final mix session with the director.
24. Obtain approval of the content of the opening titles and end credits as well as title design and opticals.
25. Obtain approval of the answer print or edited master.
26. Deliver the final product in the format requested by the buyer/executive.

Our Philosophy of the Ideal Producer

The animation producer is the central person around whom a production flows. When a production is running smoothly, people often wonder what a producer actually does. In this case, the animation not only looks good, but also is on budget and on schedule. In this ideal scenario, the producer has done a good job and has thought through all areas of the process. How is this ideal state achieved? It starts with a producer who is knowledgeable about the process of animation. They are comfortable asking questions and eager to learn more. Such producers know how to put the right people in the right places, to delegate, and to trust their staff's expertise. They are able to anticipate problems before they happen and are able to communicate their needs effectively. They always know the status of the production and can seamlessly make changes when small problems arise. On the other hand, when a production is in trouble, the producer is the first person to be identified as the responsible party. If they can't figure out how to make the production work, their job may quickly be put on the line.

Leadership

Although each producer brings his or her own individual skills to the table, there are fundamental qualities necessary to all producers. One vital quality for any "good" producer is the ability to lead. As the primary individual responsible for hiring the cast and crew, each employee looks to the producer for guidance and answers. Standing at the apex of the production pyramid, the producer literally sets the tone for how a production is run. If the producer is organized, punctual, capable of juggling many tasks at the same time, and fulfills his or her commitments, then the crew will very likely attempt to emulate their leader.

Communicator

Strong, clear communication skills are also necessary for a producer. From the start, the producer needs to communicate the project's overall creative vision and timeline to the crew in order for them to understand their common goal. Keeping the staff informed of the status of the production is also a priority. It is not important for each member of the team to know every detail, but weekly or daily meetings for key staff—and perhaps monthly or quarterly meetings for the entire crew—will help keep the staff enthused about the production.

Nurturing Creativity

Maintaining a creatively fertile environment as the project goes through rewrites and revisions is another significant function of the producer. At

times, artists may become frustrated by the production as they see their work deleted again and again due to story changes. They may feel alienated because they are not able to see how their work fits into the larger picture. Again, it is up to the producer to communicate the big picture and explain why the changes are necessary, and how the additional work will improve the end product. Chances are that the producer is equally dismayed by the changes, yet presenting a positive attitude and remaining optimistic toward the project motivates the artists to continue to do their best work.

Forward Thinking

Although it is impossible to anticipate every hurdle that a production may encounter, the producer must be prepared for the unexpected. Thinking through every step in advance enables the producer to alter the schedule and budget as necessary, without halting the flow of production. In response to the inevitable production problems, the producer must be proactive and come up with creative solutions. This is where it is advantageous for the producer to have put together a team that works well together under pressure, so together they can forge new paths in production.

Delegator

Producing animation requires an individual who can pay attention to detail without losing sight of the larger picture. Delegating duties to other staff members, and knowing when to follow up instead of attempting to micro-manage every detail, enables the producer to function successfully. On productions with a large production staff, it is important to set up a computer tracking system not only as a production management tool, but also so that the producer can have full access to all areas of the production at any time. (See Chapter 11, "Tracking Production," for more information.)

Energizer

Another critical attribute for a producer is the ability to understand, respect, and carefully pace the creative process. In essence, the producer energizes the project. This is especially the case in animated projects, since the process is slow and it is easy to get drained. It is up to the producer to decide when it is time to push and meet or exceed the weekly quotas and when it is appropriate to be flexible. On those projects that are behind schedule, the staff may be required to work late and on weekends as the deadline gets closer. While getting paid overtime is always attractive, being separated from one's family is not. The producer has to work extra hard to make the crew feel appreciated and suitably rewarded for their work. A never-ending challenge for the producer is negotiating how to function as the team's supervisor but at the same time remain approachable so that all members are comfortable to share their thoughts and opinions.

Decision Maker

A producer also has to be capable of making unpopular decisions. While this is not easy, the producer's job is to keep the best interests of the project in mind at all times. An example of such an action may be firing an under-performing employee. A fair producer should give the employee constructive feedback, warnings, and ample opportunity to do better. If there is no improvement, however, the producer will need to make a tough decision. Making the choice to fire an employee sends a message to the rest of the crew that their performance matters. Under these circumstances, the producer's best approach is to try and make the transition as easy as possible through communication and by keeping the crew aware of the upcoming change at the appropriate time. Although the actual details of a dismissal must remain confidential, the producer should be sensitive to the staff, as they may feel vulnerable and think their jobs are also in jeopardy. It is imperative to actively do damage control. By having an open-door policy and encouraging discussions, the producer can avoid paranoia, and stop rumors from spreading around the studio and wasting valuable production time.

Ambassador

So far we have described the role of the producer within the production hierarchy. Another equally challenging responsibility for the producer is representing the project to the outside world. Meeting the buyer's/executive's needs has to be a top priority for every producer. At the same time, a completed project can be killed with poor marketing or ill-conceived promotional campaigns. Therefore, the producer will need to interact closely with the ancillary groups such as publicity and merchandising. Providing them with artwork and other production material in a timely manner is critical to maintaining a successful relationship.

What Makes a Good Animation Producer?

We contacted industry professionals in all areas of the field to ask them what they looked for in a good producer. We spoke to studio heads, producers, directors, artists, and members of production teams to get a well-rounded point of view on this question. The multi-faceted nature of the role of the producer is evident from the variety of responses we received.

We consider ourselves very fortunate to be have been able to gain insights from the individuals who are quoted and who share their experiences in the following section. For each quote we have listed the person's name, highlights of their career (when applicable), and in most cases the year they started working in the entertainment and/or animation business. The section begins with thoughts from studio heads and executives responsible for

hiring producers. We include quotes from producers next, with comments on how they themselves view their role. Following the producers, we have included quotes from creative staff such as directors and writers who collaborate with producers to develop projects. Finally, we have presented quotes from artistic and production crews, arranged in the order of the production pipeline. (Please note that we collected these quotes between August 1999 and May 2000. Thus, the credits and titles listed for each person reflect this time period.)

Roy E. Disney

Vice Chairman of the Board of Directors, The Walt Disney Company; Chairman, Walt Disney Feature Animation; Executive Producer, *Fantasia 2000*

Started 1953

I think the most important attribute of being an animation producer (or anything else for that matter) is PATIENCE. Everything in the process takes time, almost always longer than you expect it to, and the ability to wait it out, to keep hold of your original vision, to work with a wide variety of people, and to settle only for what is THE BEST is paramount. It will always be harder than you think, and take longer, too, so be patient!

Ann Daly

Head of Animation, DreamWorks SKG; previously President, Buena Vista Home Video, North America

Started 1983

A good animation producer is a visionary, a collaborator, a creative problem solver, and, most of all, someone who can pull out the best in artists and filmmakers and steer them towards making a film that is uniquely entertaining.

Chris Meledandri

President, 20th Century Fox Animation

A great producer creates an environment in which the director(s) and the artists can do their best work. The producer must understand the director's vision and must guide the crew to deliver a film that realizes that vision. All of this must be done within the budget and schedule parameters. To achieve this, the producer must be a great strategist and must have a keen understanding of each part of the process. The great producer makes all of this look easy.

Sander Schwartz
President, Sony Pictures Family Entertainment; previously Vice President of Business Affairs, Columbia Pictures Television; Senior Vice President, TMS Entertainment

Started 1979

A successful animation producer today must possess technical expertise as well as creative and strong leadership skills to manage and motivate the staff. As a significant portion of a producer's responsibility is managing and coordinating the artistic and production processes, it is vital that the producer be knowledgeable about the latest production tools available, and know how to deploy them to maximum advantage in telling an engaging story. It is vital that they harness every means available to get the best work from their team, and to spur them on to realize the creative vision of the creators of the work.

Don Spielvogel
President, VirtualMagic Animation; previously Chief Financial Officer, USAnimation

Started 1980

A good producer is someone who can marry the creative vision of the director to a successfully adhered-to budget, while also meeting the schedule of the distributor or client. This requires almost superhuman characteristics, especially if the producer comes out of this experience admired, respected, and even liked by the members of the project team. Combining a strong personality with creative sensibilities, technological virtuosity, an industrial engineer's time-management skills, the gene for money, and a huge amount of luck are the ingredients required for this superhero.

Suzie Peterson
Executive Vice President, Universal Family and Home Entertainment

Started 1982

It's a given that a good producer has to be able to balance financial and creative issues. Some attributes tend to be inherent in certain people—talent (along with the ability to recognize and nurture talent in others), the ability to manage complicated people and a complex process, and the ability to keep learning (especially with the rate of change in technology). A good producer respects the audience and the genre of any given project. I think the biggest differentiation is the degree of what I'll

call the "sane passion" a person brings to the process. The drive to keep making it as good as it can possibly be, down to the very last detail, is what really separates the good from the merely competent. Never settle for "good enough" unless time or money forces you to move on.

Cella Harris
Senior Vice President of Production, Klasky Csupo; previously Production Executive; Producer, *Rugrats, Real Monsters*; Supervising Producer, *Wild Thornberrys, Rocket Power*

Started 1971

A good animation line producer is as important to the production as a creative producer and is just as artistic. Stretching the dollar is as creative as stretching a character.

Sometimes artists believe that the line producer's job is to make their lives miserable, that their only concerns are schedule and budget. Not so in my experience. Production schedules and budgets are very real, and it's the line producer's job to work within the time and fiscal limitations of a production, getting every possible dollar on the screen while still keeping the studio doors open and maintaining the artistic integrity of the show. Now that's creative!

When hiring a line producer, I not only look for someone who is fiscally responsible, but also someone who understands and respects the creative process; someone who has strong people skills as well as strong accounting skills. I prefer to work with producers who have an art background, or enough experience to know what it actually takes to create and produce a show, not impose an unrealistic schedule and insist it's done in that timeframe regardless. Unrealistic deadlines and expectations will alienate artists, who in turn don't produce effectively. On the other hand, a strong line producer doesn't succumb to the "artist tantrum," as I refer to it. I've seen and heard artists act out in all sorts of ways to get what they want. I've heard them accuse the line producer of not caring about the artistic integrity of the show, and throw furniture to get their way. In my opinion, no amount of talent excuses people from respecting others. Yes, we know, the schedule is always too short!

Without a strong line producer, the show might go on, but not for long.

Lenora Hume
Senior Vice President, Worldwide Production, Walt Disney Television Animation; previously Executive in Charge of Production and Supervising Producer, Nelvana

Started 1976

A good producer must have the ability to maintain the delicate balance between good filmmaking and good business. The producer must pull together a creative team that works towards the common goal of producing a film with a clear, unified vision. The producer draws on the strengths and supports the weaknesses of the assembled crew, making judgment calls on a continual basis, ensuring the timely delivery of an excellent product on budget and above expectations.

Chuck Richardson
Senior Vice President and General Manager, Blue Sky Studios; previously Vice President of Physical Production, Fox Feature Animation; Vice President of Production, Turner Feature Animation; Executive Producer, *Cats Don't Dance, Family Dog*

Started 1972

Breadth. The scope of a producer's skills must encompass the entirety of the show: what you make, where you do it, how you finance it, who you hire, when to say enough.

Amanda Seward
Senior Vice President of Business and Operations, Warner Bros. Feature Animation; previously Vice President of Business and Legal Affairs, Turner Broadcasting System and Hanna-Barbera, Inc.; Assistant General Counsel, International, CNN International

Started 1986

A good animation producer is someone whose judgment the director, artists, production staff, and studio can trust. He or she will plan the production so that the money spent will hit the screen. The best ones are collaborative and flexible, yet decisive and willing to take responsibility. They are critical thinkers and know how to bring out the best in those involved in the creative process.

Linda Steiner
Senior Vice President of Creative Affairs, Warner Bros. Television Animation; previously Vice President, ABC Children's Entertainment

Started 1985

What makes a good animation producer is someone who has a vision and style so distinctive that you can define that producer from their work. Nothing is more frustrating than when you meet a producer who doesn't have a point of view and style that you can identify.

Another very important quality is the ability to work well with others and communicate. You'll need to be solid in your vision, because people will immediately try to change it! This is just the process, but people will respond to your passion. The key is to communicate that passion.

Barry Weiss
Senior Vice President of Animation Production, Sony Pictures Imageworks; previously Co-Producer, *Cat's Don't Dance*, *The Pagemaster*

Started 1990

A good animation producer is someone who can speak and translate the languages of art, money, schedule, marketing, and studio politics. Most importantly, it's mastering the art of planning and pre-planning the expected and planning for the inevitable unexpected. It's the ability to keep a very diverse group of artistic and technical people focused on doing their best work within the confines of a budget and schedule. And it's the ability to help navigate that work through the realities of a corporation trying to create a commercially viable and franchisable property.

Ellen Cockrill
Vice President of TV Programming, Universal Family and Home Entertainment Production; previously Executive Director of Development, Hanna-Barbera Cartoons.

Started 1992

In an animation producer, I look for someone who has all the talents of a good production manager and who is also creative. Pretty much every issue that comes up in a production will have both financial and creative impacts. I look to the producer to be able to find the right balance between the two—which involves a lot of creative problem solving.

I ascribe to the belief that no one thanks you for delivering a bad show on or under budget, nor do people care much in the long run if you're a little over budget if the show is great and delivers. A good producer needs to believe this is true, but also be fiscally responsible.

Ken Duer
Vice President of World Wide Production, Warner Bros. Television

Started 1984

In my opinion, a producer should be a generalist rather than a specialist. In the animation age today, we have writer-producers, director-producers, designer-producers, and even accountant-producers and lawyer-producers. Every one of these producers are specialists and may

have an area that they are well experienced in, but lack knowledge in other crucial areas that make up the business. Lack of knowledge can easily be fixed. Experience, however, does not come in a manual—it comes over time. Thus, most producers today may be very talented designers or writers, but lack project managerial skills and business sense.

It is difficult to actually define the role of a producer, but it would only make sense to let the directors direct and be creatively responsible for the project and let the producers manage and create a "stage" for creative artists so that the artists can do what they do best. In order to create that stage, producers must know the process, the system, and the industry inside out. Not only know the process, but also know the people it takes to get the project done from project development to making deals with facilities, to bringing in skilled artists and managers, to post-production and even to marketing. The project not only must be completed, but also must be financially successful, and therefore financial management skill is a priority. In addition, with today's changing technologies, knowledge in production technology cannot be ignored. With these skills, you are finally ready to produce and take full responsibility of a project.

Beth Stevenson
Partner/Vice President Production and Development, DECODE Entertainment Inc.; Producer, *Watership Down, Angela Anaconda, Rainbowfish*

Started 1987

A producer's essential role is to nurture each individual contributing to the project so that the end product is the absolute best it can be creatively. Animation is an artistic domain in a commodities marketplace. This makes for constant care and control of the balance between artists and making the numbers work. Financing animation independently is a sincere challenge. The result is inevitably several financial contributors who are all entitled to input. So the juggling begins. In the case of international co-productions, there can be really fun things like language barriers and cultural differences. For example, globally, everyone has a different belief in "what's funny." The producer's task is to ensure that all parties are satisfied with the end product and that the creator's vision has not been compromised.

Mark Taylor
Vice President, General Manager, Nickelodeon Animation Studio

Started 1984

A good producer has the ability to guide a project responsibly from both a creative and fiscal standpoint so that the budget is maintained. All of this guidance must be coupled with good people skills.

Douglas Wood
Vice President of Creative Affairs, Universal Studios; previously Vice President of Creative Affairs, Warner Bros. Feature Animation and Turner Feature Animation

Started 1990

The best producers I've worked with have been able to do the following three things simultaneously: 1) make quick but informed decisions 2) not lose sight of "the big picture" while making those decisions 3) keep a calm head.

Some elaboration:

Every single day a film is in production, it is fraught with problems, big and small, whether they involve the product, scheduling, finances, creative issues, or interpersonal ones. A producer's job, essentially, is to problem solve all day long, which means making many immediate decisions that sometimes have huge ramifications. In making wise decisions, good producers always seem to remember the picture at large. Obviously, this kind of decision making lends itself to reacting impulsively to the crisis of the moment, and emotions can sometimes get in the way. Even the best managed productions seem to exist in a maelstrom of chaos, and good producers are able to remain detached and clear-headed and present a demeanor that's in control.

It's easy to become overwhelmed while making a film, due to the sheer number of workers involved, the vast amounts of money, and the long time-span of the project. A good producer is able to keep the machine running smoothly, put out the daily "fires," and ensure that the quality is forever maintained. The best producers I've worked with are able to do this while appearing totally in control. Whether they ARE actually in control in all the craziness is almost irrelevant.

John Andrews
Executive Producer of Commercials and Special Projects, Klasky Csupo; previously Vice President, MTV Animation; Supervising Producer, *Beavis & Butt-Head*, *MTV's Oddities*, *Aeon Flux*, *The Brothers Grunt*, and *Daria*; Co-Producer, *Beavis & Butt-Head Do America*

Started 1986

No matter what level of producer you are, you will be responsible for hiring. So you have, first and foremost, to be good at the "casting" of a production, making sure—through your contacts and those of people you trust—that you bring together a team of professionals—from writers and directors through designers, storyboard artists, animators, and production people—who can make this a creatively successful

project that delivers on time and on budget and, if possible, causes no heart attacks, divorces, falling outs of friends, and/or future professional difficulties for good people or undo windfalls for liars, backbiters, gossips, or slackers.

Jonathan Dern
Executive Producer, MGM Animation; previously Vice President, MGM Animation; Associate Producer, DIC Enterprises

Started 1988

Understanding the strengths of each member of the production team is critical. When producing, it is most important to cast specific work to studios and experts in each area of production on a project-by-project basis. From the appropriate director to the right post-production on-line colorist to the specialties of an overseas studio, each piece must have the right sensibilities for the creative.

Bringing experience, reasoning, common sense, and forecasting skills, the producer is the glue that holds together the production team.

Jeff Fino
Co-Founder/Executive Producer, Wild Brain

Started 1991

An effective animation producer is someone who can create and work within a shoestring budget and tight schedule and still run a production that will deliver high quality. It is someone who can inspire, coerce, council, mediate, and at times yell. It is someone who needs to be firm but who knows how to compromise, someone who must be decisive yet considerate. A good producer is action-oriented but calm in the face of catastrophes that strike a production every 20 minutes.

Buzz Potamkin
Executive Producer, Producer, Producer/Director, and Studio Executive

Animation koan: Producing animation seems more difficult than it is, yet more difficult than it seems.

Animation production is akin to building a medieval cathedral: hundreds of anonymous artisans toiling away for endless hours, concentrating on their own small part to the exclusion of the whole, with most of their work destined to be hidden in the cavernous mists of the interior. The true test of the *capomaestro d'opera* (producer) is to motivate them beyond simple wages, without having the power to grant a future in heaven.

Sandra Rabins

Executive Producer, *Tusker, Shrek, Antz*; Producer, *Prince of Egypt*; previously Senior Vice President of Production and Finance, Buena Vista Pictures

Started 1985

Animation is such a long process, I would not recommend anyone who likes to work on a project for three months to a year to participate as a producer. It takes absolutely everything you've ever learned to be a successful producer.

Paul Sabella

Executive Producer, MGM Animation; previously Vice President, MGM Animation; Senior Vice President of Production, Hanna-Barbera; Director, Producer, Animator

Started 1968

The producer is the team leader who knows the processes of animation extremely well. Ideally, he should be exposed, or have experience in, various stages of animation production.

Knowing the process allows the producer to look ahead and anticipate production concerns. For instance, when developing characters for a television series, the producer might recognize that the design is too complicated. It could be a beautiful design, but with most television animation produced in Asia at predetermined costs, the more elaborate the design, the more expensive the production will become.

The producer and director work together to get the highest quality possible within the boundaries set by the budget and the schedule.

Tad Stones

Executive Producer, *Buzz Lightyear of Star Command, Disney's Hercules* (television series); Producer/Director, *Aladdin and the King of Thieves, The Return of Jafar*; Producer/Executive Story Editor, *Disney's Aladdin* (television series); Creator, Story Editor, Co-Producer, *Darkwing Duck*; Story Editor, Co-Producer, *Gummi Bears*

Started 1974

No matter what the limitations of time and budget, a great animation executive producer knows the animation and artwork exists to support the story, be it the arc of a character's emotions or a simple slapstick gag. He or she must know enough about each area to make the writers make the most of the visuals and the artists to understand how to support and strengthen the drama or humor.

Machi Tantillo
Executive Producer, *X-Chromosome*; previously Director of Animation, MTV

Started 1981

An air traffic controller with a sense of humor!

Don Hahn
Producer, *Beauty and the Beast, The Lion King, Disney's Atlantis: The Lost Empire*

I've always thought a good producer needs to worry about one thing: The producer is there to help the director tell a story. To that end, the producer must create an environment where all the filmmakers feel the same way—that they are there to lend their ideas, expertise, and passion to the vision of the story.

There's an old saying that is not far from the truth: The producer hires the best people possible and then does exactly what they tell him to do. Sometimes this means being an advocate and defender of the film, sometimes it means being a coach, a cheerleader, and even a psychotherapist. But the film will never work and the effort will be in vain if the producer can't rally a team of artists/filmmakers around a single vision. Yes, there are perimeters of budget, schedule, and commerce, all important components of the job, but nobody remembers the budget of *Snow White and the Seven Dwarfs*, nobody knows if the animators met their quota on *Peter Pan*, but everybody remembers the movies.

Max Howard
Producer, *Spirit of the West, Sinbad, Wish*; previously President, Warner Bros. Feature Animation; Senior Vice President, Disney Feature Animation

Started 1986

A good producer brings perspective to the project and maintains that perspective by balancing the artistic vision with the time and money allotted. If you can do that, then you have succeeded.

Allison Abbate
Producer, *Iron Giant*; Co-Producer, *Space Jam*; Associate Producer, *Runaway Brain*

Started 1989

Flexibility is key. You have to be up for everything. On a bad day, you have to get your crew motivated, and on a good day, you have to keep them focused and moving.

In my experience, I have found that no job is too small. If it means closing a line for the Animation Check department, I am happy to do it. Anything to get the work completed.

Libby Simon
Producer, *The Rug Rats Pilot, The Ren and Stimpy Show, Happily Ever After Fairytules for Every Child;* Production Manager, *FernGully, The Last Rainforest;* Women in Animation International Board of Directors, Chair of Historical Committee

Started 1970

Producing is a juggling act in patience, perseverance, commitment, and cooperation. The important thing that I try to remember is to use my experience and knowledge from the past—good and bad—and never think that I know everything.

David Sproxton
Producer, *Chicken Run;* Executive Producer, *A Close Shave, The Wrong Trousers;* Director of Photography, *Sledgehammer;* Producer, Director of Photography, *Creature Comforts;* Co-Founder and Managing Director, Aardman Animations

Started 1972

A good producer is one who anticipates and plans, protects both the creative vision and the artists, and delivers on time and on budget. They also need to be excellent plate-spinners, fire-eaters, and circus ringmasters, with an inherent ability to herd cats.

Lee Dannacher
Independent Producer; previously Vice President/Supervising Producer, Rankin/Bass Productions, *ThunderCats, Noel, SilverHawks, Life and Adventures of Santa Claus*

Started 1979

In today's burgeoning world of Internet animation, it's refreshing to see digital producers who are not yet saddled with the heavy infrastructure of large companies where so much of one's time is taken up with the "politics" of production. The new web platform is infused with old show-biz enthusiasm, and the producers, unfettered with layers of executive oversight, are enjoying this freedom and keeping the focus on their work. In a freer milieu reminiscent of 60s television production, they are experiencing the joys and trials of essentially making things up as they go. However, the fundamentals of traditional production remain the same. Producers shape the business structures (selling the projects, devising budgets, assembling all the creative ele-

ments, shepherding everyone through the production process, working out distribution and beyond) while simultaneously creating each project's unique "environment" that will best serve both the artistic and economic needs of the show. New media, new methods, yes . . . but the underlying traits of a great producer are the same . . . as well as the age-old "golden triangle" that prevails as the producer's bottom line: to deliver on quality, on time, on budget.

Faith Hubley

Independent Producer, Director, Designer, Animator, Painter, *My Universe Inside Out, Beyond the Shadow Place, Africa, Witch Madness* (distributed by Pyramid Media)

Started 1955

For me, a good producer is a person who has a clear vision, an ability to schedule realistically, a talent for finding and correctly spending money, and a natural ability to encourage others.

Gina Shay

Co-Producer, *Jimmy Neutron*; Line Producer, *South Park, Bigger, Longer and Uncut*

Started 1990

Producing is about absorbing, and not reflecting, so that when enjoying the wrap party, the crew is genuinely distraught that the "family" is breaking up, while the producer is booked on the red-eye to Jamaica.

Antran Manoogian

Associate Producer, *Genie's Great Minds, Sonic The Hedgehog, The Chipmunk Rockin' Through the Decades*; President, ASIFA Hollywood

Started 1987

A good animation producer is someone who understands the medium of animation, has a comprehensive understanding about the production process, and is capable of organizing and managing an animated production.

Brad Bird

Director and Co-Writer, *Iron Giant*; Director, Writer, Co-Producer, *Family Dog*; Writer, **batteries not included*; Executive Consultant, *The Simpsons, King of the Hill*

Simply put, a good producer protects the vision of the director while respecting the limits of time and money. He or she must be willing to fight for the best interests of the film, with the studio if need be, from

the moment pre-production starts all the way through the film's release and initial runs. There are so many ways to screw up a movie, and the best producers are those who can both anticipate problems and yet not panic when the inevitable surprises occur. The best producers walk the tightrope between art and commerce, understanding that ultimately the best show is the best business.

Darrell Rooney
Director, *Lady and the Tramp II: Scamp's Adventure, The Lion King II: Simba's Pride;* Disney Television Animation: *Three Little Pigs*

Started 1978

A good producer is a combination of many things: part scheduler, part strategist, part supporter, part politician, part cheerleader, part friend, part co-conspirator, part realist, and always part dreamer. They must also be very good at hiding money so when a director comes looking for it, it's there.

A good producer must be able to hold a director's vision in the palm of his/her hand and know they can make that vision a real thing.

Peter Chung
Creator, Writer, Director, *Aeon Flux;* Designer, Director, *Rugrats;* Designer, Director of commercials for Honda, Pepsi, Levi's, Nike, MTV, Rally's and others; Designer, *Alexander, Phantom 2040*

Started 1981

Acting as a producer puts you in a very delicate position. On the one hand, the artists see you as someone enacting the studio's agenda to deliver the project quickly and cheaply. On the other hand, the studio executives may view you as the person spending money liberally to indulge the whims of the creative staff. In my experience, a good producer knows how to handle the production needs so that he or she is not perceived as an instrument for either camp. Most importantly, he or she must remember that the meaning of the title of producer is someone whose job is to produce a film, not to produce money.

Mike Vosburg
Director, *Spawn* (TV series); Storyboard Artist, *Roswell, Tales of the Crypt*

Started 1985

It took me a long time to learn that WHO you work with/for is so much more important than WHAT you are working on. Producers who treat you with respect, fairness, and encouragement bring out the best in their staff and the product will reflect that. While creativity CAN flour-

ish in the worst of situations, adversity from the producer is not a necessary part of the mix.

Brenda Chapman
Co-Director, *The Prince of Egypt;* Head of Story, *The Lion King;* Story and Development, *The Hunchback of Notre Dame, Beauty and the Beast, The Rescuers Down Under*

Started 1985

A great animation producer is someone who protects the vision of the movie and supports those who are pouring their hearts and souls into its creation.

Piet Kroon
Co-Director, *Osmosis Jones;* Storyboard Artist, *Iron Giant, Quest For Camelot;* Director, *T.R.A.N.S.I.T, DaDa*

Started 1989

A good producer has loyalty and backbone.

At the outset of a project, the producer should become an ally. The producer helps pull the director's vision into focus, helps define goals and objectives, establishes priorities, and then safeguards those throughout the production.

That's where the backbone comes in. As a movie gets made, delays and setbacks will throw off the original plans. The producer has to navigate ever-changing waters. It takes courage to defend the vision of a film to studio executives, whose knee-jerk reaction to troublesome projects is to change producers. It takes courage to stand up to a director and enforce an alternative course to deliver the same goods. And it takes courage to be open and direct in dealing with the crew (and not just run the production through APMs).

A producer is the backbone of a production, a negotiator between dream and reality.

Tom Sito
President, Motion Picture Screen Cartoonists Union Local 839 IATSE; Co-Director, *Osmosis Jones;* Head of Story, *Pocahontas;* Storyboarding Artist, *Prince of Egypt, The Lion King;* Animator, *Beauty and the Beast, Aladdin, The Little Mermaid, Who Framed Roger Rabbit*

Started 1975

A good producer is one with a positive attitude and a sincere desire to collaborate. The relationship between Union and management does not by its nature necessarily have to be combative and adversarial. I

find that it's ideal when that is not the case, and the producer is big enough to work in true partnership. This in turn allows us to extend ourselves to make their project as successful as possible. Because ultimately, the success of their show benefits us also.

Liz Holzman
Producer, Director, *Pinky and Brain, Animaniacs, Baby Blues*

Started 1976

The person who you want sitting at the very top of a production is one who is sensitive to every aspect of the project and is not caught up in their own ego. He or she will need to meet the needs of everyone on the crew, ranging from the person doing the copying and shipping to the most highly paid and valued artist on the show. The producer never devalues the work of anyone because every crewmember is an integral part of the production structure. The team needs to be nurtured and allowed to do what they are hired to do. The producer in turn has to know when to get out of the way and take advantage of their expertise.

Corky Quakenbush
Director, Producer, Writer; *Mad TV*, Award Winning Independent Shorts and Films; *Clops I, II & III, Reinfather, A Pack of Gifts Now, A Common Condom Complaint, One Hand, Left*

Started 1982

In stop-motion animation we run in the gray area between live-action production and traditional animation. As in live-action filmmaking, sets must be built and lit, props (including puppets) and wardrobe must be created, and the camera must be set up in different configurations for each shot. The physical space of the studio must be divided to accommodate construction and shooting, unlike traditional animation in which everything (basically) is drawn at tables or on a computer.

On the other hand, like cell animation, each frame must be shot individually, which means only seconds of film each day and possible multiple scenes being shot simultaneously.

In the realm of production, stop-motion is more like live-action than animation in the most important ways. A good stop-motion animation producer knows how to coordinate the endeavors of all departments so that scenes are put together with all the appropriate bits and pieces, from exposure sheets to forced perspective miniature sets, so that as the physical creation of the scene is completed, the animators will be able to come aboard and do their jobs. If there are limitations on

the space (as in many live-action productions), sets will need to come down after the scene is shot and be replaced by the next sets, which then need to be dressed and lit. Ideally, the animators will go from one ready set to the next.

Roy Allen Smith
Supervising Director, *Family Guy*; Producer, Director, *Land Before Time II, III, & IV* (direct-to-video)

Started 1978

A producer's job is find the most talented people available and know when to get out of their way and let them do what they are hired to do. In a word, delegate.

Alan Bodner
Art Director, *Clerks, Iron Giant, Carrotblanca*

Started 1980

My ideal producer can tastefully make choices about story and visual content without using a brush.

Bill Perkins
Art Director, *Space Jam, Fantasia 2000, Aladdin*; Layout Artist, *Beauty and the Beast, The Little Mermaid, Oliver & Company*

Started 1986

> Understanding of the ways of art.
> Understanding of all types of business.
> Understanding of collaboration.
> Being able to see the true value in all things.
> Set clear standards of performance and follow through consistently with rewards and punishment.
> Realize that no one does anything alone in this business, and people are your greatest resource.
> The leadership to inspire great effort from them.
> The compassion to listen to your people.
> Courage to be honest.
> Courage to stand for something with meaning.
> Courage to delegate and stand behind your people.
> Courage to ask questions when you don't know something.
> Courage to turn down the job if you don't love the project, or the people, and find purpose in the collective outcome.

Never do the job or hire anyone to do their job if you or they are doing it to look good. You will make a lot of people miserable. Do it because you love it. And doing a job well done.

Sounds impossible doesn't it? But so is the job unless you have help!

Bob Schaefer
Art Director, *Lady and the Tramp II: Scamp's Adventure*; Background Artist, *Fern Gully, Land Before Time II, III, & IV, Jetsons: The Movie*

Started 1965

I would like to work with a producer who respects my work and the decisions that I make, and tries to seek the best creative and visual solution to a problem, as opposed to just the most expedient one. In my book, being straightforward and honest really counts.

Henry Gilroy
Writer, Story Editor, *Mouseworks/House of Mouse, Tazmania, Batman, The Tick*

Started 1988

In my experience, the best producers are ones who a) have a strong creative vision and the skills in all phases of production to see that vision through to the final product, **or** b) are financial masterminds who trust their creative personnel enough to do whatever necessary to meet the needs of those same creative personnel, and help them achieve their vision.

Kevin Hopps
Writer/Producer, *Disney's Quack Pack*; Writer, Story Editor, *Buzz Lightyear of Star Command, Disney's Hercules* (television series); Writer, *Animaniacs*

Started 1989

Obviously, you are talented beyond belief as an artist or writer (or possibly both) to get to the esteemed position of producer. Therefore, the trick becomes one of management, learning to pass your passion for your project on to your staff, and creating the team spirit needed in this highly collaborative medium. And, as with any good trick, be it magic or otherwise, this requires a lot of practice and patience. And a really, really good assistant.

Simon V. Varela
Visual Development Artist, *Titan A.E., Dracula*

Started 1990

What makes a good producer is someone who knows how to recognize talent and do whatever it takes to hire them on the project and

then let them do what they are hired to do. And most important of all, trust them. Many producers hire great artists, but restrain them from putting out good work.

Spencer Stephens
Vice President, Technology and Digital Production, Disney Television Animation

What's important—even with digital production—is knowing how to animate with the tools you have. Unless you know what you're doing, spouting off TLAs (three letter acronyms) doesn't get the job done. A computer is just a pencil with a keyboard.

Teddy T. Yang
CG Supervising Technical Director, *Magic Lamp*; CG Supervisor, *Mission to Mars*; CG Designer, *Iron Giant*; CG Artist, *Quest for Camelot*

Started 1989

In producing a CG project, there are always a few unknowns—new software or new design(s), etc. A good producer weeds out the unknowns by: a) allocating ample time and money for doing tests or R&D prior to start of production, and b) when they get an estimated time to complete various tasks from the CG supervisor, they cross-check the numbers with an animator and a technical director in order to verify the information and allocate the resources in the most optimal way.

Jerry Mills
Director of Digital Technology, *Rugrats The Movie, Cats Don't Dance*

Started 1971

Any producer, good or bad, needs stamina. The process is long and demanding, bringing out the best and sometimes the worst in us all.

Mark Andrews
Head of Story, *Osmosis Jones*; Storyboard Artist, *Iron Giant, Quest For Camelot*

Started 1992

I believe that a good producer should not force an artist to sacrifice the integrity of their vision, but instead encourage the artist to find options that retain integrity while remaining within the productions boundaries. Of course making a movie is a two-way street between the producer (staying on budget and schedule) and the director (realizing his

vision), but the first key ingredient I think is that both must want the same thing: to make the best movie possible.

Joanna Romersa
Animation Sheet Timer and Slugging Director, *Lady and the Tramp II* (video sequel), *Aeon Flux* Series; Producer and Director, *The Flintstone Christmas Carol*; Director, *The Book of Virtues*; Inker, *Lady and the Tramp* (the original Disney feature, 1954); previously Supervisor of Animation, Hanna-Barbera Productions

Started 1954

A good producer conveys their viewpoint clearly. They are very specific about what to emphasize rather than leaving details up in the air. They know the story they want to tell and how the characters should be portrayed (i.e. any particular qualities and or idiosyncrasies that should come through in the animation). They give guidelines in terms of what creative latitude the timer is accorded and are available for feedback.

Darren Holmes
Editor, *Lilo and Stitch*, *Iron Giant*

Started in live action 1977, in animation in 1995

Since on animated projects the editorial department is involved in pre-production, production, and post-production, it is essential for the editor to have a working relationship with the producer and know what problems and concerns are lurking behind the scenes. The producer has to be able to communicate the vitals to the editor on a consistent basis. As much as I want to give the directors everything they want, unless I am alerted to the production issues, I am not able to catch the problems and avoid the scenes from coming back to editorial again and again.

Ginny McSwain
Casting Director, *Voice Director*, *Woody Woodpecker*, *Quack Pack*, *Sonic the Hedgehog* (television series), *Return of Jafar* (direct-to-video)

Started 1986

A qualified person who knows the animation business, who still believes in experience and a system. Someone who has the unique quality of trusting each person hired for their expertise and letting them do their jobs! I've had the privilege of witnessing this particular process work over the years and presently; it's a rare and beautiful thing.

Andrea Romano
Casting Director, Voice Director, *Batman and Beyond, Batman, Superman, Pinky & the Brain, Animaniacs* (television series), *Land Before Time Sequels* (direct-to-video)

Started 1978

Always helpful to a casting/voice director is a producer who is savvy to the current pool of talent and is familiar with the not-so-famous names in the animation voice-over field.

Accessibility is vital. Much time, effort, and, most importantly, money can be saved if a producer can be asked direct questions by those needing to act on the answers.

Encouragement to try something new, something not done before, offers challenge to those manning a project.

And finally, a good producer is one who can be relied upon to be truthful—one who will stick to his guns regarding decisions he's made.

June Foray
Voice Actor/Independent Producer, Rocky/Natasha (*Rocky and Bullwinkle*); Cindy Lou (*The Grinch Who Stole Christmas*); Jokey Smurf (*The Smurfs*); Independent Film (*You Can't Teach an Old Dog New Tricks, But You Can to a Naughty Old Man*)

Don't use your own money if you're an independent producer, even though your animators, actors, and post-production studios are incomparably competent. One can never determine the preferences or loyalty of the public and/or distributors.

Armetta Jackson
Track Reader, *Iron Giant, Mickey's Christmas Carol, Bebe's Kids, Kissyfur*

Started 1977

One of the best experiences I've had was with a producer who acted as one of the crew. Actually running tapes down the hall, stopping by to see how things were done, and always wanting an understanding of who and what was going on without interference or intimidation. What it did was make everyone want to work harder because we had a leader who was with us. On other shows, the producers had given me the sense of "somebody's watching you," or feeling like a nobody, while they were to be treated as Gods, if you will. So, in a nutshell, I would say that it helps if the producer understands the flow of production and also shares the passion for the project and the craftsmanship that everyone brings to the project.

David Womersley

Layout Supervisor, *Dinosaur, Cats Don't Dance;* Layout Artist, *Page Master, We're Back;* Overseas Background Supervisor, *Once Upon a Forest;* Background Painter, *Fievel Goes West*

Started 1990

A good producer fits the following descriptions:

1. Knows what they are doing—no on the job training.
2. Doesn't play favorites—above the line or below the line.
3. Respects and trusts the ability, talent, experience, and knowledge of staff.
4. Recognizes incompetence and deals with it appropriately.
5. Communicates necessary information in a timely manner.
6. Does not patronize the staff. Treats them like adults.
7. Can delegate.
8. Has to be accessible and realizes that a good relationship with the artists and production staff is just as important as a good relationship with the executives.
9. Supports the creative vision of directors and artists.
10. Can instill reality in the minds of directors and supports the department heads in instilling reality in the minds of directors.
11. Can help create an atmosphere in which the greatest possible creativity can thrive within the limitations of budget, time, and resources.
12. Leaves artistic decisions to artists.
13. Makes timely and well thought-out decisions.
14. Doesn't confuse quick decisions with good decisions.

Steve Wilzbach

Scene Planning Supervisor, *Osmosis Jones, Iron Giant, Quest For Camelot*

Started 1970

A good producer says "thank you" when it is deserved and understands the power of positive reinforcement. Simple recognition for a job well done brings big dividends in the form of loyalty and passion for the project at hand. Everyone on a crew loves to feel like they're getting respect for their work, and a good producer will understand this and act on it. That loyalty from the crew translates into "going the extra mile" when called upon.

I have known producers who have come on to a project not knowing the animation business at all and were able to pull it off, but I've found that the best producers, the really good producers, *know* ani-

mation. They've come up through the ranks and have gotten down and dirty with the rest of the crew. Those with a lot of animation experience never ask for or demand hitting unrealistic goals. A good producer will know what is needed and when, what is and is not possible in any department at any given time. This *knowing* can only be achieved by experiencing the ups and downs of any animation production.

When a producer comes to a project with a reputation for being experienced and decisive with a good sense of logic and reason (humor and patience help), I know I'm going to have a good working relationship with that person. If you're fortunate enough to work with that kind of producer and be working on a project you feel passionate about, with crewmembers you like and respect, there is no business like the animation business.

Andreas Deja
Supervising Animator, *Hercules, Runaway Brain, The Lion King, Aladdin, Who Framed Roger Rabbit*

Started 1980

The ideal producer is one who shelters the artists from all the stress and anxiety attached to creating a show. Although there may be political problems dealing with top management or technical issues that seem impossible to resolve, a good producer remains calm and doesn't allow any of the tension to filter down. He or she informs us on the production goals and enables us to focus on our job rather than worry about issues that are out of our control.

Scott Bern
Final Line Character Lead Key, *Spirit, El Dorado, Quest For Camelot, Space Jam, Cats Don't Dance*

Started 1991

A good producer understands the goals of the project and caters to each production according to its specific objectives. He or she must be a good project manager with an understanding that the inspiration, creativity, motivation, and heart that it takes to produce an exceptional piece are not found in any written plans. Based on experience or information gathered, a good producer is willing and capable of making an independent decision. He or she knows when to be involved and when to allow the people hired to fulfill certain needs to exercise their expertise. And, when possible, if the producer can manage to serve the needs of the individuals involved with a project while achieving the desired results, the experience itself can be as rewarding as the end product.

Allen Foster
Head of Digital EFX, *Osmosis Jones, Iron Giant, Quest For Camelot, Space Jam*

Started 1964

The ideal producer should know the line between creative content and production requirements and dovetail with the director to support the ultimate vision of the film.

Hilmar Koch
Senior Technical Director, ILM; Visual Effects Supervisor, *A Simple Wish*; Digital Effects Supervisor, *Bunny*; Technical Director, *Wild Wild West, Jack Frost*

Started 1991

My "ideal producer" is the show's compassionate arbiter. He or she knows what is important to the audience, clients, creatives, and the budget. He or she has the ultimate decision-making capability but will use it only when really needed, only when the river of creativity and passion is not flowing steadily.

Jim Hickey
Background Supervisor *Carnivale, Cats Don't Dance, Page Master*

Started 1976

While I wouldn't expect a producer to be as passionate about animation as myself, I would expect that person to be knowledgeable about the process of animation and to empathize with the quirky, sometimes eccentric nature of the people who create it.

Kathy Barrows
Animation Checking Supervisor, various commercials for Bear Animation Studio, 1989–1991, *Linus the Lion Heated, Sugar Bear* (television series); Animation Checker, *Who Framed Roger Rabbit*

Started 1955

From the vantage point of animation checking, where everything funnels through that will be on the film or video, the quality that I appreciate in a producer is their understanding and familiarity with what goes on in each department The more they know about the process, the more they can facilitate the entire production moving smoothly and at its most creative potential.

Nancy Ulene
Lead Color Stylist/Designer, *The Lion King II: Simba's Pride, Lady and the Tramp II: Scamp's Adventure, Mickey's Once Upon a Christmas, The Recess Movie: Summer Vacation*

Started 1980

The more vision a producer/director can articulate or communicate to the color stylist the better. Once communicated, give the stylist creative freedom to follow through with the art. As the stylist works, he/she can embellish on the sequence and possibly give the producer even more than he/she expected.

Koji Takeuchi
Representative Director of the Telecom Animation Film Co, Japan, *Little Nemo* (feature film), *Cybersix* (television series)

Started 1975

To be a good animation producer, you need to:
1. Produce as much as possible. You should not sit and wait for the perfect project to come your way, as you may not have work.
2. Do your best to bring out the interesting parts of every project. If you don't find the project appealing, neither will your audience.
3. Choose the appropriate staff.
4. Be satisfied with the resources you have and make the most of them.
5. Always walk a step ahead of your crew.
6. Communicate your vision and make sure that everyone is in sync with you.
7. Depending on the needs of the project, be smart about where you allocate your resources. This will allow you to produce the best film possible, and get the most for your money.

Seok Ki, Kim
President of HANHO Studio Korea; Chairman of Korean Animation Producer's Association; highlight projects subcontracted at Hanho: *Scarecrow* (video), *Swan Princess* (feature), *The King & I* (feature), *Buster & Chauncey* (video)

Started 1986

To be a good animation producer, you need the following qualities:
1. The ability to be insightful and identify market trends.
2. A good eye for selecting projects.

3. A personality that is flexible and understanding. The ability to respect the individual needs and varieties of artists and people associated with a project.

Claude Chiasson
President, Yowza Animation Inc., Toronto, Canada; Producer, Director; recent projects subcontracted to Yowza for animation and clean up: *Titan A.E.*, *Werner III* (feature), *Bartok The Magnificent* (direct-to-video), *1001 Nights* (television special)

Started 1981

A good producer is a number of things—a motivator, a diplomat, a good judge of character, and someone who can think on their feet and diversify. Some of the best producers I have worked with have had some firsthand experience in the animation process. The experience has made them more sensitive to the artists' needs, and thus they gain respect from them. It's amazing what an animator will do for you once you have gained that respect.

A good producer can inspire the artists, balance the budget, and meet the schedule so that both the management and the creative sides are happy.

Sylvia Edwards
Production Manager, *ChalkZone, Oh Yeah! Cartoons!, Cow and Chicken, Dexter's Lab, What A Cartoon!*

Started 1992

There are indeed consistent, identifiable qualities in the best animation producers:

- They have a basic understanding of the animation process. This understanding is usually founded in some type of "in-the-trenches" experience with animation production. The best producers not only have a comfort level with number crunching, but with managing the artists as well as the production crew. They have a true grasp of the dynamics involved in producing an animated product within a specific time, with finite money, and an incredibly diverse human element.
- They have an understanding of both the client (network) side of the equation and of the production crew side. They work at keeping communication lines open with both.
- They have a sense of storytelling and what makes a good story. The best producers in animation do not have to be able to draw a straight line, but their understanding of what makes a story work or not work is essential.

Igor Khait
Production Manager, *Disney's Atlantis: The Lost Empire, Quest For Camelot, Bebe's Kids*

> *Started 1989*
>
> The job of an animation producer is to provide leadership for two distinct groups of people: the artists and the production staff. A *good* animation producer will do it by fostering the artists' creativity and their self-confidence, while offering an example to the production staff of how to channel such creative expression to meet specific production goals and guidelines.

Marcia Gwendolyn Jones
Story Department Manager, *Monsters, Inc., Quest For Camelot, Pocahontas*

> *Started 1994*
>
> Someone who is not afraid to make decisions and take responsibility for them; someone who is willing to fight for their people in a pinch; someone who can give the directors what they want, even if it means showing them that they have to give up something else to get it; and someone with a great sense of humor.

Lewis Foulke
Coordinator/Production Assistant, *ChalkZone, Baby Blues, Spawn, Spicy City*

> *Started 1994*
>
> A good producer is a good team leader. If a team feels supported by its producer it will do anything to get the job done well. Paying equal respect to everyone (from director to PA) creates a sense of unity that in return promotes pride in one's job and the project itself. Failure to acknowledge the individual accomplishments within the team structure will slowly generate a breakdown and replace enthusiasm with apathy and general unrest. The team will internally revolt and start presenting work that is nothing more than adequate. The producer must instill a sense of pride.
>
> The team in return must respect their producer and often trust that his/her decisions are made to benefit the team as a whole. A fair, take-charge authority with a human touch will often resolve a conflict better than an order barked from an invisible office from above. Good producers should make themselves present and show interest in the team's work. A good team will produce good work, but a caring producer can enhance that work by showing a commitment to fairness and a genuine interest in the state of affairs of his/her team.

E. Tavares Black
Production Assistant, *Osmosis Jones, Iron Giant, Quest For Camelot, Space Jam*

Started 1994

After surviving five years as a production assistant in feature animation, I have a certain perspective on the whole process, particularly in regards to the role of the producer. Now I've seen producers come and go (literally) and I'll tell you it's not a job for the weak. Usually the producer is automatically seen as the bad guy on the film (this designation isn't given to the director(s) until after the final color stage). I personally don't think the producer is a bad person, they're just an easy target. When things go wrong, whether it's no food for the overtime crew or the wrong color pencils for the dropout color, the producer is usually the one that catches hell. This makes perfect sense, since the producer is the highest "exec" directly associated with the film. The opportunity to complain to this person is like having one's own bitch-session with the gods. I mean, you're actually allowed to complain to someone that makes ten times as much as you and can fire you at the blink of an eye. Because of this, it's very important that the producer be very visible and accessible. That they have an "open-door policy" that allows anyone from the PAs to the ink and paint crew to vent their gripes without repercussion.

Richard Sigler
Entertainment Attorney Specializing in Animation

Started 1971

A good animation producer to his attorney is, first of all, one who works regularly! Second, and almost as important, is a producer who keeps in mind what the attorney needs to do—reduce the producer's deals to clear written form. If the deal is not clearly understood between the parties, it will take more time to draft and negotiate. It may also jeopardize the deal if unresolved points are later discovered to be the "deal-breakers" to one party or another. The producer has to walk a fine line between getting the right talent and keeping them enthusiastic, while buttoning down legal details and staying within the budget. If they emphasize one side over another, the transaction might go away.

James Goldin
Production Accountant, *FernGully, The Last Rainforest, Thief and the Cobbler* (feature), *Spawn, Futurama, Baby Blues* (television series)

Started 1991

A good animation producer communicates well with his production accountant. This is absolutely the most significant attribute from my

perspective. The production accountant must be aware of everything going on during the production in order to generate an accurate cost report, his primary function. In order to do this, the accountant must be able to freely discuss cost issues with the producer. The producer must make sure the accountant is copied on all production memos, and include him in all production meetings. It is also very important that the producer consult the accountant before making decisions that will impact the cost report. The accountant can provide an incredible amount of information based on his records and experience. In addition, the producer and accountant should work together when creating a budget. This will result in a better budget and will facilitate calculations that the accountant must make when working on the cost report.

Shirley Walker
Composer, *Turbulence* (feature), *Batman Mask of the Phantasm* (feature), *Spawn* (television series), *Asteroid* (mini-series), *Batman* (animated television series)

Started 1965

A good producer is:

- Smart enough to know what they don't know.
- Able to spend money well (cheaper is not always better).
- A cheerleader whose fear never shows.

A good producer:

- Includes holidays in their schedule.
- Makes decisions and communicates them to everyone.
- Controls manipulative behavior and political infighting.
- Knows when to pull the plug when things aren't working.
- Knows that where there's no solution, there's no problem.
- Hires a smart assistant who is a good hand-holder.

Jeannine Berger
Post-Production Supervisor, *Osmosis Jones, Iron Giant, Quest For Camelot*

Started 1991

A good producer is a good communicator. This is a person who keeps their team informed about upcoming events as they become aware of them. This means the production team can work to a realistic schedule. Communication between a post supervisor and the producer will help both keep their budget (i.e., informed and planned decisions save money).

A good producer must be confident enough in their own abilities to ask questions of their team to enable them to do the best job possible.

This also implies that the producer hires the best possible team in order to make the best film possible.

Cheryl Murphy
Vice President of Post Production, Walt Disney Television Animation; previously Post-Production Supervisor, Walt Disney Feature Animation; Post-Production Supervisor, Southern Star

Started 1984

The best animation producers are those who thoroughly understand every single step an animated project has to go through—from treatment and script through boarding—and all the steps of animation, color, and post-production for both picture and sound.

Also, good producers understand the collaborative nature of animation and work with all the teams to help them understand their contribution to the whole project. And last but not least, good producers understand the creative tension between the budget and what the director wants to achieve, and deal with this inevitable stress with good humor and flexibility (the flexibility they have because they understand the entire process).

Heather Kenyon
Editor in Chief, *Animation World Network*

Started 1993

I think it is important for producers to involve their publicity representatives beginning very early on in production, all the way through to the end. Not only does this build a sense of teamwork, which is crucial at launch time, but a trip around the production—meeting background artists, seeing storyboards and animatics, playing with the ink and paint system—will pique a publicist's interest. If a PR rep is excited about a project, that translates to publication editors. It also inspires a publicist to come up with new angles to pitch and different venues to pursue for coverage. Unless a publicist is walking down the halls of the studio with the producer, meeting and greeting and discussing the animation process, they might not know that the film/series contains a technical first, or that the head designer used to be an Olympic athlete. From trade publications to human-interest stories, these are the tips a publicist needs to know in order to go out there and "sell" a project.

The Producer's Thinking Map

The purpose of the "Producer's Thinking Map" is to provide you with a visual guide for the main steps involved in producing an animated project. For each topic listed in Figure 2–1, you will find a more detailed discussion in the corresponding section of the book. All three formats—feature, television, and direct-to-video—go through similar steps during the pre-production and the post-production stages. The most significant difference is where and how the production phase itself is handled. Features are often animated in-house, while direct-to-video and television series are usually out-sourced to subcontracting studios. We have illustrated these differences by allocating separate columns under the production category for feature versus television and direct-to-video.

One way of comparing the three formats is to look at their respective production pace, which is based on the time and costs necessary to produce each product. (For more details, see Chapter 1, "Introduction.") When producing a television show, whether it is 13 episodes or 65, the speed of the project is like that of a sprinter. Knowing how to get all the elements in place, shipped out in time, and put through post-production to meet air dates is similar to running at top speed at all times. With a short schedule and limited resources, there is little time for revisions and alternate versions. The key to success in producing for television is being quick on your feet and delivering fast. Direct-to-video projects enjoy a slightly more flexible schedule than television productions do, but overall they are also fast-paced.

In features, an attempt is made in just about every stage of production to further refine the story. Whether in the storyboard phase or color styling (a.k.a. selecting colors; see Chapter 9, "Production," for more information), time is spent on tweaking each scene in order to creatively "plus" it as much as possible. Unlike episodic television, where the turnaround allows you to view the fruits of your labor in just weeks, in features, the pace is much slower and you will not see your hard work on the big screen until two or three years have elapsed. This method of filmmaking is equivalent to running a marathon. It is crucial to have stamina and to pace yourself on a project so you can hit the end line still standing. In all formats, the producer needs to be a master juggler. The Producer's Thinking Map is a visual tool to help guide you through the elements that come into play.

	DEVELOPMENT	PREPARATION SET-UP
PRODUCTION STRUCTURE / STATUS	• Begin to Build Core Team: Director, Writer(s), Visual Development Artist(s), Legal Department and Business Affairs, Technology, Accounting, Recruiting, Training, and Human Resources	• Continue to Build Core Team • Identify Production Space • Begin to Purchase or Rent Production Equipment • Start Recruiting Production Team • Hire Editor and Editorial Staff • Editorial Equipment in Place • Hire Post Supervisor (Feature) • Software and Hardware Selection Based on Project's Digital Needs • Development and Testing of Software • Establish Production Process and Procedures
SCRIPT STATUS	• Writer's Deal(s) • Script Development - Premise, Outline, Treatment, Draft • Bible and Pilot (TV)	• Script Revisions (Feature) • Bible Finalized/Pilot Finalized/Other Scripts in Progress (TV) • Script Revisions/Polish (D-T-V) • Greenlit Final Script (D-T-V)
VISUAL DEV	• Conceptual Artwork: Main Character Designs and Key Locations	• Establish Style of Animation and Technique • Narrow Down Character Designs and Locations • Finalize Main Characters, Props, and Locations (TV, D-T-V) • Explore Color Treatment of Key Characters and Backgrounds
AUDIO	• Potential Cast of Voice Actors as a Selling / Promotional Tool • Song Demo, if applicable	• Hire Casting Director (Feature) • Hire Lyricist and Song Writer, if applicable • Identify Recording Facility
SUBCONTRACTING STUDIO	• Obtain Demo Reels from Subcontracting Studios	• View and Evaluate Tests by Subcontracting Studios • Narrow Down Choice of Subcontracting Studios
PROD PLAN	• Preliminary Pass on Budget, Schedule, and Crew Plan	• Finalize the Production Plan: List of Assumptions, Budget, Schedule, and Crew Plan
RELATIONSHIP WITH BUYER/EXECS	• Notes on Script Development • Notes on Visual Development • Notes on Songs, if applicable • Discussion with Ancillary Groups on Publicity, Promotions, Merchandising, Marketing, and Distribution • Establish the Final Delivery Format • Notes on Production Plan	• Agree on Creative Checkpoints • Approve Production Plan • Sign-off on Main Characters and Locations; Linework and Color (TV and D-T-V) • Sign-off on Script (TV and D-T-V) • Sign-off on Conceptual Artwork (Feature)

Figure 2–1 The Producer's Thinking Map

	PRE-PRODUCTION	PRODUCTION FEATURE ONLY
PRODUCTION STRUCTURE / STATUS	• Hire Staff Based on Crew Plan • Set-up Production Space • Continue to Purchase or Lease Production Equipment • Storyboarding: Prioritize Song Storyboards, if applicable • Broadcast Standards and Practices, Legal Script and Storyboard Review (TV, D-T-V) • Pre-Editing Story Reel, Prepare Sequence for Buyer/Executive's Approval and Recording (Feature) • Pre-Editing: Story Reel, Slugging, Track Reading, Exposure Sheets (TV, D-T-V) • Prepare and Check Shipment Package for Subcontracting Studio (TV, D-T-V) • 3D CGI Pipeline: Modeling, Rigging, Surfaces (Texture/Color), Animation Tests, Lighting and Effects Test • Start Compiling Credits	• **2D Pipeline:** Workbook, Sequence Draft: Scene Number, Footage, Dialogue, and Description, Sequence Handout and Evaluation with Department Heads, Scene Issue, Layout, Animation, Scene Plan/Scan, Rough Animation Approval, Clean Up Layout and Blue Sketch, Clean Up Animation, Visual Effects, Clean Up Animation and Effects Approval, Background Paint, Animation Check, Color Styling, Color Model Mark Up, Paint Mark Up, Ink & Paint, Final Check, Color Approval, Film/Video Output • **3D CGI Pipeline:** 3D Workbook/Staging, Animation, Texture/Color, Lighting, Effects, Rendering, Composite, Touch Up, Film/Video Output • Prioritize Production on Scenes Needed for Trailer and Promotions • Release Print Tests
SCRIPT STATUS	• Greenlit Script/Script Revisions in Progress/Production Begins Based on Approved Storyboard Sequences (Feature) • Multiple Scripts in Progress (TV) • Greenlit Final Script (D-T-V) • Numbered Script, Recording Script, Conformed Script (TV, D-T-V) • Research and Script Clearance	• Finalize Script/Storyboard on a Per Sequence and Per Act Basis • Numbered Script, Recording Script, Conformed Script • Final Script • Research and Script Clearance, as necessary
VISUAL DEV	• Design and Art Direction: Visual Style Guide • Create Model Packages (TV, D-T-V) • Title Sequence (TV, D-T-V)	• Character and Location Design on a Per Sequence Basis • Art Direction: Color Design and Application for Characters, Backgrounds/Sets, Props, and Visual Effects
AUDIO	• Hire Casting Director and Voice-Over Director (TV, D-T-V) • Finalize Deal with Recording Facility • Casting, Rehearsal (Pending the Budget and Schedule), and Recording Voice Track • Hire Song Composer, if applicable • Clearance on Music and Songs • Song Recording, if applicable	• Rehearsal and Voice Track Recording Based on Production Needs and Talent Availability • Choose Composer and Complete Deal • Prioritize Song Composition and Recording, if applicable • Clearance on Music and Songs, as necessary • Research and Finalize Deals with Post Team and Facilities
SUBCONTRACTING STUDIO	• Finalize Deal with Subcontracting Studio • Hire Overseas Supervisor, if applicable • Ship Artwork Materials and Audio to Subcontractor • Select Customs Broker for Clearing all Finished Elements to be Shipped Back by the Subcontracting Studio	• Possible Use of Subcontractor for Various Elements such as Animation, Clean Up, Visual Effects, Digital Ink & Paint, Rendering and Compositing
PROD PLAN	• Production Cost Reporting Begins	• Cost Reporting Continues • Weekly Assessment of Work Completed and Approved versus Quota • Adjustment of Schedule and Money based on Status of Production • Finalize Post-Production Plan and Schedule
RELATIONSHIP WITH BUYER/EXECS	• Receiving Notes/Obtaining Approval on Creative Checkpoints • Sign Off on Voice Casting Selection and Recording • Approve Sequences for Production (feature) • Meeting with Ancillary Groups • Prioritize Material for Ancillary Groups • Review and Sign Off on Title Sequence (TV and D-T-V)	• Final Sign Off on Key Production Design and Art Direction Choices • Receiving Notes/Obtaining Approval on Creative Checkpoints • Meeting with Ancillary Groups and Providing Materials as necessary • Market Research and Test Screening • MPAA Rating • Approval of Design and Content of Opening Titles and End Credits • Approval of the Final Cut: Lock Picture

Figure 2–1 (Continued)

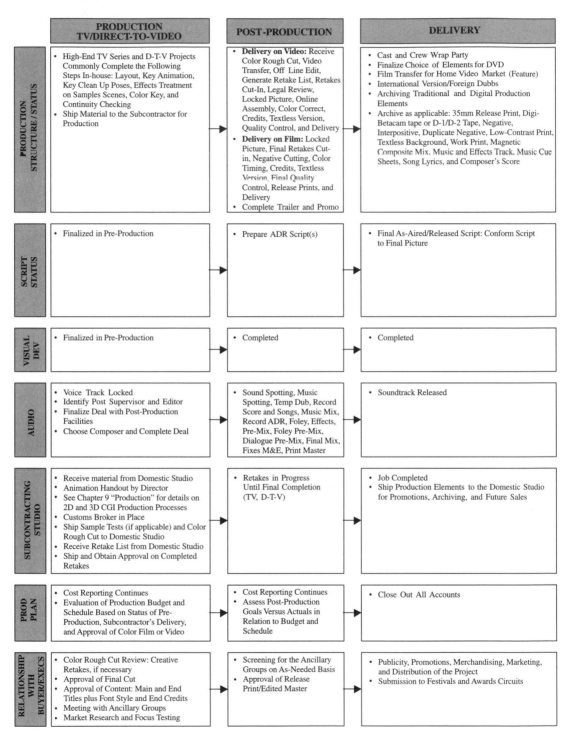

Figure 2-1 (Continued)

3

BUYING AND SELLING PROJECTS

Sources for Ideas

This is where the adventure begins: identifying a concept. As a producer, you can search for materials in a wide variety of locations. Potential story ideas can be found in comic books, graphic novels, classic tales in the public domain, toys, children's books, songs, as well as original characters and concepts. There are no set rules as to when or where a great idea can be found. The key is the ability to recognize one and know how to sell it to the appropriate buyer.

Comic books, comic strips, and graphic novels are among the easiest types of material to adapt for animation. With an established visual style, fully developed characters, and a storyline, the producer has almost all the main ingredients necessary to start pre-production. Typically, the best places to locate comic books and graphic novels are at comic book conventions. For example, every summer, San Diego hosts Comic-Con, the largest comic book convention in the world. At this convention, the major publishers, distributors, and independent creators come to show and sell their books. Many properties have been found and sold to networks and movie studios at this convention, including *The Tick* (see Figure 3–1), *The Mask,* and *Spawn.* If you are unable to get to a convention, visiting and perusing a neighborhood comic book store is also a good way to familiarize yourself with the world of comics.

Children's books are another bountiful source for animated features, home videos, and television shows. These include *Madeline,* the Dr. Seuss

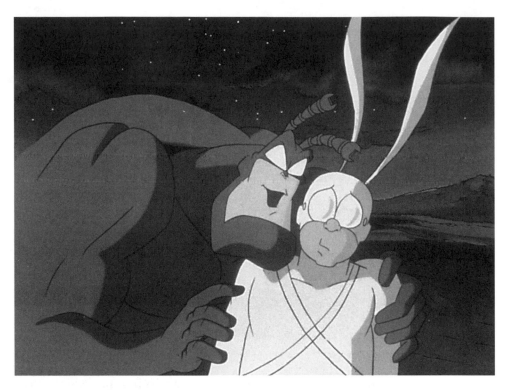

Figure 3–1 *The Tick* (Stills provided courtesy of Fox Kids. ™ and ©1994 Fox Children's Network. *The Tick* characters ™ and ©1994 Ben Edlund. All Rights Reserved.)

books, the *Babar* series, and *Pippi Longstocking* (see Figure 3–2), to name just a few. With its reliable marketability and name recognition, children's classic literature is an obvious choice for development. It is rare, however, to find a well-known children's title that has not been already optioned (which means the rights to develop and produce the property are already taken). It is therefore imperative to find good stories that are either newly published or are in the public domain (that is, anyone can use the rights as no one person or entity owns them). Examples of public domain stories are Fox's *Anastasia* (see Figure 3–3), Disney's *Tarzan*, and DreamWorks's *Prince of Egypt* (see Figure 3–4). Taking a famous story and adding a new spin to it is very popular, as is evident in the box office success of these titles.

Until the advent of Nickelodeon, selling original characters for television series was next to impossible. By taking risks and producing original material, Nickelodeon has successfully revolutionized both the look and content of the children's television landscape. Two of Nickelodeon's original and most popular series, *Rugrats* (see Figure 3–5) and *Doug* (now produced by Disney), are household names. Drawing on real-life experiences, both properties are well written and their success seems to lie in the fact that children can relate to the stories. The Cartoon Network also creates

Figure 3–2 *Pippi Longstocking* (Pippi Longstocking™ AB Tre Lindgren. Pippi Longstocking Series © 1997 AB Svensk Filmindustri/TaurusFilm GmbH & Co./TFC Trickompany Filmproduktion GmbH/Nelvana Limited. Provided courtesy of Nelvana.)

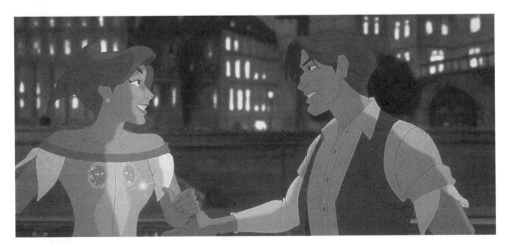

Figure 3–3 *Anastasia* (TM and ©1997 Twentieth Century Fox Film Corporation. All rights reserved.)

Figure 3–4 *Prince of Egypt* (TM and © 1998 DreamWorks L.L.C. Reprinted with permission by DreamWorks Animation.)

Figure 3–5 *Rugrats* (©2000 Paramount Pictures & Viacom International Inc. All rights reserved.)

original shorts. They have built their franchise and brand awareness with such series as *Dexter's Laboratory* (see Figure 3–6), *Cow and Chicken* (see Figure 3–7), and the *Power Puff Girls* (see Figure 3–8). As a rule, however, it is still difficult to sell original material since it does not have a proven track record. By taking a gamble on new properties, the buyer stands to lose a substantial investment. If it turns out to be a hit, however, the payoff can be extremely lucrative. The shows mentioned above have not only had long runs, but in the case of *Rugrats* and Disney's *Doug,* both projects enjoyed a very healthy box office success when produced as feature films.

Visiting comedy clubs and teaming up with well-known comedians is another way to create a property. However, if you are not an established producer, this may be a difficult route to take. Examples of projects developed and produced by popular comedians are the *Life with Louie* series by Louie Anderson, Lily Tomlin's *Edith Anne* specials, and *Bobby's World* (see Figure 3–9) by Howie Mandel. These series emerged from personas created by the comedians that were originally performed as part of their routines. Comedians are not the only entertainers who sell shows, however. Other performers who have succeeded in landing a spot in children's programming include Bruce Willis, who created *Bruno,* and Tone Loc, who developed *T Bear and Jamal*.

Figure 3–6 *Dexter's Laboratory* (*Dexter's Laboratory* and all related characters and elements are trademarks of Cartoon Network © 2000. A Time Warner Company. All Rights Reserved.)

Figure 3–7 *Cow and Chicken* (*Cow and Chicken* and all related characters and elements are trademarks of Cartoon Network © 2000. A Time Warner Company. All Rights Reserved.)

Figure 3–8
Power Puff Girls (*Power Puff Girls* and all related characters and elements are trademarks of Cartoon Network © 2000. A Time Warner Company. All Rights Reserved.)

Figure 3–9
Bobby's World (Stills provided courtesy of Fox Kids. ™ and ©1991–98 Fox Children's Network. Underlying property ™ and ©Alevy Productions. All Rights Reserved.)

If you do not have drawing or writing skills, you may want to team up with either an established artist or a talent new to the field. Animation festivals are an excellent forum for finding great material and meeting animation directors and animators. At such events, you are able to view the work of renowned artists as well as student films. Two television series that were first discovered as student projects are the Cartoon Network's *Johnny Bravo* (see Figure 3–10), by Van Partible, and Fox's *Family Guy,* by Seth MacFarlane. Original shorts may also be a good source for possible series or feature productions. Comedy Central's animated series *Bob and Margaret* (see Figure 3–11) was based on an Oscar Award–winning short created by Alison Snowden and David Fine.

Once you have found a property, it is important to identify its future format. Is it more suitable for television, direct to video, features, or the Internet? In the television arena, the markets are very defined in terms of the target audience. This definition is based on the audience demographic and the network's brand. Nickelodeon, for example, is targeted at kids, while the Disney Channel is targeted at families. Ask yourself if the concept is aimed at a pre-school, "tween," teen, or primetime audience. If it is not clear who the viewer is, you may want to reconsider your choice or make defining it a top priority during development.

Figure 3–10 *Johnny Bravo* (*Johnny Bravo* and all related characters and elements are trademarks of Cartoon Network © 2000. A Time Warner Company. All Rights Reserved.)

Figure 3–11
Bob & Margaret (*Bob & Margaret* Series © 1999 Nelvana Limited/Silver Light Productions Limited. All Rights Reserved. Provided courtesy of Nelvana.)

The audience for animated features is much broader. Unlike television, the target audience for feature properties tends to include both children and adults. While many producers have tried to emulate the Disney musical format, in recent years, there have been a number of features specifically aimed at teenagers and a more mature audience. Similar to features, direct-to-video projects also have a broad audience, but the lion's share of the market is children or, more specifically, parents buying videos for their young children.

Before you go ahead and spend money on a property, it is wise to do some research to make sure that there is actually a market for it. You may think you have found the most exciting superhero since Batman, but there may be similar properties in development, or it could be that superheroes are not currently popular. Market research is therefore essential. One studio may only look for original characters; another, pre-established properties; while yet another searches for dramatic primetime material. Although it is not easy, you should consider picking up the phone to cold-call executives and find out what they are looking for. Do your homework in advance by familiarizing yourself with the type of shows that each studio has produced. If indeed you do get the opportunity to speak with someone and your idea seems to fit the bill, be prepared to summarize and pitch your idea in just a few sentences (see the "Preparing a Pitch" section later in this chapter).

The Buyer

There are two different types of buyers. The first is a group with a distribution arm such as a network, cable company, or movie studio. Typically, it is best to sell your property directly to one of these outlets as the distribution is already in place. On the other hand, depending on the property and your background, it may make more sense to sell to an independent production house. While independent producers or production companies ultimately need to find distribution, they can have much to offer. The advantage of working with an independent is twofold. First, they tend to be more accessible. Second, they can draw on their internal resources to develop and prepare your project for pitching to targeted buyers. Depending on the size and experience of the company, they may be able to provide deficit financing. (Deficit financing is production money used to supplement the license/production fees paid by the buyer.) The independent producer could also be better equipped to turn a property into a franchise than would a network, which tends not to do this. Or, they may own an animation facility that could actually produce and develop the project.

There are several ways to find potential buyers. Read industry magazines that interview and highlight key executives, or browse the web. Depending on where a buyer works (that is, a production company, studio, network, or cable company), he or she may have a different title. The most common titles are creative executive, development executive, current

executive, and programming executive. However, the buyer's overall responsibilities are generally the same. Their goal is to identify new and one-of-a-kind concepts to develop for the company. Their success is based on getting projects greenlit, produced, and most importantly, creating a hit. Once a project has been selected, it is the job of this executive to shepherd it through the negotiation, development, and in most cases, production processes.

Creative Executive

The responsibilities assigned to an executive change from one studio to another. In some studios, for example, the development executive may work on a project's conceptual phase and remain equally involved as it goes through production and post-production. Elsewhere, when a project is greenlit for production, it may be that once it has completed development, another executive is responsible for taking over the project from the development executive. In television this position is commonly referred to as a "current executive." In this setup, after a brief transition period during which both the current executive and the development executive are involved, the current executive takes over the show. From this point on, this executive manages its creative progress until the completion of production. For the sake of simplicity and clarity, we will refer to the key creative point person on the buyer's side as the creative executive.

Creative executives identify properties for the company to pursue. They spend their time looking at all kinds of materials, including published works and original concepts. They take pitches, and they visit comedy clubs to search for new talent. It is the executive's job to sell the property to their supervisor, for development and/or production. The person they report to is typically the head of programming, the studio, or basically the individual who has the ability to purchase or greenlight a project and put the necessary funds behind it. In many cases, the creative executive will have a junior executive reporting to them at a director or manager level. This junior executive is probably the most accessible person in the hierarchy. Another person that is approachable is the assistant to the creative executive. The assistant is usually a good person to befriend, as they can be a source of information, possibly letting you know what the executive is looking for as well as getting you a meeting.

Along with searching for properties, creative executives meet with producers, directors, and creators to take pitches and find material. In general, having an open-door policy allows the executive to listen to many pitches, therefore improving the probability of finding a hit. The creative executive on your project is an integral part of the process. While they may not be individually able to greenlight the project, if they believe in it, they have the power to keep your project alive by selling it to key individuals

within their company, giving it the best chance for production. It is therefore your job as a producer to ensure that their initial enthusiasm continues throughout the lengthy and often bumpy process of development.

During development, creative executives are very involved in finding and hiring the core team, such as artists, writers, and producers, to attach to a project. Once a project is in production, the creative executive monitors its creative progress to ensure that the story is working. Depending on the budget, schedule, and deal struck by the producer, these executives have input at key creative checkpoints throughout the process. After the show is delivered, they are very involved in getting it promoted both internally on a corporate level and externally to the public, thereby helping to secure its success.

Production Executive

When a project is close to being greenlit for production, another key executive is included in the process of analyzing whether it can be produced or not. This is the "production executive." It is the production executive's job to assess whether the agreed-upon creative goals of a project can be achieved based on the fiscal parameters of the production. In most cases, production executives report to the head of production. The production executive works closely with the creative executive and the producer to structure a budget and schedule for both the development and production processes. Once a project begins actual production, the production executive monitors its progress, making certain that the creative needs of the buyer are being attended to while meeting the agreed-upon schedule, budget, and delivery requirements. When a production has problems, such as falling behind schedule, it is the role of the production executive to troubleshoot, working with the producing team and creative executive to find solutions and get the production back on track.

Preparing a Pitch

We cannot stress enough the importance of researching your potential buyer and determining exactly what type of materials they are looking for. Some buyers may be interested in a fully developed concept with a completed script and visuals while others may only wish to see a premise and some rough designs. It may also depend on the profile of the project. If it is a well-known franchise, little or no development may be necessary. Many different approaches can be equally effective; it all depends on your concept and the would-be buyer. When preparing, bear in mind that people can only take in so much before you start to lose them; therefore, keep the materials simple. No matter what form of pitch you choose, the three key elements to have in place are the concept(s), character(s), and the story(s).

For television, from the start, there are two main ingredients to set up: a clear concept and a defined target audience. You should be able to explain what the series is about in a logline, or one or two sentences. You must also have several stories prepared in order to illustrate that the property has a life beyond the pilot episode and that there is a reason why viewers would want to tune in each week. In most cases, if it is an original primetime property, it is best to have a pilot script prepared. Keep in mind that if the network goes forward with optioning the property, they will probably do further development to the materials to shape it for their specific audience.

For feature films and direct-to-video projects, you should be able to take the buyer through the main storyline using the classic structure of a beginning, middle, and end. Introduce the main characters and a few supporting characters as you come to them in the story rather than at the beginning. Be prepared to explain the subplots when questions arise, but don't try to include them in the main story pitch, as you want the story to be crystal clear. Be able to outline the rules of the universe. For example, do humans and animals interact? Define the target audience and describe the tone using frames of reference such as other movies. Artwork is not vital; however, a few carefully selected quality setups illustrating the characters in their world can be useful. If a composer is already attached (although this is not necessary), have a demo tape available. It is good to have a brief treatment prepared to leave behind. It should be no more than two pages, containing only the key story beats. Prior to pitching, do not feel that you need to have ancillary partners such as merchandising in place. This aspect of the process is usually handled later on, and is really not necessary to the pitch. Depending on the buyer, having a business partner can be helpful, but at this stage, the main goal is to sell the idea on its own merit.

Before going into a pitch, practice your presentation. Brief is best. You should have the presentation down to 10 minutes or under for a series and 10 to 15 minutes for a feature—no more! If you have a creative partner, decide on who will handle what. Evaluate the strengths and weaknesses of the partnership. Your strength may be in drawing, while your partner is in selling and telling the story. Take practice runs, setting each other up rather than stepping on top of each other.

Pitching

Let's assume you have managed to get in the door to pitch. The creative executive's goal is to determine whether your project is suitable for their studio. Since you need to establish an ongoing relationship with this person, be smart about the meeting. If this isn't the project for them, take the rejection gracefully. You want to leave a good impression so that they will want to see you again, at this job or their next, as executives tend to move around a

lot. (It has been said that the average life of a creative executive at a studio is between one-and-a-half to three years.)

When pitching, try to remain as natural as possible. Analyze your audience's response and try to cater to what their needs are rather than taking the pitch in a direction that is suitable for you. Again, be short and to the point—don't waste time. Summarize what you are selling and get the concept across in just a few sentences.

When I (Catherine) worked as a creative executive, I saw people make basic strategic errors. In one pitch, the creator was told in advance that we were looking for primetime content. We were assured that that was exactly what we would see. After everyone was introduced and we sat down to begin the usual small talk that takes place prior to a pitch, the creator stood up and commenced to sing and dance. This individual literally bounced around the room singing his heart out and sweating away for 30 minutes straight. It was impossible to cut in and ask a question. He performed an entire animated musical without a break. Since this project was suitable for a children's special, he had unfortunately wasted everyone's time, including his own. The next time he called to pitch a project, I chose not to hear his new idea since I was not sure what I would get, and my time was very limited.

On another occasion, a seller brought 20 different projects to our meeting. The materials were placed in front of me, and like an auctioneer, this producer began to rapidly extol the merits of each, asking me to pick out the ones I wanted. In this case, she should have done her homework (researched our programming needs), selected the strongest concepts, and handed me one or at most three properties. Instead, she lost my attention within the first three minutes as I had little desire to sift through all the projects and figure out what was appropriate. There may have been a gem in the pile, but I had no urge or time to do her work for her and find it.

After a pitch, it generally takes time to get a response. Creative executives have many projects cross their desks each week. Consequently, it is almost impossible to get back to everyone in a timely manner. Unless you meet with the person who can greenlight optioning a property, the creative executive still needs to sell it to their superiors, who may want you to pitch the property again. They may also ask you to send more materials. You should thus expect to wait at least three to four weeks before hearing anything.

Representation

If possible, it is advantageous to have a lawyer or an agent in place when you pitch your project. As a company policy, some executives may not even meet with you or review a property unless you have representation. Executives prefer that the creator and/or producer be attached to a lawyer

or agent for a number of reasons. It helps to avoid any potential misunderstandings when a similar project is greenlit, or put into development. If they decide to option the property, you will be in the position to make a deal. It also indicates that your material has been reviewed by an industry professional who is confident that the material is developed appropriately and ready for pitching.

If you do not already have representation, the best way to find a lawyer or an agent is through recommendations. Speak to other artists or producers who can lead you in the right direction. If you do not have any connections, review the various animation journals (see the Appendix, "Animation Resources," for more information) to help you identify potential candidates. In order to make sure you are hiring the right person, consider interviewing a few people. Your agent or lawyer is ultimately a reflection of you and your style. Since they represent you to the people you are going to be working with, you want to be sure that the relationship is intact when the project begins development. General questions to ask potential representation include: How long have they been in the business? What is their business philosophy? What is their negotiation style? Could they provide you with a list of clients? What are their rates? What is the method of payment?

It is necessary to set up the terms of your relationship with your lawyer before you go forward with negotiations on your project. As a rule of thumb, agents take 10 percent of the fees they negotiate, and entertainment lawyers are paid an hourly fee ranging from 200 to 350 dollars per hour. The advantage of hiring a lawyer who is paid on an hourly basis is that once you have paid the fees, there are no additional costs. Some lawyers, however, prefer to work on a percentage, which typically translates to 5 percent of your entire deal. In this case, the lawyer's payment is similar to an agent who is entitled to their percentage portion of the backend benefits. (Backend is a percentage of profits you receive on items such as domestic and international sales, soundtrack, home video release, and merchandising.) The advantage of this type of contract is that since your agent or lawyer shares the financial rewards with you, they are highly motivated to get you the best deal possible. Also, if you hire an agent, you do not need to lay out any money until you are paid by the buyer. Another plus to working with an agent is that they can be instrumental in finding new opportunities for you as executives call agents when looking for talent.

The Negotiation Process

Patience is vital when heading into the negotiation process. After everyone has agreed that they would be interested in developing a property, it goes into the world of "business affairs," where the attorneys work out the deal points to option the property. It is our experience that these negotiations can average three to nine months before everyone is in agreement and the

contract finalized. The exception to this rule would be if the project is on the "fast track" and someone in a decision-making position is interested enough in it to make it a top priority.

Many steps take place internally (meaning at the buyer's place of business) in order for everyone to agree to the costs involved in developing and producing a property. Once internal meetings take place, the buyer's business affairs person will make an offer to your representative. After the offer has been put forth, it is up to you and your representative to counter the proposal. In order to do this, you need to think about what is important to you in the deal and what is not. After discussing this with your representative, he or she will go back to the buyer with a counter offer. This back and forth negotiating process continues until everyone comes to terms that are satisfactory to all parties.

A short-form contract is negotiated first, and then a long-form contract is drawn up. The short-form contract typically spells out the key deal points, including option fees, compensation, services to be rendered (that is, producing, writing, and so on), the term (the length of the option period), back-end percentages, credits, ownership, and purchase price of the project once production is commenced. The long-form contract is a detailed legal document that includes all of the material stipulations negotiated in the short-form contract as well as terms that are standard and customary in the industry. These conditions include representation and warranties, termination, indemnification, and force majeure, for example. In most cases, they are non-negotiable terms. The studio's backend definition is usually attached as a rider to the long form.

Be realistic in your expectations. You are probably not going to get everything you asked for. Negotiating entails compromise. Your representative should be able to provide you with current market rates. By thoroughly considering all options offered, you should be able to make educated decisions as you forge through this process. Various factors, including your experience and the buyer's policies, standard negotiation practices, and the studio precedents, can make the final results somewhat out of your control. It is essential that you feel satisfied enough with the deal so that you can work with enthusiasm on the development of the project. However, be flexible, and when you give in on a point, let it go and move on. It is important to preserve the relationship and keep goodwill intact on the part of your buyer. After all, once the negotiations are completed, you will be working together on the same team.

Once agreements have been signed, development can begin.

4

THE CORE TEAM

An Overview of the Core Team

When you are taking the first steps to start a feature-length animated film, a direct-to-video project, or a television series, a select number of staff members need to be in place prior to the start of production. This skeletal group is what we are calling the *core team*. In most cases, the producer is the central person, pulling this team together based on the fiscal and creative needs of the project. The formation of the core team typically starts during development with the initial creative group, which includes the producer(s) and the writer and/or creator/originator of the concept. (See Chapter 5, "The Development Process," for more information.) Along with this group, it is necessary to add the director(s), visual development artists, business affairs and legal executives, accountants, technology team, recruiters, training department (if applicable), and Human Resources. Some of the members of this team may already be on staff (that is, business affairs and legal staff, recruiters, training staff, and Human Resources). If this is the case, the producer brings these people into the mix on the project as necessary.

Each individual plays a significant role in getting a production up and running. One possible example of this process is as follows: The project has become solidified in terms of story. A director, if not already attached, needs to be hired to guide its visual development and to collaborate with the producer, buyer/executive, and writer on the script. The recruiter helps identify a potential director. The business affairs and legal departments negotiate their deal. Once on board, Human Resources coordinates the director, filling out the necessary paperwork, and the production accountant processes their payment. The director works with the recruiters to cast and hire the visual development artists. The technology group is instrumental in securing and supporting the software and hardware needed for the production pipeline. If it's necessary to bolster the artistic team and a dearth of artists exists, the

training department scouts fresh talent and starts organizing classes. All of these steps are overseen and managed by the producer. On productions with a limited budget or in independent studios, some of the above roles may not be filled or one person may handle several of these responsibilities.

The Role of the Director

The director is the primary storyteller on a project. It is his or her vision that is the guiding force. A director also sets the visual style of the animation. In this position, they have to be able to communicate their thoughts effectively and make certain that it is understood by both the artistic and key administrative members of the production team.

The director and producer collaborate with the recruiting team to select artists. Once hired, the director supervises the artists, handing out assignments and reviewing their work throughout the development process. One of the director's top priorities is to put together a style guide that best illustrates the visual look of the project. (See Chapter 8, "Pre-Production," for more information on the visual style guide.) The director either works with a production designer or may lead the team of artists developing and designing the style guide. At first, this is an experimental process, and the artists are given as much creative latitude and freedom as possible. As the style becomes more solidified, the director gets more specific in order to hone in on the final look of the project. During pre-production, it is the director's job to give constructive criticism and notes on all of the various visual elements designed, as well as on the storyboard. In many cases, the feedback is verbal; in others, it may be visual. Some directors can communicate more clearly to the artists by drawing or making corrections on sketches.

Once the project is ready for production, the director is in charge of handing out assignments, either directly or through department supervisors, and viewing and approving all artwork generated by the in-house artists and subcontractors. The director is also responsible for leading the various technicians, such as technical directors. During the casting and recording of a project, the director is involved in all steps of the process including choosing and recording the actors. Depending on their experience and comfort level, they may direct the voice talent or work with a voice director. In terms of music, the director and the composer collaborate to explore themes and choose a style. Throughout post-production, the director continues to lead the team by articulating the overall vision of the project to such staff members as the sound designer, dialogue editor, video editors, and telecine colorists. (For more information on the duties of the director, see a detailed list below. Also see Chapter 8, "Pre-Production," Chapter 9, "Production," and Chapter 10, "Post-Production.")

Given that the director is an intrinsic part of every step of the process, they should be hired as early as possible and have input on the script, sched-

ule, and budget. By involving the director at this early stage, he or she can determine how to tell the story while getting the highest quality animation based on the style and financial stipulations of the production. However, hiring a director early may not always be possible. Often times a television director is handed the final script and has to start production immediately. Time and budget restrictions leave little room for the director to develop the project further.

On television productions, in those cases where an executive producer is in charge, the role of director is not as all encompassing as described above. In this setup, the director's job is to ensure that the executive producer's overall creative vision is understood and followed through by the pre-production artistic team. The director supervises the artists and reviews all creative stages, giving input and making notes throughout the pre-production process. They may or may not be involved in production and post-production, as this may be handled directly by the executive producer or supervising director when there are multiple directors.

Prevalently, animated feature films are led by two directors. This structure is usually set up as a method to expedite the production process. It works in several ways. One system is to simply divide the sequences between the directors. Another approach is to assign different departments to each director based on his or her strengths. Another commonly practiced system is to divide the sequences between four or five directors who primarily focus on the acting or animation. These directors are called sequence directors. In this case, there may be one overall supervising director who oversees the work of the sequence directors to ensure that the story and animation work in their entirety. This same system can also be used on series production where there may be several episodic directors led by one supervising director.

The best directors are able to easily amalgamate the two distinctly different worlds of words and images. An ideal director is articulate, inspirational, and able to lead his or her artistic team through the thick and thin of production. The most important asset for directors is to know what it is that they are looking for, and to be able to communicate that vision to their crew. Artists thrive on working for a mentor who is able to appropriately cast the artistic assignments, and who through constructive criticism can draw out their best work.

A great producing and directing team is a flexible one. By respecting each other's roles and goals, there is a healthy friction between the producer and director. The producer's job is to help the director bring his or her vision onto the screen. The director, in essence, pushes the limits of the project creatively, and the producer does all that he or she can to help achieve these goals while pulling back on the reins when necessary. It is key that when problems arise, the director and producer work together to find solutions. Together, they must continually motivate their team. They should

communicate to their crew on a consistent basis, ensuring that everyone understands both the project's creative goals and its time and budgetary restrictions. Sharing pertinent information with the crew enables them to feel invested and eager to do their best work.

Director's Responsibilities

Based on the production's time and budget, and the skills and experience of the director(s), they may take on all or a combination of the duties listed below. Please note that when we refer to the executives, we are addressing the individual(s) responsible for overseeing and/or funding the production. (For more information on the specific production steps noted below, see Chapter 8, "Pre-Production," Chapter 9, "Production," and Chapter 10, "Post-Production.")

1. Developing and completing the script in collaboration with the writer, the storyboard artists, the producer, and the buyer/executive.
2. Communicating with the producer and the buyer/executive in regards to all artistic developments.
3. Incorporating creative notes given by the producer and the buyer/executive.
4. Communicating with the production designer and/or art director regarding stylistic choices and the color scheme selected.
5. Understanding and giving input on the project's final budget and schedule.
6. Selecting, approving, and managing all artistic staff and department supervisors in collaboration with the producer.
7. Casting and/or directing voice talent under the supervision of the producer and the buyer/executive.
8. Selecting and approving musical talent, including the composer, lyricist, and vocalist, in collaboration with the producer and the buyer/executive.
9. Coordinating efforts with the associate producer, artistic coordinator, and/or department supervisors to make shots less time consuming and more cost effective, when applicable.
10. Selecting and approving outside production studios in collaboration with the producer.
11. Developing and approving the style guide for viewing and signoff by the producer and the buyer/executive.
12. Approving color/surface treatment (characters, locations, props).
13. Understanding and agreeing to creative checkpoints with the producer and the buyer/executive.

14. Approving storyboards for viewing and signoff by the producer and the buyer/executive.
15. Creating and approving the story reel/animatic/leica reel for viewing and signoff by the producer and the buyer/executive.
16. Evaluating the workbook with department supervisors, artistic leads, and members of the production team.
17. Approving all key production steps. (See Chapter 9, "Production," for a listing of 2D and CGI production steps.)
18. Approving final color and signoff by the producer.
19. Editing the picture with the editor and producer.
20. Delivering the final cut.
21. Giving input on the selection of the post-production facility.
22. "Spotting" sound effects and music with the producer.
23. Supervising automatic dialogue replacement (ADR) with the producer.
24. Supervising the music recording session with the producer.
25. Supervising the final mix session with the producer.
26. Reviewing final credits.
27. Reviewing the answer print or edited master with the producer for signoff by the buyer/executive.

There are many areas in which the director's and the producer's duties overlap. Here again, it is necessary to note the importance of the synchronicity between the director and the producer. Establishing an understanding of the director's responsibilities from the outset is therefore critical.

Visual Development Artists

Conceptual artists are commonly referred to as visual development artists given that it is their job to conceive the overall look and style of the project under the guidance of the director and production designer/art director. For the core team, a group of artists are selected who have a strong aptitude for character and location design along with color styling. (See Chapter 5, "The Development Process," for further information on this topic.)

Being both prolific and flexible are necessary attributes for these artists. After all, coming up with material that has strong entertainment value is not a simple task. Out of a hundred drawings, there may be only one that is close to the target. The artistic development of a project is an exploratory process that involves searching for the right style and treatment. Building on the vision of the director and the producer, the visual development artist creates the main concept for the project, which is followed by the rest of the crew. These artists tend to be on staff for features, while they are often hired on a freelance and as-needed basis for lower-budget projects.

Business Affairs and Legal Department(s)

Depending on the structure of a studio, legal and business affairs may be two separate entities or combined into one department. The producer works closely with the legal and business affairs executives, and creative and/or production executives, when hiring key personnel who need to be put under contract, such as directors, line producers, associate producers, writers, artists, and voice actors. The business affairs and legal departments are also involved in any deals with subcontract studios and outside facilities. The producer is responsible for giving these executives the fiscal parameters from which to put together a deal. Furthermore, the producer outlines the roles and responsibilities of all individuals under contract. By delineating the duties from the start, all parties are made aware of the expectations of the job, thereby avoiding possible future misunderstandings. Once a project is in production, the producer uses this department for advice and guidance on business, personnel, and union issues. The producer provides this department with production materials to review for legal notes and clearance at specific checkpoints throughout the process. It is the role of the producer to ensure that these notes are implemented to avoid any potential problems once the project is complete.

It is the job of the business affairs executive to make deals for a project by negotiating the short-form contract. (See Chapter 3, "Buying and Selling Projects," for more information on contracts.) Throughout the negotiations, business affairs executives ensure that the overall business philosophies and strategies of their company are followed. All deals created need to be consistent with the studio's corporate policies and the project's or company's fiscal parameters. Another objective is to make sure that new deals are in line with contracts that have been previously established. Once the key deal points have been locked down by the business affairs executive, the baton is handed over to the legal executive. This executive is responsible for negotiating all of the finer deal points that spell out the final agreement or long-form contract.

The main duties fulfilled by the business affairs and legal department are as follows:

1. Handling acquisition agreements (that is, the purchase of intellectual property).
2. Handling title clearance (establishing chain of titles and clearing ownership of property).
3. Handling copyright issues (identifying and clearing any copyright issues).
4. Registering the title of properties with the Motion Picture Association of America.

5. Negotiating talent agreements, including writers, creators, artists, actors, studio facilities, creative and technical consultants, musicians and composers, subcontract studios, and any other person/company that may require a contract.

6. Negotiating and drafting short- and long-form contracts.

7. Coordinating writers' and any freelance staff payments with the payroll department as noted in each individual's contractual agreement.

8. Functioning as a liaison between production, Human Resources, and the union, if applicable.

9. Negotiating union agreements.

10. Collaborating in the development and implementation of all studio policies such as hiring issues, benefits, holidays, overtime payment, and termination.

11. Obtaining visas and work permits for those artists relocated from another country.

12. Maintaining a complete list of all contracted employees/consultants and their pertinent information, such as option notification and contractual pick-up dates.

13. Reviewing the script and identifying all references to products or brand names that need to be cleared.

14. Obtaining music clearance (verifying that they are public property and negotiating fees to be paid for copyrighted material).

15. Compiling contractual screen credits.

16. Reviewing and signing off on final screen credits.

17. Verifying accuracy of promotional material in connection with details of contracts, such as size and placement of credits.

The Technology Department

The technology department is responsible for providing and maintaining computer hardware and software for the artistic and administrative staff. Depending on the size of the studio and the extent of digital production to be used on the project, this department can be just a handful of people or upwards of 80 staff members. Whether the project will be fully digital or have moderate use of the computer, the producer and the director should meet with the technology group as early as possible. This helps to pinpoint the specific needs of the show and set realistic goals that can be met within the budget and schedule. Following the producer's guidelines, this team is responsible for identifying equipment, negotiating deals, and maintaining all contracts and licenses for hardware and software. Since technology is so multi-faceted, the group may be divided into separate departments rather

than falling under a single one. Areas covered in technology include technical direction, systems administration, information systems, and research and development.

Technical Direction

The role of a technical director is dependent on the amount of digital production required on a project. 2D technical directors work closely with the production team in evaluating the story reel and identifying areas that can be either created or enhanced digitally. Depending on the studio setup, the 2D technical director's duties can cover many areas, including scene planning, digital effects, digital painting, digital animation checking, and compositing. Technical directors also have a very involved role on 3D CGI projects. (See Chapter 9, "Production," for a detailed discussion on the technical director's involvement in CGI production.) At most studios, technical directors work alongside the production staff to monitor the digital production and to troubleshoot when necessary.

On projects that use subcontractors, it is essential that the studios involved either use the same or compatible equipment. If they don't, the technical director must evaluate whether the cost of installing the machinery and training the staff at the subcontractors makes fiscal sense versus doing the work in-house or possibly finding another studio with compatible equipment. A significant financial investment may only be wise when there is a long-term commitment with the subcontracting studio. The technical director also determines the best way to transfer data back and forth between the two studios. In some countries, for example, the government regulates the use of sending data over telephone wires. For this reason, the technical director must thoroughly research this topic and address any issues prior to the start of production.

Systems Administration

This division of the technology department plays a central role in digital production studios. It is this team's role to purchase the necessary hardware and software for the studio. They also assemble, manage, and support all the digital systems and their capability to interface with each other. If there is a complex in-house tracking system, systems administrators oversee its operation. The production team relies on its systems administrators for full-time support and technical problem solving.

Information Systems

Commonly referred to as IS, the information systems group sometimes falls under the technology department. This group takes care of installing

and administering all computer-based office equipment. They make sure that all computers, networks, servers, back-up, and e-mail systems are up and running. When any of these systems are not functioning, it is their job to resolve the problem promptly.

Research and Development

The research and development group oversees the development of new digital tools to be used for servicing the projects' creative requirements. They also figure out ways to make a production more efficient and streamlined. In studios that produce strictly digital projects, it is critical to have ongoing software development to stay competitive in the industry. Remaining current with the latest technology and evaluating the most recent tools, programming, and platform changes is a priority for this group.

Production Accounting

The production accountant functions as the producer's right-hand person by keeping track of every penny spent during production. It is the production accountant's job to be aware of and communicate the financial status of a production to the producer. In most cases, the production accountant reports to both the producer and the studio executive. In larger studios, the production accountant may work under the supervision of a production controller, who oversees the accounting of a number of projects at the same time.

At the inception of a project, the producer and the production accountant work closely together to establish the details of the budget based on the schedule and the artistic needs of the production. Once the project is green-lit, it is the responsibility of the production accountant to constantly monitor the weekly progress of the production from a monetary point of view. The production accountant attends project meetings and is given pertinent production information on a consistent basis by the producer, director, the associate producer, the management crew, and the department supervisors in order to assess the status of the budget. This analysis is done through the generation of a cost report or an estimate of final costs (EFC). A cost report is a line-by-line breakdown of all costs incurred to date and the amount of money remaining in each category. It compares the actual work completed on the project versus the work to be done. (See Chapter 6, "The Production Plan," for more information on building the budget.)

By evaluating the various financial reports, along with the schedule and status of production, the production accountant tracks expenditures. Under the guidance of the producer, the production accountant can determine areas in which there are savings as well as areas that may require additional funds. Together, the producer and the production accountant decide on where to move funds based on the creative and upcoming needs of the

project. Even though the production accountant is not creatively involved in the project, it is imperative to keep him or her aware of all developments on the production. Unless the production accountant is informed on all revisions and issues, he or she will not be able to do the job effectively. It is the role of the production accountant to highlight or bring to the attention of the producer any potential problems that may affect the budget.

The production accountant is also responsible for processing payroll, all purchases, and invoices. Timecards are signed by the production manager and/or the producer and are then forwarded to the production accountant to review and process for payroll. Once completed, paychecks are prepared for staff members and freelancers. Every purchase, ranging from small items paid for from petty cash to acquiring big-ticket items such as animation desks, will require the approval of the producer. In the case of larger items and services rendered (such as voice recording at outside facilities) a purchase order (PO) is issued. A PO states the purchase or service, its projected cost, and the line item to which the cost should be attributed within the budget. A PO is used as a check and balance system to manage costs. When invoices are received, the production accountant uses the PO to match up the invoice, cross-checking that the amount charged doesn't exceed the amount the producer originally signed off on. If it does, the production accountant informs the producer, who makes a decision on how to proceed. After the invoices are approved, these costs are entered into the accounting system and checks are cut.

Human Resources

The Human Resources department is typically involved in the hiring of new employees. Working closely with the producer regarding the terms of employment, they handle communicating and negotiating offers. They are responsible for welcoming new artistic and administrative staff and integrating them into the studio. Typically, on the first day of starting a job, each employee attends an orientation meeting organized by Human Resources. At this meeting, new staff members fill out the start-up paper work needed for payroll purposes. They are also informed of the studio's rules and regulations and receive important items such as identification cards and parking passes, if applicable.

Another equally important aspect of Human Resources is resolving interpersonal conflicts. In many cases, a producer can help solve issues. However, if the producer is not available, or the matter needs an objective third party, Human Resources is responsible for this task. It is Human Resources' duty to make sure that the studio's philosophies and the Department of Labor's laws are followed by the production. In the case of studios that have an agreement with the local union, Human Resources oversees the implementation of union codes. If there is ever a discrepancy between the

studio's philosophical objectives and the rights of the employees, Human Resources is responsible for both finding and applying the appropriate solution. If necessary, Human Resources works closely with the producer and the business affairs and legal department to resolve any disputes.

Human Resources is involved in all aspects of the people side of the business. The following list outlines their main responsibilities:

1. Creating job descriptions that fulfill production needs and adhere to labor laws.
2. Setting up interviews.
3. Setting up personnel reviews.
4. Hiring and negotiating salary with production personnel.
5. Processing all start-up paper work, including W-4s and I-9s.
6. Coordinating efforts with payroll for payment of fulltime crewmembers.
7. Organizing accommodations and providing general information for artists relocated from other countries.
8. Tracking and administering salary parameters and annual raises.
9. Maintaining a database on the status of employees and studio headcount.
10. Dealing with disciplinary actions.
11. Ensuring that a healthy work environment is maintained.
12. Handling all internal disputes.
13. Resolving discrepancies with payroll for payment of Motion Picture Health and Welfare Pension if the studio has an agreement with the local union.
14. Tracking and administering benefits such as life insurance, health benefits, and 401K programs.
15. Conducting exit interviews.

Recruiting

Not every studio has the luxury of having a recruiting team. In some cases, there may be just one person handling all submissions or producers may have recruiting added to their list of duties. The recruiting department is responsible for finding the best candidates available for both production and administrative jobs. Working with the producer, the recruiter(s) are informed of the creative and administrative needs of a project. It is the recruiter's role to search and identify potential candidates to fill the available positions. Methods of recruiting include advertising in the trades, on the Internet, and in the local union, if applicable. Another effective means of recruiting is organizing booths at animation festivals or other related arts such as comic book conventions and special effects/computer graphics

conferences. At these events, artists can view conceptual artwork created for future projects at each studio and have their portfolios evaluated. Some studios go through the expense of throwing parties during festivals and conferences so that artists can get to know the studio executives and department supervisors better and vice versa.

Artists and production personnel who are interested in an advertised position drop off their portfolios and resumes with the recruiting department. This office sets up reviews of the portfolios by a committee that generally consists of the director, the producer, the production designer and/or art director, and the appropriate department heads. Resumes for production assistants and coordinators are sent to the producer and production manager, who select the qualified candidates and conduct interviews with them.

Once a decision has been made in regards to hiring an artist or a production staff member, additional interviews are set up to discuss availability, salary, start date, and benefits. In cases where the option to "pass" on the portfolio or resume is exercised, the recruiting department keeps a copy of the selection committee's or the producer and production manager's evaluations. When new openings on the current production or future projects crop up, they review these resumes in case a match can be made. When there are no artists available to fill the positions, a member of the recruitment team will travel abroad to hire and relocate talent. Since the immigration process is a costly and lengthy one, this type of arrangement should only be made for an artist who is not needed immediately and who can be utilized on a long-term basis or on a number of different projects.

Training

Larger studios that have a long-term commitment to producing animation often invest in a training department. This group works with the recruiting team and producers to identify the training needs of the studio. The goal is to set up a highly rigorous animation program that educates future artists brought in as interns. The interns then attend classes led by in-house talent and outside animation pros. The training department also organizes additional classes, such as life drawing and improvisation, for the in-house staff. Keeping the artists inspired and excited about the project is a very important priority for the producer. Together with the training department, the producer can organize workshops, lectures, and outings that allow the staff to hone their artistic skills and learn more about the project. Equally as important is creating workshops in which the staff can cross-train and learn about what other team members do. This approach enables the crew to have a deeper understanding of the thinking and the skills that go into job categories other than their own. Offering classes on the latest technological advancements also allows the studio to remain competitive in the rapidly changing world of animation.

5

THE DEVELOPMENT PROCESS

Development Process Overview

The development phase is the time when the creative foundation for a project is set up through visual and written materials. Inspired by an idea or a vision, writers and artists strive to capture the unknown. To some, it is a seemingly simple process; however, it is much more involved than one might imagine. To start with, there are no hard and fast rules to development. The approach taken is dictated by the property, its source, and the people initially attached to it, such as the creator (hereon referred to as the seller) and the buyer. Putting together a strong development team to bring the concept to life is one of the most important steps in creating a successful project. While it can be challenging to match up key players who have a creative chemistry, when the right people are in place, there is no limit to the potential of a project.

The Role of the Producer During Development

It is important that a producer be involved in the development phase as early as possible. Working closely with the buyer and the writer, the producer has input into how the script is created. During this process, one of the producer's primary duties is to determine that the project is suitable for animation. Working with a select group of artists, the first step is to establish the appropriate style and quality of animation. Factors that directly influence this process are the story content and the project's budget and schedule. Equally as important is satisfying the buyer. Just because a property is

in development, there are no guarantees that it will get produced. The buyer needs to be completely confident that investing the significant funds required to start production is a sound business decision.

In exploring the possible paths to developing a project, the producer needs to assess its strength and weaknesses. If the property is based on written material, it may be used to create the visuals. On the other hand, it could be the reverse, whereby the visuals drive the script and a writer needs to be identified. It may be, however, that the project is based on a property that already has both elements in place (such as a comic book). In this case, the seller may act solely as a consultant or may be responsible for either the visual or written material, depending on his or her experience. In all of the possible scenarios, the producer works with the creative executive, who is typically the representative of the buyer and the seller, to find and interview the appropriate candidates to attach to the project.

In order to keep costs down, projects with lower budgets (such as a television series) use freelance artists. When negotiating and hiring talent, the producer needs to be clear as to whether they are "attaching" the talent to the project or simply bringing them on as a "work for hires." If someone is integral to the project's success and is instrumental to selling it—such as an "A-list" writer or top director—the producer will probably attach them to the project. This ensures that the talent is available should the show go forward. If the talent is not crucial to the project, they would most likely be hired only for their specific services. The producer needs to be cautious in terms of who gets attached and who is guaranteed to play a role on the production should it go forward. If the buyer is not impressed with an artist's work, yet they are attached to the property, it could hinder the project getting picked up for production. Another item for the producer to consider before hiring an artist for the duration of the project is how easy or difficult it is to work with him or her. Getting a project produced is challenging enough without having to deal with personality conflicts.

Features, on the other hand, are generally created by staff producers, directors, and visual development artists. Writers may or may not be on staff. Studios that are dedicated to feature filmmaking frequently have a number of artists on staff who focus solely on conceptual artwork. As the primary storyteller, the director guides the artist(s) towards his or her vision. If no talent is initially attached to the project, the producer will select visual development artists, and possibly a director, to develop the look of the show. (See Chapter 4, "The Core Team," for more information on this process.) In those cases where the director is already on board, he or she works with the producer to review portfolios and find the appropriate talent for the project.

In television, unlike features, the overall creative visionary on a project is usually the executive producer, who is often referred to as a "show runner." It is their responsibility to oversee the storytelling process and manage the directors or production designers. In both cases, the producer

typically negotiates deals with the artists and creates a schedule for visual development. Working closely with the executive producer, the director, the seller, and the creative executive, the producer makes sure that everybody's notes are addressed.

When a writer is hired on a television series from its inception, he or she creates a "bible" prior to writing a script. The bible sets up the concept, characters, their world, and some potential story lines. Using the submitted written material, a pilot is created for the show. Note that if the property is the writer's concept, depending on their background, the writer typically plays the role of the executive producer.

In both television and features, the producer, in cooperation with the writer, generates a schedule based on the key milestones of the script as it evolves from premise to final draft. The writer is given creative notes by the producer, the director, the seller, and the creative executives at every stage of the scripting process. The purpose of this input is to make sure that the script is meeting the project's creative objectives from a narrative perspective as well as in terms of character development.

It falls on the producer's shoulders to pace development appropriately, allow creativity to thrive, and to meet long-term schedules. Although it is essential to adhere to schedules in production, applying strict deadlines to development can at times hinder the creative process. The producer has the balancing act of ensuring that the creative team has enough time and money to achieve their artistic goals, and that the quality of artwork created is suitable for production. As a result, the producer has to use his or her intuition to know when to push and when not to push. An artist's worst fear is working with a producer who has an assembly line approach towards artistic endeavors. And yet, how can network delivery deadlines be met if there is no schedule? Can a studio afford to lay off hundreds of talented and trained artists because the next project is not ready for production?

It is the nature of development to move slowly. Unlike a film in production, which has a set schedule, a concept in development can take many months—or even several years—before it is greenlit, as it is constantly changing and evolving. An important responsibility for the producer is to keep the buyer and other significant players excited and enthusiastic about the future product.

In the case of a larger studio, one approach to getting a project funded is by obtaining the support of other division or ancillary entities within the company, such as the consumer products group. The Internet can also be a successful avenue. The more revenue a project is likely to generate, the more quickly funds will be released for its production. Items that can help bolster the case for making a particular feature include a potentially successful toy line or soundtrack. Another option is to contact other division heads to see whether a feature can be made into a television series or has potential for a direct-to-video sequel.

One important item to note prior to getting into the development process is confidentiality of material. Starting at this stage of the production, it is critical for the producer to establish ground rules safeguarding the project from piracy. Confidentiality policies and procedures typically apply to script, all forms of artwork, characters, and software development, and must be adhered to throughout production and post-production (i.e., story reel, dailies, rough-cut tapes, etc.).

Visual Development

The visual elements necessary to set up the world of an animated project are characters, props, and locations. Depending on the budget and scope of the intended production, there may be many line and color drawings created, or just a few conceptual paintings. More than 20 artists may be developing a show or there could be as few as one or two people wearing multiple hats.

It is during the conceptual stage that the style of a show is established. Is it going to be cartoony, realistic, highly stylized, or a combination? If there is absolutely no visual starting point on a property, one approach may be to assign several visual development artists to design the key characters and locations in a variety of styles. The director and producer can then review the artwork and use it as a jumping-off point for creating the look of the show. Conceptual art usually begins as a fairly loose approach to the characters and their environment. As development progresses, the style becomes more distinct and the artwork is further refined to match the direction that the project is taking.

When the show gets close to the pre-production phase, the producer's most consequential task is to have finalized and approved artwork. The standardization of the character designs, location, and props is a requirement for the smooth transition of a project from development onto production.

This early stage in visual development is an opportune time for the buyer and other members of the team to make changes and give their input. At this point in the process, it is not that expensive to explore new ideas or even re-start if the current ideas are not working. Given the enormous cost of revisions once a project is in production, it is crucial to nail down and agree to as many key decisions as possible during the development stage. Animation is very time intensive and expensive. When revisions are made, a domino effect occurs since so many different elements need to be altered in order to keep the show consistent. (See Chapter 9, "Production," for more information on this process.) As a result, the cost implications to the schedule and budget can be significant. On lower-budget television projects, there may not be enough money to make changes, so it is necessary to finalize all key creative decisions prior to the start of animation. Once the model package is shipped to a subcontracting studio, it is usually a locked item, and the producer and director are no longer able to make any revi-

sions. (See Chapter 8, "Pre-Production" for more information on the model package.)

Even though designs can be finalized and approved, as a producer, you never know how people will react to seeing the characters move for the first time. On a project I (Catherine) produced, the creator signed off on all the main characters during the development stage. One year later, when we received the first work print back from the subcontracting studio, she reviewed the film frame by frame. She didn't like the costume of the main character or the shape of the ears of other significant characters. The only way she would be happy was for us to change them. Since she had signed off on these character models in advance, this response came out of left field. There were tens of thousands of frames of these characters fully produced, and the cost and schedule implications of such a change were huge. My job as the producer was to analyze the requested revisions and assess the financial consequences. I also had to come up with different options to solve the problem. It was up to the buyer to decide how important these changes were to the overall project, and whether they wanted to pay for these costs or not. Keeping the creator happy from a publicity standpoint was important to the buyer of this particular project. The decision was therefore made to make as many costumex and ear changes as possible to scenes already shot on film during the post-production phase, and be pro-active for those episodes still in production.

In post-production, we used a video system called "the Fire" that allowed us to take the close-up scenes and modify the necessary frames to match the revised character model. It took many days, at a rate of 400 dollars per hour, to make these fixes. For those episodes still in the line-drawing stages of storyboarding or animation and clean up, we sent revised models to be followed by the crew. Shows that had progressed further down the production line had to be revised, and the subcontracting studio billed us for the overage. It was an immensely expensive ordeal, impacting hundreds of people, to ensure that everyone had the information they needed within the domestic production house and the subcontracting animation studio. We also had to scramble and push the schedule harder to make the changes and meet air dates. Ultimately shortening the schedule had an adverse effect on the quality of the project in other areas. It would have been considerably cheaper and easier if the creator had stuck to her original decisions; however, it was a good lesson for me as a producer, teaching me to be mentally prepared for almost anything.

The Writing Process

The key to a successful project is a great script. You can have some of the most beautiful and complex animation in the world; however, if the story doesn't work, chances are the show won't either. In animation, there are

several ways to approach scripting depending on the genre, format, and length of the project. In the old days, most of the famous cartoon shorts were created directly from an outline to storyboard. Gags would be conceived in a room of artists bouncing ideas off each other. These ideas would then be pitched or acted out by the directors and/or animators. This enabled everyone to be spontaneous and come up with some classic comedy. This method is still a popular technique used for short-form projects. In terms of longer formats, once a script is available, it is common to hold brainstorming sessions with the story artists to come up with gags and/or solve story problems. Whatever the method used, the script typically has several stages that it needs to undergo, as described below.

Script Stages

The script progresses through a number of stages before it is ready for production. This process includes establishing and setting up the characters, their world, their conflict(s), and the resolution. As mentioned earlier, in a television series, a "bible" is created prior to writing a script. In long-form production such as direct-to-video, features, or television specials, the writing process begins with the outline of the story. The following sections offer explanations of each of these stages.

Series Bible

A *bible* is the written concept that sets up the key elements for a series. Developing the bible is the process by which you create a series. It includes a description of the show as a whole, and defines the main characters and the relationship between them. Also written are premises for potential stories and episodes. Once the visuals are designed, they are placed in the bible to help enhance the storytelling. After the bible is assembled and signed off by all the necessary people (including the buyer, the seller, the executives, and the producer), it has multiple functions. Primarily it is used as a tool for the writing team to help ensure consistency throughout the writing process. It is also utilized by the casting director to select voice-over talent. Finally, it is used by the artistic crew to gain a better understanding of the show and how the characters and plot are intertwined.

Pilot Script

The *pilot script* is used in television and in some ways is similar to the series bible. Its purpose is to give the reader a sense of the show and to set up the characters; however, it is more fully realized than a bible. If this script is successful, it may be produced as a story reel or be fully animated prior to a series being greenlit. Like all scripts, it would follow some or all of the various steps outlined below.

Premise The *premise* is a paragraph or two that outlines the main story concept. Included are the main characters, the basic conflict, any complications, and how they are resolved. Usually used in television shorts and episodic series, it is one to two paragraphs long.

Outline The *outline* is a more detailed version of the premise. It is generally a sequence-by-sequence breakdown of the story with a few lines of dialogue added to flesh out the characters, giving a project with multiple writers a sampling of the tone. In the outline, the flow of the action is spelled out. It is a good place to start at rather than going straight into script format since it is easier to change the structure of the story at this point. The number of pages ranges from 2 to 10 depending on the format being produced.

Treatment The *treatment* is a more detailed and longer form of the outline. It is a scene-by-scene breakdown of the story that lays out the story arcs. Used in long-form production, the treatment can be from 20 to 30 pages long.

First Draft Script

A script can take on several drafts. The first draft fleshes out the story arcs, adding dialogue and action. In the case of a television series, a story editor may ensure that the script is ready for production. The story editor also makes sure that the writing is consistent in following the characterizations and tone of the series as established in the bible. Once complete, the first draft is given to the key creative staff on the project—usually the producer, director, and creative executive—for notes. A half-hour script is between 25 to 35 pages long. A feature script for an 80-minute film can be anywhere from 80 to 110 pages depending on whether it is dialogue heavy or action driven.

Second and Third Drafts

Each draft incorporates new notes given to the writer. The process of writing continues until the script is considered ready to go into production. On series, the story editor may be responsible for inputting the notes after the second draft. In long form, it is very common for the script to go into production in segments while the rest of it is still in development.

Polish

This is the stage at which final touches are completed on the script. Rarely is the structure of the script altered at this point. The focus is most often on improving dialogue. It is not uncommon on feature films to attach a new writer to the project for the final dialogue pass.

The Feature Script

In general, the feature script is never locked by the time pre-production begins, the reason being that the story is further developed by the storyboard artists and the script writer. The storyboard artist takes a written sequence and visualizes the action. The goal here is to improve the script. If the budget allows, the scripting process may be concurrent with the storyboarding process. (See Chapter 8, "Pre-Production," for more information on this process.) Using the treatment or outline as a starting place, the writer holds a series of meetings with the project's storyboarding supervisor, the director, and several of the storyboard artists to work out the story and flesh out the characters. Tracking these key character and story arcs as well as plotting out what is accomplished in each scene enables this group to further refine the story.

After these meetings, the writer writes a draft of the screenplay. The storyboard artists illustrate sequences based on the written material. Upon completion of this assignment, the group meets again to review the board and come up with more ideas and ways to improve the story. The artist pitches the board to the producer, director, and writer. Based on the producer's and director's decision, the board and script are revised as necessary. This process continues until everyone is satisfied that the sequence works and is ready to go into production. This approach is a very interactive and productive method of improving the script. Given that animation is a visual medium, it helps insure that the words in the script make the transition to the screen effectively. (For more information, see Chapter 8, "Pre-Production.")

Writer's Deals

The business affairs department, with input from the creative executive and producer, negotiates the writer's contract. Rates paid depend on the type of project, budget, and the background and experience of the writer.

For a series, writers' fees can range from 7,500 dollars for a traditional half-hour "Saturday morning" script to 20,000 dollars-plus for a primetime show. Feature scripts traditionally start at 60,000 dollars and the sky's the limit from there depending on the stature of the writer, the number of writers brought in to work on the script, and their quote (the amount they received on their last project). It is standard that a writer is not expected to make less than his or her quote, and can often expect an increase in price. Animation is presently not covered by the Writer's Guild of America. If a studio is a member of the animation union, on the other hand, writers are covered. In such cases, writers can expect minimum scale rates. However, since these fees are considered low, scale would only be an appropriate payment for a first-time writer.

Each buyer has their own standards and processes in place for payment if the writer is non-union. If the writer is union, payments must be paid per union rules. Commonly, the payment installments are made based on the breakdown of the script. In most cases, certain payments will be guaranteed to the writer and others will be considered optional, based on performance. Payments are made as the writer reaches key milestones. An initial fee is usually paid upon commencement of writing. The balance is paid once the outline is completed, and the rest is delivered, for example, when the draft is handed in for review and notes.

In most companies, no payments are made until a Certificate of Authorship (C of A) has been signed. The C of A assigns the material rights to the buyer for the writer's services on the script. This means that all written material and ideas are the property of the buyer.

Production Scripts

Once production begins, the greenlit script goes through a number of stages. It needs to be constantly updated throughout the production process as lines and scenes are revised, added, and deleted. This information must be carefully tracked so that everyone affected by the changes is informed and that nothing is missed during production. The following sections define the different types of scripts.

Numbered Script

In the *numbered script*, each line of dialogue in the production script is numbered. This script is used during the track recording session as a reference tool. These numbers are used and referred to by the actors, director, recording engineers, and editors. All the description and scene information is left in the script.

Recording Script or Engineer's Script

In the *recording script*, all descriptions and scene directions are deleted, leaving only the lines of dialogue. This script is used to keep track of the recorded dialogue and the various takes the actor records. The director's select takes are circled on the script and are given to the editor to cut into the track. These lines are referred to as *circle takes*.

Conformed Script

Once the storyboard is locked for production, the script is updated and conformed to match the storyboard. All changes or deletions are included in the *conformed script*. Conforming the script can be an ongoing process as opposed to a one-time step.

Automatic Dialogue Replacement (ADR) Script

The *automatic dialogue replacement (ADR) script* shows the additional and replacement dialogue only. Used during post-production, the ADR script contains the lines of dialogue with their corresponding line number. These lines are also numbered with reference to time code. (For more information on ADR, see Chapter 10, "Post-Production.")

Final As-Aired/Released Script

Since many changes can take place in post-production, the *final-as-aired script* is conformed to match the actual as-aired or released version. It is very important that this script be created since it is needed for closed captioning and foreign language dubbing.

Conclusion

Using the script, bible (if applicable), and conceptual artwork, the producer creates the production plan, with input from key executives (production and creative). The development materials (the script and the artwork) produced along with this plan are used to get a greenlight for production. After the project has been greenlit and all of the above items are completed and signed off on by the key players, the script is ready to go into the next phase of the process: pre-production, which we will discuss in Chapter 8.

THE PRODUCTION PLAN

Production Plan Overview

Mapping out a production plan is a creative process. This is where the producer has to commit his or her vision to paper. If this vision is not working, as in any creative process, the producer must be flexible and open to questioning and changing his or her parameters in order to come up with alternative scenarios. Devising the plan entails making assumptions at each step of the way. Because every phase in animation is dependent on the successful completion of the previous, the producer must anticipate and plan for all possibilities. Working with input from the buyer, the director, and other key parties such as the seller, the producer's main task is to ask questions and gather as much information as possible. Once this information is assembled, the producer must figure out the best way of allocating money throughout the budget. These allocations are based on the show's specific requirements. If, for example, a project is strictly story driven with simple character designs that warrant limited animation, it would be necessary to put significant funds into the areas of writing and cast/recording rather than animation. Whatever the balance that suits the project best, the producer needs to ensure that all areas are addressed and accounted for in the budget, so that there are minimal surprises mid-production.

List of Assumptions

Once the budget, schedule, and crew plan are assembled, the producer must put in writing all of the areas or the parameters upon which the production plan is based. This is the producer's *list of assumptions*. It enables everyone to have a mutual understanding of the project and its requirements. When changes are made to the plan, this agreed-upon template makes it easier for

both the producer and the buyer to identify and evaluate the costs and schedule revisions. Since this list outlines the areas to be planned for, we use it for the framework of building the production plan and preparing the final budget. Typically, the following items need to be addressed in a list of assumptions:

- The delivery date
- The schedule
- The project's format, length, and technique
- Complexity analysis
- The level of talent
- The crew plan
- The role of key personnel
- Creative checkpoints
- The buyer's responsibilities
- Marketing, licensing, and promotions
- The payment schedule
- The physical production plan
- Training
- Relocation costs
- Reference and research material
- Archival elements
- The contingency

Getting Started: The Production Plan

The following sections discuss each of the elements in the production plan in detail.

Delivery Date

In most cases, the delivery date for the project is the producer's starting point for creating his or her strategy. This information comes from the buyer and is based on air or release dates. These dates can come from a number of sources, including ancillary groups involved in distribution and possibly merchandising/promotion or a studio's overall production plan. If the delivery date is very tight, it will drive the pacing of the project. It is also a determining factor in whether the production will be done in-house or with a subcontractor or multiple subcontractors. In a perfect world, a budget and schedule are worked out without a specific delivery date so that the plan itself is driven by the creative needs of the project. Although this is the exception to the rule, it does take place in some cases.

The Schedule

It is critical that the producer has a schedule for reference when budgeting a show. Using the delivery date as a starting place, the producer can begin to put a preliminary schedule together. The schedule is the number of days, weeks, months, or years needed to complete the project from conception to delivery. As numbers are plugged into the budget, the schedule will probably be moved around to accommodate both the creative and fiscal needs of the production. It is also important that the producer has this information available for reference so that he or she can assess staffing requirements. If the producer is using subcontractors, it is important to investigate and plan for national holidays and local traditions that may affect the schedule.

Each project has its own specific stipulations and, as such, the schedule's length can vary widely. In the case of features, for example, schedules are produced with targeted weekly footages or quotas for each department and individual artist. For television, generally this information is not as precisely defined by the producer. Because production is handed off to subcontractors who return the completed episodes and manage this step of the process themselves, it is their responsibility to define quotas for their studio.

When creating the schedule, be realistic about what can be accomplished in the time available. If you are not able to evaluate the time needed per department, ask questions from reliable sources such as the director or the department head (if available). This will help insure that the project is managed well in all areas.

In this chapter we have included generic master timelines and schedules that outline production timeframes for television, direct-to-video, and feature projects. Note that these samples are to be used as guidelines and should be modified to suit the processes and needs of the particular production. Note also that when a production is up and running, the master schedules should be further broken down into more detailed schedules, called micro-schedules, for each department. (See Chapter 8, "Pre-Production," for more information on the role of the producer during the pre-production phase.)

The TV master schedule shown in Figure 6–1 illustrates 13 episodes in pre-production, production, and post-production phases. In Figure 6–2 we have broken down a single episode and listed the specific production steps involved, starting with model design and ending with delivery. All of the episodes follow the same schedule and overlap. Note that these schedules outline a 2D production path. The direct-to-video schedule shown in Figure 6–3 includes a few additional steps in comparison to television productions. With a longer pre-production schedule, frequently time is set aside to complete the project and to do key character and clean up animation poses before shipping artwork to the subcontractor.

| WK | 1 | 2 | 3 | 4 | 5 | 6 | 7 | 8 | 9 | 10 | 11 | 12 | 13 | 14 | 15 | 16 | 17 | 18 | 19 | 20 | 21 | 22 | 23 | 24 | 25 | 26 | 27 | 28 | 29 | 30 | 31 | 32 | 33 | 34 | 35 | 36 | 37 | 38 | 39 | 40 | 41 | 42 | 43 | 44 | 45 | 46 | 47 | 48 | 49 | 50 | 51 | 52 | 53 | 54 | 55 | 56 | 57 | 58 |

Pre-Production — 37 Weeks
Production — 38 Weeks
Post-Production — 30 Weeks

* All shows have a two week period between start of production.
* Subcontract production based on 14 weeks.

Figure 6–1 Generic 2D 13-Episode Series, 58-Week Schedule

104

	# OF WEEKS	1	2	3	4	5	6	7	8	9	10	11	12	13	14	15	16	18	18	19	20	21	22	23	24	25	26	27	28	29	30	31	32	33
	MODEL DESIGN; Char, Loc, Props																																	
	STORYBOARD ROUGH																																	
	RECORDING																																	
	ANIMATIC - SCANNING & BLDG																																	
P	STORYBOARD FIXES & CLEANUP																																	
R	TRACK READING																																	
E	SHEET TIMING																																	
	BG KEYS																																	
	COLOR STYLING																																	
	CHECKING																																	
	SHIPPING																																	
P	SUBCONTRACTOR/PRODUCTION																																	
R																																		
D	RETURN COLOR & RETAKE LIST																																	
	RETAKES																																	
P	LOCK PICTURE																																	
O	VIDEO ASSEMBLY																																	
S	AUDIO - DIALOGUE, BG'S, & SFX EDIT																																	
T	FINAL MIX																																	
	DELIVERY																																	

Figure 6-2 Single 2D Episode Breakdown (33 Weeks per Episode)

Figure 6–3 Direct-to-Video Generic 2D Schedule (70 Weeks)

We have also included a generic schedule for a 2D traditional feature (Figure 6–4) and a CGI feature (Figure 6–5). Since the processes for producing CGI tend to vary widely based on budget and technique, Figure 6–5 should be viewed with this in mind.

In terms of features, the master schedule takes into account the key departments and how they overlap. For a detailed analysis on a per-department basis, we have included sample "micro-schedules" for 2D layout (Figure 6–6) and animation departments (Figure 6–7). Although the calculations need to be modified, these charts can be used for either 2D or CGI feature animation (typically calculated in frames versus footage).

Managing a feature production requires two different modes of tabulation. One is the total number of scenes to be completed in layout and background departments, and the other is the actual footage to be animated. In order to build the charts in Figures 6–6 and 6–7, we picked a feature that runs approximately 75 minutes. One minute is equivalent to 90 feet. In order to come up with the length of the film in feet, we multiplied 75 minutes by 90 feet, which equals 6,750 feet. A rule of thumb commonly used in producing animation is that an average scene is roughly 5 feet (or 3.33 seconds). Using this guideline, we divided 6,750 feet (the total length) by 5 feet (an average scene), which gives us 1,350. We then built a schedule to accomplish the goal of completing 1,350 scenes or layouts. Figure 6–6 shows how the workload has been divided over 52 weeks (which is the time scheduled for completion of rough layout.) Also noted on this figure is the number of layout artists working each week and the number of layouts expected per artist.

Following the above example of a feature, Figure 6–7 shows the number of feet that have to be completed through animation on a weekly basis. Using the total length of 6,750 feet and dividing that by the number of weeks (65) and artists budgeted allows us to come up with a total number of feet needed per week in order to meet the targeted quota.

These figures are used to pace a production and to set up a system by which enough work is generated in every department to create ample inventory for the artists. By evaluating the work completed in relation to the quotas on a weekly basis, the producer can assess the status of production in relation to its delivery date and budget. (See Chapter 11, "Tracking Production," for further information.)

Please note that these charts do not take into consideration sick days, vacation time, national holidays, and union holidays. All the above items must be accounted for when creating a schedule in order to set up realistic goals for the production team. Another item to consider when creating this type of a budget is ramp-up time. In both charts we have started the artists on a low number of layouts and gradually increased the number as they become more familiar with the style and requirements of the show. Ramp up should be part of each department's calculations.

	56	Weeks
Pre-Production		
Production	103	Weeks
Post-Production	17	Weeks

NUMBER OF MONTHS: 1 2 3 4 5 6 7 8 9 10 11 12 13 14 15 16 17 18 19 20 21 22 23 24 25 26 27 28 29 30

P R E
- KEY PRODUCTION DESIGN/ ART DIRECTION
- STORYBOARD (SCRIPT REVISIONS)
- EDITORIAL/STORY REEL

P R O D U C T I O N
- WORKBOOK
- ROUGH LAYOUT
- SCENE PLANNING/SCANNING
- ANIMATION
- CLEAN UP LAYOUT
- CLEAN UP ANIMATION
- VISUAL EFFECTS
- BACKGROUND PAINTING
- ANIMATION CHECK
- INK AND PAINT
- FINAL CHECK
- COMPOSITING/FINAL RENDER
- FILM OUTPUT

P O S T
- POST-PRODUCTION
- TEST SCREENING (TEMP DUBS/MIXES)
- RELEASE PRINT

Figure 6–4 Generic 2D Feature Schedule (30 Months)

108

NUMBER OF MONTHS	1	2	3	4	5	6	7	8	9	10	11	12	13	14	15	16	17	18	19	20	21	22	23	24	25	26	27	28
P KEY PRODUCTION DESIGN/ART DIRECTION	▓	▓	▓	▓	▓	▓	▓	▓	▓	▓	▓	▓																
R STORYBOARD/STORY REEL (SCRIPT REVISIONS)			▓	▓	▓	▓	▓	▓	▓	▓	▓	▓	▓															
E SOFTWARE DEVELOPMENT				▓	▓	▓	▓	▓	▓	▓	▓	▓	▓	▓	▓	▓	▓	▓	▓	▓	▓							
MODELING				▓	▓	▓	▓	▓	▓	▓	▓	▓	▓	▓	▓	▓	▓	▓	▓	▓								
RIGGING				▓			▓	▓	▓	▓	▓									▓								
SURFACES (TEXTURE AND COLOR)/LOOK DEVELOPMENT				▓	▓	▓	▓	▓	▓	▓	▓	▓	▓															
P 3D WORKBOOK/STAGING							▓	▓	▓	▓	▓	▓	▓	▓	▓	▓	▓	▓	▓	▓	▓	▓	▓	▓				
R ANIMATION										▓	▓	▓	▓	▓	▓	▓	▓	▓	▓	▓	▓	▓	▓	▓				
O LIGHTING												▓	▓	▓	▓	▓	▓	▓	▓	▓	▓	▓	▓	▓				
D EFFECTS												▓	▓	▓	▓	▓	▓	▓	▓	▓	▓	▓	▓	▓				
FINAL RENDER														▓	▓	▓	▓	▓	▓	▓	▓	▓	▓	▓	▓			
COMPOSITING AND TOUCH UP														▓	▓	▓	▓	▓	▓	▓	▓	▓	▓	▓	▓			
FILM OUTPUT													▓	▓	▓	▓	▓	▓	▓	▓	▓	▓	▓	▓	▓			
P POST-PRODUCTION																								▓	▓	▓	▓	▓
O TEST SCREENING																					▓			▓				
S (TEMP DUBS/MIXES)																												
T RELEASE PRINT																												▓

Pre-Production	90	Weeks
Production	82	Weeks
Post-Production	17	Weeks

Figure 6–5 Generic 3D CGI Feature Schedule (28 Months)

109

	TOTAL NUMBER OF LAYOUTS TO BE DONE: 1350		TOTAL # OF WEEKS: 52		
	TOTAL NUMBER OF LAYOUTS COMPLETED: 0		# OF WEEKS REMAINING: 52		
	NUMBER OF LAYOUTS TO DO: 1350				

WEEK	WEEK ENDING	# OF ARTISTS IN DEPT	WEEKLY OUTPUT PER ARTIST	SCENES EXPECTED PER WEEK	ACCUMULATED SCENES PER WEEK
1	03/22/2003	6	1.0	6	6
2	03/29/2003	6	1.0	6	12
3	04/05/2003	6	1.0	6	18
4	04/12/2003	6	1.0	6	24
5	04/19/2003	6	1.0	6	30
6	04/26/2003	6	1.0	6	36
7	05/03/2003	6	1.0	6	42
8	05/10/2003	12	1.0	12	54
9	05/17/2003	12	1.0	12	66
10	05/24/2003	12	1.0	12	78
11	05/31/2003	12	1.5	18	96
12	06/07/2003	12	1.5	18	114
13	06/14/2003	12	1.5	18	132
14	06/21/2003	12	1.5	18	150
15	06/28/2003	12	1.5	18	168
16	07/05/2003	12	1.5	18	186
17	07/12/2003	12	1.5	18	204
18	07/19/2003	12	1.5	18	222
19	07/26/2003	12	2.0	24	246
20	08/02/2003	12	2.0	24	270
21	08/09/2003	12	2.0	24	294
22	08/16/2003	12	2.0	24	318
23	08/23/2003	12	2.0	24	342
24	08/30/2003	12	2.0	24	366
25	09/06/2003	12	2.5	30	396
26	09/13/2003	12	2.5	30	426
27	09/20/2003	12	2.5	30	456
28	09/27/2003	12	2.5	30	486
29	10/04/2003	12	3.0	36	522
30	10/11/2003	12	3.0	36	558
31	10/18/2003	12	3.0	36	594
32	10/25/2003	12	3.0	36	630
33	11/01/2003	12	3.0	36	666
34	11/08/2003	12	3.0	36	702
35	11/15/2003	12	3.0	36	738
36	11/22/2003	12	3.0	36	774
37	11/29/2003	12	3.0	36	810
38	12/06/2003	12	3.0	36	846
39	12/13/2003	12	3.0	36	882
40	12/20/2003	12	3.0	36	918
41	12/27/2003	12	3.0	36	954
42	01/03/2004	12	3.0	36	990
43	01/10/2004	12	3.0	36	1026
44	01/17/2004	12	3.0	36	1062
45	01/24/2004	12	3.0	36	1098
46	01/31/2004	12	3.0	36	1134
47	02/07/2004	12	3.0	36	1170
48	02/14/2004	12	3.0	36	1206
49	02/21/2004	12	3.0	36	1242
50	02/28/2004	12	3.0	36	1278
51	03/06/2004	12	3.0	36	1314
52	03/13/2004	12	3.0	36	1350

Figure 6–6 Generic 2D Feature Rough Layout Weekly Quotas

	TOTAL FOOTAGE REQUIRED: 6750			TOTAL # OF WEEKS: 65	
	TOTAL FOOTAGE COMPLETED: 0			# OF WEEKS REMAINING: 65	
	TOTAL FOOTAGE TO BE DONE: 6750				

WEEK	WEEK ENDING	# OF ARTISTS IN DEPT	WEEKLY OUTPUT PER ARTIST	FTG EXPECTED PER WEEK	ACCUMULATED FTG PER WEEK
1	04/19/2003	12	1.5	18	18
2	04/26/2003	12	1.5	18	36
3	05/03/2003	12	1.5	18	54
4	05/10/2003	12	1.5	18	72
5	05/17/2003	12	2.0	24	96
6	05/24/2003	12	2.0	24	120
7	05/31/2003	12	2.0	24	144
8	06/07/2003	12	2.0	24	168
9	06/14/2003	20	2.0	40	208
10	06/21/2003	20	2.0	40	248
11	06/28/2003	20	2.5	50	298
12	07/05/2003	20	2.5	50	348
13	07/12/2003	20	2.5	50	398
14	07/19/2003	20	2.5	50	448
15	07/26/2003	20	2.5	50	498
16	08/02/2003	20	3.0	60	558
17	08/09/2003	20	3.0	60	618
18	08/16/2003	28	3.0	84	702
19	08/23/2003	28	3.0	84	786
20	08/30/2003	28	3.0	84	870
21	09/06/2003	28	3.5	98	968
22	09/13/2003	28	3.5	98	1066
23	09/20/2003	28	3.5	98	1164
24	09/27/2003	28	3.5	98	1262
25	10/04/2003	28	3.5	98	1360
26	10/11/2003	28	4.0	112	1472
27	10/18/2003	28	4.0	112	1584
28	10/25/2003	28	4.0	112	1696
29	11/01/2003	28	4.0	112	1808
30	11/08/2003	28	4.0	112	1920
31	11/15/2003	28	4.5	126	2046
32	11/22/2003	28	4.5	126	2172
33	11/29/2003	28	4.5	126	2298
34	12/06/2003	28	4.5	126	2424
35	12/13/2003	28	4.5	126	2550
36	12/20/2003	28	5.0	140	2690
37	12/27/2003	28	5.0	140	2830
38	01/03/2004	28	5.0	140	2970
39	01/10/2004	28	5.0	140	3110
40	01/17/2004	28	5.0	140	3250
41	01/24/2004	28	5.0	140	3390
42	01/31/2004	28	5.0	140	3530
43	02/07/2004	28	5.0	140	3670
44	02/14/2004	28	5.0	140	3810
45	02/21/2004	28	5.0	140	3950
46	02/28/2004	28	5.0	140	4090
47	03/06/2004	28	5.0	140	4230
48	03/13/2004	28	5.0	140	4370
49	03/20/2004	28	5.0	140	4510
50	03/27/2004	28	5.0	140	4650
51	04/03/2004	28	5.0	140	4790
52	04/10/2004	28	5.0	140	4930
53	04/17/2004	28	5.0	140	5070
54	04/24/2004	28	5.0	140	5210
55	05/01/2004	28	5.0	140	5350
56	05/08/2004	28	5.0	140	5490
57	05/15/2004	28	5.0	140	5630
58	05/22/2004	28	5.0	140	5770
59	05/29/2004	28	5.0	140	5910
60	06/05/2004	28	5.0	140	6050
61	06/12/2004	28	5.0	140	6190
62	06/19/2004	28	5.0	140	6330
63	06/26/2004	28	5.0	140	6470
64	07/03/2004	28	5.0	140	6610
65	07/10/2004	28	5.0	140	6750

Figure 6–7 Generic 2D Feature Animation Department Weekly Quotas

Project's Format, Length, and Technique

Format

The possible formats for an animated project include television series, TV special, short format (either for the Internet, television, or theatrical release), interstitial (small segments, shorter than a commercial, such as a promo), commercial, direct-to-video, and feature. Before embarking on a production plan, the producer must know the format of the project. Also to be determined up front is the medium (film, video, or digital file) on which the project will be delivered.

Length

Early in the planning stages, the script is timed to determine the total length of the project. TV series for network distribution generally run 22 minutes long, direct-to-video range from 60 to 80 minutes, and a feature can vary anywhere between 70 to 90 minutes. To get a ballpark running time of a script, a director may use a stopwatch to estimate its length. Although this method is not precise, it allows the producer to assess the project's running time. The rule of thumb is that one page is equivalent to 1 minute. This method doesn't always work, if for example, there is a song title inserted in the text or if an action sequence is described in just a few words.

Once the length is figured out, the producer can calculate the project's approximate footage. Since animation is created one drawing at a time, with each drawing shot for a specific number of frames, the measuring system used is in feet and frames (also referred to as footage). Sixteen frames constitute 1 foot, and 90 feet equal 1 minute. Table 6–1 is a reference chart converting frames into feet and seconds.

Technique

Deciding upon the animation technique that is most suitable for the project is critical since it directly impacts the production process and the cost. The most commonly used techniques are 2D, 3D, and CGI. 2D animation utilizes flat art, such as hand-drawn images or cutouts. 3D animation uses the process of stop-motion photography by shooting frame by frame three-dimensional objects such as puppets, clay figures, or, in the case of pixelation, real people and life-size props. In CGI, all of the designs are created, animated, and shot on the computer—be it character, environment, prop, or visual effects. An animated project may draw on one of these methods or combine them. The animation can be limited or full or somewhere in between. (See Chapter 9, "Production," for a detailed discussion on 2D and 3D CGI production processes.)

Table 6–1
Converting Frames into Feet and Seconds

Frames	Feet	Seconds
1	0.0625	0.041
2	0.125	0.083
3	0.187	0.125
4	0.25	0.166
5	0.312	0.208
6	0.375	0.25
7	0.437	0.291
8	0.50	0.333
9	0.56	0.375
10	0.625	0.416
11	0.687	0.458
12	0.75	0.50
13	0.812	0.541
14	0.875	0.583
15	0.937	0.625
16	1.0	0.666

Complexity Analysis

The following sections discuss the different factors affecting the complexity of the project.

Script Content Analysis

A *script content analysis* is a detailed evaluation of the script that enables the producer to gain overall insight into what will be involved in producing the project. Additionally, the analysis helps the producer identify those sequences that may need to be prioritized and/or require special attention. The script is scrutinized for a number of specific elements that can affect the size of the budget. Questions to delve into are: How many characters are in the main cast? Are there many crowd shots and how often are they needed? How many locations/sets will there be? What kinds of special effects will be necessary and will the project be effects-heavy? Are there songs? If so, how many and what is their purpose (that is, are there big production numbers or soliloquies)? Are there characters or props that should be produced digitally? How much re-use is possible?

On CG productions, it is important to allow time to complete tests for each unknown element such as new software or a challenging character design. Without such tests it is impossible to accurately determine what kind of talent and technology setup may be needed.

The next step for the producer is to assess what materials will and will not be produced in pre-production, since this sets up the flow of production. On features and direct-to-video projects where budgets are higher, all design elements, including characters, locations, props, and effects, are designed in-house. On television projects, this is not always the case, as there may be some elements left to be designed by the subcontract studio (such as special effects and some props). Once the number of main character models has been established, the producer, working with the director, should analyze the number and complexity of locations and effects. Conceptual artwork and any completed designs are used to analyze the complexity of the project's style, helping to determine the amount of time or number of staff hours it will take to create the various elements from a production standpoint.

Style/Design

In the best-case scenario, the style is clearly established during the development phase. The producer can then evaluate the complexity of the artwork and create a schedule and a budget accordingly. Unless there is an agreed-upon style, the producer has no choice but to prioritize and allocate funds to resolve all outstanding stylistic questions. (For more information, see Chapter 8, "Pre-Production.")

Number of Drawings/Images per Foot

In the case of traditional animation, the number of drawings per foot needs to be established (that is, full versus limited animation). If it is on ones or twos, for example, the animation should be extremely smooth, since every frame or every other frame is drawn. An example of this type of animation can be found in Disney's feature titles such as *Tarzan*. If, on the other hand, it is to be animated on eights (only two drawings for every 16 frames) or have only portions of the character animated, the animation will be limited, as illustrated in MTV's *Beavis and Butthead* series.

Average Number of Characters per Foot

Assessing how many characters are to be animated on a per-foot basis is also key. Aside from crowd shots, does the story involve at least two or more characters in an average scene or will the focus be primarily on one character? Equally as consequential is how much contact there is between the characters. For example, in 2D animation, if there are two characters with

no physical contact, the animation for both characters can be cleaned up concurrently by more than one artist. When the character is riding a horse, however, there are registration points that have to be adhered to as the character's body touches the horse's torso. In this type of scene, the artwork can only be handled by one artist at a time, which results in a much smaller footage output and will therefore slow down production.

Production Methodology

Establishing a production pipeline from the outset is essential. It should include all of the steps to be taken and how they will be handled, including milestones and approval points. The technique used directly affects the methodology chosen. In traditional animation, a scene goes down the production pipeline on a linear path. Unless a retake or change is required, a scene only goes in one direction. Each production step builds on the previous one; that is, animation cannot begin before rough layout has been completed. On a CGI project, on the other hand, many of the pre-production and production steps take place concurrently. A character model can undergo both animation and texturing simultaneously, for example. It may even return upstream for further modeling and rigging work until final animation is completed and final texturing approved. (See Chapter 9, "Production," for further information on 2D and 3D CGI processes.)

One of the first decisions to be made is whether the budget allows for completing all the production elements in-house. If so, the producer should create a general crew structure, including the number and types of team members on both the artistic and administrative sides of the process. Additionally, the producer should address the issues of space and equipment for an in-house production. On projects that will depend on subcontractors, materials will have to be prepared with outsourcing in mind and the producer should plan for fees and other costs associated with subcontracting, such as customs brokers and shipping. The crew plan establishes this in more detail but is driven by an agreed-upon production methodology. (For further information on subcontractors, see Chapter 7, "The Production Team.")

The Crew Plan

Using the preliminary master schedule, the next step for the producer is to build a detailed crew plan. This plan is a budgeting tool used by the producer to track the number of staff members needed in each category. It includes the number of weeks it will take them to produce the elements they are responsible for, and outlines their start and end dates. The crew information is also important for the producer in terms of figuring out office space requirements. Additional items contingent on the size of the crew

include production equipment, supplies, telephone systems, parking availability, office furniture, and fixtures. Similar to the schedule, the crew plan remains in flux until the budget is honed down and finalized and the production is greenlit. As a show moves through the production process, the crew plan will be revised and updated on an ongoing basis. Once the budget is signed off on, however, the bottom line figure remains the same, and the shifting of talent will be based on how the work can get done most efficiently.

Prior to creating the budget, another important piece of information the producer needs to research are salary rates. Salary information is drawn from a variety of places. If a producer has worked his or her way up through the ranks, much of this information comes from a knowledge base regarding typical rates within the industry. Although an applicant's past experience and the demands of the job help determine a number, it is not always easy to come up with the right figure. Assuming that you have never produced before and you do not have access to a sample budget, you should consider doing a little investigative work. Don't be timid about picking up the phone and asking other producers. In fact, over the years we have contacted a number of producers and asked them for their input. Due to confidentiality issues, they can't get too specific, but their answers enable us to get a range. Once we have done our research we most often come up with a rate that reflects the current salary for the role in question. We should add that we have not actually met all of our "salary consultants," yet they have always been very helpful.

If you don't know other producers who can help you with a rough idea, then try to get a range from the potential employees themselves. You don't need to agree to a salary. You can gather the information and talk with your director to see if it is in the appropriate ballpark. Meanwhile, the Cartoonist's Union Local 839 has salary scale minimums that must be followed by the producer if the project is a union one in Los Angeles. (See the Appendix, "Animation Resources," for contact information.) In most cases, if the artist is experienced, they are paid above scale, and in some cases significantly more than this. In the animation industry, however—as in most industries—the rates are based on supply and demand. When the industry is booming, rates are inevitably at a premium. When it slows down, wages are adversely affected and decrease accordingly.

An important item a producer should remember to plan for is overtime. Overtime is usually charged for any work done over 8 hours per day or on weekends. Since most projects get into a "crunch" or push time when overtime is necessary, there should be money allocated in each job category accounting for this potential cost. A rule of thumb is that 10 percent of all applicable labor costs are overtime costs. It is common to place this money in an overtime contingency category. See below under Contingency for more information. Also, if the project is a union one, the producer needs to allocate money for severance pay.

One final item to think about is buffer money in the area of staff hours. This money can be put towards ramp-up time as a production gets up to speed or to cover vacations and holidays. On long-term projects, production staff will need time off—typically a minimum of 10 days per year. These days are usually paid for by the employer as part of the weekly salary budgeted. On such weeks, the footage may lag and a department may require alternative methods of making up the difference (such as freelance work or additional overtime).

Figure 6–8 is a sample chart for a crew plan. It has been partially filled out for illustration purposes. It shows typical staffing categories and should be altered based on your particular project. Its purpose is to illustrate the total number of weeks for each position and where they overlap. For each crewmember, start and stop dates are input, with a bar graph representing their total number of weeks on the project.

The Level of Talent

It is wise to clarify the level of artistic and directorial talent that is expected on the project. The range in experience level and salaries between artists can vary drastically. It may be that the budget is set up so that a substantial sum of money is used on the initial production design, with the intention of creating a style that can be animated in a subcontracting facility without compromising quality. Another example would be to allocate funds and hire acclaimed animation artists but simplify the story so that the budget can withstand the high cost of the talent.

In terms of the voice track, the level of star talent to be pursued for the project should be established at the beginning so that it can be accommodated. A question to address at this point is whether the project can afford "A-list" star talent (for publicity purposes, for example), or whether lesser-known character or voice actors are able to fit the bill. In most cases, it is a combination of the two. Since the rates vary widely, this information needs to be reflected in the budget and list of assumptions. Another item to wrangle at this stage are the number of rehearsals (if possible) and recording days necessary. (See Chapter 8, "Pre-Production," for more information on voice tracks.)

The Role of Key Personnel

In certain cases, it may be important to define areas of responsibility. In television, for example, there are often many producers. So that it is clear to all concerned, clarifying areas the various producers are responsible for can be useful. An example of this would be that one producer handles the writing, casting, and voice track while another, usually a line producer, is responsible

TITLE	NAME	START	END	#WKS
ABOVE THE LINE				
PRODUCER	John Doe	31-Dec	27-Dec	52
DIRECTOR	Jane Smith	31-Dec	27-Dec	52
PRODUCTION STAFF				
PROD MANAGER		14-Jan	13-Dec	48
COORDINATOR 1		14-Jan	29-Nov	46
COORDINATOR 2		28-Jan	14-Jun	20
ART DIRECTION				
ART DIRECTOR		14-Jan	30-Aug	33
BG PAINTER		28-Jan	23-Aug	30
MODEL DESIGN				
ARTIST		14-Jan	14-Jun	22
CLEAN-UP ARTIST		28-Jan	31-May	18
STORYBOARD				
ARTIST 1		11-Feb	28-Jun	20
ARTIST 2		11-Feb	28-Jun	20
LAYOUT				
ARTIST 1				
ARTIST 2				
ASST. LAYOUT ARTIST				
ANIMATION				
1				
2				
3				
4				
SCENE PLANNING				
1				
2				
SCANNING				
1				
2				

Figure 6-8 Sample Crew Plan

for the creation of all pre-production artwork and management of the production process.

Creative Checkpoints

Working with the buyer, the producer needs to establish the points at which they will review materials and give input before finalizing the schedule. These reviews are called *creative checkpoints*. Examples of creative checkpoints include the selection of the voice talent and the approval of script(s) and storyboard(s). When planning for a production, the producer should keep these steps in mind so that there is enough time for revisions to materials and potential changes and delays in the schedule. The producer also needs to determine response time from the buyer so that the production doesn't go on hold unnecessarily while the crew waits for notes. For a detailed list of creative checkpoints, see the Producer's Thinking Map in Chapter 2.

Buyer's Responsibilities

The producer should clarify up front the costs that are not covered in the budget and how they will be handled should they come up. Examples of such overages include script or design changes after the buyer has already signed off, the decision to re-cast voice talent after the track has been recorded, the addition of new elements such as a song, and the buyer's travel costs.

Marketing, Licensing, and Promotions

Depending on the project, there may be a multitude of requests from ancillary groups such as marketing, licensing, and promotions. The producer may need to budget for a point person to produce materials (such as a style guide) and to coordinate artwork or film as necessary. Often, before the production is fully underway, there is a need for a promo or teaser. The promo is used as a sales tool for attracting potential licensees or promotional partners. Or, if the studio is releasing a videocassette of another film, they may want to use these materials to advertise the project on the new cassette release. Finally, toy prototypes as a rule need to be produced at least one to two years before the release of a project. Also to be considered is the time required of the producer or director to review and sign off on such materials.

Payment Schedule

A payment schedule is a document that outlines when payments are to be made from the buyer to the producing entity. A production accountant usually prepares this schedule with input from the producer. It is based on

information obtained from the budget and schedule, and is not usually prepared until the budget is finalized. The producer should keep in mind that if the buyer is from a foreign country, the exchange rate or a range should be determined up front whenever possible. The payment schedule should also take into account any international holidays that may delay the arrival of funds. Figure 6–9 is a sample cash flow chart. Similar to the crew plan, this chart should be customized to meet the needs of the project. When preparing the payment schedule, all costs for each month need to be indicated. This list must be itemized and should be inclusive of staff salaries in addition to any other fiscal expenditure anticipated for a given month. Once the numbers for all months are added up, the figure should match the grand total budgeted for the project.

The Physical Production Plan

Once all of the above steps have been worked out, the producer uses this information to plan for the infrastructure of the project. Understanding the methodology and the scale of the project, the producer will need to research overhead and facility costs. Is there a pre-existing space available for the production? If so, it may not be necessary to purchase desks and other such equipment. If not, the producer must establish what items need to be purchased, built, and installed. While evaluating the production needs, the producer, in cooperation with the technology group, researches and selects the hardware and software required. For more information on the role of the technology group, see Chapter 4, "The Core Team."

There is much to think about in order to get an office space up and running. An example of one issue is the telephone system. If there is no system in place, the producer must decide on the best system available to serve the studio's needs. The producer's key to success is to think about everything necessary to ensure that production can proceed effectively with the least amount of interruption.

Training

If a project has special creative requirements, such as the use of a new software program, it may be necessary to provide additional training for the crew. Consultants may need to be brought in or sent abroad when material is being subcontracted. These costs are most often allocated for high-end productions such as specials and features and should be provided for in the budget. For more information on training, see Chapter 4, "The Core Team."

DEPARTMENT	ITEM / EMPLOYEE NAME	COST	MONTH 1	MONTH 2	MONTH 3	MONTH 4	MONTH 5	MONTH 6	MONTH 7	MONTH 8	MONTH 9	MONTH 10	MONTH 11	MONTH 12	TOTALS
TOTALS															

Figure 6-9 Sample Cash Flow Chart (12 Months)

121

Relocation Costs

If there is a shortage of talent where the project is to be produced, it may be necessary to hire people from other locations. In such cases, it is common to pay for airline travel, temporary housing, transportation, and possibly a daily per-diem. Additionally, the production will be responsible for obtaining visa and work permits when necessary.

Reference and Research Material

Depending on the scale of the production, this category may be minimal— that is, limited to the purchase of a few books, videos, or laser discs— or it may involve the creation of an entire library with full-time staff. On feature productions, it is not uncommon to set up meetings for artists to meet experts or consultants and possibly get training in a specific field in order to lend more credibility to the project. If an animal is going to play a major role in the film, animators will more than likely be provided an opportunity to get up close and personal—whether it is a lion or a falcon. Often times, field trips are set up for key production staff to visit a location similar to the one being recreated for the production in order to allow them to have firsthand experience of the environment. In all of these cases, the extent of reference material and research necessary must be analyzed from the start so that monies can be set aside for this purpose.

Archival Elements

Elements should be archived in case they are to be used for future productions or preserved for potential revenue sources such as gallery sales. It is critical that an efficient archiving system be in place—whether it is for artwork on paper, board, cels, or digital files—so that these materials can be easily retrieved. The producer should clarify from the outset who will be paying for this process. In most cases, costs associated with archiving and storing the artwork are separate from the production budget and are paid for by the buyer upon the completion of production. Elements to be archived include:

- Artwork on paper (such as conceptual work, designs, storyboards, and animation artwork)
- Any traditionally painted materials (such as backgrounds)
- All digital files
- Original cels (if applicable)

Contingency

The contingency is a pot of money that is separated from the production budget. Typically, the amount ranges from 5 to 10 percent of the budget. While it is advisable to have a contingency, not every production can afford this cost. For those productions that can, there are usually two main purposes behind when and how this money is spent. The first includes instances when it is necessary to cover costs for unexpected production problems. The other is to cover the costs of creative changes that are above and beyond final and signed-off materials.

In terms of unexpected production problems, it is not uncommon for the pipeline to breakdown. While producers try to do everything in their power to plan for all costs, there can be a multitude of unanticipated issues that unfold and challenge a production. When unanticipated issues arise, the producer judiciously taps into the contingency money to cover the costs. An example of a situation warranting the use of the contingency would be a project where new processes are being tried, such as a fully digital production. In such a case, system errors can have a significant effect on the pipeline, forcing the production to shut down in order to solve the problems. A system shutdown can result in a loss of digital work. Also, if artists are unable to work due to computer malfunction, they will need to make up for the missed time.

Although elements and materials are signed-off and finalized during production, the creative process cannot always be controlled. It may be that someone comes up with a fantastic idea that needs to be implemented and could elevate the project to a higher level of quality and hopefully success. Or, it may be that in order to help a project in trouble, it is necessary to re-cast a voice actor for a lead character. Under these circumstances, scenes that were already animated may need to be re-worked, and this work, along with re-casting and re-recording, can be costly. A very common reason for creative changes is audience or buyer feedback. If a show is tested and gets feedback that justifies re-examining certain creative issues, further refinements will more than likely be necessary. Scenes may need to be added or deleted to clarify a key plot point, for example. The costs of unanticipated creative changes such as these must be covered, and in most cases the contingency is used. It should be noted that for most features, creative changes are anticipated up front as part of the process. The nature of the changes, however, is unknown, and therefore it is simpler to set contingency funds aside, knowing that they will be used for creative improvements throughout the production.

Depending on the budget of the project, the contingency can be a significant amount of money. The key to successful use and control of the contingency is clarifying up front in the early planning stages the parameters

surrounding its use. A system needs to be designed that defines who has the ultimate authority over spending the money and how approvals are obtained. In most cases, prior to spending any of the monies, the producer budgets exactly what the anticipated costs are and how they will be spent to cover the overage. This breakdown is then given to the final authority, in most cases the buyer/executive, for approval.

Building the Budget

Once all of the above information has been gathered, and a preliminary schedule and crew plan are in place, the producer can begin the task of building the budget. There are two levels to a budget: detail and summary. The summary is usually no more than two pages long, while the detailed budget lists each and every line item and the specific costs associated with it. The summary groups the line items into major categories to simply illustrate where the money is allocated from a macro point of view. On the summary sheet, for example, there is one line devoted to the "storyboard" category and next to it, there is a sum total of costs for this phase of production. The detail budget is further divided into storyboard supervisor, storyboard artist, storyboard clean up artist, overtime, material and supplies, and fringe benefits. Each item has its own separate dollar amount listed, with the sum total matching the number under "storyboard" in the summary budget.

Most budgets are divided into two sections: above and below the line. The above-the-line numbers are commonly those numbers based on contracts. Such numbers include rights payments, options, royalties, and script fees. Also included are deals and payments to be made to producers, directors, and writers as well as any other key talent associated with the project (such as actors). These figures are considered the creative costs of the production. The below-the-line items are all other monies required to produce the project, such as the crew, equipment, subcontractors, and so on. Such expenses are generally fixed in terms of what the production itself will cost in order to be completed. The distinction is made between the two categories because some of the above-the-line costs may be deferred. Above-the-line talent often participate in backend profits or have points. It also makes it easier for executives to review the budget and easily see the differences between the lead creative fees and actual nuts and bolts production costs.

The producer also needs to establish what the fringe benefits or fringes will be for the project so that they can assign these costs throughout the budgeting process. Fringes are those costs above and beyond the actual contracted or purchase price of an item. Standard items are guild and/or union pensions, health and welfare contributions, FICA, employer matching contributions, Medicare, unemployment taxes, and so on. Fringe rates

must be paid and range between 20 to 30 percent of labor costs depending on the studio. The percentage charged for each individual item varies depending on the location of the studio, benefits provided, and whether it is union or non-union. Table 6–2 defines a number of fringe payments that may or may not need to be made.

Chart of Accounts

The chart of accounts, also known as C of A, is used as a template for building a budget. Figure 6–10 shows an all-encompassing C of A that can be utilized for traditional, CGI, and hybrid productions. It lists line items including personnel, equipment, etc., to be budgeted for and their respective account codes (e.g., 0200 Producer's Unit). These account codes are also used by the production accountant and crew to assign and track costs for each line item. Depending on the studio, there may already be a standard numbering system in place, in which case these codes will need to be adjusted accordingly. No matter how your project is produced, the purpose of having all items included in the C of A is to remind you of all potential costs to be incurred on your production. As with all templates in this book, the producer should tailor the information to suit his or her particular production requirements.

There are different ways to create a budget. For example, you can build your own spreadsheets using software such as Microsoft" Excel. The most commonly used budgeting system in the entertainment industry however

Table 6–2

Sample Fringe Payments

Employer Contributions	Amount paid by employer for employees' taxes, withholding, benefits, etc.
Handling Charges	Fees paid to payroll services
CWT	City Withholding Tax
FICA	Federal Insurance Compensation Administration (social security)
FUI	Federal Unemployment Insurance
FWT	Federal Withholding Tax
OST	Other State Tax
SUI	State Unemployment Insurance
SWT	State Withholding Tax
Taxes	Sum of FICA + FWT + OST + SUI + SWT

Chart Of Accounts

Acct#	Description	Acct#	Description	Acct#	Description
		0100	**STORY FEES & SCRIPT DEVELOPMENT**		
0101	Option Fees	0102	Rights Payments	0103	Bonuses
0104	Royalties	0105	Writer(s)-Script Fees	0106	Writer(s)-Bible Fees
0107	Story Editor	0108	Script Coordinator	0109	Secretary
0110	Consultants	0111	Research and Reference Materials	0112	Script Copy Fees
0113	Clearance Fees	0114	Title Registration Fees	0115	Copyright Fees
0116	Writer Travel and Accommodation	0117	Fringe Benefits		
		0200	**PRODUCER'S UNIT**		
0201	Executive Producer	0202	Producer	0203	Co-Producer
0204	Line Producer	0205	Associate Producer	0206	Producer's Assistant
0207	Producer Travel and Accommoda...	0208	Entertainment	0209	Fringe Benefits
		0300	**DIRECTOR'S UNIT**		
0301	Director	0302	Supervising Director	0303	Sequence/Episode Director
0304	Assistant Director	0305	Director's Assistant	0306	Director Travel & Accommodation
0307	Entertainment	0308	Fringe Benefits		
		0400	**CASTING & RECORDING**		
0401	Principal Cast	0402	Supporting Cast	0403	Casting Director
0404	Dialogue Director	0405	Welfare Worker/Teacher	0406	Vocal Coach
0407	Casting Coordinator/Assistant	0408	Studio Costs	0409	Editing
0410	Stock & Transfers	0411	ADR Recording	0412	Loop Group
0413	Working Meals	0414	Mileage/Parking	0415	Travel & Accommodations
0416	Cast Exams	0417	Fringe Benefits		
			TOTAL ABOVE THE LINE		
		0500	**PRODUCTION STAFF**		
0501	Production Manager	0502	Production Supervisor	0503	Assistant Production Manager
0504	Production Coordinator	0505	Production Assistant	0506	Production Secretary
0507	Production Accountant	0508	Production Consultant	0509	Temporary Help
0510	Materials and Supplies	0511	Rentals	0512	Working Meals
0513	Overtime	0514	Fringe Benefits		
		0600	**ART DIRECTION & VISUAL DEVELOPMENT**		
0601	Production Designer	0602	Art Director	0603	Artistic Coordinator
0604	Character Designer	0605	Location Designer	0606	EFX Designer
0607	Background Painter	0608	Color Stylist	0609	CGI Artist
0610	Sculptures/Maquettes	0611	Research and Reference Materials	0612	Travel and Accommodations
0613	Materials and Supplies	0614	Overtime	0615	Fringe Benefits
		0700	**MODEL DESIGN**		
0701	Character Design	0702	Location Design	0703	EFX Design
0704	Prop Design	0705	Materials and Supplies	0706	Overtime
0707	Fringe Benefits				
		0800	**STORYBOARD**		
0801	Storyboard Supervisor	0802	Storyboard Artist	0803	Storyboard Clean Up Artist
0804	Materials and Supplies	0805	Overtime	0806	Fringe Benefits
		0900	**SONG PRODUCTION**		
0901	Song Composition Fees	0902	Lyricist	0903	Demos
0904	Song Copyrights	0905	Original Song Purchase	0906	Song Producer
0907	Singers/Chorus	0908	Song Coach	0909	Orchestrator/Arrangement Fees
0910	Conductor	0911	Musicians	0912	Instrument Cartage
0913	Instrument Rentals	0914	Music Editor	0915	Copyist/Proofreader
0916	Studio Session Fees	0917	Travel and Accommodation	0918	Overtime
0919	Fringe Benefits				
		1000	**ANIMATION DIRECTION; PRE-EDITING/FEATURE EDITING**		
1001	Editor	1002	Assistant Editor	1003	Apprentice Editor
1004	Dialogue Editor	1005	Animation Timer - Slugging/Sheet...	1006	Track Reader
1007	Editorial Equipment	1008	Materials and Supplies	1009	Overtime
1010	Fringe Benefits				
		1100	**TRANSPORTATION & SHIPPING**		
1101	Messenger & Courier Services	1102	Mileage	1103	Fuel
1104	Taxis & Limousines	1105	Postage	1106	Freight Charges
1107	Custom Brokers & Fees	1108	Materials and Supplies	1109	Fringe Benefits
			TOTAL PRE-PRODUCTION		

Figure 6–10 Chart of Accounts (ANIMATION BUDGET BUILDER Copyright 2000. Screenplay Systems Inc. Movie Magic Budgeting.)

Chart Of Accounts

Acct#	Description	Acct#	Description	Acct#	Description
		1200	**LAYOUT**		
1201	Workbook/Layout Supervisor	1202	Workbook Artist	1203	Layout Artist
1204	Blue Sketch Artist	1205	Assistant Layout Artist	1206	Materials and Supplies
1207	Overtime	1208	Fringe Benefits		
		1300	**ANIMATION**		
1301	Directing Animator	1302	Animation Lead	1303	Animator
1304	Assistant Animator	1305	Rough Inbetweener	1306	Materials and Supplies
1307	Overtime	1308	Fringe Benefits		
		1400	**SCANNING**		
1401	Scanning Supervisor	1402	Line Art Scanner	1403	Color Scanner
1404	Overtime	1405	Outside Labor	1406	Fringe Benefits
		1500	**SCENE PLANNING**		
1501	Scene Planning Supervisor	1502	Scene Planner	1503	Materials and Supplies
1504	Overtime	1505	Fringe Benefits		
		1600	**CLEAN UP**		
1601	Clean Up Supervisor	1602	Lead Key Clean Up Artist	1603	Key Clean Up Assistant
1604	Clean Up Assistant	1605	Clean Up Breakdown Artist	1606	Clean Up Inbetweener
1607	Materials and Supplies	1608	Overtime	1609	Fringe Benefits
		1700	**VISUAL EFX**		
1701	EFX Supervisor	1702	EFX Animator	1703	EFX Assistant Animator
1704	EFX Breakdown Artist	1705	EFX Inbetweener	1706	Materials and Supplies
1707	Overtime	1708	Fringe Benefits		
		1800	**BACKGROUNDS**		
1801	Background Supervisor	1802	Background Painter	1803	Assistant Background Painter
1804	Materials and Supplies	1805	Overtime	1806	Fringe Benefits
		1900	**ANIMATION CHECKING**		
1901	Animation Checking Supervisor	1902	Animation Checker	1903	Materials and Supplies
1904	Overtime	1905	Fringe Benefits		
		2000	**INK & PAINT**		
2001	Color Styling Supervisor	2002	Color Stylist	2003	Color Model Mark Up Supervisor
2004	Color Model Mark Up Artist	2005	Ink and Paint Mark Up Supervisor	2006	Ink and Paint Mark Up Artist
2007	Ink and Paint Supervisor	2008	Ink and Paint Artist	2009	Materials and Supplies
2010	Overtime	2011	Fringe Benefits		
		2100	**FINAL CHECKING**		
2101	Final Check Supervisor	2102	Final Checker	2103	Materials and Supplies
2104	Overtime	2105	Fringe Benefits		
		2200	**CAMERA**		
2201	Camera Supervisor	2202	Camera Operator	2203	Materials and Supplies
2204	Overtime	2205	Fringe Benefits		
		2300	**SUBCONTRACTORS**		
2301	Traditional Subcontract Fee	2302	Digital Subcontract Fee	2303	Pencil Test
2304	On Time Bonus	2305	Overseas Supervisor Salary	2306	Overseas Supervisor Per Diem
2307	Overseas Supervisor Transporta...	2308	Overseas Supervisor Accommo...	2309	Other Charges
2310	Fringe Benefits				
		2400	**CHARACTER MODELING- CGI**		
2401	Lead Character Modeler	2402	Character Modeler	2403	Lead Rigger
2404	Rigger	2405	Overtime	2406	Stock Model Fee
2407	Fringe Benefits				
		2500	**ENVIRONMENTAL DESIGN- CGI**		
2501	Lead Environmental Modeler	2502	Environmental Modeler	2503	Overtime
2504	Stock Model Fee	2505	Fringe Benefits		
		2600	**EFX/PROP DESIGN- CGI**		
2601	Lead EFX/PROP Modeler	2602	EFX/PROP Modeler	2603	Overtime
2604	Fringe Benefits				
		2700	**SURFACES:TEXTURE AND COLOR- CGI**		
2701	Surface Lead	2702	Texture Painter	2703	Digital Painter
2704	Overtime	2705	Fringe Benefits		

Figure 6–10 (Continued) (ANIMATION BUDGET BUILDER Copyright 2000. Screenplay Systems Inc. Movie Magic Budgeting.)

Chart Of Accounts

Acct#	Description	Acct#	Description	Acct#	Description
		2800	**STAGING/WORKBOOK - CGI**		
2801	3D Workbook/Layout Supervisor	2802	Workbook Artist	2803	Layout Artist
2804	Overtime	2805	Fringe Benefits		
		2900	**ANIMATION - CGI**		
2901	Directing Animator	2902	Animator Lead	2903	Animator
2904	Lead Technical Animator	2905	Technical Animator	2906	Overtime
2907	Fringe Benefits				
		3000	**LIGHTING - CGI**		
3001	Lighting Supervisor	3002	Lighting Artist	3003	Overtime
3004	Fringe Benefits				
		3100	**EFX ANIMATION - CGI**		
3101	Lead EFX Animator	3102	EFX Animator	3103	Overtime
3104	Fringe Benefits				
		3200	**RENDER**		
3201	Rendering Supervisor	3202	Renderer	3203	Overtime
3204	Fringe Benefits				
		3300	**COMPOSITE**		
3301	Compositing Supervisor	3302	Compositor	3303	Overtime
3304	Fringe Benefits				
		3400	**TECHNICAL DIRECTION**		
3401	Chief Technical Director	3402	Senior Technical Director	3403	Technical Director
3404	Overtime	3405	Fringe Benefits		
		3500	**SOFTWARE**		
3501	Research and Development Man...	3502	Researcher	3503	Programming Supervisor
3504	Programmer	3505	Consultant	3506	Purchases
3507	License Fees	3508	Overtime	3509	Maintenance Contracts
3510	Fringe Benefits				
		3600	**HARDWARE**		
3601	Workstations	3602	Render Stations	3603	Digital Disk Recorders
3604	Servers	3605	Installation Fees	3606	Rentals
3607	Scanners	3608	Networking Equipment	3609	Maintenance Contracts
3610	Consultant				
		3700	**SYSTEMS ADMINISTRATION**		
3701	Systems Administration Manager	3702	Systems Administrator	3703	Audio Visual Engineer
3704	Overtime	3705	Fringe Benefits		
		3800	**OTHER PRODUCTION COSTS**		
3801	Incorporation Fees	3802	Legal Fees	3803	Bonuses
3804	Insurance	3805	Severance Fees	3806	Rent/Leaseholds
3807	Utilities	3808	Janitorial Services	3809	Office Supplies
3810	Working Meals	3811	Research Materials	3812	Furniture/Equipment Purchases
3813	Furniture/Equipment Rentals	3814	Depreciation	3815	Copiers
3816	Repair and Maintenance	3817	Dues and Subscriptions	3818	Telephone
3819	High Speed Lines/DSL/Internet	3820	Technical Expendables	3821	Storage
3822	Wrap Party	3823	Crew Gifts	3824	Training
3825	Recruiting	3826	Final Continuity Script		
		3900	**BELOW THE LINE TRAVEL**		
3901	Airfares	3902	Hotel	3903	Ground Transportation
3904	Per Diems				
			TOTAL PRODUCTION		
		4000	**POST-PRODUCTION STAFF**		
4001	Post-Production Supervisor	4002	Sound Supervisor	4003	Post-Production Coordinator
4004	Editor (TV and D-T-V)	4005	Assistant Editor	4006	Materials and Supplies
4007	Overtime	4008	Fringe Benefits		
		4100	**VIDEO**		
4101	Film to Tape Transfer	4102	Tape to Film Transfer	4103	One-Light Transfer
4104	Off-Line Editing	4105	On-Line Editing	4106	Color Correction
4107	Cassette Duplication	4108	Protective Masters	4109	Element Reel
4110	Character Generator	4111	Materials and Supplies		

Figure 6–10 (Continued) (ANIMATION BUDGET BUILDER Copyright 2000. Screenplay Systems Inc. Movie Magic Budgeting.)

Chart Of Accounts

Acct#	Description	Acct#	Description	Acct#	Description
		4200	**FILM AND LAB**		
4201	Telecine	4202	Film Development	4203	Lo-Con Prints
4204	Negative Cutting and Assembly	4205	Interpositive	4206	Internegative
4207	Answer Print	4208	Composite Check Print	4209	Re-print
4210	Digital Film Printing	4211	Film Stock	4212	Tests
4213	Protective Master	4214	Release Print	4215	Stock Footage
4216	Materials and Supplies				
		4300	**TITLES AND OPTICALS**		
4301	Main and End Titles	4302	Bumpers	4303	Interstitials
		4400	**MUSIC**		
4401	License Fees	4402	Underscore Composer	4403	Demos
4404	Music Producer	4405	Conductor	4406	Orchestration
4407	Musicians	4408	Instrument Cartage	4409	Instrument Rentals
4410	Music Editor	4411	Copyists/Proofreaders	4412	Studio Session Fees
4413	Travel and Accommodation	4414	Album Mastering	4415	Other Charges
4416	Overtime	4417	Fringe Benefits		
		4500	**POST-PRODUCTION SOUND**		
4501	Audio Transfers and Stock	4502	Sound Design	4503	Effects Editing
4504	ADR/Looping Facility	4505	Dialogue Editing	4506	Foley Recording
4507	Foley Editing	4508	Temp Dubs	4509	Final Re-Recording Mix
4510	Foreign M & E Mix	4511	Optical Track Negative	4512	Equipment Rental
4513	Working Meals	4514	Sound Package Deal	4515	Sound Effects Purchase
4516	Other Charges	4517	License Fee - Dolby Digital	4518	License Fee - SDDS
4519	License Fee - DTS				
		4600	**SCREENINGS/PREVIEWS**		
4601	Facility Charges	4602	Projectionist	4603	Catering Costs
4604	Audience Testing Fees	4605	Preview Expense Miscellaneous	4606	Travel and Accommodation
4607	MPAA Rating Administration Fee	4608	Fringe Benefits		
			TOTAL POST-PRODUCTION		
		4700	**PUBLICITY**		
4701	Publicist	4702	Entertainment	4703	Travel and Accommodation
		4800	**CONTINGENCY**		
	Percentage of Budget				
		4900	**OVERHEAD ALLOCATION**		

Figure 6–10 (Continued) (ANIMATION BUDGET BUILDER Copyright 2000. Screenplay Systems Inc. Movie Magic Budgeting.)

is called Movie Magic. It is an interactive software application that is specially designed for production accounting. The chart of accounts shown in Figure 6–10, named the "Animation Budget Builder," is also available on Movie Magic budgeting software at the website address MovieMagic Producer.com.

Cost Reports

On each production, the production accountant, along with the producer, issues *cost reports*. These are also referred to as *variance* or *Estimated Final Costs (EFCs)*. These reports are used to evaluate the financial status of the budget on an ongoing basis. They are created from the final signed-off budget and schedule and are distributed to key personnel for review. (For further information on accounting, see Chapter 4, "The Core Team.")

7

THE PRODUCTION TEAM

The Role of the Producer in Structuring the Production Team

As an animation producer, building the crew is where you get the opportunity to perfect your juggling skills. Hiring a team for an animated project does not happen all at once since not everyone is needed at the same time. As a result, start dates and end dates are staggered. Unlike live-action filmmaking, there is no one moment in which cast and crew work on the same scene simultaneously. The staff's work is very segmented as each scene independently proceeds from one department to the next. See Chapter 6, "The Production Plan," for more information on putting together a crew plan. The producer paces the production in terms of the number of artists and production staff needed. This is more easily said than done since projects are always in a state of flux. The producer thus has to protect the budget and yet be willing to take risks and hire the artists prior to the production pipeline becoming fully functional.

One major difference between feature production and that of television and direct-to-video projects is their staffing needs. For qualitative reasons, most features are produced in-house. This methodology puts the producer in the position of having to identify and hire potentially upwards of 450 staff members for a project. Typical television or direct-to video projects, which are much more limited budget-wise, subcontract the production portion of the process. In order to create a pre-production team for these types of shows, the producer hires approximately 25 to 40 people for the in-house crew, with the bulk of the production crew hired by the subcontractor.

Subcontracting work can be very useful to the producer in helping to control costs and make up for shortfalls in their crew (to keep from falling behind schedule, for example). If subcontractors are to be involved in pre-production work, it is important that the producer research their availability

and talent prior to the project being greenlit. This pre-planning helps to assure that they are ready to go as soon as the producer requires their services. When they are involved in some or all of the production phase, the producer should put a deal in place as early as possible during pre-production to ensure that materials are created to suit the subcontractor's needs. We will discuss subcontractors in greater detail later in this chapter.

Whether the producer is crewing up for a feature or a television show, when the project gets close to being greenlit, he or she must put the word out on the personnel needed. Based on the response, the producer will get a sense of the artistic and administrative staff's availability and the kind of recruiting efforts that will need to take place. Depending on the size of the studio, there may or may not be a recruiter available to help in the hiring process. (See Chapter 4, "The Core Team," for more information on recruiting and training.) If there is no recruiter, the producer contacts individuals they have worked with before and solicits recommendations from colleagues. The formal announcement of a production starting is commonly advertised online and in print through industry trades and animation magazines; however, word of mouth is the most common method of "crewing up." Some studios use websites and job lines to post the details of available positions and who to contact. When it is a union project, information on the production is also listed in the union's monthly newsletter.

As the time comes for the producer to select artists, he or she needs to look at the creative team as a whole to ensure that all members suit the project and are able to work well together. Specific skills are necessary for each job category. For example, the most important aspect in evaluating storyboard artists is their ability to tell a story. You can make this assessment while reviewing their portfolios. As you look at their artwork, you should also be comparing their style to that of the show. Perhaps they are flexible and can handle a range of projects, or maybe their expertise can best be tapped for a particular genre such as comedy. Another significant issue to keep in mind is the artist's capability in terms of speed and output. If the director or producer has had no previous experience with the artist, the answer to this question may require a phone call to a colleague who is familiar with their work.

The next consideration is how to build your storyboarding team with artists who complement each other. Some artists are able to spell out each scene down to the last possible detail, while others tend to focus primarily on the acting. The tendency is to have both types of artists on a show so that they can address the key moments of the story as well as illustrate how the characters interact. Lastly, it is almost an animation tradition to develop future talent by having interns work alongside experienced artists. This method helps the less experienced artist see firsthand what type of ideas work and how they are executed. Although interns may not be able to contribute to the show, they are an important asset to future projects. (For a de-

tailed description of the artistic staff and their duties, see Chapter 8, "Pre-Production," and Chapter 9, "Production.")

Since it is crucial for the producer to delegate responsibility, it is vital for them to trust their leads. When selecting supervisors, key artistic staff, and production personnel, it is highly consequential to hire individuals who are experienced in their respective roles. By choosing people who know the ins and outs of their position, you will be able to run the project efficiently. The producer can create a fantastic mix of talent when they know how to sprinkle the crew with old-timers and newcomers. In some instances, the producer may be faced with a dilemma. They may come across an extraordinary new talent who can make all the difference to the success of the project but they insist on only joining the team if they are hired as a supervisor. If that is the case, the producer may choose to set up an internal structure to support the first-time supervisor. The team can be made up of senior artists who can lend a hand if production problems arise, or the new talent may be paired up with a more experienced artist who can share the supervisory duties with them. We will discuss the role of the department supervisor later in this chapter.

When assembling the production crew (or the non-artists) and the artistic team, the producer should also find a way to create and maintain a positive chemistry in the group. Just like any other collaborative art form, animation requires the talent of many different types of people who have to work well with each other and communicate effectively. Depending on how the production is set up, the artistic team and management group, if not mutually respectful of each other's roles, can find themselves locked in a never-ending battle. Artists may think that the schedule is unrealistic and feel they are treated as though they were forced labor, for example. On the other hand, the production staff may believe that they have to act like they are running boot camp or the project will never get done. This kind of negative approach towards work often results in zapping the production of its creative juices and lowering morale. The producer is the individual responsible for rectifying these kinds of problems, and damage control has to be immediate.

Key to running a successful production is informing and updating everyone about their shared goals and, most importantly, the means to get there. Unless the producer actively works on creating team spirit, the production can quickly get derailed. Probably the most effective means of creating a good working atmosphere is making sure that the crew knows that they have an outlet through which they can communicate. If the producer's schedule or style doesn't allow them to be accessible, they should be sure to hire an associate producer or production manager who is available to the staff. If the staff feel that they have a voice and are treated with respect by the leaders of the project, they will do all they can to put forth their best efforts for the production.

Once it is established that an individual is to be hired, negotiations begin. Negotiations for most above-the-line or high-end talent such as directors and producers are handled by the business affairs department. (For more information on the business affairs department, see Chapter 4, "The Core Team.") For non-contract personnel, the producer—or a production executive at a larger studio—handles the negotiations. In some cases, the associate producer or production manager is involved, especially for freelance artists and production staff. If a contract is not necessary for the new hire, a deal memo should be put together by the producer. Deal memos are very useful in that they outline important details such as salary, terms of agreement, start date, title, and credit. By establishing this information prior to an employee starting work, any future discrepancies can be dealt with quickly. In our opinion, up-front clarity regarding a position is a form of proactive troubleshooting.

While a production is in progress, it is crucial that the producer monitor the hiring process very carefully. When a production gets off track, it is important to adjust the crew plan and hire accordingly. In studios where the staff are already hired and slated to go onto the production by a specific date but the project is not ready, the producer must collaborate with the production executive and find means to delay the start of the artists on their budget. One scenario is to loan the artists to other productions, either in-house or at other studios. Another method may be to confer with the artists and see if they are willing to work shorter weeks so that there is less impact on the budget. When there is no other solution, the producer may have no choice but to abide with the previously agreed-upon start date and do the best they can to get useful materials created. Depending on how far behind the project may be, the producer needs to then strategize on how to make up for this lost time. Possible solutions include the hiring of additional artists on a freelance basis, allocating money for overtime, or simplifying the story and finding a means to reduce the artwork needed. This reshuffling of resources is constant throughout all stages of production.

On a direct-to-video project I (Zahra) co-produced, I was responsible for recruiting and hiring artists. As we approached the production start date, I was very excited to learn that three highly talented storyboard artists were recently laid off from a feature production. Since it was rare to find experienced artists of this caliber available, I quickly contacted them and we were able to agree on a salary and a start date. Much to my dismay, however, our initial plan for the delivery date of the final script fell apart when the production executive and the director/producer decided to hire a different writer to take a new pass on the story. Although I had given the storyboard artists my promise to start them within a few weeks, the production start date was now postponed indefinitely.

At this point, I had to take a few chances and hope for the best. I contacted the new writer and asked her how long she would need before a draft

was ready for our review. Although I did not want to pressure her, I did tell her about my circumstances and asked her to keep me informed of her progress. She promised to have "something" for us to look at in one month. I had to work with a number of variables. First, would she meet her deadline? And second, what if her pass was not successful? I spoke with the director/producer and told him that I felt very strongly about honoring my promise to the storyboard artists despite the fact that we did not have a script for them to work on. He asked me to contact them and work it out. Each artist had a different response. One insisted on being hired on the date promised. Another said that he would like to be put on retainer until the script was ready. And finally, the third artist said that he was happy to take a longer vacation but could not go beyond a two-week delay.

Once I got the producer/director's feedback on the artist's requests, I contacted the artists with a new offer. As agreed upon, they could start on the original date, but I wanted their help on character development and location design rather than storyboarding. My solution enabled the artists to get on payroll and at the same time helped me in preparing for pre-production. As a producer, I was not only concerned about the bottom line but also about the individuals on the team. This approach paved the path for a very rewarding relationship. My gamble to hire the artists as promised paid off when the writer faxed us a portion of the script within two weeks and it was approved for production. At last, we were able to get the project off the ground. I did everything in my power to accommodate the artists, and in return they went beyond the call of duty to work hard in order to make up for the lost time. Thanks to their extraordinary efforts, within weeks we were able to recover from the shaky start and hire the rest of the crew as planned.

Just as important as honoring a promised start date, the producer has to be direct with the artists when end dates approach. It is extremely difficult to inform the crew that within a short time they will be out of a job. There are a number of factors to consider when the end of the project is near. Inevitably, the last weeks of a show require the artists to do more work then before in order to meet deadlines. Telling artists their end dates may diffuse their enthusiasm for the project and they may spend time and energy looking for another job instead of focusing on completing their assignment. Yet it is key to give artists advance notice so that they don't find themselves in a financial bind. Experienced artists know that end dates are part of any job and that fulfilling their part of the bargain is a necessity. After all, chances are you will be working together again and it is important not to have a tarnished record.

The Production Crew

A producer's management crew or production staff performs a vital part in keeping the project together and moving it forward. In television and direct-to-video shows, this group is usually limited to a few key individuals. These

include the production manager and, depending on the size and scope of the project, a handful of coordinators and production assistants. Because of this limited size, the ability to wear multiple hats is a necessity for these roles. On features, there can be upwards of 30 individuals making up the production management team and as such, their responsibilities are much more specialized. The production manager has an assistant in almost every department and depending on the number of artists in the department, assistant production managers (APMs) may have one or two production assistants helping them.

When hiring a production crewmember, there are a few ground rules to follow. In general, the crewmember should have:

- Previous animation experience (necessary for both production managers and coordinators/APMs and preferred in production assistants)
- Strong interpersonal skills with both artists and management
- Enthusiasm for the job
- The ability to prioritize
- The ability to ask questions and get guidance
- Strong organizational skills and the ability to pay attention to detail
- An aptitude for problem solving and troubleshooting
- Data inputting and production tracking skills
- A proficiency at delegating (for production managers and coordinators/APMs)
- The ability to follow through on action items
- A goal-oriented attitude

The Production Manager

The production manager is usually hired at the onset of pre-production and, depending on the budget, may continue through post-production. This position reports directly to the producer and, based on how the project is set up, to an associate producer or hands-on production executive. (For a discussion on the role of the associate producer, see Chapter 2, "The Animation Producer.") The coordinator(s) and the production assistant(s) report to the production manager on television series and direct-to-video projects. On features, the department supervisors, APMs, and production assistants are all answerable to the production manager.

The production manager essentially functions as the producer's right hand and is directly responsible for managing the details of production in order to keep the project on track. The production manager assists the producer in creating the master schedule and all departmental micro-schedules.

(See Chapter 6, "The Production Plan," for sample master schedules and Chapter 11, "Tracking Production," for sample tracking charts.) When changes such as script revisions are made to the project, the production manager modifies the schedule with input from the producer. Additionally, the production manager creates and maintains weekly production status reports. Establishing priorities and communicating information to the staff are integral parts of this role.

When dealing with a subcontractor, production managers make certain that all the material shipped is exactly to the agreed-upon specifications. Prior to sending out artwork, they must review the contents of the package in order to make sure that the shipment is complete. They set up a reporting or tracking system so that the progress on the work at the outside facility can be closely monitored. At the same time, they should be accessible to the subcontracting team for any questions. Upon obtaining the producer's approval, the production manager provides additional material when requested. If the subcontracting studio is in need of information on structuring the production from an administrative point of view, the production manager may be asked to travel to the animation house and offer on-site training.

On projects that are animated in-house, production managers have a large amount of artwork to track. For this reason, they have APMs in almost every department. On some projects, certain APMs—such as the director's APM, the producer's APM, and the APM of technology and disk space management (in digital productions)—may function as liaisons in relation to other staff members. If the production uses a number of outside animation facilities, the production manager would also benefit from having an APM dedicated to working with the subcontractors in order to coordinate shipments, monitor timely progression of the work, and follow up on their requests.

The production manager's most important duty on a feature film is to find a way to have adequate inventory in each department so that weekly quotas can be met. (See Figures 6–6 and 6–7 for sample weekly quotas.) The momentum of the production or the necessary workflow between departments is determined by the schedule. After the main character and location designs are finalized, the first item the production manager must tackle is making sure that enough storyboard sequences are approved for production in order to start feeding the pipeline. If this is not possible (that is, script problems are plaguing a project and causing delays), the production manager works with the production accountant to devise new schedules and tabulate the costs of the delay. Once sequences are approved and there are enough scenes issued to meet the required footage per department, the production manager needs to keep a vigilant watch over meeting the weekly targets. When APMs encounter problems meeting their quota, the production

manager works with them to find solutions since their shortfall may impact other departments. Possible scenarios to troubleshoot for successful inventory flow include:

- Assess all scenes in the department as well as the possibility of putting other scenes on the fast track in order to reach the necessary number. If there is no way to meet the quotas in a given week, the next option is to see whether the department can make up the missed quota in the following week, thereby meeting the targeted number.

- Evaluate the workload to make sure that the expected quotas are realistic and achievable.

- Analyze the individual artists' performances to make certain that all creative staff are producing as expected.

- Take a closer look at how artwork is assigned so that the same artists are not always given the most complex work and that the artists are cast according to their strengths.

- If quotas are consistently missed and there is no possibility of catching up, the production manager must get approval from the producer to ask the staff to work overtime and/or hire freelance artists. Overtime should be used strategically since it is demanding on the artists, and can be costly. Unless it is paced properly, it can have diminishing returns.

- When the budget is locked and there are no additional funds available for freelance artists or overtime, the only choice is to further simplify the scenes. The director and the producer must approve all scene simplification passes. Typically, the associate producer and the artistic coordinator concentrate on this aspect of production.

Over the course of production, the production manager at one time or another may have to utilize all of the above scenarios. However, the best approach is to be proactive and assess each scene's level of complexity during workbook and make certain that resources are available for their successful completion. (For more information on this topic, see Chapter 9, "Production.")

During post-production, the production manager focuses on tracking retakes and aiding the post-production supervisor in coordinating film or video elements. The production manager may be involved in scheduling sessions and, in some cases, in attending them based on the producer's requirements. The production manager may also be responsible for upkeep of the script by tracking and inserting any revisions, along with making sure that all automatic dialogue replacement (ADR) lines are recorded. (For further discussion on ADR, see Chapter 10, "Post-Production.")

Department Supervisor

On higher-budget productions, artistic leads are selected from each department to guide the team and oversee their work. The department supervisor works with the director and, when applicable, the art director in order to get input on the creative expectations of the show. They work for the director on creative issues and collaborate with the production manager on all production-related topics. The department supervisors are usually hired prior to the start of their department so that they can explore and establish the look of the project and be involved in selecting their team members. They are responsible for assigning work to the artists in their department. They attend approval meetings with the director, weekly production meetings and workbook (also know as the bluebook) evaluation sessions. (For more information on the workbook, see Chapter 9, "Production.") At the production meeting, department supervisors are expected to provide the producer, the director, the associate producer, the artistic leads, the production manager, and APMs with an up-to-date report on their departments. At this meeting, they can also express production concerns that pertain to the show in general. Department supervisors also hold weekly meetings with their own teams and update them on how the project is progressing.

When it comes to regulating the workflow, the supervisor and the APM work together to plan and schedule for the department. Taking weekly targets into account, along with the complexity of work and the individual staff available to do the work, they strategize on how to allocate assignments. Each attacks this challenge from his or her own point of view, collaborating to find the best solution to ensure that both the creative and administrative needs of the project are met. Together they work with the individual artists to find a suitable due date for assignments that stays within the budgeted number of hours available.

Something to keep in mind when choosing a supervisor is that there is often a compunction to select the most prolific and/or talented artist for the role of the department head. Since this position requires the individual to attend numerous meetings and work one-on-one with their crew in order to help them solve problems, they are the least likely to get anywhere near the drawing board or computer and produce artwork. For this reason, it is probably more useful to choose an artist who is highly experienced, is well respected among their peers, and has strong interpersonal and administrative skills.

Production Supervisor

The role of the production supervisor falls somewhere between the production manager and the coordinator. The position is most often used in

television and direct-to-video projects. The responsibilities assigned are commonly a combination of tasks delegated to a coordinator and production manager.

Production Coordinator or Assistant Production Manager (APM)

In general, production coordinators and APMs have many job responsibilities in common; however, in television and direct-to-video projects, the role is commonly described as coordinator, while on feature productions, it is called an APM. APMs usually work closely with department supervisors and their job tends to be more specialized. In both formats, however, the coordinator and the APM report to the production manager and they manage the artists' work in order to meet production deadlines. Depending on the budget and studio structure, they may or may not have production assistants supporting them in their daily tasks. Coordinators are primarily employed during the pre-production phase; APMs are hired based on the department start and completion dates.

Coordinators and APMs are responsible for tracking artwork, artists, and their output. As artwork is completed, it is their responsibility to ensure that it has been reviewed by the director and/or department supervisor for approval or revisions, thereby ensuring progress on the artwork at hand. The only way to evaluate the status of a project is by being able to assess the detailed progression of each scene/shot down the production line. Because of the necessity for accuracy, conscientious upkeep of the tracking system by the coordinators or APM is crucial. Whenever there are any changes on the status of the script or artwork, the information should be updated. Typically, the data entered into the system indicates the artists currently assigned to the work, the date they started, the expected due dates, and the date when their scene is approved. Once the artwork is completed and the director has signed off on it, the coordinators and APMs organize, file, and distribute the material as necessary. The coordinator prepares the material for shipment while the APM forwards the artwork to the next department.

The coordinator or APM must focus on developing good working relationships with the artists. Being straightforward about deadlines and the overall production schedule is essential in order for artists to be given a chance to complete their assignments on time. If artists don't consider the allotted time to be sufficient, the coordinator or APM should work with them in order to find a more suitable schedule. If past experience shows that an artist is consistently late and rarely working, the coordinator or APM may find it necessary to follow up with the artist on a more frequent basis. In re-

sponse to having to adhere to the stricter due dates, the artist may feel that he or she is being put under too much pressure to produce. Under these circumstances, it is important to involve the department supervisor so that the problem can be resolved promptly. When "due dates" are not met, production goals will inevitably be missed. When this is the case, it is vital to alert the production manager as soon as possible.

When the work is subcontracted, the coordinator has to make certain that the final artwork is ready on the agreed-upon shipment dates. The coordinator thus schedules the shipment and fills out the necessary paperwork. The coordinator acts jointly with the production manager and continuity checker on the preparation of the material. He or she functions as the contact person for the subcontracting studio and must facilitate all their production needs as quickly as possible. On features, it is up to the APM to make sure that when a scene leaves the department it contains all the elements listed on the scene folder and that the material is fully prepared for the following department.

In an animation studio, the coordinator or APM must monitor and maintain certain items. The most important prerequisite is making sure that artists have the material they need in order to work on their assignments. Whether it's a piece of art from another artist, reference material, or special art supplies, it all must be prepared prior to the handout session. Equally as important is making sure that the equipment is in working order. If not, a report must be made immediately so that equipment failure does not result in production delays. Also, as we have established before, creating an artist-friendly environment is an absolute necessity for any production. It is not uncommon to have situations in which one artist is unhappy with a neighboring artist's loud music, for example. Again, it is up to the coordinator or the APM to resolve the problem or seek help from the department supervisor and/or production manager.

The coordinator or APM must also keep everyone apprised of the crew's status. Maintaining a master calendar that shows information on artists who are on vacation, on leave of absence, or have taken ill is very helpful. Generating a contact list for the crew and a confidential list of home phone numbers in case of an emergency is also useful. Finally, since they see artists on a daily basis and are aware of the number of hours worked, coordinators and APMs are responsible for reviewing their timecards before they go to the production manager for signature.

As the production begins to wrap up, coordinators and APMs are involved in closing down the department as necessary. They are also responsible for archiving the artwork. Depending on the nature of the material, it may be copied on disks, be put in storage, preserved in a library, or sent to a gallery for exhibition and sale. The coordinator or APM creates an inventory list of all archived items for future reference.

Script Coordinator

On television and direct-to-video productions, the role of script coordinator entails working with the story editor and writers. The script coordinator assists in tracking the status of their work along with taking care of any production needs to do with the script. As scripts go through various drafts, they ensure that everyone involved in the writing and approval processes (executives and producers, for example) have the most recent version. If there are page changes rather than entire new drafts, they distribute the specific pages. This is done on colored paper, with the various colors indicating the specific revision. Each new page should include the date and draft number, with the new writing being indicated with an asterisk. Once a script has been finalized and greenlit to move into production, script coordinators distribute the script to in-house staff as well as the casting director and voice director, who are responsible for getting all materials to the actors and the recording engineer.

When changes are made during production and/or the recording session(s), the script coordinator updates the script and distributes all revisions to the appropriate individuals. It is their responsibility to keep a record of all versions of the script for reference and archival purposes so that executives and/or producers can refer back to materials at any time. They are also responsible for preparing sides for casting sessions and reformatting the script for recording sessions. They collaborate closely with the casting director and may be asked to attend recording sessions to help the producer(s) and recording engineer by keeping track of circle takes and other pertinent information. (For further information on this topic, see Chapter 8, "Pre-Production.") When a project is completed all the way through production and is delivered, script coordinators are then responsible for preparing the as-aired script (in the case of television) or the as-delivered script (for direct-to-video and feature projects). On shows that do not have a script coordinator, the production manager is usually responsible for these duties.

On features, the above duties are usually divided between a number of APMs. The story APM is responsible for script distribution, upkeep, filing, and archiving. The editorial and recording APM gets involved with all duties having to do with the recording session. When there are script changes, the two APMs work closely in making sure that the production script reflects the latest revisions.

Production Assistant

The production assistant's job is to support the coordinator or APM and the artists. Their duties include labeling and pasting-up artwork and copying and filing either hard copies or digital copies. They are also responsible for

aiding the coordinator or APM in tracking the status of the artwork. Next to the artists, production assistants have the most contact with the actual artwork. Diligent and conscientious handling is a requirement for the production assistant in order to prevent costly losses to the production. When there is artwork missing, the production assistant must search and recover the lost item. Once the project is close to completion, they assist the coordinator or APM in archiving the material.

Aside from focusing on the artwork, the production assistant takes on any other tasks that may need administrative support. Should the artists require reference materials such as books, videos, or drawings from another scene (that is, "same as" elements), it is their responsibility to find them. When new artwork is created or a design is revised, production assistants ensure that all artists are up to date and have the materials for easy reference. The production assistant may scan in the artwork for the editor when it comes to creating animatics or story reels. If animation is being handled in-house, in the case of 2D, production assistants shoot pencil tests. They also make sure that art supplies are available and reordered as necessary. Essentially, the production assistant gets exposed to many areas of the production. As such, this role provides the newcomer to animation with a great learning opportunity.

Production Secretary

The production secretary is integral to the smooth operation of a production. Much of their job is focused on seemingly mundane office work, including typing, copying, filing, distributing memos and faxes, and taking messages. However, if not handled well, these functions can lead to possible communication breakdown among the production staff. The production secretary essentially works for the team as a whole. If there is no dedicated assistance for the producer or the director, the secretary may also be responsible for coordinating daily schedules and setting up meetings. The producer relies heavily on his or her assistant to take care of many details, including internal meetings and all dealings with the ancillary groups, for example. Given their workload, in most cases, producers require a dedicated secretary.

The production secretary should be able to multi-task. On productions that require crewmembers to fly to other animation facilities, production secretaries make travel arrangements and assist the staff in completing their expense reports. Depending on the studio structure, they may also be in charge of ordering production supplies and making sure that all necessary material for production is in stock and readily available. If there is no shipping clerk on the project, the production secretary coordinates package pickup and delivery as necessary.

Figure 7-1 Sample Organizational Chart for Television and Direct-to-Video

EXECUTIVE PRODUCER

PRODUCER

DIRECTOR

STORY EDITOR

WRITER(S)

SCRIPT COORDINATOR

PRODUCTION MANAGER

PRODUCTION COORDINATOR

PRODUCTION SECRETARY

PRODUCTION ASSISTANT

ART DIRECTOR

TECHNICAL DIRECTOR

STORYBOARD ARTIST(S)

SLUGGING DIRECTOR

REEL EDITOR

TRACK READER

SHEET TIMER(S) (Mouth Exposure)

LAYOUT SUPERVISOR*

LAYOUT ARTIST(S)*

KEY ANIMATION POSER*

KEY CLEANUP POSER(S)*

KEY EFFECTS DESIGN ANIMATOR(S)*

CONTINUITY CHECKER

CHARACTER DESIGNER(S)

LOCATION DESIGNER(S)/ LAYOUT ARTISTS

PROP DESIGNER(S)

KEY BG ARTIST(S)

COLOR MODEL STYLIST(S)

* ADDITIONAL CREW TYPICAL FOR DTV PROJECTS ONLY

* ADDITIONAL CREW TYPICAL FOR DTV PROJECTS ONLY

On features, the production secretary is usually the individual responsible for creating and updating a document that is commonly referred to as the "draft." It is first produced when a sequence has been completed through workbook, and has been divided into scenes. The draft includes information such as the sequence number, scene number, scene description, scene footage, dialogue, and page number. The draft is updated by the APMs as the scene goes through their respective departments. This document functions as the official record of the film and is used as an information base that is referred to on a consistent basis by the artistic and production staff. Since this document contains critical data, it is imperative that it be maintained accurately. The production secretary issues all notes generated in sweatbox sessions. (On some projects, if this role warrants a full-time person, they are called the "sweat box" APM. For more information on this topic, see Chapter 9, "Production.")

Figure 7–1 is a model for an organizational chart applicable to television and direct-to-video production.

Subcontractors

Using subcontractors is very common practice within the animation industry. At present, the lion's share of subcontracting takes place on 2D projects. As more CGI-based studios are established and the process gets further standardized, subcontractors will inevitably become a greater part of these studios as well. Subcontracting occurs in all formats of the business. On feature projects, while the goal of most studios is to produce everything in-house, there are cases where specific components such as clean up animation are outsourced. The majority of subcontracting takes place on television and direct-to-video projects where typically the entire production portion is shipped to an outside studio. (See Chapter 9, "Production," for detailed information on the steps of production. Note that the subcontractor may not follow the production steps exactly as outlined in this chapter, but may instead use a variation depending on the budget and their methodology.)

Producers use subcontractors for many reasons, the primary reason being that subcontractors tend to be cheaper. This is often because wages are lower at international studios. From a budgeting standpoint, it is also less expensive for the producer to hire an outside group rather than carry all of the overhead costs associated with a full production crew. A lack of available talent is another reason for subcontracting a show. It may be that there is a shortage of artists or there is a specific crew best suited to the project at an outside studio. Finally, subcontractors can help with meeting a schedule. If a project is behind, a subcontractor may be able to assist in getting the project back on track by temporarily providing the needed resources the producer requires.

Identifying and Selecting a Subcontractor

Identifying and selecting a subcontractor can be difficult the first time around. Once you have worked with a number of studios, it becomes easier to choose one as you build a list of contacts that you can depend on. If you do not already have contacts, one way of finding a studio is to watch the credits of shows you are impressed with or that stylistically match your project. Identify and contact the subcontractors listed and ask for their demo reels and credit lists. Note that production houses that do subcontracting work are located all over the world—in the Far East, India, Australia, Europe, Canada, as well as within the United States. In some cases, larger subcontracting studios have offices and/or representatives set up in North America. If not, you will need to e-mail, call, or fax the studios directly—which can sometimes be tricky due to language barriers. Another good way of finding subcontractors is by speaking with colleagues at other studios. Ask for recommendations. Find out whom they have worked with and what went well and what didn't.

When choosing a subcontractor, the producer must be sure to cast the project with the appropriate studio, especially within Asia, where each country has its own specialty. Japan, for example, is excellent at realistic animation and effects. Korea, while it is also experienced in these areas, is more adept at cartoony work. As noted earlier, one way of choosing a studio is to review sample reels. Although it may not always be clear what type of pre-production materials the studio had to work with, reels can still be a good indication of a studio's capabilities, as they will only show their best work. If you find yourself interested in a couple of studios that have offered bids in the same range, you may want to test the studios to help you make a final decision. It is not uncommon to ask a studio to animate a scene or two, especially if you have never worked with them. This way you can compare quality and make an educated choice. The only problem with testing is that typically the subcontractor will put their top talent on the test in order to secure the work; however, this talent may not be a true representation of the studio's capabilities, so you need to be judicious in making your final decision. One tactic we have found to have good results is to set up a creative partnership with the subcontracting studio. We have done this by involving the subcontract team's key artists in reviewing the pre-production materials for potential complexity or production problems prior to finalizing them. Another method is for the studio to actually participate in the creation of the pre-production artwork. By doing so, they also have a vested interest in the product as they have had the opportunity to put their mark on it.

In selecting a studio, be very cautious that it has the capacity to handle your work. You need to take into account both the schedules you are requesting and the level of quality you are expecting back. It is not unusual

for studio owners to get overly ambitious and overbook themselves. When this happens, your subcontractor may end up subcontracting your work to another subcontractor, who in turn hands it off to another subcontractor. There have been many occasions when I (Catherine) have been touring studios and have noticed colleagues' work that is supposedly being handled by another studio being produced at the studio I am visiting. This practice is very typical in Asia and when it happens, the quality of the production may be adversely affected. Each time your project is passed on, money is scraped off the initial budget and generally is no longer put towards the quality of your show.

In certain cases, the subcontractor may not have the capacity or the capability to handle every stage of production in-house. In order to provide full services, they will need to outsource the work to other studios with which they have relationships. Under these circumstances, the subcontractor should clarify from the beginning what stages of production will be sent out and which studio(s) will be completing the job. It is important for the producer and the director to visit all facilities working on the show to confirm that they have the background and experience to handle the work. Additionally, this information must be covered in the contract, ensuring that the original subcontracting company hired is solely responsible for the production and on-time delivery of the show. This process is very typical in a country such as Japan, where actual physical studio space is limited. For example, a company may do all production planning, tracking, and line artwork (i.e., animation and clean up) in-house but use a subcontractor for painting backgrounds and ink and paint. Depending on the project, its specific needs, and the subcontracting studio's setup, there may be a myriad of different production structures.

If there is a studio you want to work with yet you feel they may not be able to handle all the material, it may be necessary to split up the project among two or three studios, depending on the number of episodes or sequences. There are positive and negative potential outcomes from making this decision. The positive is that schedule delays should not be an issue since the subcontractor's capacity theoretically will not be over extended. Also, if there is the opportunity for future work, a team that has been hired to animate only a segment of the project this time may work extra hard to impress the producer in hopes of getting all of their next show. The negative is that there may be inconsistencies between studios in terms of how the final product looks. In this case, it is the responsibility of the producer to be sure that materials and as much information as possible is shared between the groups. Sending material between studios for reference is one way to address this issue. Another method is for the director or overseas supervisor to visit with both studios on a regular basis to check the materials and pass on information.

Finally, an important issue to consider is cultural sensitivities towards certain materials when choosing a studio. In most cases it is not an issue, especially when it comes to children's programming. It may be a problem, however, if you find yourself working on a more adult-oriented project. On one of the late-night television series that I (Catherine) produced, a couple of episodes included some minor nudity. Although the subcontracting studio had only worked on children's programming up to this point, their sales representative told me that the content would not make any difference to the crew. Prior to finalizing the deal, I took the time to show the studio representative the main models, bible, and scripts, and discussed the types of stories we were telling. Once again, he assured me that he had checked with the studio and that it wouldn't be a problem. They were all very excited about being a part of our project, I was told.

Several weeks later, the director and I went to Korea to hand out the show. We had a large group of people waiting for us at the handout meeting, including all of the studio's department heads, the studio's director for the show, and the president of the company. This handout meeting was unlike any I had attended and I knew that something was wrong. We spent a mere four hours going over the series as a whole, a process that can sometimes last days. Also, normally in a handout meeting there is a charged atmosphere in the room, a constant back and forth of questions being asked and answered so that everyone is clear as to the director's vision. In the case of this studio, however, the room was dead silent. It seemed there was little or no enthusiasm for the project. To make ourselves feel better, the director and I assumed that the studio's personnel were very shy or possibly nervous because the president was present.

After the meeting ended, the president invited us out for dinner. Relieved that we were maybe going to get some answers on what was happening, we quickly accepted. During dinner we discussed a range of topics that had nothing to do with our production. Since it is usually the way in the Far East to avoid topics of business up front, I waited patiently. As we were leaving the restaurant, the president told me that his staff was very concerned about the content of the show. He also said that none of the women in his studio would be able to work on the project. This was a big problem given that the entire ink and paint department was made up of women. I told him that I was confused and that we were assured by his point person in LA that the show was something his studio was very happy to handle. It was a very awkward moment for everyone. He said that they would be willing to work on it; however, he said he would maybe need to find another studio to help him out. This suggestion meant to me that he would probably subcontract our work to another subcontractor.

That evening I made the decision to find another studio to handle the project. The next day the director and I returned to the studio, packed up all of our materials, and prepared them for shipment to another production

house. Although I thought I had covered all of my bases, I had not antici-
pated that the studio would not have been informed about the content of
our show. When I returned to the US, I let the studio's point person know
that I was very disappointed with his misrepresentation. I believe he was
only concerned about getting his commission and had failed to communicate
the pertinent information to the studio he was representing, ultimately put-
ting all of us in an uncomfortable position and endangering the delivery of
our show.

Negotiating the Deal

After you select your subcontractor, the next step is to negotiate a deal.
Working with the business affairs office, the studio's production executive
or the producer negotiates a deal. In our experience, at larger studios, the
production executive is usually responsible for handling overseas deals.
By handling the contractual agreements for the studio as a whole, these ex-
ecutives can get better deals by negotiating in bulk. In those studios where
this is not the case, the producer usually handles the actual negotiations but
keeps business affairs or legal in the loop, as they will be responsible for
preparing contracts and dealing with any litigation issues should they
arise.

When negotiating, the producer needs to establish the following areas:

1. **The subcontractor's scope of responsibilities.** This includes the exact
 elements they will be responsible for producing as well as their delivery
 format.
2. **Production elements from the producer**. This includes the artwork and
 various materials the producer and domestic studio are expected to
 provide. (Such items will be discussed later in this chapter.)
3. **A schedule.** The schedule should outline the projected shipments (date
 and amount of footage) from the producer to the subcontractor as well
 as projected shipments from the subcontractor to the producer. Both do-
 mestic and overseas holidays should be accounted for in the schedule.
4. **Fees.** For television series and direct-to-video projects, the fee is gen-
 erally all-inclusive and is based on the length of the show. Feature pro-
 ducers generally negotiate deals on a per-footage basis based on the
 work being outsourced.
5. **Fees for changes/fees for creative retakes.** For more information, see
 the "Receiving Material from the Subcontractor" section later in this
 chapter.
6. **Bonuses.** Negotiating bonuses for on-time delivery is always a good
 way to help ensure you will meet your delivery dates.

7. **Approval stages.** It needs to be established at what stage elements will be reviewed by the producer and/or director for comments before they are considered final. Also to be included is the format on which the project will be delivered (that is, T1 lines, tape, or film).

8. **Terminology.** Ensure that all parties have the same understanding of the terminology used for the various job categories. For example, the title "key assistant" may not have the same meaning for the domestic studio as it does for the subcontracting studio. (For more information, see Chapter 9, "Production.")

9. **Payment schedule.** For series and video productions, it is common practice to pay 50 percent upon shipment of the materials package, 25 percent upon producer's receipt of first color, and 25 percent upon producer's receipt of all retakes and final color. On a feature, the subcontractor is not paid until the director approves the scene. In this case, there is typically an allowance of one or two revisions on a given scene.

10. **Talent.** It is helpful to establish in writing the level of talent agreed to, along with any key artists to be assigned to the project.

11. **CGI elements.** In the case when there are CGI elements to be produced by the subcontractor (for example, 3D props or digital effects such as rain), the number and/or description of elements should be included.

12. **Qualitative expectations.** Referencing a project of similar production value is one way of addressing that production quality standards are understood up front. The average number of drawings per foot or per episode should also be spelled out so quality is consistent across the board. It is important to be clear as to what your expectations are (for example, if characters are off model or the animation is much more limited than originally bargained for, then retakes will be called).

13. **Travel.** Establish who will be responsible for the cost of the subcontractor's travel, if applicable.

14. **Shipment of materials.** Establish which parties will pay for duties and shipping costs. Generally, the outbound party is responsible for the shipping costs. The receiving party is responsible for their country's customs fees. Final elements (such as original drawings, backgrounds, and so on) are covered by the producer and shipped via boat back to the US. If specialized art supplies are requested, determine who will be the responsible party for purchasing and shipping the items.

15. **Communication and decision making.** Set up point people at each studio for communication and decision-making authority. If video conferencing is to be used, establish who is responsible for the costs.

16. **Exchange rate.** Since exchange rates can fluctuate over the course of a production, it is helpful to define a rate or range the currency can increase or drop to.
17. **Production reports.** Establish when and to whom production reports should be sent.
18. **Title sequence.** If there is a title sequence being handled by the subcontractor, outline fees and any other applicable information.
19. **Technology.** It is important to be clear about what the technical requirements are in terms of hardware and software. Systems must be compatible. If there are any purchases required for the project, it may be useful to clarify who the responsible party is for these costs.
20. **Credit.** Clarify how credits will be handled and placed. On television projects where the credit time and space is limited, it is customary to credit the studio and key artists or department heads. On direct-to-video and feature projects, typically, all members of the crew are accorded credit.

When setting up a deal with a subcontractor, it is important to provide yourself with an option to withdraw the contract should the subcontractor not perform up to par. A few years ago, I (Zahra) worked on a feature film where approximately 600 feet (or almost 7 minutes) were set aside for special effects work by a subcontracting studio. We had selected this particular group since they had done an excellent job on another production and came highly recommended. In order to acquaint the subcontracting studio with the show, we flew in the studio head and the production manager to our studio for a handout meeting. Right from the start, however, we ran into problems. The first order of business was to set up a meeting for the director and the studio head to meet and go through the artwork. Though we had specifically organized the trip for this purpose, the subcontractor's studio head showed up to the meeting very late. Without any apologies for keeping everyone waiting, he sat back in his chair and promptly nodded off. I had been warned that he was not the easiest person to work with, but that his work was worth all the hassle. Attributing his behavior to jet lag, we decided to set up another meeting for the handout. At the following meeting, the director discussed her specific needs for the sequence and the subcontractor's studio head listened without asking any questions. Again, his lack of response was alarming, but we decided to move forward anyway since we had gone this far and were assured this studio was worth the effort. I next met with the production manager and informed him of the weekly quotas expected from his studio. I also reviewed with him our required weekly progress chart so that we could track the status of the scenes. The production manager seemed to understand what I was requesting and was eager to fulfill his new responsibilities.

For a number of weeks, I contacted the studio production manager to follow up on the status of production. Every time we spoke, however, there was a new excuse as to why the work was not ready. To be fair, it should be noted that we had made revisions on some of the material they had received and asked them to hold off on working on those specific sections. Yet there were plenty of other scenes they could have started on. Nevertheless, weeks went by and they were not producing any footage. Finally, scenes started trickling in one by one, but the work was substandard. I contacted the studio head to find out what could be done to speed up and improve their output and fix the problematic scenes. His response was that he was a far superior director to the director on the project and that he was fulfilling his promise to work on the show only as a favor to our production executive. Clearly, they did not have any interest in producing their best work on our show. I had no choice but to share this information with the production executive and the legal department. Given that we were not happy with their work and they did not want to work on the project, it seem that voiding the contract was our only choice. But to take the step to withdraw the work from the subcontracting studio was unprecedented. Getting familiarized with a show and establishing a relationship takes time, and finding another studio with such a great reputation made us think twice about switching teams.

Rather than taking such drastic measures, we decided to send a production staff to their studio in the hopes that we could save the relationship and continue working together. The effort was futile. Our director became increasingly impatient with the poor quality of artwork sent to us and asked if it would be possible to find another studio. Having lost too many weeks and a substantial sum of money, I had to research alternate production houses and spread the work to two studios in order to make up for the lost time. Once we informed the subcontracting studio to let them know that we had decided to withdraw the work from them, they were genuinely shocked. Luckily, we were very careful to set up the contract with terms that clearly stated approval of their work as key to their continued employment on the project. We were able to break the deal without any legal or financial repercussions. As a final note, I should add that we did manage to place the work in another special effects house that had just been started by a former colleague. They did magnificent work at a substantially lower price. This is all to say that if you see signs from the start that a relationship is going to be rocky, don't be timid about researching and finding new subcontractors.

Overseas Supervisors

The overseas supervisor functions as the liaison between the domestic studio (that is, the director) and the subcontracting studio. Often working through interpreters, the overseas supervisor's job is to ensure that the proj-

ect is being produced at the level expected by the domestic studio. If the overseas supervisor feels that there are problems with the project or potential schedule delays, it is his or her job to inform the producer and director as soon as possible.

Not every project can afford an overseas supervisor. It is customary for the producer to pay for housing, business class transportation, a competitive salary, and daily per-diem. As such, it is important to hire a competent person to handle the wide varieties of responsibilities entailed in this role. Before you make the decision to hire a supervisor, assess whether it is a necessity for your production or not. In many cases, the personnel and talent at subcontracting studios are very qualified and accustomed to working directly with the domestic studios. Unless it is a first-time studio or a very special project, it may not be worth spending the money. The reason we mention this is that it is very hard to find good supervisors with all of the necessary credentials. If you do feel that it is in the best interest of the project to have a representative on site, there are certain qualifications that are necessary for the role.

First and foremost, it is crucial to hire a supervisor who has strong people skills. They must be a team player and culturally aware. It is their job to get the most out of the producing team. They should therefore be flexible and sensitive in handling the many individuals and issues that they will inevitably encounter. It is important to keep in mind that subcontracting studios typically dislike having a supervisor in-house. Therefore, the person hired must be able to effectively ingratiate their staff. The supervisor must have an extensive technical background in animation production. Since they will be working with experienced directors and department heads, it is essential for the overseas supervisor to have a working knowledge of all aspects of production. If the supervisor is weak in the fundamentals of animation, it will quickly become apparent and the subcontracting team will not have the level of respect necessary for the supervisor to be effective. The producer and director will also not be well served since the supervisor may not catch all of the mistakes and fix them.

On higher-budget projects, there may be several supervisors sent to the subcontracting studio to review artwork (for example, a layout supervisor, animation supervisor, and clean up supervisor). In most cases, however, there is only one supervisor. The supervisor's job is to review scenes on a daily basis from all departments, knowing which areas of the show require extra attention and potentially have to be prioritized for promotional purposes. When the right person is cast for this role, they can be a tremendous asset for both the domestic and the subcontracting studios.

Overseas supervisors must also be good communicators. It is their job to answer a variety of questions on topics ranging from creative and technical to cultural issues. For example, a supervisor can bring to life the comedy in the project by explaining why it is considered funny and performing

the parts for the crew. Given that comedy is very much culturally based, the supervisor on such projects plays an intrinsic role in ensuring it is understood by all. They are responsible for staying in constant communication with the project's director, especially when it comes to making creative judgment calls. Since they are the director's eyes and ears, the supervisor needs to discuss all creative decisions with the director, especially if the supervisor is not clear on how the director would handle a question. We have had problems in the past with overseas supervisors forgetting this very important point. They have independently made creative decisions that the subcontracting studio has followed. However, after the work has been seen by the director, retakes have been called completely opposing the supervisor's instructions. Such retakes send a mixed and confusing message to the show's crew and ultimately undermine the role of the supervisor. Given that the director's representative made this decision, the subcontracting studio has the right to charge for the retake.

Material Packages/Shipments

The key to working with a subcontractor is clear, concise communication and information on the part of the producer and director. In our experience, with the exception of a few studios, if the material shipped is not solid, you will get equally weak if not weaker material back. Likewise, if a pre-production package sent out for animation is organized, well thought out, and contains all necessary elements, chances are the quality of the film or video produced will reflect this original package. It is thus a good idea to have a continuity checker or an animation checker go through all the elements to ensure that everything is consistent, hooks up, and is easily understood. Although the director approves all items being shipped, it helps to have a checker review all the material to catch any possible problems that could hinder production. More often than not, the producer and director may miss important elements since they are already so familiar with the show.

Depending on the material to be produced by the subcontractor, a producer should include some or all of the following elements. (The number of copies to be included in each shipment is determined by the producer and subcontracting studio.)

- Script
- Storyboard
- Main model pack (visual style guide)
- Episode/sequence model packages
- Model color keys
- Background layout keys (black and white artwork)
- Background (BG) keys (color paintings)

- Digital audio tape (DAT) or mag track (whichever format is applicable)
- Audio cassettes
- Story reel
- Exposure sheets
- Videotape of director going through the sequence or episode and discussing the specific needs for each scene
- Reference materials (books, videos)
- Route sheets (a summary of each scene, its length, applicable camera movements, EFX shots, and color styling information along with names of staff members overseeing the work)
- Shipping list
- Commercial invoices

Subcontractors usually have a preferred shipping company that functions as their main carrier service. The producer should contact the selected shipping company and set up an account. It is a good idea once a shipping company is chosen to call and find out how long it will take to get packages to and from the subcontractor. When creating a schedule, it is important to remember to factor in clearing customs and delivery of materials. Items such as the Mag track tend to take longer in customs and therefore should be shipped separately. Also, time zone differences must be taken into account. It is always possible that the package will not be received on the same day that it is due in the country. Keep in mind that in post-production, one day or even hours can be critical. It is therefore necessary to build in some additional time in the schedule to account for unpredictable delays.

When a shipment is sent, shipping documentation needs to be filled out outlining the contents of the package, the receiver, and the value of the enclosed materials. Each shipping company will have its own individual paperwork and forms. For the return of materials, the producer needs to communicate exactly where and how they expect the elements to be shipped. The producer must also hire a customs broker. The customs broker will be responsible for clearing all materials through customs and paying any necessary duties. Prior to clearing any materials, the customs broker needs to set up a bond on behalf of the producer. This bond is a requirement of the federal customs authority. It can take some time and therefore should be handled well in advance of materials being shipped by the subcontractor.

Handing Out the Project

At the beginning of a new production, the project's director and producer should visit the subcontracting studio to hold a handout meeting and set up the overseas supervisor if one is on the project. This is an opportunity for all of the subcontractor's key personnel, including directors and department

heads, to ask questions. Depending on the scope of the production, this meeting can take as little as one day or as much as a week. If the director is not able to travel, he or she can videotape instructions and send them with the shipment. On series production, if there is a supervisor hired, he or she would be responsible for holding handout sessions each time a new episode is received. One other method of handing out a project or getting the production team prepared is to have lead artists visit the domestic studio. This visit allows them to spend time with the crew and familiarize themselves with the project prior to it shipping. Another department that commonly requires a trip is background painting. It is helpful for painters to communicate in person so that everyone is on the same page regarding techniques and art direction.

Monitoring the Progress of Production

Once the production gets started, it is essential that the producer or their production manager closely monitor its progress by establishing a system of weekly reports on a per-episode or footage/quota basis. (See Chapter 11, "Tracking Production," for a sample report.) These reports will help the producer identify whether an episode is behind schedule. Weekly or bi-weekly phone calls are also important. It can be challenging sometimes if the communication is handled through translators, as some information can get confused or lost through the wires. Although e-mail and fax communication is helpful, a visit during production is very beneficial. We have found that much more information is gained from an "in-person" visit versus communication through the telephone or fax. Creative or technical questions that may have been difficult to articulate over the phone can get resolved much more quickly in person.

Receiving Material from the Subcontractor

Once the film is returned, it is the job of the producer and the director to review it for retakes. There are two types of retakes: technical and creative. A technical retake is, for example, an ink and paint or camera mistake. The subcontractor is responsible for this type of retake and must fix the scene at no charge to the producer. A creative retake is a change that the producer or the director request that is not consistent with the materials previously sent and completed by the subcontractor. They may have asked for the character to walk but upon viewing the pencil test decide that they would prefer to see the character jumping, and therefore new animation is required. In this case, the subcontractor will bill the producer for the changes accordingly. After the film has been viewed, a retake list is sent to the subcontractor. The list must be accurate and succinct, especially when it may require translation. Whenever possible, it is useful to include illustrations with the retake notes.

It is also customary to include information on whether the retake is considered to be creative or technical. By taking this last step, you can avoid many headaches when the subcontractor sends you the final bill. You want to be sure that nothing gets confused, allowing for the best shot at getting a perfect scene back. A scene may go through several retakes until it is approved. During the retake process, the producer needs to make sure that revisions are methodically tracked. Sometimes there may be as little as 10 percent fix on a project, or it may be as high as 100 percent. In most series, there will also be several episodes going through this stage at the same time. It is therefore very challenging to keep everything organized to ensure that each and every final scene placed in the show is approved. Please note that the production manager (along with the editor) usually tracks retakes. (See Chapter 11, "Tracking Production," for a sample retake chart.)

Expect the Unexpected

Film gets lost or held up in customs, supervisors quit, or studios can burn down. Be prepared! Early on, while working as a production executive in charge of international production at one of the major studios, I (Catherine) learned to have the philosophy to expect the unexpected. In this role, I had to select the overseas facilities that best suited the style of our shows. (The studio was producing over 100 half hours of episodic television shows a year along with several made-for-television movies and specials.) Alongside the television production, I was also overseeing the ink and paint portion of a feature film at this Far East studio.

Before I started, there were extensive management changes taking place at the studio, and no one had been attending to the international aspects of the business. When I began the job, most of the projects for the upcoming season were only weeks from being shipped abroad and yet did not have any subcontracting studio lined up for production. We were also having personnel problems at the Far East studio that were interrupting the flow of production. One supervisor was not getting along with the head of the studio and another was threatening to quit unless he got a raise. Our studio was one of the largest in Asia and needed to have significant amounts of product flowing through it to be cost effective. The problem, however, was that several of the shows we were producing domestically were best cast for production in another Asian country given their style of animation. Although there was some work available to send them, we needed to find projects from other studios to keep all of the staff working since it was illegal to lay people off.

I found myself constantly on the go. Traveling all over Asia and Australia to set up the production season I also had to check on projects already in progress and handle the various issues I came across at every studio I visited. It seemed that for every problem I solved, several others cropped up

and I had to hop back on a plane and deal with another issue. In one case, a subcontractor felt they had been promised a certain amount of work from our studio on a yearly basis and was threatening to sue if we didn't deliver. No one in the present management team was aware of this deal. I began to wonder what I had gotten myself into.

After several months of craziness, many of the issues were finally addressed and it seemed that the season had begun to fall into place. I started to feel confident that everything was going to work out for the best. Within a week, this sense of security quickly collapsed when my boss called me into his office. He was on the phone with the head of the Far East studio getting an up-to-the-minute report on how the facility was burning down. At first I thought he was kidding. Fortunately, the fire took place in the middle of the night and no one was hurt. Needless to say, however, we needed an immediate assessment of the damage caused by the fire and status of all the works in progress. It was impossible to wrap my brain around this turn of events. I had just gotten work flowing through the Far East production facility from our studio as well as work from various outside groups. All of the personnel issues had been handled, the feature was finally up and running after several difficult starts, how could this be?

Within 24 hours, I was back on a plane to assess the damage in person. Luckily, the entire facility did not end up burning down, only a portion of it. The problem was that the studio itself needed to be rebuilt due to structural problems caused by the fire. We had to find a temporary location to set up and get everyone working again, as it was the height of the season and we had little time to waste. As luck would have it, the head of the studio was well connected and able to find space and relocate the staff quickly. A significant amount of work had been destroyed, including almost everything produced on the feature as well as work we were producing for outside studios. While we knew we had to somehow deal with schedule delays, the challenge came when we realized that most of the art supplies for the season were damaged. This included the specialized materials required by the feature group that had been imported from the US. The amount of paint needed was very large and had to be specially made to match our palette. Shipping could take months, and even if we shipped the materials, they would often end up sitting in customs for weeks at a time due to government bureaucracy. In order to deal with this, we began a series of hand carries. Every few days a different person from the studio flew over with materials. Thanks to a tremendous effort on the part of many people, especially the head of the studio, within three weeks we managed to get the studio up and running with enough supplies to begin production. After this experience, nothing I came across could really faze me.

PRE-PRODUCTION

The Role of the Producer During the Pre-Production Phase

As a producer, if you have reached this phase in the process, you should be patting yourself on the back. It is a huge achievement to get a project green-lit, meaning all the funds are in place and you have the go-ahead from the buyer to produce the show. You have made it through some of the toughest hurdles and now the fun begins with pre-production. Pre-production is the phase in which the elements that lay down the foundation for the production are assembled. Whether a production goes smoothly or not depends on how the producer procures the key ingredients at this juncture. (See Figure 2–1, The Producer's Thinking Map, for reference.) The following is a list of all the items necessary in order to begin pre-production:

- A final script (for television series, specials, direct-to-video projects, and approved sequences for features)
- The series bible (and at least three final scripts for a series)
- Conceptual artwork
- An approved budget and schedule (See Chapter 6, "The Production Plan," for more information on budgeting and scheduling.)
- A summary of assumptions (See Chapter 6, "The Production Plan," for a list of assumptions.)
- The crew plan (See Chapter 6, "The Production Plan," for more information on crew plans.)

Now, the producer's task is to recruit a crew. As the production is geared up for new employees, the producer begins to delegate duties to his or her administrative staff. For producers who have limited resources for a

support staff, prioritizing their daily goals in accordance with the production's needs is essential.

There never seems to be enough hours in a day to produce a show, let alone make sure that every new employee is taken care of. But facilitating the crew has to be a top priority for the producer. Working with operations or the office manager, it is the producer's job to ensure that space, equipment, and supplies are ready for each person when they start. The production crew is responsible for getting all the applicable material, such as script(s) and artwork, for the artists. It is also essential to establish a system to inform the staff about who is starting on what date. These small details make a big difference to the individual joining the team. Although this information seems obvious, it is all too often overlooked. Items to consider when preparing for the arrival of a new employee include an informal meet-and-greet with the producer and director. This meeting serves as an opportunity to welcome the new employee and tell him or her the status and goals of the project. Other details to organize for new employees include start-up paperwork, assignment handouts, a studio tour, instructions on telephone use, a parking pass, and identification (if applicable). First impressions count so it is important for a production to work like a well-oiled machine by both facilitating the new staff and also setting up the standard of expectations.

While doing everything possible to make sure that a production is on course, another equally important role for the producer is that of creating a link between the project and the ancillary groups. Unless these departments (publicity, advertising, promotions, and consumer products) are on board with the show, its degree of success once it has been completed can be limited. It is therefore critical for the producer to meet with the ancillary groups early in the production process and then on an ongoing basis. The purpose of these meetings is to update individuals on the status of the project and provide them with information that may be helpful to them, including story, character and location design, color artwork, and voice and musical talent, especially if stars are attached to the project.

As pre-production ramps up, the producer and production manager begin to track all of the artwork created. The producer devises a master schedule before the start of pre-production, which he or she uses to create detailed department micro-schedules. Areas scheduled in this manner on episodic television, for example, include designs, storyboards, casting, recording sessions, song sessions (if applicable), color models, and background keys. These schedules aid in tracking, planning quotas, and projecting the length of time needed to produce each element. (See Chapter 11, "Tracking Production," for more information on scheduling.)

Before the production gets too far underway, the producer and director hold a kickoff meeting. The purpose of this meeting is to communicate the creative and administrative goals of the production. The producer and director let everyone know what their expectations are and how they intend

to reach their goals. The crew also gets the chance to ask questions. A kick-off meeting is a great opportunity to harness everyone's enthusiasm and get the project started on the right foot. Crew meetings should be ongoing throughout pre-production to keep everyone informed and on board with the project. Keeping the team enthused is key, especially when a project gets derailed by revisions and the workload is increased.

As pre-production begins to flow, it is the producer's role to ensure that the buyer gives their input on the various elements produced before they get too far into the process and it becomes too cost prohibitive to change. Creative checkpoints as established in Chapter 6, "The Production Plan," must therefore already be established in order to allow for this feedback. The buyer commonly has input on all key elements, including voice casting, the voice track, all main character and location designs (in black-and-white line drawing and in color), the storyboard, and/or story reel. The storyboard may be viewed as either rough or cleaned up artwork depending on the experience of the buyer. (Storyboarding and story reels are discussed in greater detail later in the chapter.) If the buyer requests significant changes, they may need to have a second review of the materials. If they are satisfied with the work, the producer will only need to communicate that the changes are being handled. When revisions are not being dealt with per the buyer's requests, the producer's relationship with the buyer can quickly get off track as the trust between the two groups erodes.

This was the case on a project I (Catherine) was involved in. I was hired by a buyer who had no previous animation experience to act as the producer on their first animated series. Early into pre-production, we were forced to break our contract with the animation studio the buyer had chosen to produce the project. The primary reason was that the director and creator did not share the same vision for the show. At the same time, the buyer had been assured the studio could attract top talent. Recruiting efforts, however, had been anemic at best, and only a very skeletal crew was in place. The talent that was on board, however, was not versed in the graphic realistic style of our show. Another important reason that led us to void the contract was our discovery that the studio was, in fact, not equipped to handle a large-scale production. The facility itself was still under construction and the crew was forced to work in a cramped location that was not conducive to creativity. The working area also hindered recruiting efforts given that competing studios were spending significant dollars on designing attractive office spaces. The final issue that forced this decision was that materials delivered for our review were late, and, more importantly, were not at the level of quality promised. Every sign indicated that a mistake had been made in the studio selection and the situation was unlikely to improve in the near future.

It was left up to me to find an alternative studio or set up one on my own in order to keep the project alive. The buyer made it abundantly clear that they didn't want to spend any more money and that the schedule could

not be extended much beyond the original plan. I knew that if the project did not find a home in a very short period of time, it would be shut down. At the time, my choices were very limited. I knew the graphic style of the show required unique talent that was not easy to find in every studio. At the same time, a number of feature animation studios were paying top dollar to staff up their multi-million-dollar productions. Although it was a very challenging proposition, I opted to set up a studio from scratch. I felt that the project I was producing was one of the first of its kind and would therefore naturally attract strong talent, and as such I was willing to take the risk. My biggest task was to ensure that all of the problems we encountered with the first studio were addressed promptly or we would find ourselves in the same position again. I had a matter of weeks to find a location, have animation desks built, hire a director, and assemble a full pre-production team.

Fortunately, I already had a small hardworking administrative crew hired on the project who were enthusiastic about this new challenge. I refocused their efforts from the production itself to helping me create a studio. Almost immediately, we found a location in the building where we had been working. We were lucky since it was Christmas, a quiet time in the construction business, and we were able to find a reliable and efficient contractor. We quickly began some minor construction to make the space usable as a studio. After the location was found, everything else began to fall into place. A director whom I had been in communication with for several months suddenly became available. His background was perfect for the project, and, more importantly, he had a congruous vision with the creator. He eagerly signed on and joined our new studio. Once that happened, we started recruiting talent and began putting a team in place.

Although I love shopping, in the case of the studio, it was a daunting task in that I had to find and purchase every item necessary for a running studio on a very strict budget and in very little time. After some extensive research, we found a carpenter who built animation desks. We also found a number of animation suppliers who provided us with items such as light boards and tables, a pencil test machine, and an avid. My production manager and I visited IKEA, which luckily was having a sale. We got all the office supplies you could imagine, from clocks to office chairs and bookshelves. It was an intense time and I found myself dreaming at night about garbage cans, and woke up panicked that we didn't have enough for every employee. It was, however, a very exciting experience. Everyone involved was enthused about being a part of a start-up studio and did all that they could to make it a functioning team. After just six weeks of preparation, we had a small pre-production studio in place and we were ready to begin the project.

The first challenge we faced was that we were behind schedule before we even started. We were told to use as much of the existing artwork produced at the original studio in order to save money. Starting pre-production without a visual style guide and well-established art direction in place was

a risky proposition, but to keep the show going forward, I agreed to these cost-saving measures. Unfortunately, these key missing materials had a ripple effect on the entire project. Given that the original artwork did not work, many of the elements being produced had to be held back as the style became solidified. Thanks to these delays, the "on-hold" elements got us further behind schedule, which forced the artists to work overtime to catch up. Despite all our efforts to recycle artwork, in the end, most of the original artwork was discarded.

Another problem we faced was that only two final scripts were ready for storyboarding. The buyer was responsible for delivering scripts but was struggling to meet deadlines, yet unwilling to extend the schedule. We therefore found ourselves in the difficult position of trying to implement rewrites into final pre-production materials that in most cases were ready for shipment. Our shipment dates could not be altered since we had already cut too much time out of the overseas production schedule. We had no choice but to re-record lines of dialogue and revise the animatics and the show's timing. Models that had been finalized and were already in color had to be revisited. We had to re-do months of work in a very short time in order to meet our schedule and ultimately our air dates. It was a costly endeavor as the artists had to put in significant hours of overtime to accomplish these revisions. Although we were attempting to save money on the front end, essentially it cost us on the back end in wasted artwork and lost time. All of the revisions were not budgeted for, and although I did everything possible to avoid it, the buyer was forced to pay some overages.

In many cases, I believe that at this point in production, a crew would have become terribly frustrated and disillusioned. In order to ward this off, I drew from my experiences on other projects. I made sure that the environment within the studio was very artist friendly and mutually respectful between production management and talent. Each day I made a concerted effort to walk the floors and hear both the artist and production crew's concerns. I worked closely with my production manager to push the crew when necessary and to pull back and find alternatives to ease up the schedule when possible. Along with my director, I held monthly staff meetings to inform everyone about the direction we were taking as a studio and the achievements we had made on the shows to date. I encouraged the artists to make the studio their own and let them decorate it as they saw fit. What developed was a crew eager and willing to meet challenges by working together and getting beyond the rough spots. Everyone appreciated the opportunity to have a voice and felt respected. As a result, we had little trouble recruiting. Many artists turned down higher-paying positions at other studios to be a part of our team. In terms of the buyer, together we assessed the results of the decision to start before enough scripts were ready for production and the art direction was pinned down. Although it was an expensive lesson, in the end, everyone agreed that on future projects, we

needed to have all the elements prepared and approved prior to start of production.

Design and Art Direction

Next to having a solid story, the visual style of the project is the most important area for the producer to focus on. Since every element in an animated project needs to be designed and created by artists before it can be animated, it is crucial to allocate adequate time and money to seek out suitable talent. The strength of the show's design not only helps sell it, but also attracts artists to join the team and inspires them to do great work.

The look or design of a show is created through both line drawings and color images. The style of a show can vary from cartoony to realistic to highly stylized. It is the job of the production designer and/or art director to follow the director's guidelines and both lead and supervise the development of the stylistic choices for the project. On some projects, there are no strict differences between the roles of a production designer and an art director. On features, the distinction is typically that the production designer establishes the actual "look" of the film by creating character and locations designs. Their job is usually completed after they have established these main elements. The art director's role, on the other hand, is to take the design and apply it to film (that is, taking the location design and creating layouts). They also work with background artists and color stylists in order to devise a color palette for the project and carry it through on every scene. Depending on the production budget and its format, the art director may work with a handful of artists or have dedicated crews working on each element, such as character design, background painting, and color modeling, or in the case of a 3D CGI show, develop character and set models.

The design phase of a project can be its most exciting stage. It is the time to invent a new world and create characters that fit the part. Often on high-budget projects, the director, producer, production designer, art director, and key department supervisors (such as the background supervisor) travel to the location where the story takes place. The purpose of these trips is to explore and develop a more intimate understanding of the environment depicted in the show. By shooting videos and taking photographs, they attempt to capture the reality from which they create the imaginary world. On projects with limited budgets, the producer must make certain that enough funds are allocated for reference material so that the artists have access to books and videos when necessary.

In order to create the animated world, three design categories need to be developed: characters, props, and locations (or environments, as they are referred to in 3D CGI projects). Characters are divided into two sections: main and incidental. The primary actors in the story are called "main" and the

secondary actors are described as "incidental." Props are any non-character items that animate, such as a vehicle or a chair. Locations/environments are the actual places or sets that a scene takes place in.

From the onset, it is essential for the director and the producer to be in sync with regards to what kind of artwork best suits the project. One important issue that should be addressed at this stage involves the show's aesthetic requirements versus its budgetary limitations. For example, if a main character wears a costume that has intricate details such as lace and buttons, every scene in which they appear will require a lot of pencil mileage, or line work, in 2D projects, and additional development and render time in 3D projects. This is therefore the stage at which the producer must assess whether the additional time taken by this artistic choice merits the extra money and talent required. To decide this, the producer needs to make the following inquiries: What does the story gain by the complicated design? Will the show be stylistically flawed if a simpler costume is used? In the example provided, each scene that involves the character with a detailed costume will take a long time to complete, both in clean up animation and ink and paint (or texturing/lighting, in 3D CGI projects). Is there an adequate budget available? Together with the director, the producer must determine what is best for the show.

Using the script for reference, the production manager—or the art director's APM—highlights all elements to be developed and produces a design list. The purpose of this list is twofold. It notes the main designs for characters, props, and locations, which, once compiled, are referred to as the *visual style guide, main model pack*, or *stock model pack*. It is also used for generating drawings that are only needed for a specific film sequence or television episode. These drawings constitute what is described as a *model pack*. It is important to note that in the case of a project produced in CGI, the 2D design step is merely the first step in the modeling phase. (For more information on the additional pre-production steps required in 3D CGI, see Chapter 9, "Production.")

The Visual Style Guide

The visual style guide is created to convey basic design information to the entire crew on a production and to ensure the overall consistency of the project. Although it is time consuming and costly to create a comprehensive style guide, it can greatly enhance the project's production value. The more information artists have access to, the better they can delve into the imaginary world and bring out the best the story has to offer. Once the overall style of the project has been nailed down during development, a visual style guide is produced. Depending on the budget, the guide can be incredibly detailed or have just a few items. The producer and director work together to choose the items to be designed based on the story needs and budget

limitations. It is consequential for the producer to establish with the director the approximate amount of re-use or recycling of drawings expected on the production. In features, the rule of thumb for locations, for example, is 30 percent re-use. However, it all depends on the story. If, for example, the characters are on a journey, traveling from one land to another, it may not be possible to re-use locations. The producer therefore has to devote an appropriate dollar amount for the creation of locations/environments and painted backgrounds. This is a perfect example of why we stress the importance of the producer and director communicating and sharing the same vision for the project.

In order to illustrate how a story can be developed and adapted for an animated project, we selected a piece of poetry ("The Lion and the Beasts") from a book entitled *The Mathnawi of Jalalu'ddin Rumi*. For the purpose of this book, we have condensed the poem to its basic story line. Using this story line, our artist created conceptual, pre-production, and production elements wherever possible to illustrate these steps. The story goes something like this.

There once was a menacing lion who, in search of his meals, tormented all the other animals in the jungle. Chaos prevailed among the animals as one by one they fell prey to the lion. In order to put a stop to this daily terror, the animals made a proposition to the lion. "If you stop chasing, ambushing, and slaughtering us, in return, once a day, one of us will come to your den to be your meal," they offered. Excited by the thought that he would no longer have to go on hunting forays, the lion considered the idea and accepted it in good faith. This new system worked for all the animals and calm was restored in the jungle—until the day the rabbit was picked. The rabbit had no desire to sacrifice his life for the good of the others. Rather than go to the lion, the rabbit sat in his hole and debated what to do until he heard a commotion outside. The animals were very angry with him and knocked on his door until he came out. "How can you jeopardize all of our lives for your own safety?" they asked. The rabbit was stuck. If he refused to go, he would be picked apart by the other animals and delivered to the lion. Or, he could walk to the den and live a little longer. The rabbit, knowing that the end was near, had no choice but to follow orders. Reluctantly, he went to the lion's den.

Meanwhile, at the den, the lion was getting hungrier by the second. He was extremely upset that his meal was late. When the rabbit arrived, the lion growled and told him off for not being on time. The rabbit cowered in the corner and sheepishly explained that another lion, who was by far the most ferocious lion he had ever seen, detained him en route. "What? Show me to him," the lion roared back. The rabbit said that he would lead the way but that he was extremely afraid of seeing the other lion again. Acting all shaky and worried, the rabbit took the lion through the woods and pointed to a clearing. The lion stepped forward to view it and let out a loud roar. Before he was done with his roar, an even louder roar came back. The lion looked at the rabbit and

said, "I will show him who is king of the jungle." He moved closer to the clearing and looked down a well where he saw his own reflection in the water. Seeing the image of a fierce lion looking back at him, the lion jumped in the deep well and drowned. The rabbit returned to the jungle to tell everyone the good news. They celebrated his victory and called him a hero for finally getting rid of the lion.

As we noted in Chapter 5, "The Development Process," the first step in creating a style is conceptual artwork. Figures 8–1 and 8–2 show sample styles that were created in order to find the right look for our story.

It is important to note that on features, visual development artists first develop character designs. These designs are then further refined by character designers, and are finally solidified by the lead animators. Once the character designs are finalized and approved, it is customary to create a sculpture of the main models. These sculptures, also known as macquettes, are used as aides for animators. Depending on the software used and the style of the show, some 3D CG productions use the macquettes as the initial step to building the 3D model. In 2D, by having access to a three-dimensional model of the character, the animator can more easily draw any angle necessary. For television series, commercials, and shorts, character designers generate the designs. Included with main and incidental characters are special costumes.

The style guide typically includes a series of model sheets that cover the following areas for character design:

- Character poses (front, back, and three-quarter view; see Figure 8–3)
- Character in action (see Figure 8–4)
- Close-ups of character in differing emotional states (surprised, elated, angry, and so on; see Figure 8–4)
- Character lineup showing the scale of all characters in relation to each other (see Figure 8–3)
- Character's construction (basic shapes showing structure and details of the character's body parts; see Figure 8–2)
- Walk cycle (see Figure 8–5)
- Mouth chart (close-up of the character's mouth as it forms different sounds—for television and direct-to-video use only; see Figure 8–5)

Props

These non-character objects (such as vehicles, weapons, and furniture) are created by a prop designer. The style guide covers the following areas for props:

- The front, back, and interior (if applicable)
- Construction (if the prop has complex elements)
- Size comparison to character(s) and/or background layout
- Guidelines on how the prop works (if it is a complicated device)

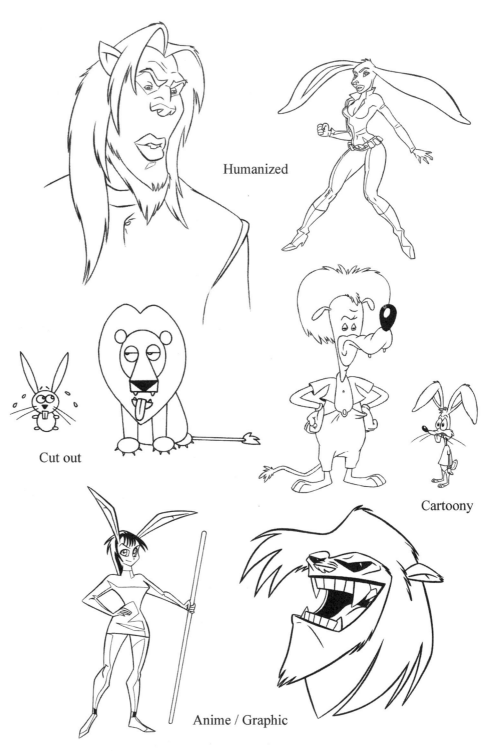

Humanized

Cut out

Cartoony

Anime / Graphic

Figure 8–1 Exploring Characters

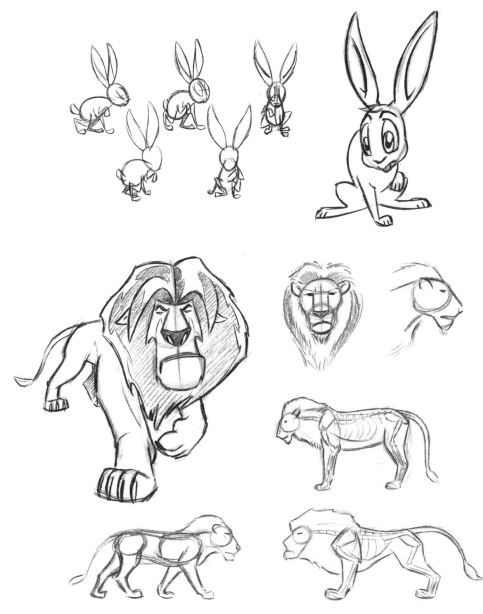

Figure 8–2 Conceptual to Final Design

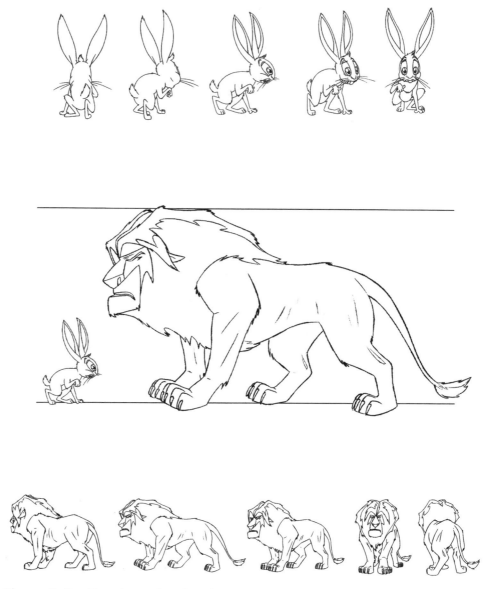

Figure 8–3 Turn Around and Scale Comparison

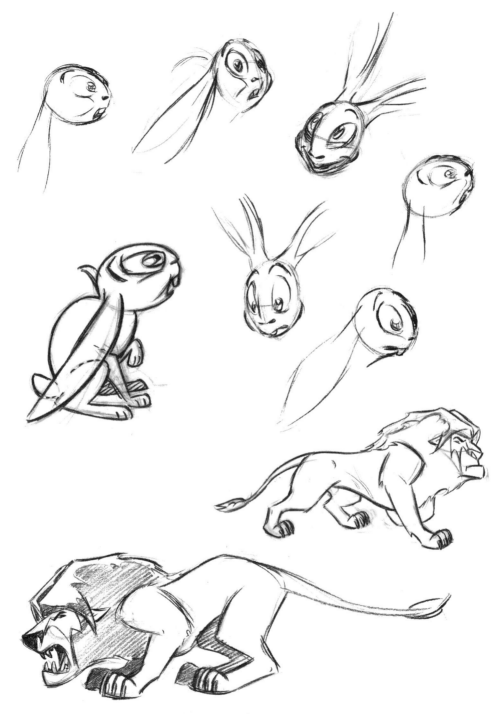

Figure 8–4 Character Expressions and Poses

Figure 8–5 Mouth Chart and Walk Cycle

Figure 8–6 Exterior Woods

Location/Environment Design

The world and settings that the character occupies are produced by the production designer or location designer. The style guide includes the following items for location designs:

- Exterior shots (including establishing such shots as well as close-ups)
- Interior shots
- Reverse-angle shots
- A "schematic map" of the overall setting or environment
- A lighting guide indicating source and direction of light

In Figure 8–6, our artist storyboarded a portion of the story and created a background using the first scene.

Painted Background and Background Keys

The lighting and mood of the imaginary world is achieved through color by the background painter. Key backgrounds function as the color guide for the project by establishing the nuances of the environment through lighting and by setting the tone for each sequence. On feature films, the art director selects key scenes in each sequence for color treatment in order to provide direction for the painters. For television series and direct-to-video projects, only a few backgrounds are selected for painting, which are then shipped

to the subcontracting studio in order to communicate the needs of the show. (For more detailed information on these steps, see Chapter 9, "Production.")

Color Styling

Under the guidance of the art director, characters and props are colored. In the case of character, the color of the costume, skin, and hair color is also set by the color stylist. Although digital ink and paint offers many options in terms of color, the most basic color palette shows the characters in daylight, at nighttime, and when they are wet. Using a painted background as guideline for the palette, the color stylist puts together a lineup of all characters in color. The purpose of the color lineup is to see how all the characters relate to each other and their environment in addition to developing visual themes (for example, all villains may be in tones of purples and browns, while the protagonist wears brighter colors). It is important to note that *color styling* is a term used for color design steps undertaken in 2D. *Texturing* or *surface color design* is the commonly used equivalent term for projects created in 3D CGI. (See Chapter 9, "Production," for 3D CGI pre-production steps.)

Model Pack

After the visual style guide is created, further model packages are created on a per-sequence basis for long-form projects or a per-episode basis for television. These packages include additional main characters, incidental characters, props, and locations specific to the particular sequence or episode. As in the visual style guide, the degree to which designs are fleshed out depends on their importance to the story and the budget. In some cases, there may only be a front and back design for a character, while other characters would have additional drawings, including body poses and emotional expressions, for example.

The production manager or APM of art direction is responsible for prioritizing the order of assignments for the artists and tracking the artwork. They manage the design schedule with the artists to ensure the artwork is being handed in on time and reviewed by the director for notes. When the director asks for changes or additions, the production manager/APM evaluates its impact on the schedule and informs the producer. Every time there is a revision to the script, the design list and model package is updated to reflect these changes on characters, props, and locations. If the model pack has been distributed, all newly revised designs need to be replaced in the model pack. In television, generally speaking, these packs are "locked" and aren't changed once they are shipped to the subcontractor. Although it is highly advisable to complete all visual development prior to start of production, on features, designs tend to evolve alongside production. For this

reason, the producer has to budget and schedule for the design elements accordingly. It is a tricky area, however, because unless the designs are finalized, animation on the scenes can't get started, and when revisions and/or additions are made, the consequences can be severe.

On a feature project that we both worked on, the creative executives decided that placing a small blanket on a character who was ill and close to death would create more sympathy for her plight. The character was a main character and was therefore in a significant number of scenes. At the time this change came through the pipeline, 50 percent of the scenes with this character had been animated and were at various stages in the production process. Another 25 percent had made it through ink and paint. Those scenes in ink and paint had to be pulled all the way back to clean up animation and go through the entire pipeline again. Scenes at other stages of animation also had to have the blanket added and go through all of the production steps. This took up a great deal of time. We added up the number of drawings that were affected and estimated that over 3,750 drawings needed to have the blanket inserted. This addition made a significant amount of overtime necessary in order to avoid further delays. After having been through this experience, it made it clear to us that no one had fully thought through the implications of this change. Had the design been added earlier, much of the wasted time and effort could have been avoided.

The Voice Track

The right choice of actors during casting, combined with a great performance during the recording, are two of the most critical steps in the production process. Since the voice track serves as a guideline and a source of inspiration for the animators, if it's weak, not even the best animators can produce good performances. The animation, timing, and overall success of the project, therefore, hinge on the quality of the voice track.

Casting

Casting is the process by which actors are chosen to play parts on the project. Unlike in live action, actors are not seen by the audience, only heard. It is the producer's job to determine the casting expectations of the buyer/executive, seller (or creator), and director in order to focus the process in the right direction from the start. When stars are attached, their names can be used as a marketing tool. It therefore needs to be established whether the project can afford them and wants to pursue them. Prior to the start of casting, it must be decided whether the production is going to be union (that is, Screen Actors Guild [SAG]) or non-union. If the show is non-union, casting choices can be limited. Most professional actors are union members

and are prohibited by SAG or any other acting union from working on non-union shows.

Casting begins when a casting director is hired onto a project. Large studios usually have their own in-house casting department. On the other hand, smaller studios tend to hire a casting director on a freelance and per-project basis. It is the producer's job to share with the casting director the amount of money and time allotted for casting sessions (auditions), the rehearsal of the script, and the recording of the voice track. Armed with information on the time and fiscal boundaries of the project, the casting director works with the producer, director, and creative executives to come up with a list of potential talent to audition. A brainstorming session takes place at which everyone suggests ideas for talent based on the characters to be cast. It is typical to refer to "like" types. (An example of this would be "like Woody Allen in *Antz*.") At these sessions, reference artwork is helpful for inspiration. Following the creators' and/or directors' prerequisites for the voice talents, the casting director begins the search for actors.

Once a list has been made, the casting director reviews his or her inventory of CDs or talent cassettes, contacts his or her roster of agents, and researches the availability and interest of the talent to audition for the part. The casting director also asks about other actors represented by the agent who may be appropriate for the project. If the voice actor is not someone the casting director is familiar with, the agent submits sample tapes to review before including him or her in the casting session. Agents are more than happy to send out materials. In fact, it may be necessary to limit the number of actors they can submit. On occasion, the casting director sends scripts or sides to agents to ask actors to record an initial audition at the agency. Most established agencies have small recording booths set up just for this purpose. This pre-screening process gives the casting director a sense of whether the actor is the right type without having to spend the time and money for a studio audition.

In cases when a star talent is being considered for a role, the casting director has the careful balancing act of timing when this information gets communicated to the agents. Some star talent will not audition for animation. This talent is called "offer only." As a result, if a phone call is made to the agent and the actor is interested, the creative team must be willing to greenlight the actor without hearing him or her. Most experienced casting directors know who will and will not read for them. In such cases, the casting director can pull previous work together on an audio cassette for the producer, buyer, and director to listen to for reference. Everyone including the casting director, voice director (if applicable), buyer/executive, director, and producer should be completely in sync in terms of who they want to go after and what strategies they will use to get the actor to sign on.

On one project that I (Catherine) produced, the casting director took it upon herself to offer a lead part to a very high-profile actor with whom she

had a personal relationship. The good news was the actor was very interested in the role. The bad news was that this choice of talent was an offer-only person and the creator and creative executive assigned to the show did not consider him the best choice. Given the stature of the actor, it was impossible for the studio to back out of hiring him. This misstep by the casting director created a great deal of stress on the production. First, we were forced to use a talent that we considered inappropriate. Second, the talent refused to be recorded with the rest of the cast, and we had to spend additional money to record him separately and cater to his specific needs. The casting director had the best interests of the project in mind, but failed to discuss her plans with us. As a producer, I learned that I should have double-checked that everyone was on the same page before the casting director had any conversations with the talent.

In order to prepare the talent for an audition, specific material should be sent to them before the casting session and should be made available on the actual day of the session. For a large project, a casting coordinator may be hired to help the casting director. It is the casting coordinator's duty to schedule talent for auditions (a typical audition slot for animation is 5 to 10 minutes of record time for the actor), process any necessary paperwork, and prepare the following materials:

- **Casting bible:** The casting bible is a written description of the project and the characters to be cast, including any pertinent information, such as personality, age, and vocal quality. Character designs are also included in the casting bible.
- **Script:** It is important that this is the most recent version of the production script. (See Chapter 5, "The Development Process," for more information on the stages of production scripts.)
- **General information sheet:** This sheet includes the time of call, location, and parking instructions for the recording facility. The actor should also be told who or what character they are auditioning for.
- **Sides:** Sides are portions of the script specific to a character that best reflect their personality. These sides are read by the actors and recorded during the casting session. The casting director, voice director, or producer usually chooses the sides.
- **Visual materials:** This includes any color artwork that shows the characters and their environment. If the project is based on published material with illustrations that are used as reference on the show, it is useful to have them on hand.

The casting session takes place in a recording studio. Generally, the producer, director, and casting director attend these sessions. Depending on the director, there may or may not be a voice director hired to direct and communicate with the talent. Some animation directors are not comfortable

playing this role. In feature production, the director usually directs the talent. In this book, we refer to the individual responsible for directing the actors as the *voice director*. The voice director has the actors read their sides individually or with other actors playing opposite parts. Often on television shows and direct-to-video projects, actors are given sides for several parts as it is cost effective to have a versatile talent that can play different parts. Working with the casting director, the producer ensures that the session is moving on schedule, allowing for extensions with certain actors and schedule changes throughout the day when people drop out or are late.

After the director and/or producer select the preferred performances or "circle takes," the chosen lines are edited onto a final listening tape. If they do not like any takes from an actor, the entire audition is dropped. This is called a "no print." Edited tapes, along with a list of talent recorded, are given to key team members such as the buyer/executive for review. Each person listens to the tape, makes notes, and ranks his or her choices. The casting director gets everyone's feedback and sets up callbacks. The purpose of callbacks is to re-record the talent in order to finalize casting. The original list is trimmed down significantly for these sessions. It is important to note that if you have a third callback for the same actor, SAG rules state that the producer has to pay for this and any further sessions. If none of the voices fit the part, additional casting may be necessary. The final choice of talent is a collaborative process. Actors are chosen based on their vocal quality, ability to bring the character to life, their star power, versatility, availability, and the budget. In those cases when there is a tie between actors for a part, the buyer or the creative executive will usually make the final casting decision.

Before auditions, the casting director typically communicates to the talent (through their agents) what the standard fee is. There should therefore be minimal negotiations necessary. For those actors above union scale or above the flat rate paid for non-union actors, negotiations need to take place. These negotiations are generally done by business affairs in concert with the producer and creative executive/buyer. In case there is any visual likeness to the actor in the design of the character they are playing—which sometimes happens with star talent—the design needs to be legally cleared in advance. Other issues to be agreed upon for star talent are fees, size and placement of credit, and publicity. In the case of musicals, the topic of singing needs to be discussed. If the talent cannot sing, another voice will be used to perform the songs. If the talent can sing, there will be a different rate paid, and the details of soundtrack royalties must be addressed. The business affairs department negotiates with the star talent's representative regarding the actor's willingness to conduct interviews and his or her availability for other promotional purposes. Generally, star talent is paid a fee to take part in promoting the project.

Rehearsal

Before going into the record booth, it is ideal to have a table read or rehearsal with all the actors. At first glance, setting aside funds for rehearsal may seem excessive, but in our experience it has proven to be very beneficial. Actors are almost always appreciative of rehearsal time. Realistically, it may be impossible to insert additional time and money in the production of episodic television or to try to assemble star talent for a table read, but it has been done, especially for primetime shows. On direct-to-video projects, however, rehearsals are common practice. A table read allows the cast an opportunity to read through the entire script in one day. This exercise enables the actors to have a better grasp of their own part in relation to the other roles, and get input from the director, producer, and any executives as an ensemble, thereby improving their performance. After the rehearsal, actors tend to nail their lines on the first or second take, saving the production a substantial amount of recording studio time and money.

Another important advantage to a rehearsal is for the director and producer to ascertain which parts of the script require rewrites. It is far more efficient to get the revisions incorporated into the recording script rather than try to set up additional recording dates or try to fix the problems in automatic dialogue replacement (ADR). (For more information on ADR, see Chapter 10, "Post-Production.") It should be noted, however, that some directors prefer spontaneity and do not request a rehearsal. This form of recording without rehearsal is called a "cold reading." In this case, directors like to see how the actors handle their part initially and then give notes. It is up to the producer to confer with the director and decide what procedure works best for the production.

Session Preparation

Once the rehearsal and recording dates are established, the appropriate facilities must be set up. On features, after casting is completed, if star talent is selected one of the following people may be responsible for contacting the agents and booking the talent: the creative executive, the producer, the casting director, or the post-production supervisor. On television and direct-to-video shows, however, the casting director and/or his or her coordinator continue to do the scheduling. On non-union projects, booking is handled with the actors directly. If it is a union project and children are being recorded, a welfare worker or teacher must be hired to attend the session. It is this person's job to manage how the children are treated and be available to help them with any necessary schoolwork. Upon scheduling the talent for union projects, the person responsible for handling bookings must contact the union to ensure that the actor is in good standing with the union (meaning

all union fees are paid). On SAG projects, this process is called "station 12." When an actor is not cleared, they are not allowed to work. It is up to the producer to contact the actor's agent and straighten out the problem before the recording session. If the actor works without being cleared, the producer will be fined.

Prior to the rehearsal and recording session, materials need to be sent to the actors. Whenever possible, the producer should ensure that these materials are sent out far enough in advance to allow the talent time to prepare. This may not always be possible due to last-minute script changes, but it is something to aim for. The following items or a combination thereof should be sent to the actors:

- **Record script:** If possible, it is important to include any "wallas" or specials sounds (grunts, heavy breathing, laughs, and so on) within the recording script to ensure that all necessary sounds are recorded for the character.
- **Production script:** The production script helps the actor understand the scene and action in more detail.
- **Paperwork:** This includes contracts; documents such as a SAG Information Sheet (if the project is union, SAG paperwork must be used and can be purchased through the union); I-9s; W-4s; a general information sheet listing time, location, parking, and scheduling information; and the producer, casting director, and agent's telephone numbers in case of emergency.
- **Artwork:** This includes black and white character designs and color models.
- **Storyboard or story reel:** This is included to show the actor where and how the action in the scene is staged, if recording from a storyboard.
- **Video cassette reference for the section being recorded:** When, for example, a new set of lines has been inserted and the animation for the earlier scenes has been completed, the actors can benefit from seeing how their news lines will fit into the previous section.
- **Audio cassette reference for the section being recorded:** This may be useful when the actor needs to reproduce a certain sound or previous performance, or imitate the voice quality of another performer.

Recording

Before the recording session, the person responsible for coordinating the session communicates to the facility to let them know the number of actors attending, the recording booth setup in terms of microphones, as well as any other special needs. On the day of the recording session, extra sets of materials should be provided along with a sign-in sheet. This sheet is used

to keep a record of the time spent by the actors in case overtime needs to be calculated. In most cases, it is best to get all of the contract paperwork filled out before the session starts.

On television series and direct-to-video projects, the recording of the script is usually completed in one day. On features, however, there are two types of recordings: scratch recording (or temporary dialogue) and production dialogue. These sessions take place throughout the production. With a makeshift recording studio set up in the editorial department, scratch dialogue is typically recorded using staff members such as animators, editorial staff, and the directors. This type of voice track is generated when a storyboard sequence is initially approved and ready for the reel. The editor cuts the temporary dialogue with the digitized story sketches to create a story reel. The purpose of this track is to experiment with the story and dialogue/timing before finalizing it. This method helps keep recording costs to a minimum until the sequence is approved. It is then time to set a date for a production dialogue recording session and have the professional actors read the lines. Keeping track of temporary dialogue and production dialogue and the subsequent revisions can be an enormously demanding task that the producer delegates to the editorial/recording APM.

As a rule, on projects with higher budgets such as features, the star talent is recorded individually and may be called upon to read new lines or revised lines as many as four to six times. An ongoing challenge for the producer is juggling the actor's availability, the production needs, and the budget. It is not uncommon for the director and producer to fly to another city where an actor may be working on location. If there are budget or time limitations, it is possible to digitally patch two recording studios and record the performance long distance. Always helpful is to have the animator who will be animating the character that is being recorded present at the session. Watching the actor perform their lines can inspire the animator and they in turn may be able to provide the actor with more insight into the character they are voicing.

A key factor to a successful recording session is clear direction. The voice director should be very familiar with the script and prepared with thoughts and notes prior to the session. The producer should also establish who will be giving notes to the actors, what is expected to be accomplished in the recording session, and how communication to the actors will be handled. This understanding can be important in helping to ensure the recording session does not spin out of control and go overtime. In some cases, you cannot predict what will take place and must therefore be flexible and prepared for anything.

On a project that I (Zahra) worked on, an Academy Award-winning actress was selected to play the part of the villain. Before the recording session, the actress was told by the director to try to play the part with an Eastern European accent, but to not go overboard. The production executive,

however, said that the part should be played with a thick Chinese accent. The actress was understandably puzzled with the unclear directions and was at a loss as to how to perform the part. Being a professional, she attempted to combine a non-descript Eastern European and a thick Chinese accent, which resulted in an entirely unusable (but very funny) track. She finished the lines, but was visibly upset with the lack of coherent vision for her part. Fortunately, the director was able to convince the actress to come in for another recording session. At the subsequent session, it was made clear to all in attendance that the only person giving directions was the director, and if there were any disagreements, they should be resolved before the date of the recording.

In some cases, actors are videotaped. This footage is used as reference for the animators and possibly for promotional purposes. To avoid any problems, it is important that the talent is told in advance through their agents that there will be video taping or photography while recording.

During the session, the recording engineer records the lines. An assistant engineer or a production staff member such as the script coordinator or editorial APM tracks the lines recorded and marks the circle takes. In television and direct-to-video projects, these takes are edited together and returned to the production. There are two ways to edit the initial track. The first is called "normal pause," whereby four frames are placed equally between each line of dialogue. The other system is called "natural pause editing." In this system, the natural breaks are kept between lines, and if lines are overlapped, they are left that way. Cassettes of the session are typically distributed to the director, producer, and the buyer/executive for review. On features, a tape including the select takes as well as any alternate lines is delivered to the editor, who builds the story reel in collaboration with the director. (For more information, see the "Animation Timing" section later in this chapter.)

Storyboarding

It is every filmmaker's goal to come up with an innovative way of telling his or her story. In animation, it all begins with the storyboard. After all, it is the first time the words are taken from the script and translated into images. The storyboard artist's job is to draw panels that illustrate scenes depicting the characters, their action, and their environment. At this stage of the game, there is a full range of possibilities open to the director since they are starting with a blank slate.

By allotting adequate time for storyboarding, the producer gives the director and the artists the opportunity to nail down the story and improve it as much as possible. The more time spent on fixing script problems in this stage, the better. In fact, in an ideal world, production does not start until the majority—if not all—of the boarding is completed and approved. Since

the storyboarding phase is the last comparatively inexpensive portion of production, it is one of the best places to allocate resources to avoid potential problems down the line. If, for example, the story is not entertaining or is predictable, this is the time to delve into it. In such cases, production should be halted, if possible, or slowed down so that writing issues can be addressed before spending further monies. Unfortunately, we have worked on too many shows where the deadline to start production and/or the lack of funds has forced this phase to be rushed. The result is that story points left unresolved at this point haunt the entire production. To quote a veteran storyboard artist, "Somehow there is never enough time to do it right, but there is always time to do it over."

Getting Started

Before the director can hand out an assignment to the storyboard artist, the following items must be in order:

- The script
- The voice track (if available)
- Character models
- Location designs
- Prop designs
- Office space and supplies (if the artist works in-house)
- Page and panel setups
- Sample completed storyboard panels illustrating the show's style and complexity level (if applicable)

Initially, the director divides the script into sequences. Each sequence is further broken down into scenes that become the individual units that go through the production pipeline and are then assembled to make the final project. The location where the action takes place and the time of day are typically the factors that the director uses to delineate a sequence. On a primetime 22-minute show, for example, it is common to have three artists working for six weeks (or 18 staff-weeks) on a storyboard. Due to time and money limitations, once the artist gets guidance from the director, they focus their efforts on making the story work. For the most part, however, there aren't many departures from the script. On these types of shows, storyboard artists in essence take on the role of editors and cinematographers. They work on how the show should be cut by the way they depict the scene, asking such questions as: Is it in a single master shot? Or are there many cuts? They also create the template for the look of the film through how they choose to set up camera angles and how the characters are framed and composed within the scene.

The primary goal for the feature storyboard artist on the other hand is to tell the story. In long format, the script often plays second fiddle to the storyboard. Instead of the script being closely followed, it provides a frame of reference that the artist can use and improve upon. On a 75- to 80-minute project, the storyboarding staff has approximately a year to complete their task. Often when there is only a treatment or a description of a particular event, the storyboard artist is given the material in order to explore a theme and come up with possible paths to be followed by the script. As the feature storyboards evolve, the script is revised to match the latest set of boards. (See Chapter 5, "The Development Process," for more information on the relationship between feature storyboarding and the script.)

Another distinction between feature and television storyboarding is that on features, there is usually a department supervisor. This person functions as a liaison between the director and the artists. The department supervisor also manages the workflow through his or her department with the aid of an APM. In this department, the story goes through many variations; it is the role of the story APM to keep track of the creative notes and update production personnel on script changes. They meet with their crew on a weekly basis to discuss the overall status of the script and talk about the work in progress.

When a sequence is ready for storyboarding, the department supervisor assigns or casts it to the appropriate artist (i.e., depending on the project, someone who works well with drawing action adventure or has a knack for timing and illustrating comedy). Another approach is to have a group of artists work together on the same sequence. The artists are each assigned a story beat to work out. After artists finish their sections, they are pitched to the group for comments. Their panels are either approved for viewing by the director or sent back for revisions.

Because the storyboarding procedure is the cornerstone of any production, it is vital to establish a few ground rules. It should be noted that before starting storyboarding, the size of the panels must be standardized. The ratio used for television and direct-to-video projects is approximately 1.33:1 (soon to be changed to 1.78:1 when the digital format begins to take over). For direct-to-video projects that are intended for limited theatrical release and for feature films, the standard ratio is 1.85:1. For projects that opt to use the cinemascope format, the ratio is 2.35:1. These ratios are captured in Figure 8–7.

For both television and direct-to-video projects, sample storyboard pages should be created so that all artists use the same setup. It is common to have three panels per page and allocate space underneath each panel for dialogue and action. On series and direct-to-video productions, it is advisable to distribute an approved storyboard section to the artists. This is used as a tool to ensure consistency of style for the show and to standardize the amount of detail expected on each panel. The model storyboard also has

1.33:1

1.85:1

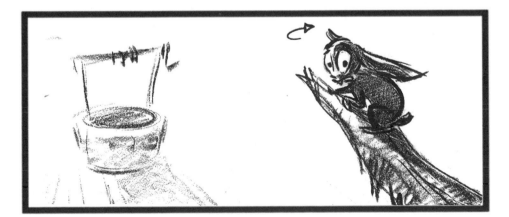

2.35:1

Figure 8–7 Aspect Ratio

other benefits. One important advantage is for the artist to be able to gauge their assignment in correlation with its due date. The sample storyboard enables everyone to see the final goal and have realistic expectations of the show's requirements.

The Three Stages of Storyboarding

Over the years, we have found that this three-step system is both cost effective and highly conducive to good storytelling. However, due to budgetary restrictions, not all productions can afford the time necessary for the board to go through all the phases that we have listed below. As we have noted earlier, however, the more time spent honing the story at this stage, the better the foundation for the production.

Thumbnails

First, the artist draws thumb-sized panels in order to illustrate the action. Since the images are so small, the artist is able to fit many panels on one page, thereby enabling the director to see how the action flows. A thumbnail is a form of shorthand drawing that has numerous benefits. One benefit is that artists can make sure they are in sync with the director. If there are any miscommunications, the artists can revise panels without losing too much time. Another benefit to creating thumbnails is that the director can see whether what he or she had envisioned actually works. Since the drawing of thumbnails is relatively quick, the director may ask the artist to come up with a few different approaches. By requesting alternative drawings, the director takes advantage of the storyboard artist's expertise and may potentially come upon a version that works even better than what they had in mind. Figures 8–8a through 8–8d show a sample series of thumbnails based on our story of the lion and the rabbit (which was provided on page 166).

Rough Pass

After the director views the thumbnails, changes are usually made to the panels, such as character placement and camera angles. This version is referred to as the *rough pass*. The panels used for the rough pass are substantially larger than the thumbnails (that is, the production panel page setup of 1.33:1), which enables the artists to draw out more details of the characters, their action, and their environment. This version of the board is much easier to read for the non-artist. The characters are for the most part on model and the backgrounds are easier to decipher. On television and direct-to-video projects, this version of the board goes to the producer and the buyer/ executive for story notes. On some productions, at this stage, the panels are shot or scanned into the computer in order to create a story reel. (Anima-

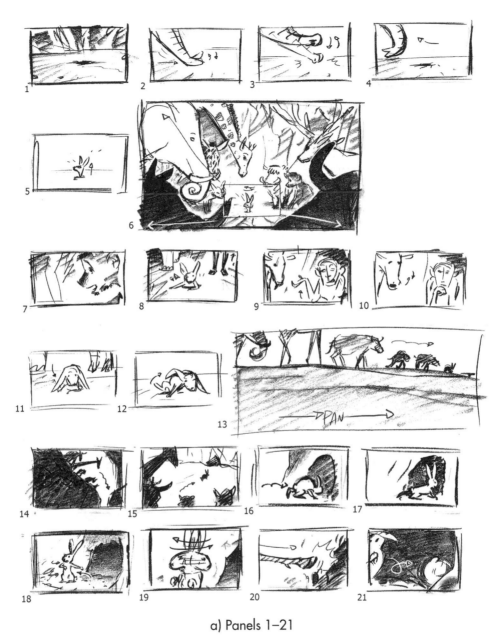

a) Panels 1–21

Figure 8–8 A sample series of thumbnails.

tion timing, animatics, story reels, and leica reels are discussed later in this chapter.)

At this checkpoint, the board is often revised to serve creative notes. These changes will probably require deletion of some panels and drawing of new ones. Once the revisions are completed, the board is ready for the clean up phase. On television and direct-to-video projects this version of

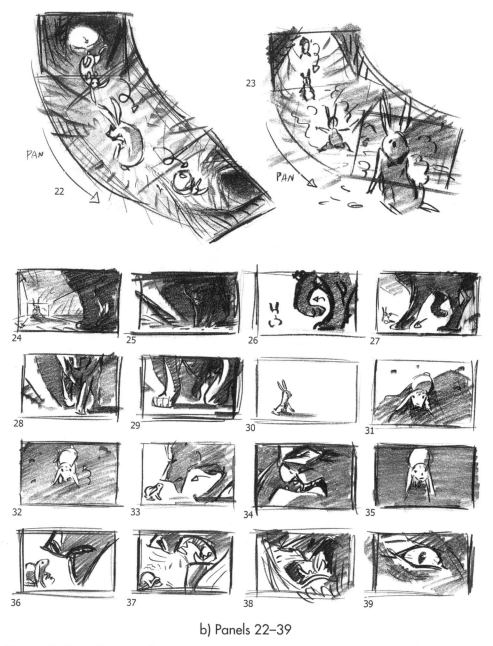

b) Panels 22–39

Figure 8–8 (Continued)

the board is also reviewed by the legal department for any potential problems such as trademark infringements or copyrighted material that requires clearance. Additionally, the storyboard is checked as to whether it adheres to broadcast standards and practices (BS and P). Broadcast standards and practices monitor the storyboard for any items that deviate from

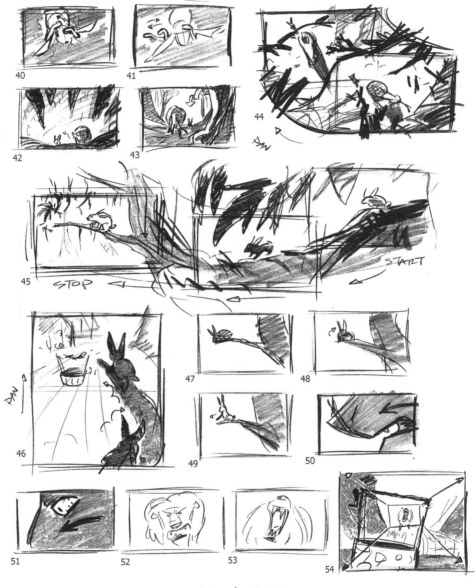

c) Panels 40–54.

Figure 8–8 (Continued)

the television regulations, such as showing passengers in a car who are not wearing seat belts.

 On feature projects, the artist uses the rough pass of the board to pitch the sequence to the director, the producer, the writer, and sometimes, the buyer/executive. Some studios, however, do not involve the producer until

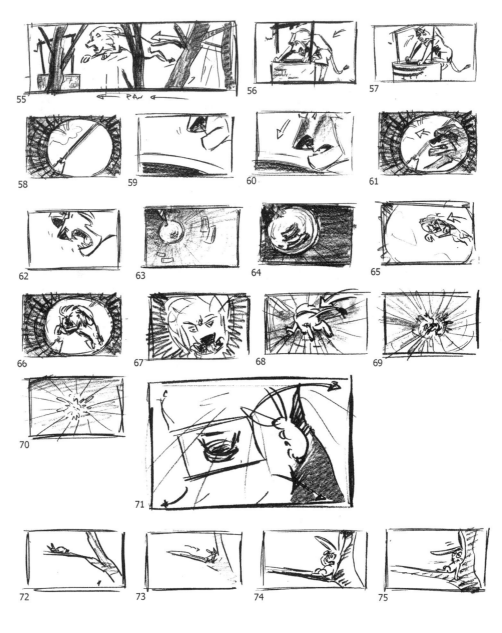

d) Panels 55–75

Figure 8–8 (Continued)

the storyboard has been completed through the clean up stage. In our experience, it is more advantageous for the producer to be included before too many weeks have been spent on boarding a sequence. Since the producer is viewing the sequence for the first time, they can act as a test audience for the director and the artist. During the storyboard pitch, it is

immediately apparent what areas read well and what sections may require additional work. The producer views and offers feedback based on the following objectives:

- Does the story work?
- Will it fulfill (and hopefully exceed) the buyer/executive's expectations?
- How complex is the sequence? Are there ways to tell the same story with simpler shots without compromising the director's vision?
- If this sequence requires revisions or a complete overhaul, how will this affect the budget and the schedule?

After the board has been pitched, story notes are generated and the artist incorporates them. Since revisions will require additional passes, both the budget and the schedule should be taken into consideration in terms of time allotment for storyboard fixes. If there are no changes (which is rarely the case!) the storyboard is ready to move to the next phase: clean up. Figures 8–9a and 8–9b display sample feature format storyboards, using thumbnail panels 45–51 from Figure 8–8.

Cleaned Up Storyboard

In this last stage, the panels are fully rendered to spell out all the necessary details of the scene. This stage is particularly important on shows that are sent to subcontracting studios since in some cases, particularly in lower-budget shows, the storyboard panels are substituted for layouts. By magnifying the panels on a copy machine, the artist at the subcontracting studio separates out the background and the character level, and the scene is considered ready for animation. By skipping the layout phase, the subcontracting studio saves time and money. In such cases, the cleaner the storyboards in terms of staging, composition, and camera movements, the more likely you are to be happy with the show you get back.

On television productions, it is often customary to have a clean up storyboard artist complete this version of the board. Since by this point the storyboard artist has already pinned down all the necessary information, it is cheaper to hire a clean up artist to do the final detail work. Meanwhile, the original storyboard artist is freed up to work on another episode. By working on boards that have been drawn up to this stage, the clean up artist learns the thinking process and drawing skills necessary for boarding. In time, they are able to take on assignments as full-fledged storyboard artists. This method of schooling or mentoring within the studio is common, and ultimately helps the producer build a strong team.

On series and direct-to-video projects, once the storyboard is final and cleaned up, the director reviews it again and adds any necessary directorial notes prior to shipping it. The production assistant will usually paste dialogue cut from the script onto the board so that it is easy to read. Copies are

Rabbit : **I am telling you ...**

Rabbit : **he's really gigantic !**

Lion (off screen) : **Gigantic ?**

Figure 8–9 Feature Storyboard

Rabbit : **He is ferrociously enormous !**

Rabbit (playing it up - turn to the Lion) : **I'm scared for you .**

Lion (roars) : **Out of my way,**

Lion : **you weakling !**

Figure 8–9 (Continued)

made and distributed to the story reel editor, animation timers, and the buyer/executive for any comments. The production assistant also goes through the package to check for missing designs. Often, the storyboard artists create new characters, locations, or props as dictated by script. Depending on how much detail is missing from the new design on the storyboard, it may require its own model sheets. In some cases, the storyboard is colored in for the subcontracting studio. The purpose of the color board is to function as an art direction guideline, showing the time of the day or the scene's emotional intent, for example. This version of the storyboard sometimes can even be used instead of background keys. After the board has been signed off by all, it is sent to the continuity checker along with all the other materials for shipment.

In a typical storyboard for a television series or a direct-to-video project, a few standard details must be included along with the panels. They include dialogue information, the studio name, the project title, the production number, the episode number, the page number, and the name of the artist(s). This information is necessary to keep the boards organized and to help the production team and subcontracting studio track them.

Figures 8–10a and 8–10b show sample storyboards formatted for television production.

On features, when the sequence is ready for a final pass, the story APM sets up a meeting for the director, the producer, the art director, the editor, the assistant editor, the editorial APM, and in some cases, the buyer/executive. At this meeting, the artist pitches the sequence to the selected staff members. During the pitch, the editor takes note of the action and the pacing of the sequence, along with information on where there will be camera moves, dissolves, and so on. After the artist has finished the pitch, the notes are submitted for final approval. When the storyboard is ready for the editorial department, the story APM or production assistant numbers each panel in chronological order and inscribes the sequence number.

The next step is to make a copy of the panels. The original drawings are then sent to editorial and copies are collated and made into a flipbook. The master copy remains in the storyboard department. The collated flipbooks are distributed to editorial, art direction, and the production manager. Flipbooks give the editor a reference to the panel order and illustrate the director's conception of the sequence. By looking through the flipbook, the art direction team gets advance notice of the upcoming new locations and props as well as secondary characters. The production manager's office often doubles as the production library, and the flipbook is filed for future reference and backup when necessary.

After the storyboard has gone through all of these stages, it is ready for the next step in production: the creation of a story reel.

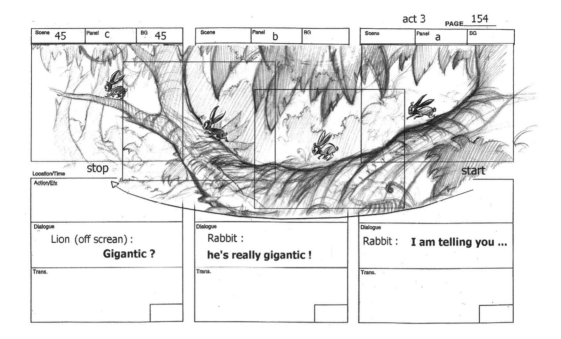

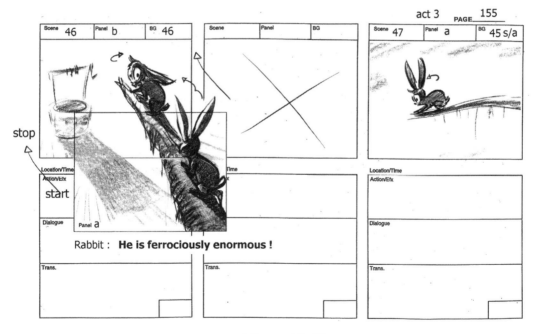

a) Scene 45–47

Figure 8–10 Television Storyboard.

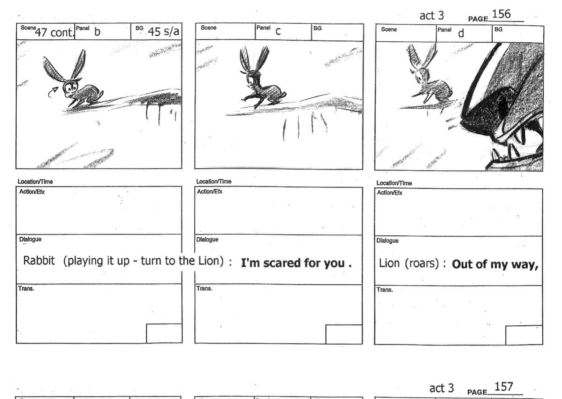

b) Scene 47

Figure 8–10 (Continued)

Animation Timing

After the story has been solidified on boards, the next step is to time them. So far, we have established the look of the show, but we don't know how long it will take for the action in every scene to take place. On animated projects, the show is pre-edited down to the exact frame before the production stage officially begins. Since the animating process is so extraordinarily time-consuming and expensive, it is important to figure out the details of what is required for each scene prior to it entering the production stream. Animation timers use their experience as animators to time the show. It is their job to pace the action on the storyboard panels in order to create the emotional beats, such as excitement, pathos, or sensitivity, as necessitated by the script. On domestically produced projects, this role is fulfilled by the animator. (For more information on the role of the animator, see Chapter 9, "Production.") For shows that are sent to a subcontracting studio, the animation timer notes all the information necessary for the artist to follow since the director will not be on hand for guidance. In order to time a scene, the animation timer and/or animatic editor (for television and direct-to-video productions) or the editor (for features) need the following items:

- The storyboard
- The dialogue track
- A stopwatch (if applicable)
- Film or video shooting/scanning and editing equipment (if applicable)
- Blank exposure sheets

Although the stopwatch technique is still sometimes used, the most common method of timing is the creation of a story reel, an animatic, and/or a leica reel. The terminology used to describe this step is yet to be standardized and therefore can be confusing. Depending on the studio setup, the terms story reel, animatic, and leica reel can be synonymous. Or in some cases, certain studios even change their nomenclature as the reels progress. For example, the initial step is called a story reel when it is made of storyboard panels only. It is then referred to as a leica reel as soon as an animated scene is cut in. No matter the term used, the creation of a reel is essentially the process of combining the dialogue track with the storyboard to pace out the show. By previewing the film in progress, versus studying the storyboard, everyone involved can make sure that the story is heading in the right direction. Also, seeing the show at this stage enables the advertising and publicity group to come up with strategies to promote and sell the final project.

Story Reels and Animatics

The most popular method of timing used is through the creation of what is called a story reel. Story reels are typically produced on non-linear, digital editing systems such as an Avid or Lightworks system. These non-linear systems enable the editor to quickly access any shot in a matter of seconds. If they need to review previous takes on a given scene, it is a simple task. Although the initial investment for these kinds of setups is hefty, they represent a flexible and fast method of editing, both in terms of accessibility of each shot and memory storage capacity.

The term "animatic" is used for two different means of putting together a reel. One is very inexpensive and quick to compile; the other is a higher-end version and can add a number of months to the production schedule. The first is commonly used in television production and requires a Macintosh-based computer and software, such as Adobe Premiere. This kind of animatic shows the scanned-in storyboard panel with the digitized sound track. It also has the advantage of being capable of producing camera moves, which also helps with early scene planning.

Camera movement is a shared quality between both the inexpensive and the high-end animatics used on feature productions. The high-end version of the animatic takes the story reel one step further by allowing the creative team to see how the scene works from a spacial/staging perspective. Created after the storyboard panels are finished, and before full animation, it is an in-between version of the show. This type of animatic includes camera moves. On a feature animatic, however, characters are typically also moved around using the cutout technique or rough poses. For the cutout technique, the character is literally cut out of the scene and moved on the background, or key character poses are drawn on the storyboard. On 3D CGI feature productions, it is common to have both a story reel and an animatic (also known as a 3D workbook). The 3D animatic shows characters in motion in relation to the camera position, angle, and lens in a three-dimensional space. (See Chapter 9, "Production," for more information on the CGI process.)

In terms of television production, it is important for the producer to keep in mind that the creation of a reel on a television show typically adds two weeks to production time and therefore can be more costly in terms of schedule, staff hours, and initial equipment purchases. The upside, however, is that much is learned from seeing a project timed out in such a format, and potential mistakes can be caught early.

Leica Reel

The leica reel, which is the original and oldest method of assembling a reel, is a film-based process. These days, most feature productions use digital ed-

iting systems and then create a final film output for post-production. If the budget allows, a film reel is produced and kept up to date alongside the story reel/animatic. Having film reels can serve many important functions. A film reel enables the director, producer, art director, and editor to see how the final product is going to look. It is used for theatrical test screenings in addition to presentations to the buyer/executive or other individuals such as members of the ancillary groups. The crew can also benefit from seeing the show in progress on film.

Building the Reel

The digital process of timing storyboards for story reels/animatics begins with the scanning or shooting of the panels into the editing system. The recorded audio track is digitized from a DAT tape into the system. It is then assembled and placed under the appropriate storyboard panels. By combining these two elements, the animation timer or editor starts building the reel by moving around the dialogue and pacing out the action. It is important to note that a combination of the traditional (stopwatch) and digital method is also used at some studios to build the reel. In such cases, the editor uses a slugged storyboard as the timing guide. In this instance, the process is reversed. The timing on the board dictates how the reel is built. When the timing is changed while the reel is being edited, the new revisions are transposed back onto the board.

The reel functions as the blueprint for the project. The director has the opportunity to focus on the timing and the pacing of the scenes with both the picture and the dialogue track. If the storyboard is not working, the director can delete and/or add new panels. He or she can also easily check for hook-up problems. For series and direct-to-video projects that are prevalently outsourced, there is the added bonus in sending this material to the subcontractor. The reel plays a vital part in closing the gap between the two production studios as it clearly lays out what the director is planning for the show. Much of the success of animation is dependent on how it's timed. Since many of the artists working on the show do not even speak English, the reel allows them to see and hear how each scene is cut and paced, and ultimately how it works as a whole.

For projects that are animated in-house, the reel is a living record of the show, which is always in a state of flux. Each scene goes through a metamorphosis as it progresses down the production pipeline. Starting as storyboard panels, the scene's first transformation takes place when it is animated. As more and more scenes are animated, the film begins to come to life when still frames are replaced by animation. It is important to note that sound also plays a large part in the development of the feature reel. It is most common to build a sound effects and music temp track alongside the creation of the reel in order to develop the overall direction the sound will

take in the production. The temp track is a necessary device for sound designers, composers, and dialogue editors since it functions as their guideline during post-production. (See Chapter 10, "Post-Production," for more details on the soundtrack.)

Executive Screenings

While the reel has many advantages, it can create a danger zone for the producer if the buyer/executive reviewing it is not made aware of its purpose and the nature of animation timing. Looking at a reel when it is made up of storyboard panels, especially in a rough form, can be very misleading for a viewer who is not familiar with the animation process. As we have noted, each scene is shown on the reel for the length of time that it will require for its animation, but for an individual who is not aware of this fact, the reel can be—for lack of a better word—boring. In order to alleviate this problem, a number of studios have made changes to the process. Some have opted to have two versions of the reel: a jazzy version for the buyer/executive that zips along at the speed of light, and a working version that takes into account the necessary timing for the scenes. The upkeep of two different reels is not only time consuming but costly and can be confusing for the production team to track.

Another approach is to create a reel that serves both purposes. Some scenes are cut very short and others are timed appropriately. When a project is paced very quickly, it is hard to register the action and follow the story. The producer may be keeping the executives satisfied during the review process; however, if the final project fails because of poor editing, no one will be happy. Yet another method used by some studios is to combine camera movement with the still panels so that the action is spelled out in a little more detail. In our experience, this system works very effectively in that the buyer/executive is better able to understand the action.

Slugging

On television and direct-to-video projects, after the reel is finalized, a few intermediary steps must be taken before creating the exposure sheets. Firstly, if there are revisions, the storyboard panels need to be rearranged to match the reel. A production assistant reviews the reel and places all the panels and dialogue information into their correct spot on the board. Once this is done, it may be necessary to have additional panels added to solve hookup or consistency issues that usually become apparent in the editing process. The next step is to slug the board based on the timing that has been used for the reel. (The origins for the term "slugging" date back to the days where old-fashioned printers were used for typesetting. The space between

the words was described as a slug. In animation, the pause created on the sound track to accommodate the action is called a slug.)

The animation timer paces the timing of a scene in order to create the desired effect. Before the onset of digital technology, a stopwatch was the sole method used to estimate the length of a scene. The animation timer starts the watch and acts out the action drawn on the board either imagining it or they may actually physically move around. The amount of time that elapses between the start and finish of the action is accounted for and calculated into feet and frames (for example 2½ seconds or 3 feet or 12 frames). The animation timer then puts the timing or the slug below the appropriate storyboard panel.

Upon completion of the conforming process, the director reviews the board and adds other directorial information, such as camera moves or key dramatic points to emphasize on a particular character, so that it can be passed on to the animation timer. Concurrently, the editor outputs the audio track onto DAT tape for track reading purposes. In most cases, this digital tape needs to be transferred into an analogue format called a Mag track.

Exposure Sheets

When the timing of an episode or a sequence is completed, exposure sheets are produced. These pieces of paper operate as the map for what is going to happen in the scene. They are frame-by-frame descriptions of every detail of the story. Without them, production can't get started. The following information gets filled in on exposure sheets:

- The scene number and footage
- Scene description
- The name of the animator
- The act number or sequence number
- The sheet number
- A description of action
- The dialogue column
- Mouth chart information (if applicable)
- Columns for levels of art
- A description of visual effects
- Camera notes
- The production number

Figure 8–11 shows a sample exposure sheet.

There are several aspects to the production of an exposure sheet. Initially, the producer has blank exposure sheets printed with the name of the

PROD.	SEQ.	SCENE		SHEET

ACTION	DIAL	EXTRA	4	3	2	1	EXTRA	CAMERA INSTRUCTIONS

Figure 8–11 Exposure Sheet (Courtesy of Cartoon Colour)

project and any key information (such as the production number) that needs to be repeated on each page. Depending on the size of the project, thousands of sheets may be required. Next, the sheets and the dialogue track are handed to a track reader.

Track reading is the process of phonetically transposing the entire dialogue track frame by frame onto the exposure sheets. Listening to the dialogue track, the track reader places the words for all speaking characters into their correct frame on the exposure sheet. Each row on the exposure sheet represents a single frame, with typically 5 feet marked per page. After the number of feet and frames are delineated, the exposure sheets for the sequence or episode can then be separated so that individual scenes can independently move down the production line. The completed exposure sheet provides the animator with a framework as to where the scene starts and stops, and what its duration is in correlation with the dialogue. (For more information on this topic, see Chapter 9, "Production.") When animating to music, the beats on the click track are transposed onto the exposure sheet so that the animator can time the animation to the beat.

At this point, scenes that are going to be animated in-house are ready for the next phase in production: the workbook. On productions that are outsourced, all exposure sheets are sent to the animation timer (also referred to as the sheet timer) for detailed direction. The animation timer, with guidance from the director, notes what will need to take place in the scene. Using the storyboard along with the audio track as a reference, they further define and clarify what action needs to be animated by the subcontracting studio. Other information is included, such as camera movements, optical effects, and special effects, when applicable. Fine-tuning the details that the animation timer has already written on the slugged storyboard, they are now able to write out the acting notes next to the actual frames. Next, they can plus the sheets with drawings that illustrate and pose out action or emotions, or they may use actual panels taken from the storyboard.

It is crucial at this stage to not take any piece of information or direction for granted. The more all details are spelled out, the higher the chances are of the show fulfilling its artistic goals. For example, if there is wind effect in the scene, the animation timer must make certain that every character or object that comes into contact with the wind is animated appropriately. Until the wind stops or there is a cut from an exterior shot to an interior shot, the wind effect must be exposed on the sheets. Every nuance added will greatly enhance the final product. The animation direction therefore also covers such detailed information as how the characters articulate words and move their body parts down to the smallest details, such as eye blinks.

Because it is not always possible for the director to hand out the show and explain the timing in person, it is important that an experienced animation timer produce the sheets. Because exposure sheets are the sole means of communication the director has with the animators on the project, the

information must be concise, clear, and legible; otherwise, the show will more than likely require many retakes.

As we mentioned earlier, a mouth chart for all key characters is added to the model pack for the non-English-speaking animator. The purpose of the mouth chart is to show how the character's mouth looks pronouncing different sounds. The applicable mouths are symbolized by letters and are noted on the exposure sheet next to the dialogue. The frame-by-frame direction by the animation timer enables the artist in the subcontracting studio to follow the director's vision even though they are thousands of miles apart. Often times, for example, comedy or a comic moment is something that gets lost in the translation. This system helps the artists to fulfill the project's objectives.

Songs

There are both creative and commercial reasons why the inclusion of songs can greatly enhance a project. To some, the combination of animation and music is almost a higher art form. Additionally, many attribute the global success of animation to its use of songs, whereby the combination of the two can transcend language and cultural barriers. Songs can also play a vital part in moving the narrative of a project forward, especially when they are cohesively intertwined with the story. Frequently a song is used as a device to cover the passage of time. Another purpose is the revelation of key information as to characters' motivations, such as their wish to take over the world.

From the commercial perspective, songs add a whole other dimension to the marketability of a project. If popular performers are cast to write the project's songs and/or sing them, the show's soundtrack is bound to result in additional revenues. At the same time, an audience that may not be interested in seeing an animated project may reconsider their position when they learn that their favorite artist has participated in its creation. There have also been a few projects where the film itself has had a fairly short run in the theaters but the soundtrack has continued to have a life of its own. One such an example is Warner Bros.' *Quest for Camelot*. With music by songwriter Carol Bayer Sager and composer David Foster and top name artists such as LeAnn Rimes, Steve Perry, and the Corrs participating, the soundtrack received a substantial amount of airplay. *Quest for Camelot* also won a Grammy and received an Oscar nomination for the song performed by Celine Dion and Andrea Bocelli entitled "The Prayer."

Songs have always been a part of animated features, dating back to Disney's *Snow White and the Seven Dwarfs*, which was produced over 60 years ago. In 1989, the enormous success of *The Little Mermaid* brought its songwriters, Alan Menken and Howard Ashman, their first two Oscars. This

musical was strongly influenced by Broadway conventions and had a significant impact on how the films that followed were conceived. In the 1990s, animated musicals became the dominant form for features, with an average of six songs per film. This trend reached its peak with Disney's *The Lion King*, which generated over a billion dollars in profits from all revenue sources. Industry professionals continued to use the musical formula in the hopes of other mega-box office hits, but no other projects to date have matched or exceeded the *Lion King* numbers.

Producing Songs

Songs should first be discussed when the script is in early development. Right from the start, it is necessary to establish how many songs will be needed, where they will be placed, and what genre(s) of music will best suit the picture. Will there be a gamut of different types of songs, such as ballads, showstoppers, or anthems? What will the purpose of each song be? Since the production of songs can be very costly, it is crucial that all key players share the same vision. Items to discuss in relation to production of songs are the artistic requirements in correlation with the budget and the schedule. Once all of these issues are decided, the producer and/or music executive at the studio can start making contacts with agents representing songwriters and composers. On some productions, music supervisors may be hired on a freelance basis to play this role. Using their contacts, they pursue well-known artists to create a commercially viable soundtrack. As we have noted before, involving musical celebrities will almost guarantee the picture a certain amount of media attention, and it can be inspiring to the artists working on the production. If the budget does not allow for a name performer, the producer or the music supervisor asks for demo reels from agents in order to identify and cast the appropriate talent for the project. The next step is to make a final selection. As soon as the musical talent is chosen, and it has been established that they are interested in the project, the process of negotiations begins. (For more information on how contracts are negotiated, see Chapter 4, "The Core Team.")

Upon completion of the contractual discussions, the director, the producer, the songwriter, and the composer start working together. Clarity of vision is essential at this stage. The more the songwriter and the composer are made aware of what specific goals are to be accomplished by the songs, the better. It is also important to inform them of production requirements and make sure that they have all the material needed in order to meet their deadlines, including executive and legal reviews.

Ideally, the songs are the first sequences of the project ready for production. There are a number of reasons for prioritizing these scenes. Externally, songs are needed for sales and as an advertising tool by the ancillary groups

such as marketing and publicity. Internally, scenes with songs can require more artistic effort than non-musical scenes. An example is a dance number where it may be necessary to hire a choreographer and set up a live-action shoot to videotape the dancers for reference. Since production can't get started on these scenes until the video reference tape has been completed, it is important to focus on this type of sequence as early as possible. Often, the director may want to have a lead animator and crew animate an entire song sequence. Under these circumstances, the song needs to be recorded as soon as possible so that the artists can work on the scenes without creating a production bottleneck. In terms of complexity, typically, song sequences require fairly elaborate artwork. Unless these scenes are given ample time in production, there may be too many creative compromises.

From the production standpoint, a positive aspect to song scenes is that their timing can't be altered since the footage for each scene is tied to the music. The fact that the timing can't be revised allows the scene to potentially go through the pipeline at a quicker pace. The drawback to song scenes is that depending on the way they hook up with each other, animators may not be able to work on their assigned scene until the scene before it has been animated. The necessity for hookups, however, can diminish the number of scenes that can be worked on simultaneously. For these reasons, the producer must focus on getting the songs written and composed from the outset of the production.

In order to get the production started on song sequences, as soon as they are approved, a click track and temp music are recorded. The click track is a timing device. It is a recording of the beat to which the animation is matched. This beat is transposed onto the exposure sheets for animation. In post-production, the tape of this recording is provided for the conductor, sound effects designer, and the voice talent for reference. While listening to the tape, they are able to match their work to the film. The temp music, as referenced by the name, is a piece of recording that is used as a substitute until the final music is recorded. After the click track and the temp music have been completed, the director is able to lock the sequence for production.

The next series of steps for song productions starts with selecting and casting the vocal talent. After they have been recorded using the click track, the next stage is to spot the music to the locked picture. This stage of the process requires the producer and the director to discuss the project's final musical and orchestration arrangement with the composer. The composer then writes the music and records it under the producer's and the director's supervision. The last stage for song production is the final mix where the music recording is combined with the picture in order to deliver the completed show. (See Chapter 10, "Post-Production," for more information on this topic.)

Title Sequence

For television shows, a separate title sequence is produced and is placed at the front of each episode. The purpose of the title sequence is to introduce the content of the show and the main characters, and, most importantly, to entice the viewer into watching the program. The title sequence should therefore be considered a marketing tool used to promote the series. For this reason, most producers spend a significant amount of money on it in order to make sure that it successfully fulfills its mission.

The title sequence goes through the same production steps as a television show, albeit on a much smaller scale. Depending on the buyer/executive's requirements, they range in length from 30 to 60 seconds. Once a concept has been selected, a storyboard is created and reviewed. When it is signed off, the title sequence continues through the pre-production process. If dialogue is needed, a recording session is held. To save money, it may be recorded as a part of a recording session for one of the episodes. It is then timed out, color styled, and a final pre-production package is assembled for a subcontractor. In special cases, if the budget and schedule allows, the title sequence may actually be completely animated and produced in-house. (See Chapter 9, "Production," for more information on this topic.)

For the producer, the production of the title sequence presents a unique opportunity to test out a new studio. Subcontractors are always eager to prove their abilities on the title sequence in the hopes of obtaining future contracts. In comparison to risking a whole series at a very low cost, producers can evaluate what quality of animation the studio is capable of creating and check out how business is handled.

In one case, I (Catherine) hired a studio that I had heard about, but had never worked with, to do a title sequence. While the studio did an excellent job on the animation, they had some business practices that I was uncomfortable with. Once the sequence was finished, they insisted that the budget had been too low. They wanted more money for their efforts. In order to push me into paying them, they threatened to hold onto the negative until we agreed to their demands. Although their request for more money was not part of the deal, after viewing their work we felt it was justified. We had every intention of paying them for their extra efforts, as they had gone above and beyond our agreement. Their approach, however, was inappropriate for the circumstances. Before we had a chance to respond to their request, they had taken the fairly drastic measure of threatening us. When I was searching for a subcontractor for my next project, I avoided hiring this particular group. This experience made me wary of any further interaction with them, even though their work was impressive. This type of business practice could put my show in complete jeopardy and force me into paying a lot of money when it was not justified. It was a risk I could not afford to take.

As a producer, if your budget is tight, another option is to make the title sequence a part of the overall deal. In many cases, a subcontractor may be willing to do the title sequence at no charge in order to win the contract.

In a perfect world, the title sequence should be completed through post-production prior to the actual episodes reaching this stage. Taking the title sequence through post-production is another great opportunity for the producer to select the right team. It lets them test out the various facilities and identify any potential problems before the bulk of the work begins to flow. It is also a chance to decide on the music and sound direction of the series and explore a variety of options. Once the title sequence is finalized, it is added to the element reel. (See Chapter 10, "Post-Production," for further details on this topic.)

Preparing a Shipment: Checking and Route Sheets

For television and direct-to-video projects, all materials need to be checked before they are shipped to a subcontractor. Ideally, the director can review the sheets and the final board before sending the show to the animation house. The continuity checker reviews the production elements for any missing materials or information. He or she cross-checks the model pack, the final slugged storyboard, the exposure sheets, and the dialogue cassettes in order to make sure that everything is clearly laid out and easy to understand. When elements are missing or if artwork requires revision, the continuity checker works with the producer and the director to rectify the problem. In the process of putting the shipment together, the checker fills out a route sheet. The purpose of this document is so that both the domestic studio and the subcontracting studio have a detailed record of the material sent and the individuals responsible for the content. The following information is noted on a route sheet:

- The studio name
- The production title
- The episode number/sequence number
- The total footage for material shipped
- The total number of scenes shipped
- The names of the director, animation timer (slug director/sheet timer), color stylist, and continuity checker
- A breakdown of scene numbers, scene footage, scene description, and effects information

Upon the completion of the above steps, the material is ready for the subcontractor. (For a list of items necessary for a shipment, see Chapter 7, "The Production Team.")

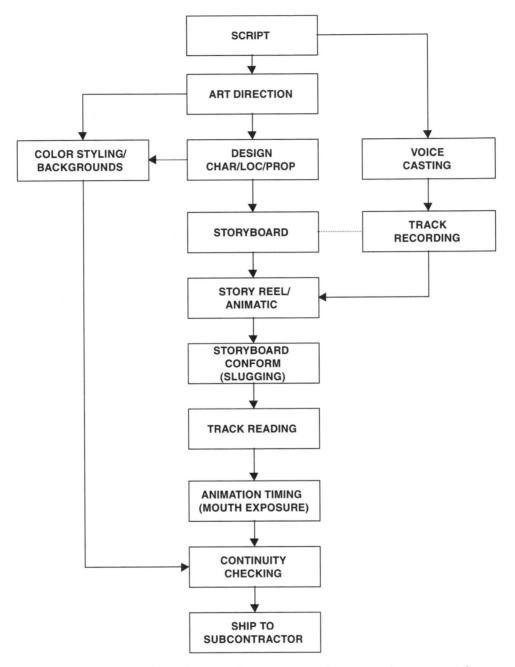

Figure 8–12 Flow Chart of Pre-Production Steps: Television and Direct-to-Video

Figure 8–12 shows a chart covering the basic steps for pre-production on television and direct-to-video projects. On features, the pre-production stage tends to overlap with the production process. Examples of 2D and 3D CGI production pipelines can be found in Chapter 9, "Production."

9

PRODUCTION

The Role of the Producer During the Production Phase

Production is the stage of the process in which the producer's multi-tasking skills are truly tested. The producer is the glue that holds everything together and, as such, usually works a significant number of hours during the production stage in order to juggle his or her many responsibilities. On most projects, when production ramps up, portions of the show are still in pre-production. The producer needs to be on top of all steps from a budgetary, creative, and technical standpoint in addition to taking care of all of the project's external needs such as marketing and consumer products. The following is the list of elements completed in pre-production that are integral to starting the production phase:

- Finalized art direction
- Character and prop designs
- Location designs
- Rigged and surfaced models and props with test animation complete (3D CGI)
- Textured and surfaced environments (3D CGI)
- The voice track*
- The storyboard*
- The story reel/animatic/leica reel*
- Exposure sheets (TV and DTV only since on features production starts with workbook)

In television series and direct-to-video projects, these items are considered final before the start of production. On features, all items marked above with an asterisk are works in progress. As a storyboard sequence is approved, it enters the production stream. Once it is workbooked and scenes are created,

they go through production at a different pace and are frequently altered or, when necessary, deleted. Due to these revisions, the storyboard, story reel, and voice track are rarely final until the picture is locked in preparation for post-production.

Having already created a workable budget, running a production efficiently has a few principal requirements. First, a production-ready script. Next, two significant items have to be balanced: fulfilling the project's creative needs and meeting the weekly quotas. Once enough work is in the pipeline, the pressure of hitting the targeted quota is what drives the production. Unless the inventory is available for the artists, there is no possible way to build the necessary momentum. A steady workflow allows the producer to ensure that the creative requirements of the property are met. Ample inventory is therefore key to leading the project in the right direction. Additionally, time needs to be set aside for artists to ramp up and learn the project's specific stylistic requirements.

For most television and direct-to-video projects, once pre-production elements are completed, the project is shipped to a subcontractor for the production phase (as previously discussed in Chapter 8). After an episode or sequence ships to its assigned studio, the producer takes on a macro role in terms of managing the elements. The producer, or one of the members of the production team, is the point person for the subcontractor (that is, the person from whom the subcontractor can request further materials, clarification, or information). The producer receives a weekly production report from the subcontractor in order to monitor the project's status. If the producer is concerned with the show's progress, it is his or her responsibility to communicate to the subcontractor or overseas supervisor. (See Chapter 7, "The Production Team," for more information on this process.) It is generally not the producer's job to solve day-to-day problems unless the delivery of the show is threatened. At this stage, it is the subcontractor's responsibility to meet the project's delivery dates at the agreed-upon level of quality. During production, the producer also continues to oversee the various other episodes/sequences being pre-produced, usually at the pace of one a week or one every other week.

On features, the producer relies on the associate producer and the production manager to handle the actual details of the production itself (tracking scenes, meeting quotas, and so on). The producer's main area of focus typically is on the following elements:

- Story development
- Production design and art direction
- Voice talent
- Music
- Overall status of production

- Buyer/executive notes and communication
- Ancillary groups

A feature producer's job is divided between the internal realm of the production itself and the external factors that can help guarantee the project's success once it has been released. Frequently, the two areas overlap, as in the case of selecting a voice talent when a celebrity's voice track is needed both as a production element and as a promotional tool. Internally, producers must make sure that the project is fulfilling its creative goals, starting with the script and storyboarding. They are also very hands-on in such areas as production design and art direction. Once the project is set up in terms of its visuals/art direction and story content, their involvement is usually more limited. In general, they attend important meetings (such as "sweat box" meetings) where they view the film's progress and have creative input when necessary. Whenever time allows, producers attend workbook evaluation meetings in order to hear the director's plans for the sequence and the supervisor's response to the handout. On a day-to-day basis, they oversee the progression of the project both creatively and fiscally while interfacing with the ancillary groups and setting up ways to promote and market the project. (For more information on the topic of the producer's role in relation to the crew, see Chapter 7, "The Production Team.")

Complexity Analysis

In order to control costs, the producer sets up an internal structure for evaluating the requirements of each scene in the workbook stage. This is referred to as *complexity analysis*. Areas that are scrutinized include character animation, visual effects, and the possibility of re-using background elements and animation. On projects that include an artistic coordinator, it is this person's role to come up with means to simplify the scenes and save money without compromising story content or creative objectives. Artistic coordinators work very closely with the director to make sure that their recommendations address the creative needs of the scene. At the same time, they coordinate their efforts with the associate producer and the production accountant to assess the cost of production on a scene-by-scene basis.

Typically, staff members involved in a complexity analysis on a workbook are the director, the producer, the associate producer, the production manager, the artistic coordinator, and, possibly, the layout supervisor/ workbook supervisor(s). In this meeting, if the film is effects-heavy, for example, the group agrees upon how much time can be spent on a given scene in the effects department and provides that information to the department's supervisor as a guideline. This early assessment of each shot allows the creative and management teams to have a strong grasp of the scene's needs and focus resources accordingly. Too many productions deal poorly with

complex scenes by exceeding the budget in order to complete them rather than proactively anticipating and analyzing what is involved. By having a handle on how many complicated scenes are in the pipeline, the production can gear itself towards meeting a specific "difficult scenes" quota number so that they don't create a bottleneck at the end. Although some people might consider this type of internal checkpoint/complexity evaluation an overly controlling means of producing animation, in our opinion, it is a necessary step in allowing creativity to thrive within budget and schedule and should be ongoing as necessary throughout production.

Buyer's Creative Checkpoints

Externally, producers should be in constant communication with the buyer/executive. The main creative checkpoints for the buyer/executive on a feature are at the following stages:

- The script
- Character design/3D CGI models
- Color-styled/surfaced character design
- Location design/3D CGI environments
- Key painted backgrounds/textured environments
- Voice talent selection
- Music composer selection
- Lyricist selection (when applicable)
- Vocalist selection (when applicable)
- Promotional material (including poster art and trailer)
- Story reel (animatic/leica; on a per-sequence basis and once the entire project is on reels)
- Credits
- The final film or video

Ancillary Groups

The producer works closely with the ancillary groups, including consumer products, publicity, and promotions. Both the producer's and the director's input and support are needed for marketing materials, such as art for posters or footage for trailer and teaser campaigns. The producer should be proactive in working with these groups to help them create strategies and campaigns to best sell the finished project. It is vital to keep these groups updated on new artwork and completed scenes. The producer is also involved in analyzing and implementing the results of market research and test

screenings for the project. The feedback received very often plays a significant role in how a project is shaped in order for it to draw in and entertain the target audience.

It is not uncommon for the project's character designs and color treatment, for example, to be influenced by the needs of consumer products. Since this is the case, producers will often find themselves having to bridge the gap between the director's creative desires and the consumer product's commercial goals. This difficult position must be handled delicately so that all parties are satisfied. On a project that I (Zahra) worked on, the protagonist's hair was first long and then cut short. The two hairstyles were designed and approved for production. In the story, the character was very eager to show that she could take on a man's world, and in an important scene, she cut off her long hair as a symbolic gesture to prove herself a worthy warrior. This story point did not work for consumer products and had to be changed. Consumer products pointed out to us that "hair play" was essential to the sale of dolls. In other words, unless the doll had long hair that the child could play with, it would be unlikely that it would sell very well. We were therefore required to revise the story and keep the hair long throughout the show. The director was perplexed by this request. The producer had to do quite a bit of cajoling before the story could be revised. It is never easy to allow commerce to overrule the artistic vision, but both the producer and the director ultimately knew that they had to make certain compromises in order to get the necessary support for the project's overall marketing, promotion, and merchandising. Chances are that the director's last priority is the toy line. Yet it is up to the producer to find a means to have art and commerce coexist.

Traditional/2D Production: From Workbook Through Film/Video Output

The following sections detail the production steps involved in producing an in-house, traditionally animated feature project. In each section, we describe the process and elements required for the step to take place, and include background information helpful for individuals working in various positions. Lastly, we note the ever-changing influence of new technology (also known as digital production) on the large-scale 2D-animation process.

Workbook

As soon as a sequence or an episode is approved on the story reel, it is put on its path through the production pipeline. The first step in this process is the workbook. Here, the storyboard panels are broken down into individual scenes or shots, assigned a number, and planned out cinematically. The

focus is on designing and staging each shot with the aim of creating a seamless flow of images that will support and enhance the storytelling. With instructions from the director, the workbook artist uses composition, character posture, placement and action, light and shadow, camera angle, and movement to convey the intent and mood of the scene and the sequence as a whole. Scene transitions and screen directions are also determined at this point. In order for workbook artists to begin their assignment, the following items are needed:

- Storyboard panels
- The style guide (character model sheets and location designs)
- A draft (including scene description, scene length, and dialogue information)

The workbook primarily functions as a guide for the layout artists, but is also referred to by artists in other departments for scene placement, continuity, and camera mechanics. The workbook artist has to be knowledgeable about film grammar (that is, be able to think through how a scene can fulfill its intended visual and narrative goal within the allotted footage). We should note that workbook artists are usually cast among the senior layout artists or those who are most proficient at setting up scenes. In order to illustrate a workbook, we selected a scene from the storyboarded section shown in Chapter 8, "Pre-Production." This scene is shown in Figure 9–1.

Key to the success of any project is the timely dissemination of important information. Workbook is no exception to this rule. One of new technology's most dramatic effects on animation production is that by digitizing the artwork, it can be accessed at every step of the process whenever necessary. Once the workbook panels have been scanned in and the information for each scene has been entered into the computer, all production members are able to refer to this blueprint of the show at any given time.

Workbook Evaluation

At the workbook evaluation meeting, which is also referred to as the blue book meeting, the director communicates the creative objectives for each scene, along with specific instructions on how they can be accomplished, to the artistic supervisors and key production personnel. It is therefore imperative to scrutinize scene content at this stage of the production and simplify as much as possible without impeding the narrative or losing production value. In preparation for this meeting, the following items are needed:

- The approved workbook
- The draft

stop

start

Figure 9–1 Workbook Illustration

- The style guide (including character and location designs specific to the sequence plus lighting information)
- A video camera, blank tape, and video operator (if applicable)

After the director completes his or her instructions on each scene, the supervisors evaluate its complexity. The purpose of grading each scene is to assess how much work is involved for the individual departments. At the same time, this evaluation helps the management team analyze how the director's creative expectations and the supervisor's grading compare with the budget and the schedule. Each production should aim for a specific number of complex scenes or money shots. There should also be a balance of "average complexity" shots and music scenes (which are shots that are background level only and do not require any animation).

Depending on the director, the workbook evaluation can be conducive to group discussions. The group may brainstorm on ways to "plus" the production on each scene while being mindful of the budget and schedule. It is helpful to videotape the meeting in case the crew needs to refer to it or if the sequence will be sent to a subcontractor.

Editorial

In many ways, the editorial department is the hub of the production since it's where the story reel is created and maintained. (For more information

on this topic, see Chapter 8, "Pre-Production.") It is in this department that the film comes together scene by scene. After workbook evaluation, the editorial department issues the scenes in order for production to get started. To begin this process, the editorial department produces a scene folder and an exposure sheet that shows the timing and the track reading for the scene. This information is also entered on the computer for tracking purposes. Like a patient's chart in a hospital, all of the scene's vitals are noted on the scene folder. On the folder itself, the editorial department notes the production number, sequence number, scene number, and footage information. From hereon, every piece of art created for the scene either travels in the scene folder (or with it, when it's oversized). The scene folder has space for the names of all artists and staff members working on the scene as it progresses from rough layout and animation through ink and paint and final check. Next to each name, columns show when the work was received, completed, and approved.

During production, the story reel is constantly evolving. As a scene is completed in rough animation, clean up, and effects and color, it is initially sent to the scene planning and scanning departments. It is then digitally sent to editorial so it can be cut into the reel in preparation for sweat box, where the film is evaluated from both the aesthetic and technical points of view. Little by little as the film progresses, there are fewer storyboard panels and more animation cut in to the reel. And in time, the black-and-white pencil test drawings are replaced with scenes that are completed in clean up and effects and, finally, ink and paint. At the same time, the director and editor review the same sequences repeatedly and make edits that result in footage changes, deletion of scenes, or creation of new scenes. There are a number of reasons why changes are made. The primary reason is that the edit will make the film better. Script revisions and storyboard changes dictate the majority of story reel changes. On occasion, an animator may discover that in drawing out a scene, the timing needs to be altered. At other times, a decision may be made to recast a voice talent, and the new recording will more than likely require new timing. When there are footage changes, the scene must be returned to the editorial department so that they can fix the exposure sheet and update the scene folder accordingly.

It is critical for the producer to have direct communication with the editorial staff in order to be kept abreast of all changes requested by the director. Often, editorial decisions may indeed help the pacing of a sequence and improve the film. However, the producer must agree upon all such changes. Change means money and time that may not be accounted for in the budget. It is therefore up to the producer to determine how the project will fare as a whole both creatively and fiscally when story reel revisions are requested.

Layout

The process of creating a layout for a scene involves drawing the location, indicating the positioning of the character(s) and visual effects levels, and giving information on camera mechanics. In live-action terms, this phase is similar to constructing a set and selecting and placing objects. In addition to establishing the background, the characters are also blocked and the camera angles, positions, and moves are planned. A feature project can have as many as 1,250 to 1,500 layouts or scenes. The layout artist needs the following items in order to begin work:

- The workbook
- Location design(s)
- The draft
- The scene folder
- Reference material

Layout artists should have a strong design sense and be able to draw in perspective. At the same time, they need to have an in-depth understanding of cinematography (camera angles, lens and movements, composition, and lighting and staging). Knowledge of the animation process is also a necessity for this role, as is an inclination towards mathematics.

In order to have a consistent look for the overall film, the production designer creates location designs that are closely followed by layout artists. Using the information provided in the workbook and the draft, the artist creates a scene by breaking the animation and background elements into different levels. The purpose of this division is to define how the character(s) and/or visual effects will interact with the surroundings. Once a layout has been completed, it will include a character and/or visual effects layout, indicating the position and the scale of the character and the effect, the fielding/camera mechanics information, and one or more of the following elements:

- **Overlay (OL):** These elements sit on top of the animation.
- **Underlay (UL):** This level sits below the animation.
- **Overlay/Underlay:** When the animation is both above and below layout levels, this element is called an overlay/underlay.
- **Background (BG):** This is the setting for the action. Every scene must have a background in order to provide the animator with information on registration points, the field and character size, and the ground plane. This item always sits below all the other artwork.

In an ideal world, layout artists are handed a stack of consecutive scenes within the same locations. When possible, they start with an establishing shot, then move on to medium shots and close-ups. Using this

approach, the layout artist can make sure that the scenes cut well together and there are no continuity problems. When scenes taking place in the same location are scattered amongst a number of artists, instead of having one person think through the scenes, a number of artists envision what has to happen. In this scenario, it is important that the artists coordinate their efforts for continuity purposes.

New technology has had an enormous impact in this department in terms of allowing an artist creative flexibility and making room for potential cost savings. It used to be that there could only be a limited number of levels for each scene. With the advent of computers, the numbers of elements are almost infinite. A shot can be set up with as many levels as necessary for effective storytelling. We should note, however, that the drawback of having an inordinate number of levels can be the cost or the extra time the scene will require in many departments, including scene planning, animation checking, and rendering. The production pipeline should therefore be set up from the outset to support a complex scene's digital requirements in terms of equipment and computer memory, so that bottlenecks can be avoided. Typically, the producer should aim for 30 to 35 percent layout reuse. The advantage of the digitized artwork is that an artist can more easily access (and when necessary, manipulate) a shot and reproduce portions of a layout, or in some cases an entire layout if it takes place in the same location or one that is very similar. One simple example is reuse of an overlay of trees. After the artwork has been scanned into the computer and filed in the directory, it can be recycled as an overlay for another scene, either as is or with slight modifications. In this example, the advantage to this process is that the new scene can be enhanced without the cost of producing new artwork.

Animation

The animator's job is to literally breathe life into the design of a character by creating key or extreme poses that allow the character to come across as though they have a personality and an agenda of their own. Similar to an actor, the animator needs clear instructions from the director (or supervising animator) on what their motivation is and what should happen in a scene. It is important that they follow directions, but also embrace the character enough so that they are able to suggest possible ways to enhance the acting. Before they start their work, animators require the following items:

- The scene folder (including layout and exposure sheets)
- The voice track
- The workbook
- Character design model sheets
- Macquettes (if applicable)

Each of the above items fulfills a different function for the animator. The layout is equivalent to a live-action set or a theater stage; it is a setting for the performance. Animators use the workbook as reference to what is happening in their particular scene along with the shots before and after it. By doing so, they are able to have a solid notion of what is involved in their scene and how it ties into the larger picture. As we have mentioned earlier, the dialogue track plays a crucial role in animation. Hearing the way the lines are delivered by the actor, the animator tries to emulate the emotions and the beats that went into the performance. While drawing the part, the animator uses the track reading on the exposure sheet as a guideline, indicating what sounds or parts of dialogue hit in on what exact frames.

Depending on the number of characters and the way in which the levels are deconstructed in a scene, animators use the columns on the sheet to expose the drawings or indicate where they should be placed. They put down instructions on how the drawings should be shot (that is, on twos or held, for example). The animator also makes notes on what is called a *breakdown chart*. The purpose of this chart is to illustrate the thinking behind key drawings, or show the "arc" of action in order to guide the inbetweener on how to handle the drawings between the extremes. After the key poses for the scene are approved, they may either draw the inbetweens themselves or delegate them to an inbetweener.

Strong drawing skills and acting abilities are a must for this position. The animator needs to have an innate understanding of how to have characters deliver their lines and interact with other characters or objects in the scene. With simple drawings, animators should be able to bring out the character's range of emotions, from subtle expressions to broad actions. Knowing how to pace or time the drawings allows the animation to be believable. Animators should also be knowledgeable about animation mechanics. (For more information on the art of animation, see the references listed in the Appendix, "Animation Resources.")

On large-scale productions, it is common to have a number of animation supervisors or leads who oversee a team of animators and inbetweeners. The supervisor may be responsible for animating a sequence or in charge of one of the main characters. Depending on the nature of the show, the second method may be a better choice since the animation will be more consistent. In this type of production structure, the animation supervisor develops the character's design and personality based on the director's dictum. The supervisor explores the character by drawing facial expressions and posture. Next, the supervisor animates the character's movements through walk cycles, and may delve further into the character's personality by finding appropriate idiosyncrasies that allow him or her to be unique. After the character design is finalized, the supervisor breaks down the drawing into basic geometrical shapes in order to teach the team and the clean up lead how the character should be drawn. The supervisor also provides this information to

a sculptor so that macquettes can be created for the characters. The purpose of the macquette is to enable the animators and the clean up artists to have a three-dimensional reference.

The benefit of digital production for animators is that they are able to easily pull up and view other scenes that have already been animated on the computer. They can therefore create a performance that is congruous with the rest of the project. When the animators have completed their scenes, the director can view their work on the computer and either approve it or make notes on it when their schedule allows. Gone are the days when animators had to stand by the pencil test machine in the hallway to ambush the director for his or her input on a scene. Another benefit of the computer is its ability to scale down or enlarge the animation whenever the artwork needs to be altered due to scene changes. This aspect of digital production is a great time-saving device. Generally speaking, the process of animation itself creates an inordinate amount of information in the way of drawings, exposure sheets, edit lists, and so on. Digital production allows the artist to non-linearly view and edit this material without having to recapture or recreate the same basic information.

Scene Planning and Scanning

The scene planning and scanning departments collaborate closely in order to make certain that the various elements in a scene (such as the animation and the layout levels) can be combined cohesively. For the first step, we need to backtrack and go to the rough layout stage. Once a layout has been approved, a pegged copy of the rough layout goes to the animator, and the original artwork is sent to the scene planning department. When artists draw or paint using the traditional method rather than the computer, they use punched paper, cardboard, or cel, which is placed on small metal or plastic strips with raised sections. This strip, referred to as a peg bar, allows the pieces of artwork to align with each other. When duplicating any artwork in 2D animation, it is crucial that the copy and the original have the same peg holes in order for the drawings to register or align. Upon receiving the original layout, the scene planner verifies that all items listed on the scene folder are labeled correctly and are intact. If there is any "same as" artwork (or a layout element that is used in more than one scene), the scene planner checks to make sure that a copy is pulled and inserted in the scene folder. Next, the scene planner creates a file on the computer directory for the scene. The scanner then digitizes the entire layout into the computer and places it in the file.

After the director has approved the rough animation in the animation department, the rough scene is sent to scene planning. The scene planner breaks the scene down into levels and makes sure that all drawings are exposed on the sheets. The planner also checks the artwork for correct label-

ing and pegging information and gives instructions to scanning as to how to scan the drawings (pegging information) and once again what directory to file the drawings under. After the animation has been scanned, the scene is returned to the scene planner for compositing. Starting with the layout artist's notes, the scene planner lays in all elements and sets all camera fields and moves. Once the composite is completed, the scene is rendered and sent to sweat box for approval.

In preparing the scene for sweat box, the scene planner must focus on the composition and continuity of background elements. Also central is continuity of the camera moves from scene to scene. Prior to the start of animation, in cases where the scene is complicated—as in a multi-plane shot with a multitude of levels—a move test may be required to make sure that the layouts will work as planned. This time- and cost-saving measure is taken in order to avoid the expense of animating the whole scene only to find that the layout doesn't work. The scene planner is responsible for putting these tests together and for coming up with solutions to problems that may come up due to the size of the artwork and the resolution.

After the rough scene has been approved in sweat box, the scene planner draws up the correct camera mechanics and makes sure all the correct information is on the exposure sheets before it is sent to the clean up layout and clean up animation departments. Upon the completion of clean up and effects, the scene is sent to the same scene planner for compositing and clean up test for sweat box. At this stage, the scene planner makes sure that the scene has all it needs before going to ink and paint. The clean up composite should be as close to final as it can be without being in color.

The scene comes back to the scene planning department one last time after ink and paint. It is the scene planner's responsibility to verify whether the scene is set up properly for the color effects (tones, shadows, glows, and so on) and to review it one last time before it goes to final check. Whenever possible, it is important to set up a system whereby the scene is worked on by the same scene planner throughout the course of production. It takes time to become acquainted with the intricacies involved in a scene. Returning the scene to the same scene planner is a more efficient way to process the work through the department.

A scene planner must be familiar with camera mechanics and proficient at using computer software. A background in animation checking is helpful since scene planners need to be knowledgeable about proper labeling of elements and cross-referencing of information on the exposure sheets. A scanner must also have an understanding of animation mechanics. Previous experience in operating the scanning system or the ability to use traditional Xerox machinery is advantageous for this position.

Digital systems have combined scene planning and compositing, making it incredibly fast to preview scene setups instead of waiting days or possibly weeks to see the end result after it has been animated and shot on

film. The director can make changes on the spot. The downside to this is that once the director realizes that it can be done, he or she may request revisions throughout the entire production process. With the cost of re-shooting film eliminated, there is a tendency to avoid any final decisions on how the scene should be set up until the final scene planning stage. Not resolving problems until the very end of the production, however, can hinder scenes getting approved in color and meeting post-production deadlines.

Sweat Box

The origin for the term "sweat box" is said to date back to when Walt Disney would view the scenes completed through rough animation with his animators and critique their work. Some attribute the word "sweat" to the fact that the screenings took place in a small theater and it got hot, while others believe that the animators would actually sweat in response to how Disney might react to their work. Either way, the same wording is used today when a scene is ready to be approved by the director in the stages of rough animation, clean up and effects animation, and final color.

We should clarify that in the case of rough animation and clean up and effects animation, the artwork (without the background or the layout levels) has already been viewed and approved by the director in its respective department. For sweat box, the animation and the background levels are *combined* so that the director can see how the scene works as a whole. The same process takes place again when the scene is cleaned up and in color, where all the elements are composited together and viewed for approval. It is common to have the scene cut in the story reel and seen on the avid and/or projected on a large screen. During sweat box, the director evaluates how the scene works in terms of acting, composition, and camera movements and in relation to the other scenes. He or she also sees whether the scene is fielded properly and whether there are any registration issues or scanning problems such as drawings being shot out of order.

Present at a sweat box session are the producer, associate producer, production manager, department supervisors, and assistant production managers. It is essential that everyone be up to date on any changes or retakes that are called during sweat box. Often, a scene may require a fix and is therefore considered a retake. It is helpful for all in attendance to observe why scenes are not approved, and, when possible, to implement solutions that can keep retakes to a minimum. This is a very important meeting for producers to attend since they can see firsthand the status of the scenes in progress and be part of the decision-making process in approving scenes. By attending sweat box sessions—which are daily events once production gets rolling—the artistic leads are alerted to the type of scenes that are coming their way. They can also take notes when special handling is necessary for a specific shot. At the same time, if the director or producer has any

questions on the scenes being viewed, department supervisors are on hand for answers. Sweat box sessions in a live-action production are equivalent to dailies or rushes.

Blue Sketch and Clean Up Layout

Once the animation in a scene is approved in sweat box, it is sent to the layout department in order for the background levels to be cleaned up in preparation for painting. The first step that must take place in order to accomplish this task is blue sketch. The purpose of a blue sketch is to designate how the animation interacts with its environment and, more specifically, to show the registration lines. It is essentially one piece of paper that shows the extreme poses of each animation level so that the assistant layout artist is able to adjust the rough layout and adapt it to the animation. In order to separate the animation level from the background level, the blue sketch is usually drawn using a blue pencil, hence the title blue sketch. Depending on how the production is set up, there may be a blue sketch artist hired to do this job or the assistant layout artists will take on the task.

Traditionally, in this department, senior artists do the rough layouts and assistant layout artists do the final line drawings of the rough layouts. In order to clean up a layout, the assistant layout artist needs the following items:

- The rough animation and blue sketch
- The rough layout
- The workbook
- Sweat box notes
- Other scenes in the same location for reference and continuity (if applicable)
- Background design elements or style guides

Similar to live action, not all actors hit their marks and they often step beyond the area specifically lit for the camera. In live action, if the actor does not follow the director's instructions, a retake would be called, while in animation, often times the assistant layout artist's job is to change the layout to accommodate the performance. For example, say a scene requires the female lead to walk down a path and sit on a park bench. The layout artist creates the setting and indicates the scale and location of the character. In the process of animating, however, the drawings may not line up with where the path is originally drawn or where the bench is situated. If the animation were to be shown without altering the layout, the character would be seen walking through trees and sitting on air. The assistant layout artist can reposition the path and the bench so that the character's feet register to the path and her body registers to the park bench. However, if the scene is a "same

as" (that is, the same layout levels are used in other scenes), then the artist has to come up with another solution. After all, if the background is changed, it will no longer work in the other scenes and a new one must be created. In this scenario, the layout artist can take advantage of the digital process by either finding a way to shift the character animation in a different direction or manipulate the overlay and the underlay and digitally reproduce the path so that the right setup is created.

Key to successful clean up layouts is stylistic and set continuity. The assistant layout artist should have access to other scenes taking place in the same area so that they can match the look and include every detail necessary in the correct position. Using the blue sketch as a guide, the assistant layout artist tightens the rough lines in preparation for the background painter. Before the clean up layout is sent to the background department, however, the assistant layout artist needs to produce a lighting guide. A lighting guide is a copy of the clean up layout that is rendered in pencil or charcoal indicating the scene lighting and position of the light source.

Clean Up Animation

In this step of the production path, a team of clean up artists, also referred to as final line artists, take the rough animated scene and create new drawings in preparation for ink and paint (also known as color). The animator draws with the aim to create a performance regardless of the line quality. The clean up artist's focus, however, is to put the animation on model with a single/solid line while maintaining the performance created by the animator. If we were to combine the live-action job categories of makeup, hair styling, and costume into one, we would be able to define part of what the clean up artists do. As the actor relies heavily on this group, so does the animator, who has to trust the clean up team to keep the integrity of the acting and make the characters presentable for the big screen. Although these drawings are still in black and white, the clean up artists must make certain that the character matches the design and looks the same from drawing to drawing. The clean up artists add the appropriate details to the character (such as costume and props) and put in every button and stitch on an outfit. If a character wears a cape, clean up artists draw in the cape and match its movements with the character's actions. They also ensure that the contact between characters and/or background and foreground elements is handled correctly and check the exposure sheet to verify that it has been filled out accurately. Items necessary to start clean up are:

- Character design model sheets
- Scenes including rough animation, clean up layout, and exposure sheets

- Sweat box notes
- The workbook (which the clean up lead refers to)

Critical to this position is having the skill to draw the final line quality while maintaining the fluidity and the lifelike performance produced by the animator. Being able to pair up the animator with the right clean up lead to supervise the clean up artists is essential for a successful performance. Typically, after teams of clean up artists are decided upon, each group works with an animation lead and focuses on one of the main or incidental characters. This method has a few advantages. The more familiar the same group of artists becomes with a character, the more likely the animation will be consistent and aesthetically superior. At the same time, the artists get faster at doing the drawings and, therefore, over time, their footage output will increase. A possible disadvantage to this scenario is that when the inventory is low and the same characters recur repeatedly in the few scenes ready for clean up, one team may have a lot to do while other teams don't have enough. Under these circumstances, the clean up lead should give the available artists from other units work that can be handled with little or no training, such as a long shot of the back of the character walking away. In this department, the sheer size of the group is geared towards large footage output, which necessitates a substantial inventory. Whenever possible, it makes business sense to hire the majority of clean up artists (such as assistants, breakdown artists, and inbetweeners) after amassing ample amount of work for them to start on.

This group is so large because they are responsible for cleaning up all the animation drawings, doing inbetweens, and finishing all details as described above. The following is a typical structure for a clean up team:

- Key clean up lead
- Key clean up assistant
- Clean up assistant
- Clean up breakdown
- Clean up inbetween

The key clean up lead collaborates closely with the animation lead to draw the final clean up model sheets for character designs and poses. Before a production gets underway, the lead teaches team members how to draw the characters and their specific nuances. Once the scenes are ready for clean up, the key clean up leads are responsible for managing their crew, their assignments, and the workflow. Each scene first goes through the lead, who draws key character poses. The scene is then passed on to the key clean up assistant, who adds in more key drawings, preparing the scene for the artists to follow. The lead's and the key assistant's drawings function as a guide for the rest of the team. Their work illustrates how to translate the

rough animation and how to handle the scene based on its length, the size of the character, lighting, and camera movements. Not all drawings require detail. This is the case in scenes in which the action takes place in semi-darkness, for example. The reverse would be true of a close-up "acting" shot where the animation takes center stage. The assistant creates secondary keys while closely following the drawings completed by the lead and the key assistant. Next, the breakdown artist takes on the scene and produces more secondary keys, filling in the gap and readying the scene for the inbetweener. As indicated by the title, the inbetweener creates the drawing between drawings with the aim to match all the preceding artwork and wrap up the scene. This is an entry-level position that enables an artist to become acquainted with the principals of animation and learn the necessary drawing skills to move up the ladder.

Upon completion of a scene, a pencil test is shot on videotape or the drawings are scanned on the computer for approval by the lead. If the scene is ready, it goes to the director for review.

There are great strides being made in developing software that can do clean up and inbetween animation. Their capabilities at this point are mostly suited for scenes that do not involve acting but that are extremely time consuming, such as crowd shots. After scanning a few miscellaneous characters into the computer, they can be dressed with a separate level of accessories. By recycling these characters, a crowd of people can be created who do not look like they are clones of each other. The program can then shift the characters' placement to make them look like they are moving. The use of such tools allows the clean up animation of crowd shots to be produced more cheaply and quickly.

Visual Effects

Visual effects artists are the magicians on the set. Like their live-action counterpart, visual effects artists take pleasure in creating the illusion of exploding buildings and devising natural elements such as rain, fire, and smoke. They are responsible for designing props and the animation of any item that is not character-related. In order for visual effects artists to get started on an assignment they need the following items:

- The scene completed through clean up animation (when it contains character animation) or the scene after clean up layout (when there is no animation)
- The design for the visual effects (if applicable)
- The workbook
- Sweat box notes

Artists in this department need to have strong drawing skills. They should also have a detailed understanding of the principals of visual effects and how they should be applied. Visual effects artists tend to have specialties, such as the ability to draw water, create waves, and/or design and animate fire and smoke. When casting artists for this department, it is helpful to match their field of specialty with the needs of the film whenever possible.

All too often, this department is overlooked in terms of budgeting and scheduling. When projects fall behind in meeting their quotas, the first items that seem to get simplified or cut are visual effects, since they are not always an essential part to storytelling. Yet effects animation does play a key part in the actual look of a film. In addition to creating excitement and dazzling the eye with fantastic imagery, basic visual effects such as tones and shadows can greatly enhance the production value of a project. Tones give the face and body dimension. Contact shadows that appear under a character when there is a direct light source can help ground the animation so it doesn't seem like the character is floating in space. Both of these effects can have a big impact on the strength and believability of a scene.

The following is a common hierarchy for the visual effects department:

- Visual effects supervisor(s)
- Visual effects animator(s)
- Visual effects assistant animator(s)
- Visual effects breakdown artist(s)
- Visual effects inbetweener(s)

The role of the visual effects supervisor is to follow the director and art director's lead in creating an effects style for the project and establishing the main designs (such as how flying insects that glow in the dark should be treated). Visual effects supervisors are also responsible for teaching team members the specifics of the various effects and their application. An important part of this role is knowing which scenes gain the most from having visual effects and which scenes can do without them. Almost every scene can have an effect, but it may not actually benefit from it. The old adage that less is more should be adhered to in order for the money shots to receive the adequate time needed and for the film to have a consistent overall look. Visual effects work tends to always be in the process of breaking the mold. The supervisor must therefore collaborate closely with other departments, such as scene planning, animation checking, color styling, and final camera, in order to make certain that the animation techniques used are acceptable and that the final color footage meets the director's objectives.

The visual effects animator's duty is to use the clean up layout and the clean up animation and apply the effects. He or she updates the exposure

sheet in order to indicate the effects level and the way it will work with the rest of the artwork. After the director has approved the rough effects completed by the effects animator, the scene goes to the assistant. The assistant is responsible for cleaning up key drawings in order for the scene to be ready for ink and paint. After the assistant has completed the drawings, the breakdown artist proceeds to follow the effects animation and produce additional clean up drawings. The inbetweener is left with the task of finishing the clean up of the remaining drawings using the completed ones as a guideline. Videotape of the scene is shot for the supervisor's approval. If no changes are made, the scene is shown to the director and is then sent to scanning and scene planning for clean up animation and effects sweat box.

New technology has significantly changed this department. For example, the digital effects artist or color styling department may be able to create the contact shadow effects described earlier using the computer. This ability enables the scene to be completed at a much faster pace, thereby saving the production time and money. Another cost-saving aspect to digital effects has to do with the fact that once an effect is created, it can become part of the library and applied to another scene with a slight variation so that it never looks like stock footage. Beyond the basic effects, however, the digital realm has enabled artists to design images that are genuine showstoppers, such as the parting of the sea sequence in DreamWorks' *Prince of Egypt*. This area of the business continues to develop at a rapid pace, with more and more software being made that pushes creative boundaries. New programs enable artists to apply many layers of effects simultaneously, such as having water and mist interact with wind. A combination of visual effects in this form would have been unheard of just a few years ago. Digital effects are not only changing the face of animation, but are also altering live-action filmmaking.

Background Painting

The background painter is a combination lighting expert and set painter. At this stage, the setting that has up to now been in black and white is finally ready for the world of color. The background painter's job is to take the cleaned up layout and apply color, thereby giving the objects weight, dimension, and texture and creating mood and atmosphere. Prior to starting their job, background painters need the following items:

- The color key background
- The clean up layout
- A lighting guide
- Other backgrounds in the same location (if applicable)
- Reference material (if applicable)

Previous painting experience in feature or television production is needed for this job. Artists should have a strong sense of color, design, and perspective. Ideally, they should be proficient at different styles of painting, with the two most commonly used techniques being acrylic and gouache. Additionally, it is important that they are able to follow the lead of the art director in order to reproduce the same background style. Being able to adhere to the layout drawing and the registration point(s) in addition to knowing animation camera mechanics are crucial aspects to this role. At times, background artists may have to do additional fixes on the clean up layout before starting to paint. They would therefore benefit from having layout skills. Artists who have had a fine arts background in oil and watercolors have successfully parleyed their skills into production painting.

Now that color has been introduced to the mix, the art director begins to play a vital part in the process. (For more information on the role of the art director, see Chapter 8, "Pre-Production.") In order to create a guideline for the background painters, the art director paints color keys. As noted earlier, color keys are typically the master shot or the establishing scene of a sequence that, once painted, enables the background artists to have a visual reference for the color treatment of the scenes taking place in that location. Some art directors prefer to start by shrinking down the workbook sketches and editing the main story beats to make a color board. This approach enables the director to see how the sequence will look as a whole and what changes may take place in the color scheme. The color board is also an effective tool for the background painters in terms of showing them the lighting nuances for a given sequence. Using the color key and the lighting guide as reference, the background painter can start painting the clean up layout. As noted before, the lighting guide indicates the positioning of the light source and the way in which the scene is to be lit.

Another key person in this department is the background supervisor. The supervisor is responsible for overseeing the work in progress and making sure the director and the art director's objectives are met. The art director and background supervisor work jointly with the background artist in establishing the initial look and maintaining it throughout the project. Invariably, the background painters will require a number of weeks to get acquainted with the style of the project. The goal is for the project to look as though one person painted all the backgrounds. In order to achieve this, artists should be trained in the proper painting methodology. Since the painted backgrounds are shown in the final film, the duplication of the exact color, texture, and design is of utmost importance. When there are specific directions on how certain items are to be painted, the art director sets up meetings to inform and/or train the artists on the technique to be used.

Technology has had a substantial effect on this department by allowing the art director to meet aesthetic goals without having to make too many compromises. Digital painting has become standard practice on many

productions. The role of a digital background artist can be limited to fixing background elements as necessary or working on the overlay and underlay levels. If the software used matches the background style of the show, the digital painter can be assigned a complete layout to paint, or, as was the case in the Warner Bros. production *Osmosis Jones*, all backgrounds can be painted digitally. The advantages to digital painting tools are many. The art director can compare backgrounds on the screen side by side and alter hues so they match. It used to be that paint touch ups were both time consuming and risky since the actual cardboard could only absorb so many layers of paint and the final color, once dried, could be different to the one desired. Today, any part of the background can be more easily and cost-effectively altered and improved. With digital paint, background elements can be added, repositioned, or deleted as needed.

Animation Checking

Once a scene has been completed through visual effects and the background has been painted, it is necessary to check all elements in the scene to make sure they are ready for the final stage of production: ink and paint. In evaluating a scene, the animation checker compares the information listed on the scene folder with its content. When any items are missing, such as a background overlay, the animation checker makes certain that they are found and inserted into the scene. The checker scrutinizes the exposure sheet making sure that all items are properly noted. With all the elements in a scene coming together at this juncture, the animation checker is responsible for ensuring that the intended camera mechanics are achievable. If the mechanics do not work, the animation checker comes up with alternative solutions to discuss with the director and implement accordingly.

An animation checker flips the scene's drawings, verifying whether the animation is inbetweened properly and works with the clean up layout. They check the clean up drawings to determine whether they are on model and accurate in terms of scale. The checker also studies the actual cleaned up animation and visual effects drawings for line quality and color demarcation lines, which are not apparent on pencil tests. The checker is responsible for catching any continuity mistakes and correcting them. If, for example, a character has a bandaged left arm in one scene, but in a subsequent scene, the bandage is on the right arm, the animation checker asks a clean up artist to remove the bandage from the wrong arm and redraw it on the correct arm. If, for example, an explosion occurs in a scene and continues into the next scene, but the intensity of effects is inaccurate, the animation checker enlists the help of a visual effects artist to add, delete, or alter additional drawings for continuity purposes. In order to start animation checking, the following items are needed:

- The completed scene through visual effects (including clean up animation and layout and exposure sheets)
- Digitized files of the scene
- The painted background
- Clean up model sheets for characters and props
- Finalized color models of each character and prop indicating color separation
- Sweat box notes

Animation checkers should have a thorough knowledge of the animation process. Being computer savvy and knowing how to retrieve and input data is a must for this position. Animation checkers should also be problem solvers. The animation checking department is not a place for the feint of heart. In the heat of production, this department often becomes flooded with scene fixing problems. Staffing this department with the correct number of checkers and artists to fix the drawings can greatly facilitate the workflow through the ink and paint and final check departments. Whenever possible, it is extremely helpful to create a "fix-it team." Artists from the clean up and effects departments who are specifically devoted to the animation checking department can help handle problems efficiently. The alternative is returning the scenes to the actual departments for clean up, with the focus being on meeting the weekly quota rather than spending time on a scene that has already been considered complete for the department. In such cases, retake scenes end up staying in their respective departments for a lengthy period while creating inventory shortages for upcoming departments, such as ink and paint.

After a scene has been checked in a traditional manner, it is sent to the scanning department. The background elements are also scanned into the computer by the color scanning department. After final scanning is complete, the scene goes to the digital checking department where the same animation checkers (also referred to as digital checkers) drop the line drawings (that is, the clean up and visual effects animation and the painted background) into the digital scene originally created by the scene planner. At this stage of the process, the scanning resolution is increased from 100 dots per inch (dpi) to 200 dpi, enabling the animation checker to study the line quality closely, verifying whether the line density or resolution necessary for the large screen has been accomplished. The animation checker checks the scene once again to make sure that all elements work together from a digital standpoint and that it is ready for the ink and paint departments.

With the advent of digital production, the number of levels to a scene has jumped from a maximum of six to over 60 or more when necessary. Exposure sheets are digitized and filled out on the computer. For the animation checker, the number of elements to examine and fix in a scene has therefore

greatly multiplied. At the same time, it is no longer guesswork as to what the scene will look like once it has been shot on film. Since the scene is digitized on the computer, the animation checker can preview the scene and make sure that the instructions on the scene have been followed (e.g., the camera movement is smooth and no inbetweening mistakes make the animation jitter). All possible drawing or mechanical problems can be detected and fixed in this department before the ink and paint stage, allowing scenes to be as close to perfect as possible.

Ink and Paint

At this phase of the production path, animation meets color. Although the phrase "ink and paint" describes part of the process, it is actually an umbrella term for a number of departments, including color styling, color model mark up, paint mark up, and ink and paint.

Color Styling

In this department, the choice of color for all of the characters, effects, and props is established, starting with the main cast. The focus here is to produce a color scheme that compliments the animation and features the makeup, hair, costume, and special effects. Using the background as a guide, color stylists create a *color palette*. In selecting colors, it is important to avoid the character and visual effects levels either blending or contrasting too much with the background unless there is a creative reason to do so. Primary areas that the color stylists concentrate on are the character's skin color (including the inside of the mouth), hair color, and costume. Additionally, they select colors for lighting effects such as tones, rims, and contact shadows. Color stylists need the following elements in place before working on a scene:

- Character model sheets
- Effects design sheets
- Approved color models for characters and effects
- Hand-drawn clean up animation and visual effects (from here on referred to as original drawings)
- Color thumbnail paintings from the background department (if applicable)
- Digitized cleaned up animation and effects levels (from here on referred to as digital files)
- A digitized background

The requirements for becoming a color stylist include extensive knowledge of color theory and its application. Being able to give the animation

dimension, texture, and weight through color are important skills for this role. Two aspects of the color stylist's job also apply to all other ink and paint staff: a familiarity with the digital ink and paint system and the ability to input information on a computer.

By the time the production gets underway, the color choices for the main character should be established. However, each scene needs to be analyzed individually so that the appropriate shades of the main color palette can be selected in order to match the environment. For example, if a character is in a semi-dark room lit by candles, the color scheme will be different than if the same character is in broad daylight. Depending on the production setup, many colors can be predetermined by color thumbnail paintings made by the background department. These are (roughly) 2" by 3" paintings created for key moments in each sequence to give an early representation of what the scene should look like, both for the final background artists as well as the color stylists. To help scenes move through the department quicker, color stylists try to color model sequences in advance by placing the standard character model sheets over the thumbnail paintings and adjusting their colors to match the scene. Thus, when the actual scene comes into the department, these palettes can be plugged in, enabling color stylists to have a quick start. Usually from this point, only minor tweaking is needed.

New technology has literally revolutionized the possibilities in the color styling department. Millions of colors are available to color stylists, allowing the art director to pinpoint the exact shade desired. When revisions are necessary, the time required to re-do the color styling is a fraction of what it was before computers. Equally as important is the capability to have color continuity throughout the film. The computer system enables color stylists to access an album of scenes so that they can compare the scene they are working on with other scenes that have been completed earlier.

In addition to color styling, new technology has also enabled this department to create certain kinds of digital lighting effects. For example, if the effects department has not created a rim or tone matte for a character for budgetary reasons or time constraints, the color stylist can produce one by offsetting the character against itself to create what is called an *offset rim* or *offset tone*. This works best when characters have a simple silhouette and do not move much. They can also create gradating color palettes so that, for example, a character can be lit by a beam of light above the belt while maintaining a cooler palette below it. Gradations can be created in any shape into which an alternate palette can be matted. The computer also allows color stylists to interpolate between palettes; for example, if a character is standing outside on a sunny day and then goes into a candlelit room, the digital system enables the color stylist to create a smooth transition of color between the two locations.

Color Model Mark Up

The artists in this department are responsible for assigning color coding to the character and effects animation according to the choices made by the color stylists. This coding then becomes a guideline for the ink and paint artists. As they process this information, the color model mark up artists also select the appropriate choice of color for the ink line or the clean up animation. Knowing which paint colors would allow the ink line to successfully integrate the color stylist's color selection with the background is a crucial part of this position. In other studio setups, the color model mark up artists do not choose final ink colors, but rather determine which regions of a character require different colors and which can share the same color. The color stylist makes the actual ink color selection in this type of production setup.

The color model mark up artist should understand animation mechanics in addition to inking and color application. Previous experience in ink and paint and paint mark up is a requirement. In order to start work on a scene, the color model mark up artist needs the following items:

- Character model sheets
- Effects design sheets
- Color-styled model sheets (character and effects)
- A color model mark up palette
- Original drawings
- Digital files (complete with the color styled frames)
- Color sketches from the animation department (if applicable)
- Artwork from the effects department (if applicable)

Color mark up is often done on paper as well as digitally. Having a hardcopy is wise for quick reference, especially when the screen is already cluttered. The advantage of using the computer is that more color choices are available for the ink line. The drawback is that the creation of models requires an inordinate number of colors for the ink line. It is important to set a precedent in terms of the possible number of colors to be used; otherwise, this process can become highly complex and costly. Since the inking process is so time consuming, there are often only two main palettes: one for medium and close-up shots of characters, containing the maximum number of inks (anywhere from five to 20), the other a more simplified version used for long shots (with no more than two inks).

Paint Mark Up

For this position, artists need to have previous ink and paint experience since they are responsible for making sure that the scene is fully prepared for the final color application. Although all the drawings have been thoroughly

checked by the animation checking department, paint mark up artists go through the digitized scene another time, checking for items such as correct registration and color demarcation. Closing off all the lines is a necessary step before the start of ink and paint, since any opening will result in the paint digitally bleeding into the next section. While the color model mark up artists indicate what colors are to be used, the paint mark up artists pinpoint the actual areas to be painted. In general, the paint mark up artists paint key frames where there may be confusion regarding regions of a character, particularly if the character turns or moves into a position not shown in the model sheet. They establish registration lines so painters are clear in regards to how the different levels of artwork in the scene will come into contact with each other. In order to start their assignment, paint mark up artists need the following items:

- Character model sheets
- Color-styled model sheets (character and effects)
- Original drawings
- Digital files (complete with color-styled frames)
- Color mark up information

Ink and Paint

The painters digitally apply paint to all animation levels (character and visual effects animation). They use the color palette available on the digital ink and paint system to add ink lines, and paint every drawing in a scene exactly as it has been modeled by the color stylists and set up by the color model mark up and paint mark up artists. In order to get started, these artists need the following items:

- Character model sheets
- Color-styled model sheets (character and effects)
- Original drawings
- Digital files
- Color mark up and paint mark up information

Ink and paint is an entry-level position that generally requires no experience. Willingness to learn how to use a computer and a lot of patience are necessary. After the initial phase of getting familiar with the process has been completed, becoming fast at painting is a great asset in helping the ink and paint artist get promoted into the ink and paint mark up department and beyond. When productions are behind schedule, it is possible to set up day crews and night crews in order to complete the ink and paint process as quickly as possible. As long as the inventory is sufficient for keeping both crews busy, it is possible to make up for lost time in this department.

Final Checking

Similar to the animation checking department, the purpose of this production step is to verify the pre-composited scene that has been completed through ink and paint and make certain that it is ready for the last production step: final composite and film output. The final checker specifically concentrates on color. While examining the scene, the checker looks for paint errors. This department is responsible for going through the scene frame by frame to avoid any potentially problematic visuals. The final checking department reviews scenes and deletes any artwork that is not intended by the director. It has happened that crew members personalize the project by inserting a joke in unexpected parts of a scene. An example might be if the scene takes place in a gothic location that is filled with gargoyles and one of the statues is shown holding a cigarette. Final checking ensures that no such drawings make it into the final picture. In order to complete their task, final checkers need the following items:

- The original scene
- Original background elements
- Digitized files completed through ink and paint
- Digitized background elements
- Sweat box notes

A final checker should be trained on the computer paint system and be able to detect and fix ink and paint errors. It is essential that they have hands-on experience in animation production and understand the process. They need to be able to pay attention to details such as line density. Should there be problems with the digitized elements such as the background banding (that is, the scene looks like it has solid horizontal lines going through it), the final checker must be resourceful and find a way to fix the artwork.

Compositing/Film Output

When compositing, the final checker retrieves and assembles all artwork specifically created for the scene. The checker makes sure all elements such as mattes are in place and that the scene is ready for final output. Taking one last look at the scene, the final checker makes sure that it is literally picture-perfect before it is rendered at 2000 dpi or 2K output. Depending on the production, the scene is then transferred to film and/or video in preparation for final color sweat box approval and completion of the production phase.

Figure 9–2 shows a traditional 2D production flow chart.

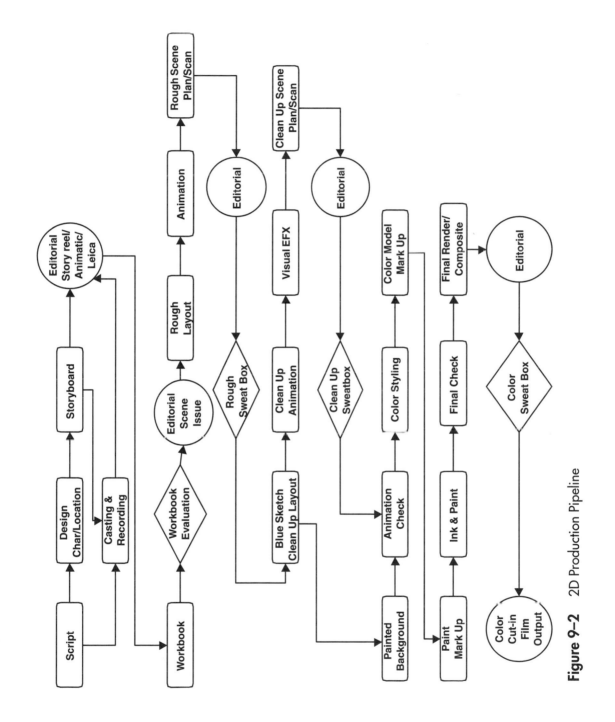

Figure 9–2 2D Production Pipeline

239

3D Computer Generated Imagery (3D CGI): From Pre-Production Through Final Film/Video Output

Perhaps the best way to understand 3D CGI is to consider it a merger of two methods of filmmaking: 2D animation and live action. The process for generating 3D CGI animated projects is very similar in many ways to traditional animation, with some subtle but significant differences in production procedures. Unlike hand-drawn animation, in 3D CGI, artists must create a three-dimensional world in the computer. Three-dimensional sets must be built, lit, and painted, much in the way that sets are constructed for live-action films. 3D CGI also resembles live-action filmmaking in terms of spatial conceptualization, lighting, cinematography, scene hook-ups, and blocking of actor's movements. To get from idea to screen, however, 3D CGI follows the traditional animation model in which the artist must go through a series of steps to first create and then define the image.

It is important to keep in mind that unlike traditional 2D animation, which follows a fully established path, CGI production is still in the midst of defining and standardizing its processes. Depending on the style of the CGI show—for example, cutout animation versus 3D—the software used and the actual production process are different. The following is a basic outline of the production steps involved in setting up a 3D CGI project.

1. Design
2. Modeling
3. Rigging
4. Surfaces (texture and color)
5. Staging/workbook
6. Animation
7. Lighting
8. Effects
9. Rendering
10. Composite
11. Touch up
12. Final film/video output

Using the 2D designs as a guideline, the first step, called *modeling*, is to describe the shape of the objects and characters to the computer. These are mathematical descriptions of the three-dimensional shape of the object. Following this step, the objects must be prepared for movement. This process is referred to as *rigging*. In the case of a character, an internal skeleton is defined, which becomes the basis for the character's motion. The surface, or "skin," of the character is attached to the skeleton in such a way that when

the internal skeleton is manipulated, the character's skin bends in the desired way. From here, the surface properties must be defined, including texture and color.

At the same time as the character is undergoing modeling and rigging, the environment or location is designed in 2D and then developed in the 2D workbook stage. After 2D workbook is approved, a rough 3D set is built matching the key drawings in the storyboard sequence. By setting the camera in different locations (per the 2D workbook), the spatial requirements for the sequence are established. Throughout this process, the space is altered as needed in order to make sure that what has been planned for in 2D also works in a 3D environment. The entire workbook must be approved in 3D before the start of animation or the building of actual set pieces. The next steps are character animation followed by lighting and effects. After the scene has been completed and approved through the above steps, it is ready for rendering, compositing, touch up (if needed), and final film or video output.

The main advantage to CG animation is that it is a non-linear process. Parts of the above pipeline can be separated out and worked on simultaneously, theoretically increasing the speed of production. For example, the final sets can be constructed while animation is in progress and lighting and effects are being developed for the scene. It is possible to animate the character in steps; that is, start with gross body movements and add subtle enhancements later. At the same time, different animators can work on a character's facial animation while its body movements are being worked on by other artists. When revisions are required on a scene, it is returned to the appropriate department to be fixed. This doesn't always mean the artists must start from scratch; they can often correct the existing artwork and the scene can continue on the path to final render and composite. Since this is a recurring pattern in CGI production, we refer to it as a "circular path." An important consideration for a producer is to create a schedule that will allow for as much research and development in pre-production so that the majority of the "circular path" takes place before the start of production. Otherwise, the management of a show will be close to impossible since it can't move forward. The producer must therefore schedule time for problem solving during production, while making sure that every effort is made to stay on target and meet weekly quotas.

Pre-Production Overview

Initially, traditional animation and 3D CGI begin pre-production on a similar path. As previously mentioned, in both cases, 2D designs create the basis for characters, locations, and the project's art direction. They both have casting, recording, and storyboarding in common as well. The words in the

script are visualized on storyboard panels that become the foundation for how the film is going to look shot by shot. The recorded lines are edited together to create the voice track. The production of a story reel is also a shared step for both traditional animation and CGI. However, in traditional animation, the story reel remains as two-dimensional line drawings throughout the timing process. A 3D story reel or an animatic, on the other hand, is built with very primitive three-dimensional shapes that replace the original line drawings taken from the storyboard. (For more information on the storyboard, voice track, and the story reel, see Chapter 8, "Pre-Production.")

Camera movements are also built in, which allows the director to see how the scene is going to play out. Since the camera can move in a three-dimensional space (that is, along x, y, and z axes), it is possible to preview the characters' blocking and tweak as necessary. By comparison, in a 2D story reel, the camera movements are typically limited to a pan or a zoom-in/zoom-out. How the shot is going to look is not fully established until the scene has been completed through rough animation and scene planning. The process of creating the story reel takes place at the same time as the development of 3D CGI elements that are needed to build each scene. This process is called *modeling*.

Modeling

The term modeling is the process of building the objects that are going to be placed in front of the camera. Whether the item is a character, prop, or an environment, it first needs to be modeled. There are a number of ways to create the initial design for an element in the computer. The most commonly used methods include digitizing a 2D design that is then modified in the computer and given volume and dimension. Another approach is to buy a software package that provides the modeler with basic three-dimensional geometric shapes, also referred to as primitives, which can be fused together to create the initial model. Yet another method is to scan in a macquette, or a sculpture. The image captured from the macquette on the computer becomes the reference for a wire-frame model. Whatever the method of building the model, a single modeler, or possibly a team, can take portions of the model and refine them at the same time. Once all of the sections have been completed, one person assembles them and cleans up the joining sections to ensure that it looks like one homogeneous piece.

A modeler should have both technical and artistic skills. Having a strong background in traditional arts is important for this role. Additionally, they should have an in-depth understanding of form and motion in relation to modeling. Also helpful is a working knowledge of linear algebra, computer science, and engineering. Familiarity with complex 3D modeling packages, computer graphics, and programming is also very useful for this role.

Render Tests

As implied by the title, the purpose of this step is to put the artwork to the test. Render tests are central to the CGI process as each element gets developed and is further refined in preparation for the next production step. Starting as early as the modeling stage, for example, the 3D object is rendered many times so that the modeler can fully examine its overall shape and volume. As noted before, the creative progression of a CGI character, prop, effect, or location can be circular. In other words, a model might be signed off in one department, but as it gets worked on in another department, it may become apparent that it has to re-track one or more previous steps. In order to check each step, a render test takes place.

Rigging or Kinematics

There are essentially two types of rigging or kinematics: forward kinematics and inverse kinematics. Kinematics basically refers to motion. Forward kinematics means that the joints of a skeleton are defined such that to move a "bone-chain" (say a shoulder-to-elbow-to-wrist), you start at the root, rotating the shoulder first, then the elbow, then the wrist to get the hand into the correct position. Inverse kinematics allows the animator to place the hand anywhere in space, and the computer figures out the rotations and placement of the upper arm, forearm, and elbow to "connect" it to the shoulder. It is similar to being able to grab the hand and move it around to within the limits of where the arm can stretch. Sometimes, rigs are designed to allow either forward or inverse kinematics for animation, as both are quite useful for different situations. To put it simply, the rigging process is adding a skeleton to the model so that body parts are connected and can be manipulated by an animator.

After the model is rigged, when one body part is moved, the rest of the body moves proportionately. The riggers collaborate closely with the modelers. As they go through the process of making a character move, it may become apparent that there are problems with the design of the model. In such cases, it is necessary to revise the model to allow for easy movement. Once the model is fixed, it is returned to this department for completion of rigging. Similar to an animator, the rigger defines a character's range. The two positions are completely co-dependent as they explore the path to achieve a particular performance for a character. The next step for a rigger is to become an animator.

Skinning

The next production step is commonly referred to as *skinning*. During this stage, muscle formation (in the case of a character) and skin coverage is

added to the model or skeleton. Skinning is really part of the modeling process. In general, it is started with the outermost surface first. A skeleton is then built inside the object, and the skin is attached to it. At this point, the model looks like it has been made of clay. Upon approval, orthographic poses are created that show the character from different angles, including front, back, top, bottom, and three-quarter view.

Test Animation

Once a model has been rigged, it will be given to the animators to test. Walk cycles and key movements are worked out during this phase. In the case of a character, the model will go to a character animator. In the case of a prop, an effects animator will work on it. It is the animator's job to explore the model and move its parts in order to ensure that it meets all requirements. If there are problems with the way a limb articulates, for example, the model may be returned to the rigging department. If the rigging department cannot solve the problem, it may be necessary to modify the model; as such, it will travel down the "circular path." The model travels between these three departments (modeling, rigging, and animation) as often as necessary until all problems have been solved.

Surfaces (Texturing and Color)

All character models, environments, and props need texture (such as wood, plastic, metal, or fabric). The surface treatment of a model is referred to as texture. The process of creating texture is in some ways similar to traditional background painting and digital color styling. When creating textures, the main thing to establish is how to combine light and color to get the desired look. A few questions to ask when developing a texture include, Is the model opaque or translucent? Does it reflect light and/or emit light? If so, to what degree? Is the surface reflective? How dark are the shadows on the surface? The answers to these sorts of questions allow the texture artist to head in the right direction. During production, the texture artist collaborates closely with the art director to create the look. Depending on the complexity of the surface, it can be a very lengthy process before the final texture is developed and approved. Once textures are placed on those models that require animation, they are tested again. If there are any problems with how the textures affect the model's movement, it may be necessary to revise it further, placing the model back on the "circular path."

The texture artist, also referred to as the *look development artist*, should be able to produce the appearance that is wanted on the project no matter what the medium. Extensive experience in traditional painting is helpful. Familiarity with software programs created for painting and lighting in

addition to an in-depth understanding of color theory and application is also useful. Previous experience in 3D CGI or traditional animation is a must for this position.

Environment

An environment can be described as the viewable space that is seen through the camera's lens in a sequence. Depending on the studio, the setting for the action may be referred to as an environment, a landscape, a set, or a location. After the 2D conceptual design is approved, it is used as a blueprint to develop the three-dimensional model for the setting. During the 3D workbook process, a "rough" set is built. This becomes not only a pre-visualization step for animation and workbook, but also serves as a template when the actual set is built. Initially, this artwork is purposefully created at a low resolution so that it can be manipulated more easily and moved around to accommodate the action. Environmental effects such as clouds, fog, water, and atmosphere are identified at this stage to be handled by effects animators.

3D Workbook

On a parallel path, as the models are developed and tested, the 3D story reel gets further refined and becomes what is referred to as a *3D workbook*. The emphasis at this stage is on final timing, composition, staging, and cinematography. Creating a 3D workbook is costly and time consuming, but it is an indispensable tool. It shows the following elements at this early stage of the production process:

- Rough model of the location (viewable in 360 degrees, if applicable)
- Character placement, broad action, posture, and interaction
- Character continuity and screen direction
- Real-time depiction of the characters' actions against the background in relation to camera(s)
- Camera position, angle, movement, and lens
- Rough lighting

The benefits to creating the 3D workbook are manifold. Although the visuals are at a low resolution, 3D workbook paves a smooth production path for a project by solving potential problems from the very beginning. It enables the director and producer to determine the audience's eye placement and avoid creating unnecessary artwork. Once a sequence is approved for production, the artistic leads can review the 3D workbook to discuss the needs for each scene in detail. The location/environment department can build the sets as indicated by the 3D workbook model, and

if live action backgrounds are to be shot, the camera crew can use this data for programming the motion control camera. The animators can refer to the 3D workbook for character placement and action against the scene's background. In the case of visual effects, artists can see what specific elements are needed (such as dust, water, or rain). The 3D workbook can also function as a tool for the lighting artist in pre-determining whether the lighting should, for example, be spot light, saturated light, moonlight, or daylight.

Having done significant pre-planning at this stage, once the 3D workbook is signed off, the computer scene file becomes the template for the final shot. The remaining steps include replacing the low-resolution, basic geometric shapes with high-resolution models, animation, texturing, adding effects, lighting the scene, and rendering, compositing, and outputting the final shot. The above steps are viewed and approved by the director in sweat box.

3D workbook artists should have both 2D and 3D experience, or at least be knowledgeable in 3D animation. They need to have a broad-based understanding of CGI and 3D camera manipulation. They are responsible for creating rough models that are used as templates for the actual 3D sets. They must have a thorough knowledge and understanding of the 3D space, as they define the setting for use by animators and technical directors alike.

Animation

Animation can begin once the 3D workbook on a scene is approved. Anything that a character interacts with, such as the ground plane or props, should be modeled prior to the start of animation. Similar to a traditional animator, the computer animator breathes life into the characters by imbuing them with personality and giving them the ability to move and interact.

The same principals of animation mechanics, acting, and timing apply for this role, except that the computer animator must also be able to use the computer as an artistic tool. Additionally, the computer animator should be trained on how to animate a character so that its construction, movement, weight, balance, and proportions are consistent. Previous experience in traditional animation, stop motion, and claymation is a great asset for a future computer animator.

After the initial pass of animation for a scene has been completed, it is dropped into the final animatic. Once the scene is approved in sweat box, final animation can start. This production step focuses on subtleties in the character performance, such as skin bunching up when a character smiles. At this step, any animation glitches are also fixed. As a scene is approved in final animation, the editor cuts it back in 3D workbook, replacing the earlier version.

Lighting

As long as the final model for animation is approved, it is possible to start exploring ways to light a scene. How a scene and/or a character are lit can greatly affect the viewer's perception and emotional reaction. Lighting creates a mood and, when necessary, adds drama. This step is very similar to live-action production in that actual lights are set up in the computer to illuminate the set. The main difference, however, is that on a 3D CGI show, the lights can be used to create shadows. Often, much time is spent on how light interacts with other surfaces, and whether the light is reflected or diffused. An advantage to 3D CGI lighting is that it can be aimed to satisfy the visual needs of the scene rather than play to physical correctness. If the shot works better without the shadow, it can easily be omitted. It can also be stylized, if need be.

The process of establishing lighting begins during the 3D workbook and is completed once animation of a scene is finished. The most basic of these so-called virtual lights are spotlight, point light, and parallel light. The spotlight emits a single beam of light to a single point. The point light produces omni-directional lighting. Parallel lights radiate an equal amount of light in the same direction. The lighting artist initially uses key lights such as the ones noted above and pluses the scene with other light sources in order to create a look for individual elements on the set and to maintain lighting continuity.

A lighting artist's knowledge of color and cinematography is key to this position. Experience in 3D lighting is a must for this role. A background in traditional painting, drawing, and photography is also helpful.

Effects

For the most part, visual effects are created through a close collaboration between effects animators and technical directors. An effects animator generally moves objects by creating key frames, while a technical director uses computer rules or algorithms (such as dynamic simulation) to procedurally define motion. Visual effects are instrumental in creating a mood and atmosphere. Analogous to their counterpart in traditional animation, 3D CGI effects animators are responsible for designing and creating all non–character-related animation. Their artwork includes items ranging from furniture to vehicles (also known as props) to natural elements such as shadows, mist, fog, wind, and fire. Similar to models, the visual effects are tested. The effects are developed in unison with the lighting to ensure proper integration with all elements. Once the scene is completed for lighting and effects, it is inserted back in the 3D workbook and is viewed in sweat box.

For a visual effects animator, a good understanding of software programming is helpful. These positions can be highly technical. Previous experience in traditional effects animation and a desire to explore new technology are highly advantageous for this job.

Rendering

The rendering and compositing processes occur at most steps in the production process. These processes end at the point when all elements are assembled and the final scene is shot at delivery-quality resolution. There are different complexity levels to the types of renders available. The least complicated render is when the image is in its germinal stage—for example, a wire frame, as described above under Render Tests. The more layers are added, such as texture and lighting, the longer it takes the computer to process all the mathematical data and generate the image. Depending on the production step, it may be sufficient to produce a low-quality image, as would be the case in a 3D workbook. However, when the final scene is ready for output, it is necessary to use the highest form of rendering in order to see how the shot is going to look on the theatrical and/or television screen. Final rendering of a shot involves the computer retrieving all the information pertaining to the scene, be it models character, props, environment, textures, lights, and camera. Depending on its complexity, a scene may require hours or possibly days before it can be fully rendered.

Compositing

At this stage, the scene is broken up into separate elements and then layered back together in preparation for final film or video output. During compositing, a scene can undergo many changes, including being re-composed and having its depth of field altered and its color tweaked.

The individual responsible for combining all of the elements is called a *compositor*. When these elements are created in mediums other than CGI, such as live-action or traditional animation, they need to visually match all material. A final composite on a scene should be seamless—the viewer should not be able to distinguish between the different mediums used for the shot. (For more information on mixed media or reasons why a project may use both CGI and traditional animation techniques, see Chapter 1, "Introduction.")

A compositor should have in-depth knowledge of digital ink and paint, specifically in relation to resolving tonal differences. The compositor should be able to troubleshoot as necessary and have the aptitude for creative problem solving in order to assemble the final shot. A background in computer graphics and strong drawing skills are helpful for this position.

Touch Up

Once a shot has been finished, a few frames may need to be fixed. Problems can be caused by software flaws, design flaws, or even the production process itself. Since it is too costly to redo a scene at this point, paint programs such as Photoshop, Matador, Amazon Paint, or Inferno are used to touch up the few frames. Once fixed, the scene is ready for final film or video output.

Technical Direction

It goes without saying that none of the above steps would be possible without the support of technical directors, who are involved in every step of the process. Depending on the studio, this title is sometimes used in reference to artists and technicians, including modelers, riggers, and lighters. On some productions, the job categories are divided into two groups: animators and everyone else, who are considered technical directors. No matter what the structure, these individuals are responsible for developing and providing the tools that facilitate the creation of the artwork. One of their main objectives is to find the means with which the CGI animator, for example, can fulfill his or her vision with as little hindrance as possible from the technological side. Additionally, technical directors may write programs and develop new software for individual productions. They are also involved in troubleshooting and resolving all computer-related problems.

For this position, thorough knowledge of the principals of 3D animation is of utmost importance. An ability to use high-end 3D graphics software, a proficiency at 3D programming, and/or knowledge of lighting are also helpful. Depending on their field of expertise, technical directors should have an advanced degree in computer science or an engineering background.

Figure 9–3 shows a 3D CGI production pipeline.

The Making of *Bunny*

Figures 9–4 through 9–11 are images and text from Blue Sky Studios' Academy Award-winning short *Bunny*, written and directed by Chris Wedge. These images illustrate the process involved in building a scene from concept to final rendering.

Step 1

Figure 9–4 shows what is known as a "wireframe." Wireframes are created to give the animators and technical directors a spatial sense of how the

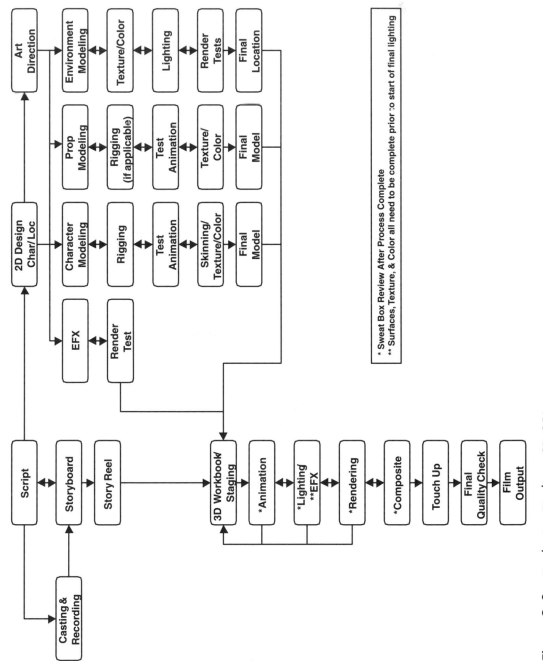

Figure 9-3 Production Pipeline—3D CGI

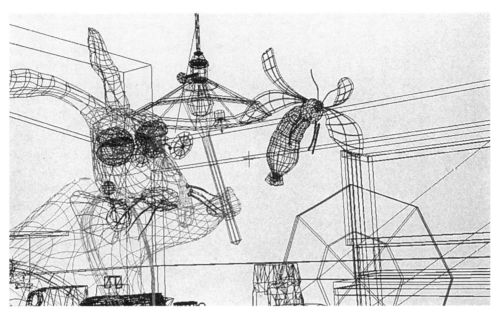

Figure 9–4 Step 1

scene will work. They also enable animators to animate the characters much more quickly, since many time-consuming details are absent. In this frame, the set has simplified stand-in models (the hutch and ceiling, in particular). Using the wireframe and rigging, the animators bring *Bunny* to life frame by frame.

Step 2

In Figure 9–5, everything in the scene has been rendered to make sure all the elements are where they should be. Here, the light source is direct illumination and there is no fill light.

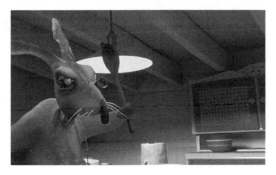

Figure 9–5 Step 2

Step 3

Once everything is in place, the technical team begins work on the "radiosity" of the background. Radiosity includes direct illumination and also light interaction between the object and the scene (also known as indirect illumination). In Figure 9–6, Bunny is in the scene without fur so that the team can get an overall feeling for how the master lighting looks in the background. Here, Bunny doesn't match the finished image. This is one of those cases in which the technical directors chose to bend the laws of physics for the sake of art. Due to the complexity of the lighting program, the team had to think like the director of photography in a live-action film, adding or taking away light that affected the aesthetics of the scene. So, just like on a live-action set, the equivalent of "bounce cards and flags"—white or black blocks—were written into the programming to tweak the lighting and put focus on the proper objects.

Step 4

In order to perfect the radiosity lighting, the scene was broken down into different layers. In Figure 9–7, Bunny has been pulled out of the scene so that the background could be properly rendered and lit with the radiosity application.

Step 5

In Figure 9–8, the focus is on lighting the characters—Bunny (still without fur) and the moth—so that they fit into the scene. Because the radiosity application used on the background creates an organic feel, close to that of film grain, the team has to be sure that the same density grain appears on both Bunny and the moth. This step is also repeated on any props that move in the scene.

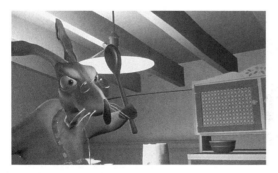

Figure 9–6 Step 3

Figure 9–7 Step 4

Figure 9–8 Step 5

Step 6

Bunny is then put over the backplate, as shown in Figure 9–9. By doing this, the shadows Bunny will throw into the computer-animated background can be seen. At this stage, the lighting concern shifts from a single image to animated scenes. Many times, elements that look fine in a still image look out of place or move incorrectly when the scene is in motion. Those problems are corrected during this step. More and more detail is also added to the images. For instance, reflection passes are added so that objects reflect on tabletops or in any shiny surfaces.

Step 7

The final step is to add fur, as shown in Figure 9–10. The fur was designed so that lighting Bunny without fur would look very much like Bunny with fur. Once the fur was added it was necessary to make some modifications to perfect the image, returning it back to lighting and the steps that followed. At this point, it is important to note that throughout the entire production process, the scene and/or individual elements were returned as necessary back to steps 2 through 7 in order to make tweaks and refinements.

Figure 9–9 Step 6

Figure 9–10 Step 7

Step 8

In Figure 9–11, we see the final image with the flare of the lamp added with Blue Sky's proprietary compositing software Compose™. Notice also that the moth is back in the frame.

Figure 9–11 Step 8

10

POST-PRODUCTION

The Role of the Producer During the Post-Production Phase

Reaching the post-production stage is a huge milestone for the producer. At this point in the process, the picture is basically locked, and what remains to be assembled are the final visual and audio elements needed to create and deliver the finished product. The project's schedule, final delivery format (film or video), and its audio requirements determine the post-production steps ahead.

The role of the producer during post-production is diverse. Activities that take center stage during this phase include overseeing the tracking and the completion of all retakes and acquiring notes and approvals from the buyer/executive in order to lock the picture. In close collaboration with the post-production supervisor, the producer sets up post-production sessions and monitors their progress. The producer also focuses on finalizing credits and main and end titles, which can be very time consuming. Working with the legal department, the producer must get legal signoff on the credits as well as the final visual and audio elements of the production. In television projects, depending on the number of episodes produced and the schedule, the producer may also be managing episodes in the pre-production and production stages at this time. The flow charts in Figures 10–1 and 10–2 detail the steps the producer must take in the post-production of both features and television and direct-to-video projects.

Prior to the commencement of post-production, the producer should establish a crew and set up deals with post-production facilities with the aid of a post-production supervisor. (See Chapter 2, "The Animation Producer," for more information on this topic and for the "Producer's Thinking

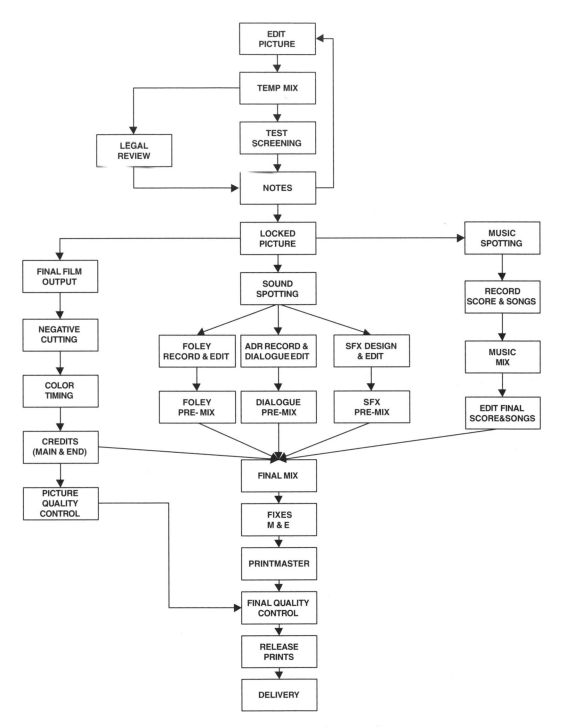

Figure 10–1 Post-Production Flow Chart: Features (Film Completion)

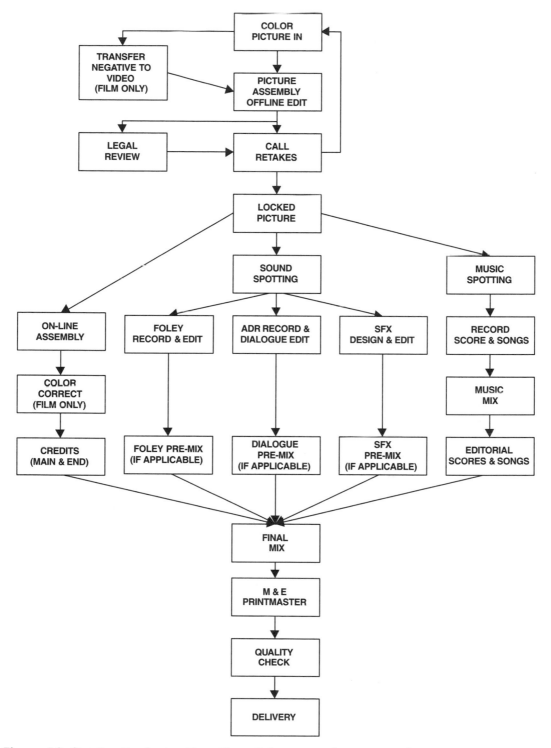

Figure 10–2 Post-Production Flow Chart: Television and Direct-to-Video Projects
(Video Completion)

Map.") The following is a list of possible staff members and elements that should be in place by this stage depending on the project's requirements:

- The picture editor and crew
- The composer
- The music editor
- The post-production supervisor
- The sound supervisor
- The audio editorial crew
- Facilities: audio, video (if applicable), lab/film output (if applicable)
- A draft of the final credits
- The video cassette duplication facility (if applicable)
- The final/locked picture to length as per the delivery requirements

On television and direct-to-video productions, a post-production supervisor needs to be hired before the start of post-production so that he or she can set up this portion of the process. In animation studios that produce a significant amount of television or direct-to-video projects, the post-production supervisor may be on staff and be assigned to the project as it nears post-production. Depending on the studio setup, a feature post-production supervisor can start as early as pre-production. In this capacity, they typically coordinate efforts with the camera department and editorial in setting up daily sweat box sessions, film tests, and screenings. The post-production supervisor may also be responsible for scheduling recording sessions. They also oversee film processing, video tape recording, editing, transferring, and dubbing during production. They frequently interface with ancillary groups and provide them with audio and video elements needed, for example, to put together a trailer or television spot. Throughout the production, the film is shown to potential promotional partners in order to market it effectively. The post-production supervisor has to make sure that all elements needed for these presentations are ready.

Before post-production begins, it is the supervisor's responsibility to prepare a schedule for the producer as well as obtain bids from the various facilities, including video houses, audio houses, labs, digital film printers, negative cutters, and cassette duplication facilities. Once facilities are selected, the producer and post-production supervisor negotiate the various rates and deals. Most post-production facilities have standard hourly rate cards for services. It is common practice for the producer to negotiate for a reduced hourly rate or possibly a package deal to include all services. In the case of a large studio, this negotiation process may be taken out of the hands of the producer and handled by the post-production department. In such cases, deals may already be set by the studio since they can negotiate in bulk and offer the post-production facility work on a number of shows.

Unexpected hurdles are part of the reality of post-production. The producer thus must be very flexible and proactive to allow for these challenges and overcome all obstacles posed by the typical reshuffling of the schedule. In the case of television, it may be that a particular episode delivered by the subcontractor has a very high percentage of retakes and cannot be completed as per the original schedule. These retakes may involve re-shoots that affect the length of picture. In such cases, locking picture on the original date may not be possible. In order to accommodate the need to receive corrections, it is necessary to delay and reshuffle the schedule. For features, an additional temp dub may be requested by the buyer/executive that wasn't planned for. Fulfilling this request automatically results in delays and overtime for the sound team since they need to create another temp dub rather than complete the final edits required for the final mix. The post-production supervisor aids the producer in determining how the schedule can be rearranged. The supervisor needs to be on top of coordinating and communicating these changes to the director and the buyer/executive, and must update all applicable vendors on scheduling changes in order to avoid costly fees due to late cancellations.

The schedule can also play a significant role in a deal negotiated with a post-production house. If as the producer you are involved in the negotiations, before signing a contract, be sure that the facility has reviewed and agreed to your schedule and delivery requirements so that no surprises come up later. It is important that the producer ask questions regarding the amount of work a post-production house already has at the time their project is going to go through the facility to ensure that they are treated as a priority client.

During post-production, the producer continues to be involved with the ancillary groups, providing all required materials. They also need to oversee that screenings are set up for executives and marketing, licensee, and promotional personnel. Finally, it is the producer's job to oversee that all audio and picture materials and final artwork are archived. This archiving can also include original materials from subcontractors shipped back for possible retail purposes. All digital files also need to be catalogued and stored in case there is ever a need to go back to the source materials.

Music

Music plays a central role in animated projects. It creates mood, atmosphere, pacing, and momentum. By hearing the score, the viewer should be able to define the show in terms of its genre (thriller, musical, comedy, etc.). This voice is realized by the composer; thus, the sooner they are brought on the project, the more they will be able to contribute to the film as a whole. As early as the script stage (if possible), it is helpful for the director to meet with the composer and share his or her vision. On features, the composer's

primary goal is to capture the essence of the film and create an original score. The time and financial limitations of television shows and direct-to-video projects, however, require the composer to write a score but cut costs in areas such as orchestration. Under these circumstances, the composer may chose to create the score by combining music produced on a synthesizer with some live recording. Often, before the show is returned from the subcontractor, the composer compiles a library of original musical themes and character cues. Once the project is returned, the music editor uses this library to build a score.

Producers have to take into consideration three elements when the time comes to select a composer: talent, budget, and schedule. On lower-budget productions, they can contact music agents, who submit sample reels of their clients. The producer and director choose the best candidates and forward their names to the buyer/executive. Together they make a decision on the most suitable talent for the project. On projects with higher budgets, the producer, together with the buyer/executive and the director, makes contact with agents representing famous composers. The advantages to selecting an "A-list" composer are of course the quality of their work and the potential revenue on soundtrack sales. This level of talent tends to be very hands-on throughout the course of production. Due to the lengthy schedule of features, however, these composers don't work on more than six to eight projects per year. In other words, the budget and schedule may be plentiful, but the talent may not be available. Whether it's a low- or a high-budget production, however, the search for the composer should begin as early as possible. (For information on the role of the composer in relation to producing songs, see Chapter 8, "Pre-Production.")

Once the composer has been selected and the negotiations have been completed, the composer meets with the director and producer to go through the project's key sequences using the script as the basis for their discussion. Articulating musical needs is very difficult. Thus, the composer must function as a detective in search of clues. They almost have to understand the director on an instinctive level. The director, on the other hand, should refer the composer to other pieces of music and feel confident about sharing his or her emotional reactions. Ideally, it is only the director's vision that the composer must follow rather than a committee's. It is up to producers to do everything in their power to keep the communication line between the director and composer as clear as possible. It also falls on the producer's shoulders to inform the composer of the project's specific needs, such as the date by which the score needs to be completed.

The extent of the music editor's role varies from project to project. On features, it is common to hire a music editor to assist the producer, director, and film editor by creating a temporary music track. The temp track then becomes a guideline for the composer in terms of the kind of music the producer and director have in mind for their show. The next step for the

composer is to put together a full mockup/synthetic orchestration for each sequence. The producer and the director hear, and sign off on, each sequence until the entire score has been generated and approved. Depending on the extent of the involvement of the buyer/executive, final approval of the score may or may not require their input.

Upon completion and approval of the score, the producer and composer set recording dates. A scoring stage is booked and details such as the number of sessions, the number of musicians per session, the picture playback format, and the recording format are provided to the person responsible for setting up the stage. The composer then employs a contractor to assemble an orchestra based on the project's allotted budget and schedule. (For more detailed information on this topic, see Chapter 6, "The Production Plan.") An average orchestra can range anywhere from 60 to 100 musicians. On many high-budget productions, the producer may opt to hire orchestras based in cities such as London, Los Angeles, and New York. Some studios may choose to go non-union or travel to other places where they can buy the talent and avoid paying union rates or residuals. This method can result in substantial cost savings, as the buyout is a one-time fee. As noted earlier, the lower budgets on most television series and direct-to-video shows limit the composer. Portions of the score, or cues, for these kinds of productions are therefore frequently reused in order to have full musical accompaniment for the entire show.

After the score has been recorded, the music editor typically oversees the mix and edits the score to picture. This is the process in which all the instrument recordings are mixed down to a manageable number of tracks, usually around six to eight. In this process, the instruments in the same family are grouped together and referred to as stems, such as the brass stem or the woodwind stem. The use of stems allows the mixers to emphasize, or if need be, remove, certain instruments during the final mix. On lower-budget productions, the final recording is delivered on DA 88 or Digital 98 to the dub stage. Feature productions, however, tend to use CD-ROMs. At this point, the score is ready for the final mix. For more information on how the music track is integrated with the picture, see Figures 10–1 and 10–2.

The Post-Production Process

This chapter covers basic post-production steps involved in taking the project from workprint/work-reel stage to final delivery. For a more detailed discussion on this topic, we recommend a number of books listed in the Appendix, "Animation Resources."

When it comes to post-production, picture editing is automatically the first step that comes to mind. In animation, however, all shows are pre-edited down to the exact frame before the production stage officially begins. (See Animation Timing in Chapter 8, "Pre-Production," for more

details.) It is therefore an anomaly to describe the picture editing process of an animated project as strictly part of post-production because it shapes the project starting in pre-production.

Locking Picture

In television and direct-to-video projects, post-production begins when the picture is returned by the subcontractor. This version of the show is referred to as "take one." The picture editor's job begins at this point. The scenes in video format are transferred into an offline editing system (a cost-effective system used in the pre-final stages of editing), where they are assembled. Once assembled, the producer and/or director, along with the editor, view the picture and call retakes. They then compile a list of retakes and send the list to the subcontractor. While they wait for these retakes or scene fixes to be completed, the editor continues to edit the picture. As revised takes are received, they are viewed, and, if correct, are cut into the picture. If the scenes are problematic, further retakes are called. Once all of the approved scenes are cut in, the picture can be locked. In some cases, however, due to schedule restrictions, the producer may have to lock picture before all of the final scenes are received. As long as the length has not changed, the online editor can replace an incorrect scene with a corrected one.

In contrast with television and direct-to-video shows, where the editor typically is hired after the picture has been completed, on feature productions, the editor plays a central role in the shaping of the films, starting as early as the storyboarding phase. The editor's primary objective is to help the director realize his or her vision as the film gets developed, from its germinal stage through final color. Casting the right talent for this role is critical since it requires editing skills in addition to an understanding of animation timing and storytelling. After all, the editor's timing sensibility dictates how the show is going to be paced. The editor's job also entails conforming the soundtrack to the picture, starting with storyboard panels through pencil test, clean up animation, and final color.

Much of the editor's and his or her team's time is spent on maintaining and keeping track of all picture and audio elements as the project goes through its many evolutions. For example, when there is a test screening or a film presentation for the buyer/executive, the film is locked in order to facilitate a temp dub. After each screening, the frenzy on notes in regard to "footage changes" ensues. At this time, the picture editor makes the required changes and documents all changes for external contractors or in-house personnel. All dialogue and effects tracks, temp music scores, and production databases need to be conformed to the changes. Exposure sheets must also be adjusted accordingly. Additionally, numerous tape transfers will have to be made in order to update in-house staff, ancillary groups, and external

contractors (if applicable). As the project begins to wrap up and the final color scenes are cut in to the reel, a feature editor's job is for the most part completed. For more information on the role of the editor, see Chapter 8, "Pre-Production," and Chapter 9, "Production."

Test Screenings

For features, there are usually a few test screenings scheduled, with the first one usually taking place after rough animation has been completed and enough color scenes have been cut in to give the audience a sense of the picture's look. The purpose of screenings is to get feedback from a targeted audience about the story and character arcs, for example. In the case of a comedy, it is also important to check that the humor is playing to the audience. Additional test screenings are set up prior to locking picture to allow for revisions, which can include adding and deleting scenes. Since the average audience is not used to seeing a film in progress, it is important to add temporary music and sound effects to the voice track. This process is referred to as a *temp dub*. There may be other types of screenings, referred to as *presentations*, which are set up for marketing and promotion of the movie. In terms of the format used for the screenings, although very costly, a film print is still a preferred choice to a digital work-reel (although work-reels have improved immensely over the years). Since most features exist purely in the digital realm, if the decision is made to show the project on film, it is important to set aside a number of weeks for its compilation.

Once all changes (including retakes, scene inserts, and omissions) have been incorporated, the picture is considered locked. A *locked cut* or a *locked picture* means that the length of the show is set in stone. Theoretically, it should no longer be possible to change a single frame. Realistically however, most directors try to do fixes on scenes up until the final moment or—in worst-case scenarios—when the release prints are being made for theatrical screening or immediately before the airing of a show in television series. It is therefore critical that the producer establish and balance which fixes are necessary and which ones are not needed from both a fiscal and creative standpoint.

Audio Post-Production

Spotting Sessions

In the sound spotting session, every scene is evaluated from the point of view of how audio can best be used to enhance and help tell the story. During this session, the director and producer determine specifically where music and sound effects should be placed. Usually, there are two different

spotting sessions: sound spotting and music spotting. At these sessions, technical issues, the schedule, and the project's creative needs are discussed.

During the production of the movie, the picture editor builds "temp" audio tracks that contain the original dialogue tracks, temp music score, and temp stock effects. While the sound spotting session is in progress, the current temp track is used as a template. The temp tracks and the director's input give the sound effects editor a more rounded view of the project's requirements. They also serve as rough guides that the editor can use to embellish upon. The temp music score is used in the same way. In most cases, the temp score provides a solid direction to the emotion that the director is trying to achieve. In many cases, the animation and picture editing works in tandem with the rhythm of the music. In our experience, although difficult to do, it is very helpful to assemble everyone involved in the building of the audio at some point as it ensures that the composer is aware of what the editors are handling and vice-versa. This setup allows the entire post-production team to work together much more effectively.

On television, a sound spotting session is usually held once the picture is locked. This is because the budgets are very limited and there is usually no money or time for the sound team to put their energy into re-conforming the audio to a revised cut. It is typical for this session to include the producer, director, supervising sound editor, and other key members of the audio team, such as the Foley supervisor.

On a feature, sound spotting can take place at various times during production, depending on the project. If time allows, sound spotting may take place before the temp dub. Otherwise, the spotting session will be set up before the final mix. The director, picture editor, and producer go through the show with the supervising sound editor and key members of the audio team such as the dialogue editor. Depending on the needs and status of a project, there may be an automatic dialogue replacement (ADR) supervisor, Foley supervisor, and sound designer also present at the session.

Traditionally, on a feature, there are a number of temp dubs for the purpose of test screenings. Due to the many temp dubs and picture changes involved, the sound team is constantly conforming, or updating, the audio tracks. If a scene length is changed, the audio track will be off by the number of frames altered, and their work will have to be re-done to match the picture. This conforming process is ongoing up until the producer or buyer deems the picture locked.

Music spotting takes place with the composer and the music editor. The decisions made in this meeting directly influence the final score arrangement and how the music editor tailors the music to picture. Once the spotting session has been completed, the music track and the sound effects/dialogue track are worked on concurrently.

Foley Sessions

In Foley sessions, all in-sync sound effects that involve physical movement are created. Sounds that would emanate from actions such as footsteps, cloth movement, and punching are all examples of audio elements that are recreated during a Foley session. After the appropriate sounds are selected during the spotting session, they are cued or identified according to time-code (which is an electronic indexing method for video) or footage (film) by the Foley supervisor. On the Foley stage, the sounds are created as per the cue sheets by the Foley artist(s), and are later edited into the picture.

Dialogue Editing and ADR

ADR is the process of recording new dialogue or re-recording old lines that have poor audio quality. This is also known as *looping*. On feature productions, the ADR supervisor and dialogue editor are hired before post-production begins. It is the dialogue editor's job to go through all the scenes and evaluate how much ADR is necessary. He or she adjusts the sync on the original dialogue track for each scene in which the voice performance does not match the character's mouth movements. In order to do this, the dialogue editor looks for alternative lines, replaces syllables within words to correct pronunciation, or fixes audio glitches. The dialogue editor also prepares the tracks for the final mix.

The dialogue editor works with the director to assess what additional dialogue will be required for scenes that can't be fixed, in addition to off-camera lines needed to clear up plot points, for example. For the ADR session, all lines are compiled and put to time-code by the ADR supervisor. Meanwhile, a studio is booked and the voice talent is scheduled. Depending on the number of actors needed, it is important to note that this is usually handled over multiple sessions, as it is not always easy to schedule the talent. During the ADR session, the cued line is located and played for the actor for review. The actor is then recorded while performing the line in sync to the picture. The dialogue editor is then responsible for taking the ADR lines and editing them into the track.

Sound Effects Design and Editing

Sound effects can range from animal calls to spaceships zooming by. They help to convey emotion, suspense, drama, and comedy, for example. They also help to place the viewer in the story by adding atmosphere. Once the spotting session is complete, the supervising sound editor goes through the show and cues the various sounds to be created and/or taken from a sound effects library.

On shows with a large enough budget for original sound effects, a sound designer is hired. It is this person's job to create original and unique sounds that do not exist in a sound library. Next, the sounds are edited to picture. Using the cue sheets as a guideline, the sound effects editor selects sounds and syncs them to picture. It is the sound effects editor's job to cover all sounds, including the backgrounds. Backgrounds or atmospheres (also known as *ambience tracks*) are ongoing sounds such as room tones, freeway noise, a refrigerator hum in the kitchen, or an underground rumble.

Music Score Record

For information on the music score record, see the "Music" section in this chapter.

Music Mix

For information on the music mix, see the "Music" section in this chapter.

Score and Song Editorial

After the composer has recorded the score and the songs have been completed, the music editor prepares the music for the final mix. (For more information on songs, see Chapter 8, "Pre-Production.")

Pre-Mix (Pre-Dub)

The purpose of a pre-mix is to combine like sound elements, which in turn helps to expedite the final mix. This step is specific to feature productions that require a soundtrack chock-full of dialogue, effects, and Foley. In this scenario, since the number of tracks far exceeds the capabilities of a mixing board, a pre-mix session is in order. By having a pre-mix, the mixer can more easily control the different audio elements during the final mix, making the process much more cost effective and time efficient.

Final Mix

The final mix, also referred to as a final dub, is where the dialogue, Foley, sound effects, and music are combined. During this session, audio stems, which are the final mixed tracks of the above mentioned elements, are created. During the final dub, it is often necessary to augment or reduce levels on a pre-mixed track. If this is the case, the mixer can return to the original stems or elements (prior to the pre-mix) of that section and adjust the levels accordingly. Typically, separate dialogue, music, and sound effects

(including Foley) stems are created. These stems are used to create the final audio deliverables for a project. Per the buyer's delivery requirements, the producer determines the mix format for the show (Dolby Digital, DTS, or SDDS). Once the show is mixed, there is usually a final playback in which key people, including the director, producer, and/or buyer/executive, request mix fixes.

Fixes

Fixes communicated at the final playback are handled during additional mix sessions. This is the fine-tuning of the soundtrack or the adjustment of audio levels after mixing dialogue, music, and effects.

Print Master

At this stage, the various final mix stems are combined, creating the finished audio tracks. Print masters are created for all the different release mediums of the picture (for example, English language digital 5.1 channel master, English language 2 channel matrixed stereo master, and 5.1 channel music and effects master). For television, typically the English language 2 channel matrixed stereo master is layed back to the master videotape. For film, a soundtrack negative is created from the appropriate print masters. This negative may contain more than one print master format and is used to make the release prints.

Music and Effects (M&E)

In order for a project to be sold worldwide, a foreign version mix, also known as an M&E, must be created. During this process, the music and sound effects stems are used to produce a mix that does not contain the original dialogue. This version is used for non–English-speaking countries that in turn translate the original dialogue into their respective language and hire actors to ADR/loop the lines. These lines are then mixed together with the M&E.

Picture Post-Production

Online Assembly

The final editing session in which the master videotape is created is referred to as an *online assembly*. The items needed for an online session are as follows: all source material on video, the deliverable technical specifications from the buyer/executive, and the edit decision list (EDL) based on the offline cut.

The EDL is a complete notation of every final edit made on the project. The online editor follows the EDL to conform the show to the final offline version. This online edit is a process equivalent to the negative cutting needed on shows that are either finished and/or archived on film.

In theory, for features where the final product is delivered on film, the online assembly only occurs once the digital data files are rendered and sent to film. The workprint, which is available on the digital editing workstation, is thought of as an offline edit. (Since the digital offline "production color" scenes are not rendered at full resolution, the scenes are only sent to "film output" once they have received a sweat box note approving the final color. From this point on, film/negative is generated for the approved scenes.) After the negative is created from the "film out," the printed scenes are inserted into a template workprint. The picture editor typically rebuilds the film workprint entirely throughout the latter part of the production process. A magnetic track is also made and is used as sync reference during 35mm workprint assembly, preview, and sweat boxing.

The editor uses the EDL to conform the 35mm workprint to its digital counterpart. After a scene has been inserted into the 35mm workprint, it has its final sweat box approval. Once all scenes are approved, the editor can create a negative cutting log, giving instructions to the negative cutter of the scene-specific details (negative roll numbers, edge numbers, and so on).

Negative Cutting

Negative cutting is the process of assembling the negative once the picture is locked. After picture is locked, a negative cutter should be hired. This is precision work, as a single frame error can result in loss of sync in the movie. The picture editor works closely with the negative cutter and provides all paperwork for the cutter to assemble the negative. Once the cutter is hired, the editor requests the film lab to forward all pertinent negatives to the care of the cutter. When a workprint reel has received final directorial approval, the negative cutting log and its matching workprint guide are sent to the negative cutter. With these materials, the cutter has sufficient details plus a visual reference and will rebuild the negative to mirror the workprint.

Preserving the negative is a top priority because it is the project's master copy and most valuable asset. For this reason, after the negative has been cut, it is duplicated. This copy is referred to as an *interpositive,* or IP. In order to avoid touching the original negative, another negative is struck from the IP. This is called the *internegative,* or IN. Next, a checkprint is struck using the internegative and is evaluated for color consistency. The final release print(s) or answer print typically is generated from the internegative.

Color Correction

The adjustment of color on film or video in terms of its contrast, hue, tint, brightness, saturation, and density is referred to as *color correction*. Whenever the source material is film, many factors can play into making the color inconsistent. These include the film's temperature, age, exposure, and stock. In order to have color balance in a scene and between scenes, color correction therefore becomes a necessity.

On projects that finish on film, the color correction, or color timing process, starts with a proof print. For this pass, selections of key frames are developed and shown as slides to the director, producer, and/or art director for their approval. After the lab gets feedback from the director(s), additional prints are made in order to make certain that all the nuances of color selection and application have been successfully reproduced for the final film output. After color timing has been completed, an answer print or an interpositive is struck from the negative, based on the budget.

Projects that are delivered on video go through telecine for the purpose of color correction. First, the cut negative needs to be sonic-cleaned so that any dirt or hair is removed. It is then transferred to tape. Next, color bars are layed down at the head of picture. Using the bars as a compass, the colorist has a broad-strokes guideline. Based on the project's color complexity, key scenes are selected and modified to match the intended color. Saving these scenes for reference, the colorist adjusts each scene one at a time. Throughout this process, the producer and/or the director are present to give input. At times, they may ask the colorist to take care of minor animation glitches by freezing a frame and repositioning an image or fixing negative scratches and dirt. When these types of fixes are requested, it is important to make sure that the image alteration does not create new problems elsewhere in the frame, such as an undesired blur or jagged edges.

The Element Reel

In the case of a television series, an element reel should be created. This reel is a master videotape upon which the various repeat elements are placed. These items include: the title sequence, the textless version of the title sequence (usually placed at the very end of a final episode's tape to be used for international distribution), main and end credits (if they are the same per episode), studio and distributor logos, union logos, etc. As the show is assembled, the element reel helps the editor use his or her time efficiently. Rather than having to access different source reels, they have all their materials on one tape. When the series is complete, the element reel is archived with all of the master episodes.

Credits (Main/Opening and End)

The credits list all talent and production staff who have worked on a project. A list of names, titles, and facilities used is compiled and kept up to date throughout the course of production by the associate producer or production manager. On television episodes, the producer has to adhere to a specific time allotment for credits. Feature and direct-to-video credits have more flexibility in terms of the number of people listed and the pacing of the credit roll.

The placement and size of the main credits and some end credits are based on deals negotiated with key talent prior to the start of production. The producer decides upon the placement of the balance of credits. In close collaboration with the legal/business affairs departments, the credits are produced and shown to the buyer/executive for approval. The size and font of the credits must be chosen or designed by the producer and director. After final signoff, the credits can be placed on a floppy disc and sent to the title house to be shot on film or reproduced during an online session for video projects.

Textless Versions

Textless versions of credits are necessary for foreign distribution, as each country/territory has very specific distribution regulations and specifications. Additional scenes may also need to be provided. If subtitles or burn-ins have been used in a scene, a textless version will need to be made so that non-English-speaking countries can burn in their own translation of the description. In addition, certain countries may require a textless version of scenes that include any signs integral to the story, such as "Danger!"

Picture Quality Control

Once the picture has been color-timed and the soundtrack negative is created, they are combined to produce the first married print. This print must be reviewed for color quality plus audio quality and sync. This process is referred to as *quality control*. Once it has been ascertained that no fixes are necessary, the print is ready for final quality control.

Final Delivery

Final Quality Control

All projects undergo this procedure so that it can be determined whether all audio, video, or film materials meet the delivery requirements. Typically, the producer or director is responsible for overseeing this process.

Release Print (Composite Theatrical Print)

The release print is a 35mm positive print of the picture that includes the credits and the final sound track. This version of the picture has been color-corrected, has undergone final quality control, and is ready for distribution.

Delivery

At this stage, the project is finally ready to be aired, mass-produced on videotape, or released in theaters. In addition to the final product itself (that is, the composite answer print or 35mm release print) and the Digi Betacam tape (D-1 tape), a number of other items should be delivered. Depending on the format, these include the final script; the negative, inter-positive, duplicate negative, and low-contrast print; the textless background; the work print; the magnetic master composite mix; the music and effects track; music cue sheets; song lyrics; and the composer's score.

11

TRACKING PRODUCTION

Introduction

Tracking animation is no easy task due to the sheer number and variety of elements that need to be coordinated. The tracking system should be an accurate and succinct overview illustrating the pace of production both on a macro and micro level. It should be created in tandem with the budget and schedule, enabling the producer to identify the status and cost of each element. Due dates create the project's tracking framework and establish how much work has to be accomplished on a daily, weekly, and monthly basis in order to complete the production on time. As a project moves forward, the tracked data shifts constantly and must therefore be updated and recalculated accordingly. No matter how the tracking system is structured, the producer must be able to rely on it to assess whether the production is meeting its projected goals. To do this, the producer reviews the scheduled work to be done versus its actual status by analyzing dates and numbers (that is, the tracking of completed footage/frames). If a project is behind schedule, the producer sets revised targets in order to get the production back on track. The producer also tries to determine the reason for the delay and whether it will be a recurring problem. If so, a solution must be found and implemented in order to avoid more slippage.

The successful management of a project comes down to documentation of detailed information. Before the production gets started, it is essential to analyze its content and nail down the specific elements that need to be tracked. It is also important to establish a numbering convention or method of labeling each item. Depending on the project, it may use all or some of the following codes: act number, sequence number, scene number, insert number, version number, and layer number. Once this is agreed upon, deciding on the best way to set up the tracking system is the next step. Depending on the

scope and complexity of the production, it may be necessary to bring in a computer programmer or consultant to design a system. Developing systems that are databased or linked is critical. This way, key schedule information needs to be updated only once and then it flows through to all other applicable charts, making the process much more streamlined and simple. A detail-oriented staff is also important. With a plethora of material being produced at the same time, it's essential for the data to be entered accurately and efficiently. On any production, it is critical to hire staff who are already trained, are meticulous about data entry, or show a strong aptitude for learning the tracking system. They should also be comfortable with creating charts and using different software such as Filemaker Pro, Microsoft Project, and Microsoft Excel.

The following sections include samples of generic tracking charts for pre-production, production, and post-production. The concepts behind each of the charts can be applied to either 2D (traditional) or 3D CGI projects. As is the case for all charts in this book, they should be reconfigured to meet the needs of the particular project. For all charts, the projected due dates for the tasks are identified using the master schedule. (See Chapter 6, "The Production Plan," for an example of a master schedule.)

Pre-Production

Pre-production tracking includes coordinating the status of script(s), designs, storyboards, story reel/animatics, casting, and the recording session. (See Chapter 8, "Pre-Production," for more detailed information on the pre-planning required for specific production steps.) Figure 11–1 shows a generic pre-production macro tacking chart. This macro tracking system reflects some of the major elements to be completed during pre-production. It is essentially a broad-strokes status check for a producer. Depending on the individual elements that require monitoring, a multitude of steps could be included beyond what is listed here, such as rigging and test animation in the case of 3D CGI.

For each of the individual macro steps, there are a number of detailed steps involved to complete a task. It is therefore necessary to create micro tracking charts that monitor the details of the various elements. Figure 11–2 shows such a chart. Assistant production managers and coordinators usually create and update these charts. The sample provided can be used to track design elements such as characters, locations/environments, and props. It is also useful to create similar style reports for all other steps, including recording sessions and story reel production.

ORDER #	SEQ / EPIS #	TITLE	MODEL PACK START	MODEL PACK END	DIALOGUE RECORDING	STORY-BOARD START	STORY-BOARD END	ANIMATIC START	ANIMATIC END	REEL/EP FTG	REEL/EP SECS	COMMENTS
1			SCHED	SCHED	SCHED	SCHED	SCHED	SCHED	SCHED			
			ACTUAL	ACTUAL	ACTUAL	ACTUAL	ACTUAL	ACTUAL	ACTUAL			
2			SCHED	SCHED	SCHED	SCHED	SCHED	SCHED	SCHED			
			ACTUAL	ACTUAL	ACTUAL	ACTUAL	ACTUAL	ACTUAL	ACTUAL			
3			SCHED	SCHED	SCHED	SCHED	SCHED	SCHED	SCHED			
			ACTUAL	ACTUAL	ACTUAL	ACTUAL	ACTUAL	ACTUAL	ACTUAL			
4			SCHED	SCHED	SCHED	SCHED	SCHED	SCHED	SCHED			
			ACTUAL	ACTUAL	ACTUAL	ACTUAL	ACTUAL	ACTUAL	ACTUAL			
5			SCHED	SCHED	SCHED	SCHED	SCHED	SCHED	SCHED			
			ACTUAL	ACTUAL	ACTUAL	ACTUAL	ACTUAL	ACTUAL	ACTUAL			
6			SCHED	SCHED	SCHED	SCHED	SCHED	SCHED	SCHED			
			ACTUAL	ACTUAL	ACTUAL	ACTUAL	ACTUAL	ACTUAL	ACTUAL			
7			SCHED	SCHED	SCHED	SCHED	SCHED	SCHED	SCHED			
			ACTUAL	ACTUAL	ACTUAL	ACTUAL	ACTUAL	ACTUAL	ACTUAL			
8			SCHED	SCHED	SCHED	SCHED	SCHED	SCHED	SCHED			
			ACTUAL	ACTUAL	ACTUAL	ACTUAL	ACTUAL	ACTUAL				

TOTAL FTG

Figure 11–1 Generic Pre-Production Macro Tacking Chart

ORDER #	SEQ/EPIS #	DESIGN DESCRIPTION	ARTIST(S)	SCRIPT PG #	HAND OUT	DIRECTOR REVIEW	ROUGH REVISIONS	ROUGH APPROVED	CLEAN UP REVISIONS	CLEAN UP APPROVED	COMMENTS
1					SCHED	SCHED	SCHED	SCHED	SCHED	SCHED	
					ACTUAL	ACTUAL	ACTUAL	ACTUAL	ACTUAL	ACTUAL	
2					SCHED	SCHED	SCHED	SCHED	SCHED	SCHED	
					ACTUAL	ACTUAL	ACTUAL	ACTUAL	ACTUAL	ACTUAL	
3					SCHED	SCHED	SCHED	SCHED	SCHED	SCHED	
					ACTUAL	ACTUAL	ACTUAL	ACTUAL	ACTUAL	ACTUAL	
4					SCHED	SCHED	SCHED	SCHED	SCHED	SCHED	
					ACTUAL	ACTUAL	ACTUAL	ACTUAL	ACTUAL	ACTUAL	
5					SCHED	SCHED	SCHED	SCHED	SCHED	SCHED	
					ACTUAL	ACTUAL	ACTUAL	ACTUAL	ACTUAL	ACTUAL	
6					SCHED	SCHED	SCHED	SCHED	SCHED	SCHED	
					ACTUAL	ACTUAL	ACTUAL	ACTUAL	ACTUAL	ACTUAL	
7					SCHED	SCHED	SCHED	SCHED	SCHED	SCHED	
					ACTUAL	ACTUAL	ACTUAL	ACTUAL	ACTUAL	ACTUAL	
8					SCHED	SCHED	SCHED	SCHED	SCHED	SCHED	
					ACTUAL	ACTUAL	ACTUAL	ACTUAL	ACTUAL	ACTUAL	

Figure 11–2 Generic Pre-Production Micro Tracking Chart

Production

With the sheer magnitude of a feature, it is easy for a scene to get lost in the shuffle. The tracking system therefore functions as a check-and-balance for the show, ensuring that everything is in place, accounted for, and, most importantly, in progress. Since so many staff members work on each scene, a good tracking system should provide the management team with scene location and status. Additionally, it should provide a record of each artist's actual output. Chronicling a scene's path as it enters the production stream includes tracking it as it goes through each department and is assigned, completed, revised, or approved for the next phase. These steps can easily add up to 50-plus entries on the tracking chart. Because of the complexity involved, most studios hire consultants or have in-house programmers design and set up systems that meet their needs. Figure 11–3 shows a generic production macro tracking chart.

The production macro tracking chart is usually produced at the beginning of the production week. It is used to analyze the production's standing on an overall basis and most specifically in the week that passed. When a particular department is ahead or behind schedule, the difference between the expected goal versus the actual work completed is shown on this chart. This number, also referred to as an "offset," tells the producer and buyer/executive how successfully the show is progressing. When the numbers fall short, the producer can detect where obstacles may be in the production path based on the offset number shown for each individual department. Questions to ask when analyzing the chart include: Is there enough inventory available for the department? Is there any "on-hold" footage that counts as inventory in a given department, but actually can't be worked on due to script revisions, for example? Are all artists aware of the needed output and are they able to produce the work requested of them? Finding answers to questions such as these and fixing problems as early as possible enables the producer to control the show and help avoid poor weekly performance.

The evolution of the scene from its inception through final color is shown in the generic production micro tracking chart in Figure 11–4. The production team is responsible for entering and maintaining this data. The chart also tracks a scene's key information, including the name of the artist presently working on the scene, the assignment date, and its due date. Dates entered on the tracking system as the scene gets completed in one department and is sent to the next are tallied up by the production accountant, who analyzes each department's output and work inventory. The detailed information on this chart provides the data used to produce the feature production macro chart.

TITLE:

PRODUCTION NUMBER:

DATE:

TOTAL WEEKS:

NUMBER OF WEEKS LEFT:

TOTAL FOOTAGE TO COMPLETE:

TOTAL FOOTAGE ON HOLD:

	PAST WEEK QUOTA	PAST WEEK ACTUAL	OFFSET (+/-)	THIS WEEK'S QUOTA	WORKABLE INVENTORY	THIS WEEK EXPECTED	QUOTA TO DATE	TOTAL TO DATE ACTUAL	TOTAL TO COMPLETE	TOTAL OFFSET (+/-)
SCENE ISSUE										
ROUGH LAYOUT										
ROUGH ANIMATION										
ROUGH SCENE PLAN/SCAN										
ROUGH CUT IN										
CLEAN UP LAYOUT										
CLEAN UP ANIMATION										
VISUAL EFFECTS										
CU SCENE PLAN/SCAN										
CLEAN UP CUT IN										
BACKGROUND PAINTING										
ANIMATION CHECK										
FINAL SCAN										
COLOR STYLING										
COLOR MODEL MARK UP										
PAINT MARK UP										
INK AND PAINT										
FINAL CHECK										
FINAL COMP/RENDER										
COLOR CUT IN										
FILM OUTPUT										

Figure 11–3 Generic Production Macro Tracking Chart

Figure 11–4 Generic Production Micro Tracking Chart

SEQ	SC	FTG		SCENE ISSUE	ROUGH LAYOUT	ROUGH ANIM	PENCIL TEST OK	ROUGH CUT IN	CU LAYOUT	CU ANIM	VISUAL EFFECTS	CU CUT IN	BG PAINT	ANIM CHECK	COLCR STYLE	COLOR MARKUP	INK & PAINT MARKUP	INK & PAINT	FINAL CHECK	COLOR CUT IN
			DATE IN																	
			ARTIST																	
			DUE OUT																	
			DATE IN																	
			ARTIST																	
			DUE OUT																	
			DATE IN																	
			ARTIST																	
			DUE OUT																	
			DATE IN																	
			ARTIST																	
			DUE OUT																	
			DATE IN																	
			ARTIST																	
			DUE OUT																	
			DATE IN																	
			ARTIST																	
			DUE OUT																	
			DATE IN																	
			ARTIST																	
			DUE OUT																	
			DATE IN																	
			ARTIST																	
			DUE OUT																	
			DATE IN																	
			ARTIST																	
			DUE OUT																	
			DATE IN																	
			ARTIST																	
			DUE OUT																	
			DATE IN																	
			ARTIST																	
			DUE OUT																	
			DATE IN																	
			ARTIST																	
			DUE OUT																	

Tracking Subcontractors

For projects that are sent to subcontractors, it is important that the producer receive a weekly production report. If a project is in trouble, it may be necessary to receive information on a daily basis. Figures 11–5 and 11–6 are sample tracking reports that subcontractors can use.

On feature productions, there is often a concern that sending material to another facility will result in a loss of control on the quality of artwork. The chart in Figure 11–5 is designed to counter this concern as it enables the production team to evaluate the progress of the work assigned to the subcontracting studio. It tracks when the material was received, who the assigned artists are, and when they expect to complete the work on each scene. The "Shipping Date" column refers to the date the work is sent for the director's review. The domestic production crew can use this information to forecast how they will meet their weekly quotas by adding the subcontractor's projected numbers to their own.

Since speed is important in television production, episodic tracking charts are much more macro in nature. The chart in Figure 11–6 monitors the number of scenes completed on a weekly basis in each department. The bar chart at the bottom gives the producer a quick overview of the progression of the episodes in key departments. The sample provided shows a project mid-production. One of these reports is filled out for each individual episode as it enters production.

Tracking Retakes

It is essential to know where each and every retake is so that nothing is missed in the final product. This process can be very time consuming and requires the documentation of a significant amount of detail. On the retake report (shown in Figure 11–7), which is sent back to a subcontractor and describes scenes that require revisions, it is necessary to include the following information:

- The episode or sequence number
- The act number
- The scene number
- A clear explanation of the problem, noting the frame numbers when applicable
- Drawings (if necessary)

When filled in, this chart summarizes the number of scenes per episode/sequence that are in different stages of revision, or "takes." It gives the producer a quick look at the project's overall status. It can also be a useful tool to evaluate the quality of work provided by a subcontractor

TITLE:

PRODUCTION NUMBER:

DATE:

TOTAL FOOTAGE TO BE COMPLETED:

TOTAL FOOTAGE EXPECTED:

TOTAL FOOTAGE RECEIVED:

TOTAL FOOTAGE COMPLETED:

OFFSET (-/+):

SEQ	SCENE	FTG	DATE RECEIVED	DATE OF HANDOUT	ARTIST	DUE DATE	SHIPPING DATE	REVISIONS DUE	APPROVAL DATE	COMMENTS

Figure 11–5 Generic Subcontractor's Tracking Chart: Feature

GENERIC SUBCONTRACTOR'S TRACKING CHART - TV
@ 10/10/2001

SHOW TITLE: THE LION & THE RABBIT
SHOW #: 001
DATE SHIPPED OVERSEAS 7/24/01
DATE DUE TO STUDIO: 11/8/01

WEEK #	1	2	3	4	5	6	7	8	9	10	11	TOTAL SCENES FINISHED	TOTAL SCENES	SCENES LEFT TO DO	% DONE	START DATE	DATE END
DATE	8/1	8/8	8/15	8/22	8/29	9/5	9/12	9/19	9/26	10/3	10/10						
DEPARTMENT:																	
LAYOUT	0	24	115	162	DONE	DONE	DONE	DONE	DONE	DONE	DONE	301	301	0	100%	8/8	8/22
KEY ANIMATION	0	0	0	25	89	42	62	51	32	DONE	DONE	301	301	0	100%	8/22	9/26
PENCIL TEST	0	0	0	0	15	DONE	DONE	DONE	DONE	DONE	DONE	15	15	0	100%	8/29	8/29
INBETWEEN	0	0	0	17	18	11	29	24	19	17	22	179	301	122	59%	8/22	
ANIMATION CHECK	0	0	0	17	18	11	29	24	19	17	22	179	301	122	59%	8/22	
BACKGROUND	0	0	0	0	0	0	0	10	92	115	42	301	301	0	100%	9/19	10/10
SCAN	0	0	0	17	18	11	29	24	19	17	22	179	301	122	59%	8/22	
PAINT	0	0	0	4	4	0	0	11	38	40	5	107	301	194	36%	8/22	
FINAL CHECK	0	0	0	0	4	0	0	0	0	0	0	4	301	297	1%	8/29	
CAMERA	0	0	0	0	4	0	0	0	0	0	0	4	301	297	1%	8/29	
RETURN SHIPMENT	0	0	0	0	0	0	0	0	0	0	0	0	301	301	0%		

ACTUAL SCENES COMPLETED VS. TOTAL SCENES TO BE COMPLETED PER DEPARTMENT

Figure 11-6 Generic Subcontractor's Tracking Chart: Television

PROD #	EPISODE TITLE	DATE TAKE 2'S CALLED	# TAKE 2'S CALLED	TAKE 2 RETURN DUE	TAKE 2 OK	DATE TAKE 3'S CALLED	# TAKE 3'S CALLED	TAKE 3 RETURN DUE	TAKE 3 OK	DATE TAKE 4'S CALLED	# TAKE 4'S CALLED	TAKE 4 RETURN DUE	TAKE 4 OK	LOCKED PICTURE

Figure 11-7 Generic Retake Summary Report

283

based on the amount of retakes needed per show. In addition to this chart, it is necessary to keep track of the status of each individual scene and its specific problems.

Post-Production

During post-production, the producer tracks and compares actual dates with the scheduled dates to assess the status of the project. (See Chapter 10, "Post-Production," for further information on the elements to be tracked during this phase of the process.) At present, all theatrical features are completed on film. The chart in Figure 11–8 tracks the various steps required for this delivery format.

Television shows and direct-to-video projects are completed and delivered on videotape. In some cases, the initial color footage may be delivered on film and then transferred to video. The chart in Figure 11–9 tracks the various stages required for this delivery format. Steps that involve film as the picture source are indicated with an asterisk.

Some studios require a cut negative be produced for archiving purposes. The buyer most often handles this process after delivery takes place. (See Chapter 10, "Post-Production," for further information on the process.)

	LOCKED PICTURE	SOUND SPOTTING	MUSIC SPOTTING	TEMP DUB	RECORD SCORE & SONGS	MUSIC MIX	ADR RECORD	FOLEY RECORD	FX PRE-MIX START	FX PRE-MIX END	FOLEY PRE-MIX START	FOLEY PRE-MIX END	DIALOGUE PRE-MIX START
SCHED	SCHED	SCHED	SCHED	SCHED	SCHED	SCHED	SCHED	SCHED	SCHED	SCHED	SCHED	SCHED	SCHED
ACTUAL	ACTUAL	ACTUAL	ACTUAL	ACTUAL	ACTUAL	ACTUAL	ACTUAL	ACTUAL	ACTUAL	ACTUAL	ACTUAL	ACTUAL	ACTUAL

	DIALOGUE PRE-MIX END	FINAL MIX	FIXES M & E'S	FINAL FILM OUTPUT	NEG CUTTING START	NEG CUTTING END	CREDITS	PRINT MASTER	COLOR TIMING	FINAL QUALITY CONTROL	RELEASE PRINTS	DELIVERY
SCHED	SCHED	SCHED	SCHED	SCHED	SCHED	SCHED	SCHED	SCHED	SCHED	SCHED	SCHED	SCHED
ACTUAL	ACTUAL	ACTUAL	ACTUAL	ACTUAL	ACTUAL	ACTUAL	ACTUAL	ACTUAL	ACTUAL	ACTUAL	ACTUAL	ACTUAL

Figure 11–8 Generic Post-Production Report: Feature (Film Completion)

ORDER #	EPIS #	TAKE #1 RETURN	*VIDEO TRANSFER	RETAKES DONE	LEGAL REVIEW	LOCKED PICTURE	ON-LINE ASSEMBLY	*COLOR CORRECT	CREDITS	SOUND SPOT	MUSIC SPOT	FINAL MIX & M&E PRINT MASTER	QUALITY CONTROL	DELIVERY
1		SCHED	SCHED	SCHED	SCHED	SCHED	SCHED	SCHED	SCHED	SCHED	SCHED	SCHED	SCHED	SCHED
		ACTUAL	ACTUAL	ACTUAL	ACTUAL	ACTUAL	ACTUAL	ACTUAL	ACTUAL	ACTUAL	ACTUAL	ACTUAL	ACTUAL	ACTUAL
2		SCHED	SCHED	SCHED	SCHED	SCHED	SCHED	SCHED	SCHED	SCHED	SCHED	SCHED	SCHED	SCHED
		ACTUAL	ACTUAL	ACTUAL	ACTUAL	ACTUAL	ACTUAL	ACTUAL	ACTUAL	ACTUAL	ACTUAL	ACTUAL	ACTUAL	ACTUAL
3		SCHED	SCHED	SCHED	SCHED	SCHED	SCHED	SCHED	SCHED	SCHED	SCHED	SCHED	SCHED	SCHED
		ACTUAL	ACTUAL	ACTUAL	ACTUAL	ACTUAL	ACTUAL	ACTUAL	ACTUAL	ACTUAL	ACTUAL	ACTUAL	ACTUAL	ACTUAL
4		SCHED	SCHED	SCHED	SCHED	SCHED	SCHED	SCHED	SCHED	SCHED	SCHED	SCHED	SCHED	SCHED
		ACTUAL	ACTUAL	ACTUAL	ACTUAL	ACTUAL	ACTUAL	ACTUAL	ACTUAL	ACTUAL	ACTUAL	ACTUAL	ACTUAL	ACTUAL
5		SCHED	SCHED	SCHED	SCHED	SCHED	SCHED	SCHED	SCHED	SCHED	SCHED	SCHED	SCHED	SCHED
		ACTUAL	ACTUAL	ACTUAL	ACTUAL	ACTUAL	ACTUAL	ACTUAL	ACTUAL	ACTUAL	ACTUAL	ACTUAL	ACTUAL	ACTUAL
6		SCHED	SCHED	SCHED	SCHED	SCHED	SCHED	SCHED	SCHED	SCHED	SCHED	SCHED	SCHED	SCHED
		ACTUAL	ACTUAL	ACTUAL	ACTUAL	ACTUAL	ACTUAL	ACTUAL	ACTUAL	ACTUAL	ACTUAL	ACTUAL	ACTUAL	ACTUAL
7		SCHED	SCHED	SCHED	SCHED	SCHED	SCHED	SCHED	SCHED	SCHED	SCHED	SCHED	SCHED	SCHED
		ACTUAL	ACTUAL	ACTUAL	ACTUAL	ACTUAL	ACTUAL	ACTUAL	ACTUAL	ACTUAL	ACTUAL	ACTUAL	ACTUAL	ACTUAL
8		SCHED	SCHED	SCHED	SCHED	SCHED	SCHED	SCHED	SCHED	SCHED	SCHED	SCHED	SCHED	SCHED
		ACTUAL	ACTUAL	ACTUAL	ACTUAL	ACTUAL	ACTUAL	ACTUAL	ACTUAL	ACTUAL	ACTUAL	ACTUAL	ACTUAL	ACTUAL
9		SCHED	SCHED	SCHED	SCHED	SCHED	SCHED	SCHED	SCHED	SCHED	SCHED	SCHED	SCHED	SCHED
		ACTUAL	ACTUAL	ACTUAL	ACTUAL	ACTUAL	ACTUAL	ACTUAL	ACTUAL	ACTUAL	ACTUAL	ACTUAL	ACTUAL	ACTUAL
10		SCHED	SCHED	SCHED	SCHED	SCHED	SCHED	SCHED	SCHED	SCHED	SCHED	SCHED	SCHED	SCHED
		ACTUAL	ACTUAL	ACTUAL	ACTUAL	ACTUAL	ACTUAL	ACTUAL	ACTUAL	ACTUAL	ACTUAL	ACTUAL	ACTUAL	ACTUAL
11		SCHED	SCHED	SCHED	SCHED	SCHED	SCHED	SCHED	SCHED	SCHED	SCHED	SCHED	SCHED	SCHED
		ACTUAL	ACTUAL	ACTUAL	ACTUAL	ACTUAL	ACTUAL	ACTUAL	ACTUAL	ACTUAL	ACTUAL	ACTUAL	ACTUAL	ACTUAL
12		SCHED	SCHED	SCHED	SCHED	SCHED	SCHED	SCHED	SCHED	SCHED	SCHED	SCHED	SCHED	SCHED
		ACTUAL	ACTUAL	ACTUAL	ACTUAL	ACTUAL	ACTUAL	ACTUAL	ACTUAL	ACTUAL	ACTUAL	ACTUAL	ACTUAL	ACTUAL
13		SCHED	SCHED	SCHED	SCHED	SCHED	SCHED	SCHED	SCHED	SCHED	SCHED	SCHED	SCHED	SCHED
		ACTUAL	ACTUAL	ACTUAL	ACTUAL	ACTUAL	ACTUAL	ACTUAL	ACTUAL	ACTUAL	ACTUAL	ACTUAL	ACTUAL	ACTUAL

Figure 11–9 Generic Post-Production Report: Television and Direct-to-Video (Video Completion)

Appendix

ANIMATION RESOURCES

This appendix lists key books, journals, and organizations that can be useful for the producer. It is divided into the following subcategories:

- Producer's Reference
- Art of Animation: Technique and Processes
- General Interest: History, Biography, Artists, Making of Books, and More
- Scriptwriting
- Post-Production
- Journals
- Key Organizations

Producer's Reference

Animation Industry Directory
Annual directory published by Animation Magazine
30101 Agoura Court, Suite 110
Agoura Hills, CA 91301-4301
Tel: (818) 991-2884, Fax: (818) 991-3773
www.animag.com

Contract Motion Picture Screen Cartoonists and Affiliated Optical Electronic and Graphic Arts
Local 839 IATSE (Booklet)
www.mpsc839.org/mpsc839
North Hollywood, CA 92001
Tel: (818) 766-7151, Fax: (818) 506-4805

Hollywood Creative Directory/Hollywood Distributor Directory/
 Hollywood Interactive Directory
www.hollyvision.com
3000 W. Olympic Blvd., Suite 2525
Santa Monica, CA 90404
Tel: (310) 315-4815

Media Law for Producers
Philip Miller
Boston: Focal Press, 1998

The Producer's Business Handbook
John J. Lee, Jr.
Boston: Focal Press, 2000

Producer's Masterguide
www.producers.masterguide.com
60 E. 8th Street, 34th Floor
New York, NY 10003
Tel: (212) 777-4002

Art of Animation: Techniques and Processes

3D Animation: From Models to Movies
Adam Watkins
Rockland, MA: Charles River Media, 2000

3D Creature Workshop (2nd Edition)
Bill Fleming and Richard H. Schrand
Rockland, MA: Charles River Media, 2000

3D Lighting: History, Concepts, & Technique
Arnold Gallardo
Rockland, MA: Charles River Media, 2000

3D Studio Max: Building Complex Models
Shamms Mortier
Rockland, MA: Charles River Media, 2000

3D Studio Max 3: Professional Animation
Angie Jones and Sean Bonney
Indianapolis, IN: New Riders Publishing, 2000

Acting for Animators: A Complete Guide to Performance Animantion
Ed Hooks
Portsmouth, NH: Heinemann, 2000

Animation: From Script to Screen
Shamus Culhane
New York: St. Martin's Press, 1988

Animation: The Master 2000 Handbook (3rd Edition)
Jeff Paries
Rockland, MA: Charles River Media, 2000

The Animation Book: A Complete Guide to Animated Filmmaking—
 From Flip-Books to Sound Cartoons to 3-D Animation
Kit Laybourne
New York: Three Rivers Press (Crown Publishing, Inc.), 1998

The Animator's Workbook: Step by Step Techniques of Drawn Animation
Tony White
New York: Watson-Guptill Publications, 1988

Cartoon Animation
Preston Blair
Laguna Hills, CA: Walter Foster Publishers, 1995

CG 101: A Computer Graphics Industry Reference
Terrence Masson
Indianapolis, IN: New Riders Publishing, 1999

Character Animation in Depth
Doug Kelly
Albany, NY: Creative Professionals Press, 1998

Character Animation with LightWave 6
Doug Kelly
Scottsdale, AZ: Coriolis Group Books, 2000

Clay Animation: American Highlights 1908 to the Present
Michael Frierson
New York: Twayne Publishers, 1994

Computer Animation: A Whole New World
Rita Street
Rockport, ME: Rockport Publishers, 1998

The Contemporary Animator
John Halas
Boston: Focal Press, 1990

Creating 3-D Animation: The Aardman Book of Filmmaking
Peter Lord and Brian Sibley
New York: Harry N. Abrams, 1998

Creating Motion Graphics with After Effects: High Impact Animation for Video and Film
Trish and Chris Meyer
San Francisco: CMP Books, 2000

Digital Character Animation 2, Volume 1: Essential Techniques
George Maestri
Indianapolis, IN: New Riders Publishing, 2000

Digital Compositing in Depth
Doug Kelly
Scottsdale, AZ: Coriolis Group Books, 2000

Digital Lighting & Rendering
Jeremy Birn
Indianapolis, IN: New Riders Publishing, 2000

Disney's Animation Magic: A Behind the Scenes Look at How an Animated Film Is Made
Don Hahn
New York: Disney Press, 1996

The Encyclopedia of Animation Techniques
Richard Taylor
Philadelphia: Running Press, 1996

Experimental Animation: Origins of New Art
Robert Russett and Cecile Star
New York: Da Capo Press, 1988

Flash 4 Bible
Robert Reinhardt and Jon Warren Lentz
Foster City, CA: IDG Books Worldwide, 2000

Flash 4 for Windows and Macintosh: Visual QuickStart Guide
Katherine Ulrich
Berkeley, CA: Peachpit Press, 1999

Flash 4 Magic (with CD-ROM)
David J. Emberton and J. Scott Hamlin
Indianapolis, IN: New Riders Publishing, 2000

Flash 5: Graphics, Animation, and Interactivity
James L. Mohler
Albany, NY: Delmar, 2000

Flash Web Design: The Art of Motion Graphics
Hillman Curtis
Indianapolis, IN: New Riders Publishing, 2000

Graphics, Animation and Interactivity with Flash 4.0
James L. Mohler
Albany, NY: Delmar, 2000

How to Draw Animation
Christopher Hart
New York: Watson Guptill Publications, 1997

How to Draw Comics the Marvel Way
Stan Lee and John Buscema
New York: Simon and Schuster, 1984

The Illusion of Life: Disney Animation
Frank Thomas and Ollie Johston
New York: Hyperion, 1995

Inside Lightwave 6
Dan Ablan
Indianapolis, IN: New Riders Publishing, 1999

Mastering 3D Animation
Peter Ratner
New York: Allsworth Press, 2000

Maya 2 Character Animation
Nathan Vogel, Sherri Sheridan, and Tim Coleman
Indianapolis, IN: New Riders Publishing, 2000

Muybridge's Complete Human and Animal Locomotion
Edward Muybridge
New York: Dover Publications, 1979

*No Strings Attached: The Inside Story of Jim Henson's
 Creature Shop*
Matt Bacon
New York: Macmillan, 1997

Paper Dreams: The Art & Artists of Disney Storyboards
John Canemaker
New York: Hyperion, 1999

The Poser 4 Handbook
Shamms Mortier
Rockland, MA: Charles River Media, 2000

Softimage 3D Design Guide
Barry Ruff and Gene Bodio
Albany, NY: Coriolis Group Books, 1998

Softimage/XSI Character Animation E/X and Design
Chris Maraffi.
Scottsdale, AZ: Coriolis Group Books, 2000

Stop-Motion Filmography: A Critical Guide to 297 Features Using Puppet Animation
Neil Pettigrew
Jefferson, NC: McFarland & Co., 1999

The Vilppu Drawing Manual: Basic Figure Drawing
Glen Vilppu
Acton, CA: Vilppu Studio Press, 1997

General Interest

7 Minutes: The Life and Death of the American Animated Cartoon
Norman M. Klein
New York: Verso, 1998

American Animated Films: The Silent Era, 1897–1929
Denis Gifford
McFarland & Co.: Jefferson, NC, 1990

The Animated Film Collector's Guide: Worldwide Sources for Cartoons on Video and Laserdisc
David Kilmer.
London: J. Libbey, 1997

The Animated Film Encyclopedia: A Complete Guide to American Shorts, Features and Sequences 1900–1979
Graham Webb
Jefferson, NC: McFarland and Co., 2000

Animated TV Specials: Complete Directory to the First 25 Years, 1962–87
George W. Woolery
Metuchen, NJ: Scarecrow Press, 1989

Animating Culture: Hollywood Cartoons from the Sound Era
Eric Smoodin
New Brunswick, NJ: Rutgers University Press, 1993

Animation Art: The Early Years 1911–1953
Jeff Lotman
Atglen, PA: Schiffer, 1995

The Anime Companion: What's Japanese in Japanese Animation?
Gilles Poitras
Berkeley, CA: Stone Bridge Press, 1999

The Anime Movie Guide
Helen McCarthy
Woodstock, NY: The Overlook Press, 1996

Art in Motion: Animation Aesthetics
Maureen Furniss
Sydney: John Libby & Company Pty, 1998

The Art of The Lion King
Christopher Finch
New York: Hyperion, 1994

*The Art of Walt Disney, from Mickey Mouse to the Magic Kingdoms
 (Concise Edition)*
Christopher Finch
New York: Harry N. Abrams, 1999

Batman: Animated
Paul Dini and Chip Kidd
New York: HarperEntertainment, 1998

Before Mickey, The Animated Film 1898–1928
Donald Crafton
Chicago: University of Chicago, 1993

*Before the Animation Begins: The Art and Lives of Disney Inspirational
 Sketch Artists*
John Canemaker
New York: Hyperion, 1996

Bill Peet: An Autobiography
Bill Peet
Boston: Houghton-Mifflin, 1989

British Animated Films, 1895–1985: A Filmography
Dennis Gifford
Jefferson, NC: McFarland & Company, 1987

Bugs Bunny: Fifty Years and Only One Grey Hare
J. Adamson
New York: H. Holt, 1990

A Bug's Life: The Art and Making of an Epic of Miniature Proportions
Jeff Kurtti
New York: Hyperion, 1998

Cartoons: One Hundred Years of Cinema Animation
Giannalberto Bendazzi
Bloomington, IN: Indiana University Press, 1994

A Cast of Friends
Bill Hanna and Tom Ito
New York: Da Capo Press, 1996

Chicken Run: Hatching the Movie
Brian Sibley
New York: Harry N. Abrams, Inc. 2000

Children's Television: The First 25 Years, Part 1: Animated Cartoon Series
George W. Woolery
Metuchen, NJ: Scarecrow Press, 1983

Chuck Amuck: The Life and Times of an Animated Cartoonist
Chuck Jones
New York: Farrar Strauss Giroux, 1989

Chuck Reducks: Drawing from the Fun Side of Life
Chuck Jones
New York: Warner Books, 1996

The Complete Anime Guide: Japanese Animation Video Directory and Resource Guide
Trish Ledoux and Doug Ranney
Issaquah, WA: Tiger Mountain Press, 1997

The Complete Guide to Animation and Computer Graphic Schools
Ernest Pintoff
New York: Watson-Guptill Publications, 1995

Dark Alchemy: The Films of Jan Svankmajor
Peter Hames, Editor
Westport, CT: Greenwood Press, 1996

Dinosaur: The Evolution of an Animated Feature
Jeff Kurtti
New York: Disney Editions, 2000

Disney A to Z: The Official Encyclopedia
Dave Smith
New York: Hyperion, 1996

Disney's Aladdin: The Making of an Animated Film
John Culhane
New York: Hyperion, 1992

The Disney Films (Fourth Edition)
Leonard Maltin
New York: Disney Editions, 2000

*The Disney that Never Was: The Stories and Art from Five Decades of
 Unproduced Animation*
Charles Solomon
New York: Hyperion, 1995

The Disney Villain
Ollie Johnston and Frank Thomas
New York: Hyperion, 1993

Emile Cohl: Caricature and Film
Donald Crafton
Princeton, NJ: Princeton University Press, 1990

Enchanted Drawings: The History of Animation
Charles Solomon
New York: Wings Books, 1994

The Encyclopedia of Animated Cartoons
Jeff Lenburg
New York: Checkmark Books, 1999

*Encyclopedia of Walt Disney's Animated Characters from Mickey Mouse to
 Hercules (Updated Edition)*
John Grant
New York: Hyperion, 1997

Felix: The Twisted Tale of the World's Most Famous Cat
John Canemaker
New York: Pantheon Books, 1996

*Film Cartoons: A Guide to 20th Century American Animated Features
 and Shorts*
Douglas McCall
Jefferson, NC: McFarland & Co., 1998

*The (Revised and Updated) Fleischer Story: The History of the Max
 Fleischer Film Cartoon Studio in the Golden Age of Film Animation
 1920–1942*
Leslie Cabarga
New York: Nostalgia Press, 1988

Forbidden Animation: Censored Cartoons and Blacklisted Animators
Karl F. Cohen
Jefferson, NC: McFarland & Co., 1997

From Mouse to Mermaid: The Politics of Film, Gender, and Culture
Elisabeth Bell, Linda Haas, and Laura Sells (editors)
Bloomington, IN: Indiana University Press, 1995

The Great Cartoon Directors
Jeff Lenburg
New York: Da Capo Press, 1993

Hayao Miyazaki: Master of Japanese Animation
Helen McCarthy
Berkeley, CA: Stone Bridge Press, 1999

The History of Animation
Charles Solomon
New York: Wings Books, 1994

Hollywood Cartoons: American Animation in its Golden Age
Michael Barrier
New York: Oxford University Press, 1999

Looney Tunes and Merrie Melodies
Jerry Beck and Will Friedwald
New York: H. Holt, 1988

Mickey Mouse
Pierre Lambert
New York: Hyperion, 1998

My Life in Toons: From Flatbush to Bedrock in Under a Century
Joseph Barbera
Atlanta: Turner Publishing, 1994

Of Mice and Magic: A History of American Animated Cartoons
Leonard Maltin
New York: Penguin Books, 1987

Pinnochio
Pierre Lambert
New York: Hyperion, 1997

The Prince of Egypt: A New Vision in Animation
Charles Solomon
New York: Harry N. Abrams, 1998

Princess Mononoke: The Art and Making of Japan's Most Popular Film of All Times
Studio Ghibi (translated by Mark Schilling)
New York: Hyperion, 1999

A Reader in Animation Studies
J. Pilling, Editor
Sydney: John Libbey & Company, 1997

The Simpsons: A Complete Guide to Our Favorite Family
Ray Richmond and Antonia Coffman, Editors
New York: HarperPerennial, 1997

Since the World Began: Walt Disney World The First 25 Years
Jeff Kurtti
New York: Hyperion, 1996

Stuart Little: The Art, the Artists and the Story Behind the Amazing Movie
Linda Sunshine, Editor
New York: New Market Press, 2000

Superman: The Complete History
Les Daniels
San Francisco, CA: Chronicle Books, 1998

Talking Animals and Other People: The Autobiography of a Legendary Animator
Shamus Culhane
New York: Da Capo Press, 1998

The Tarzan Chronicles
Howard E. Green
New York: Hyperion, 1999

Television Cartoon Shows: An Illustrated Encyclopedia, 1949–1993
Hal Erickson
Jefferson, NC: McFarland & Co., 1995

Tex Avery: King of Cartoons
Joe Adamson
New York: Da Capo Press, 1975

Tex Avery: The MGM Years, 1942–1955
John Canemaker
Atlanta: Turner Publishing, 1996

That's All Folks!: The Art of Warner Bros. Animation
Steve Schneider
New York: H. Holt, 1988

That's Enough Folks: Black Images in Animated Cartoons, 1900–1901
Henry T. Sampson
Metuchen, NJ: Scarecrow Press, 1998

Toy Story: The Art and Making of the Animated Film
John Lasseter and Steve Daly
New York: Hyperion, 1995

Walt Disney and Assorted Other Characters
Jack Kinney
New York: Harmony Books, 1988

Walt Disney and Europe
Robin Allan
Bloomington, IN: Indiana University Press, 1999

Walt Disney's Fantasia
John Culhane
New York: Abradale Press/Harry N. Abrams, Inc., 1983

Walt Disney's Nine Old Men and the Art of Animation
John Canemaker.
New York: Disney Editions, 2001

Walt Disney's Snow White and the Seven Dwarfs & The Making of the Classic Film
Richard Hollis and Brian Sibley
London: Deutsch, 1994

Walt in Wonderland: The Silent Films of Walt Disney
Russell Merritt and J.B. Kaufman
Gemona, Italy: Le Giornate del Cinema Muto, 1993

What Kids Buy and Why: The Psychology of Marketing to Kids
Dan S. Acuff
New York: Free Press, 1997

Windsor McCay: His Life and Art
John Canemaker
New York: Abbeville Press, 1987

The Wonderful World of Disney Television: A Complete History
Bill Cotter
New York: Hyperion, 1997

Scriptwriting

Scriptwriting for Animation
Stan Hayward
London: Focal Press, 1978

Story: Substance, Structure, Style, and the Principles of Screenwriting
Robert McKee
New York: ReganBooks, 1997

The Writer's Journey: Mythic Structure for Writers (2nd Edition)
Chris Vogler
Studio City, CA: M. Wiese Productions, 1998

Post-Production

Audio Post-Production in Video and Film
Tim Amyes
Boston: Focal Press, 1998

Digital Nonlinear Editing: New Approaches to Editing Film and Video
Thomas A. Ohanian
Boston, Focal Press, 1993

Electronic Post-Production Terms and Concepts
Arthur Schneider
Boston: Focal Press, 1990

Guide to Post Production for TV and Film: Managing the Process
Barbara Clark and Susan J. Spohr
Boston: Focal Press, 1998

Nonlinear: A Guide to Digital Film and Video Editing (3rd Edition)
Michael Rubin
Gainesville, FL: Triad Pub. Co., 1995

The Technique of Film and Video Editing
Ken Dancyger
Boston: Focal Press, 1993

Video Editing and Post-Production: A Professional Guide (3rd Edition)
Gary H. Anderson
Boston: Focal Press, 1999

Journals

Animatoon
71-6 Munjung-Dong, Songpa-Ku
Seoul, Korea 138-200
Tel: 822-400-2566, Fax: 822-406-8950

Animation Journal
www.animationjournal.com
AJ Press
108 Hedge Nettle Crossing
Savannah, GA 31406-7220 USA
Tel: (912) 352-9300, Fax: (912) 352-7588

Animation Magazine
www.animag.com
30101 Agoura Court, Ste 110
Agoura Hills, CA 91301-4301
Tel: (818) 991-2884, Fax: (818) 991-3773

Animation Report
20722 Lull Street
Canoga Park, CA 91306-2035
Tel: (818) 713-9701, Fax: (818) 346-1948

Animation UK
Venue Publishing
65 North Road
Bristol, England BS6 5AQ
Tel: 0117-942-8491, Fax: 0117-924-0521

Animation World Network
www.awn.com
6525 Sunset Blvd. Garden Suite 10
Hollywood, CA 90028
Tel: (323) 464-7805, Fax: (323) 466-6614

Cartoon Research
www.cartoonresearch.com
7336 Santa Monica Blvd. #650
West Hollywood, CA 90046
Tel: (323) 658-8892

Cinefex: The Journal of Cinematic Illusions
P. O. Box 20027
Riverside, CA 92516-0027
Tel: (909) 788-9828

Computer Graphics World
www.cgw.com
10 Tara Blvd., 5th Floor
Nashua, NH 03062
Tel: (603) 891-0123, Fax: (603) 891-0539

Daily Variety
www.dailyvariety.com
5700 Wilshire Blvd., #120
Los Angeles, CA 90036-3659
Tel: (323) 857-6600, Fax: (323) 857-0494

Digital Video Magazine
www.livedv.com
600 Harrison Street, Suite 500
San Francisco, CA 94107
Tel: (415) 905-2200

Hollywood Reporter
www.hollywoodreporter.com
5055 Wilshire Blvd, 6th Floor
Los Angeles, CA 90036-4396
Tel: (323) 525-2000

Kidscreen
www.kidscreen.com
Suite 500, 366 Adelaide St. W.
Toronto, Ontario, M5V 1R9 Canada
Tel: (416) 408-2300

Millimeter Magazine
www.millimeter.com
6700 Fallbrook Ave, Suite 222
West Hills, CA 91307
Tel: (818) 763-2874

Toon Magazine
www.toonmagazine.com
2828 Cochran Street, Suite #481
Simi Valley, CA 93063
Tel: (805) 526-7287

ToonTalk
www.donbluthstoontalk.com
3416 S. 48th Street, Suite 2
Phoenix, AZ 85040
Tel: (888) 363-8343

Whole Toon Catalogue: Access to Toons
www.facets.org
Facets Multi-Media
1517 W. Fullerton Ave.
Chicago, IL 60614
Tel: (800) 331-6197, Fax: (773) 929-5437

Key Organizations

Academy of Motion Picture Arts and Sciences
www.oscars.org

Academy of Television Arts and Sciences
www.emmys.org

The Animation Academy
www.theanimationacademy.com

Animation Film Society
www.asifa.com

Animation Nation
www.animationnation.com

Director's Guild of America (DGA)
www.dga.org

Motion Picture Screen Cartoonists Union #839
www.mpsc839.org/mpsc839

Producer's Guild of America (PGA)
www.producersguildonline.com

Screen Actor's Guild (SAG)
www.sag.org

Visual Effects Society
www.visual-effects-society.org

Women in Animation
www.women.in.animation.org

Women in the Realm of Computer Visual Arts, Effects, and
 Animation
www.animation.org/women

Index